'The Gates of Hell' by Auguste Rodin

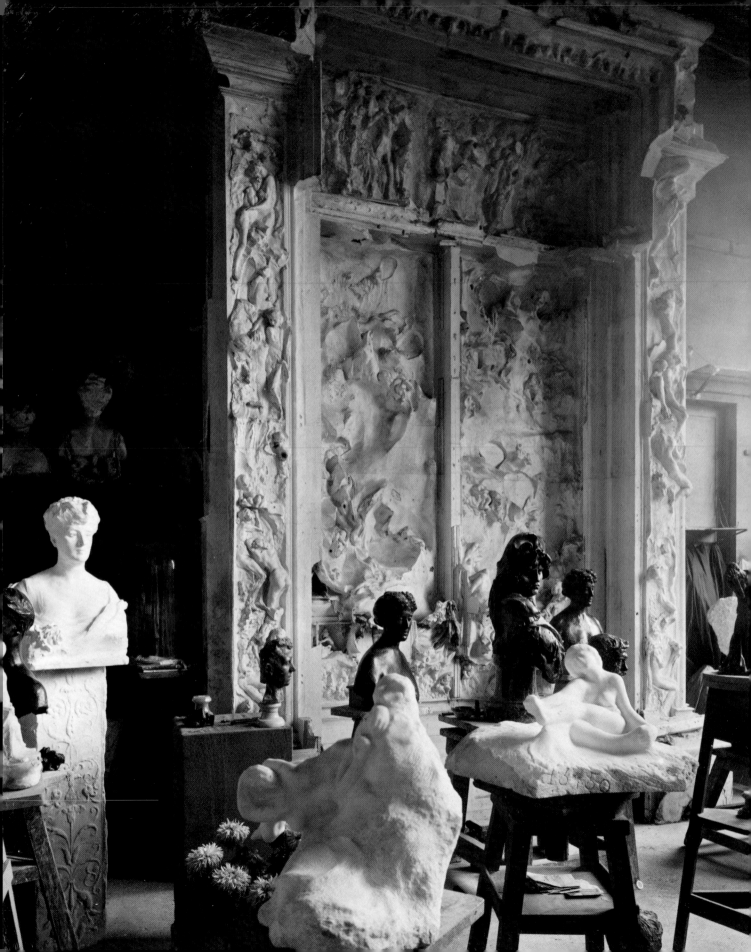

THE GATES OF HELL
BY AUGUSTE RODIN

Albert E. Elsen

Stanford University Press Stanford, California 1985

Stanford University Press, Stanford, California

© 1985 by Albert E. Elsen

Printed in the United States of America

CIP data appear at the end of the book

Published with the assistance of the
Cantor Fitzgerald Foundation

Frontispiece:
'The Gates of Hell' in Rodin's studio at the Dépôt
des Marbres, after 1900. Photo Vizzavona.

Preface

I have loved these awesome doors since that winter day in 1949 when I first stood below them outside the Rodin Museum in Philadelphia and was terrified at the prospect of writing my dissertation on *The Gates of Hell*. In one way or another, I have lived with them for thirty-five years, and yet when it comes to lecturing or writing about this great portal there are still exhilarating things to discover, accompanied by inevitable dismay over the inadequacy of one's own language and culture to share revelations. Maybe this is what makes a masterpiece, its inexhaustibility and intimidation of the scholar.

I've seen this work in four of its five bronze casts, and over three decades watched the patinas transform from brown to black to green, and even after the years of dirt and smog the portal not only changes, but in some ways looks better. I've seen the doors in museums and foundries, in plaster and wax, in negative molds and raw bronze sections, and they never fail to surprise. Look at them in the rain or when a winter sun is low and they take on different qualities. Light them at night from below, the way Rodin must have done in his studio a thousand times, and you realize you don't know them as a work of art. Read a poem by Baudelaire or Victor Hugo and suddenly you are aware of passages in the portal you had never focused on before. No other single work of sculpture known to me can so attach itself to a person for life, making constant claims on intelligence, intuition, and feeling and yet remain so fresh, changing as one changes, rewarding age and experience. You don't outgrow *The Gates*, you grow into them.

This is a second book on a great artist's work, not a re-vision of my *Rodin's Gates of Hell* published in 1960. What first encouraged this reprise was the change of administration and positive attitude toward scholarship of Jean Chatelain and Mme. Monique Laurent of the Musée Rodin in Paris. From that time, there has been a more liberal access to the vast archives and sculptures in Paris and Meudon, all of which have served to fill out and correct our understanding of Rodin and his work. One cannot have studied with Meyer Schapiro without living the rest of one's life with the conviction that one can always do something better, and should. Still another incentive was the 1981–82 exhibition and its catalogue, *Rodin Rediscovered*, which I directed for the National Gallery of Art in Washington, D.C. For this exhibition, in 1977 Mr. B. Gerald Cantor commissioned the first lost-wax casting of *The Gates of Hell*, the only one of the existing five bronze casts made by the process Rodin stipulated in writing. It was my privilege to observe the casting at the Fondation Coubertin under the direction of the master founder Jean Bernard and to see the entire portal in plaster and bronze in a more detailed and intimate fashion than I had seen it in 1949–50, when as a Fulbright scholar I studied the casts both in the garden of the Musée Rodin and in the Alexis Rudier Foundry in the Paris suburb of Malakoff. (The second Rudier cast, commissioned by Arno Breker during the Second World War, is now in Zurich.)

Mr. Cantor's decision to donate the fifth, finest, and most complete casting of *The Gates of Hell* to Stanford University has called for an appropriate academic response, which it is my intention this publication will pro-

vide. This book therefore carries with it the joyful gratitude to Mr. Cantor of the entire Stanford University community, past, present, and future.

This new publication on *The Gates* is meant not only to correct but to complement the first study by being far more of a source book. Not only is there a systematic photographic coverage of the doors, but in the text I have given more of the word to Rodin's contemporaries, those who were very much a part of the public for which Rodin carried out his commission, and whose writings reflect a culture and way of looking at art that we will never be able to completely recreate. The story of how the portal was made can now be presented in a more chronological and detailed fashion than was formerly possible, because of the greater availability of information on a subject we will always know imperfectly.

I hope that I have corrected not only my errors in the first book but also the errors of its reviewers. As indicated in my essay on *The Gates* in *Rodin Rediscovered* (on which two chapters in the present work are based), I now believe that by 1900 *The Gates* were complete just as we know them today. Aside from that, despite having had many more thoughts on the portal's meaning and significance, I am content to allow my earlier interpretations to stand on their own. My exemplar is the artist himself, who after twenty years of work on the doors, and seventeen more in their contemplation, must have felt that they were not only an entity in themselves but also a reflection of his life at another time. Not the least motive in writing again on *The Gates of Hell* is one identical to that of Rodin when at the age of seventy he wrote on his beloved cathedrals: "I should like to inspire a love for this great art. . . . But I cannot tell all. Go and see . . . let us study together."

Most helpful to me in doing the research on this book were the efforts of my wife, Patricia, who labored long and well in the archives of the Musée Rodin. Our work in this invaluable resource was made possible by the full and generous cooperation of the museum staff headed by Jean Chatelain and Mme. Monique Laurent, Claudie Judrin, curator of drawings, Hélène Pinet, archivist, and Alain Beausire, documentalist. Our research in France was made possible by the B. G. Cantor Rodin Research Fund, and Mr. Cantor himself was always encouraging and helpful with information. We are likewise indebted to Vera Green, one of Mr. Cantor's curators, for providing us with much-needed information. Mr. Cantor also made possible Bill Schaefer's systematic photographing of the new cast of the portal. Jean Bernard, one of this century's great foundrymen, was endlessly patient and helpful with respect to technical matters concerning bronze casting, and we should also like to thank his Compagnons de Devoir at the Fondation Coubertin for being so informative about the casting process of *The Gates of Hell*. We greatly benefited from the film research done by Bruce Bassett and Giselle Delmotte, which brought many important documents to our attention. Kirk Varnedoe, as always, was helpful in many ways. Joanne Paradise and John Wetenhall provided welcome assistance in putting together bibliographic and chronological documentation. Stanford's excellent art librarians, Alex Ross and Margie Grady, made research a lot more successful because of their tenacity in tracking sources. Gabe and Yvonne Weisberg were thoughtful enough to provide us with important documentation. Gordon Wright gave wise counsel on bibliographic matters concerning the historical background of the period. The writing of this book was greatly facilitated by the generosity of the Stanford University School of Humanities and Science and Dean Norm Wessells, who provided many on the faculty with word processors, thereby bringing a lot of humanists into the world of 1980's technology.

A.E.E.
Stanford, 1985

Contents

Illustrations

'The Gates of Hell' by Auguste Rodin

How 'The Gates of Hell' Came About

On August 16, 1880, Jules Ferry, the French Minister of Public Instruction and Fine Arts, signed a decree that stated: "M. Rodin, artist-sculptor, is charged with the execution, for the sum of 8,000 francs, of a decorative door destined for the Museum of Decorative Arts: 'Bas reliefs representing *The Divine Comedy* of Dante'" (Fig. 1).[1]

Except for historians, few people outside France remember the name Jules Ferry, yet in September of 1880, this chief architect of the secularization of French education and social life under the early Third Republic became the political leader of his nation. In 1880, Monsieur Rodin was a little-known but controversial forty-year-old artist who supported himself by working for three francs an hour in the government ceramics factory outside Paris at Sèvres and doing occasional decorative assignments for private clients. The Museum of Decorative Arts was never built. The "decorative door" cost far more than 8,000 francs, but it was never called for delivery by the government nor cast in bronze before the artist's death in 1917.

These few facts sketch what could have been another dismal but not unusual story of an expensive public artistic project that failed. The postscript to the story is happier, and in its own way ironic. In 1900, the site of the proposed Museum of Decorative Arts became that of a new railroad station, the Gare d'Orsay. Today, after three-quarters of a century of use and disuse, and by a brilliant renovation, it is being transformed into the Musée d'Orsay, which will replace the function of the Jeu de Paume and be a museum of French art of the second half of the nineteenth century. Among other masterpieces it will feature the fully assembled 1917 plaster cast of *The Gates of Hell*, which during Rodin's lifetime was created and worked on in now destroyed studios just a few yards away, and which is the most important work of one of history's greatest sculptors.

In 1880, the French Ministry of Fine Arts was far from casual about giving out major public commissions. Its then Under Secretary of State, Edmond Turquet, must have had a dossier on "M. Rodin," who had petitioned for the commission to do a large decorative bronze portal for the proposed Museum of Decorative Arts. This museum was to be built on the site of the former Cours des Comptes (Audit Court), which had been destroyed by fire during the 1871 Commune. Though we lack a copy of that dossier, we can fill in some of the pertinent details.

François Auguste René Rodin was born in Paris on November 12, 1840, the son of a minor official in the police department and a housewife. From 1854 to 1857 he attended a free government art school, the Ecole Impériale Spéciale de Dessin et Mathématiques, better known as the Petit Ecole, where he won prizes in drawing and showed an aptitude for sculpture. Although successful in meeting the drawing requirements, he failed three times in the sculpture examination when he sought admission to the Ecole des Beaux-Arts, and he did not enter the competition for the Prix de Rome, although it was open to nongraduates of the Ecole. Rodin had therefore no academic art training or honors. Until the outbreak of the Franco-Prussian war, during which he served in the militia, Rodin worked as an artisan, decorating objects and occasionally architecture. He tried unsuccessfully in 1864 to enter a portrait in the public Salon. Following his discharge from the militia in 1870, Rodin found work in

MINISTÈRE
DE
L'INSTRUCTION
PUBLIQUE
ET DES BEAUX-ARTS

SOUS-SECRETARIAT D'ÉTAT
des Beaux-Arts

Bureau du
Personnel et des Travaux
d'Art.

Arrêté.

Le Ministre de l'Instruction publique
et des Beaux-Arts,

Arrête :

M. Rodin, artiste sculpteur, est chargé
d'exécuter moyennant la somme de Huit mille
francs le modèle d'une porte décorative destinée
au Musée des Arts décoratifs : "Bas reliefs représentant
la Divine Comédie du Dante".

La somme allouée (8000 francs) sera imputée
sur le Crédit des Travaux d'Art et Décoration
d'Édifices publics.

Paris, Le 16 Aout 1880.

Fig. 1. Ministerial decree signed in 1880 by Jules Ferry, commissioning Rodin to make the model for a decorative door destined for the Museum of Decorative Arts. Archives Nationales de France.

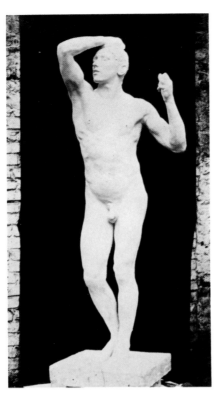

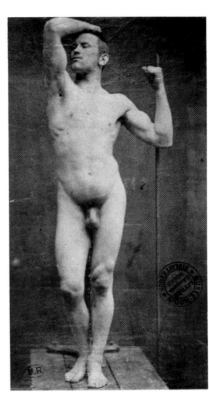

Fig. 2 (*left*). *The Age of Bronze*, 1875–76. Plaster. Photo Marconi.

Fig. 3 (*right*). Auguste Neyt, Rodin's model for *The Age of Bronze*, 1877. Photo Marconi.

Fig. 4 (*below*). *St. John the Baptist Preaching* (back view), 1878. Plaster. A plaster version of *The Kiss* (lacking certain limbs) is at the lower left.

Belgium and spent seven years there, much of this time in partnership with a Belgian artist named Van Rasbourgh. They did a number of decorative sculptures for public and private buildings in Brussels—all signed by Van Rasbourgh according to the terms of their partnership contract. (Rodin signed the works that were exhibited outside Belgium.) During this period Rodin sold to commercial bronze editors, or dealers, some "pastries," that is, appealing heads of young women, and also exhibited some serious portraits in public exhibitions in Paris and Vienna. In 1875 he traveled in Italy. Two years later he made his debut as a "statuaire" (a maker of statues) when he exhibited his free-standing nude figure titled *The Vanquished* (later retitled *The Age of Bronze*) at the Cercle Artistique in Brussels. Both in Brussels and later that same year in the Paris Salon, critics charged that the statue was not modeled but was done from a life cast (Figs. 2, 3). Similar charges were made concerning Rodin's statue *St. John the Baptist Preaching* when it was exhibited three years later (Fig. 4).

To support himself, his mistress, and son after returning to Paris from Belgium in 1877, Rodin continued to work

as a decorative artist. He was employed, along with others, by the sculptor Legrain on the decoration of the fountains for the Trocadero Museum, and beginning in 1878 he returned to work for the third time as an assistant to the sculptor Carrier-Belleuse, who was in charge of ceramic decoration at the government's Manufacture de Sèvres. He submitted entries in competitions for public monuments, notably those for a statue of Lazare Carnot in the city of Nolay, a monument to Denis Diderot for the Boulevard Saint Germain in Paris, others for Jean-Jacques Rousseau and General Jean-Auguste Margueritte, and for *The Defense of Paris* and *The Republic*. His entries seem not to have been ranked even among the finalists. He did succeed, however, in having a statue of D'Alembert placed on the exterior of the rebuilt Hôtel de Ville in Paris.[2]

Up to 1880, then, Rodin's experience and work as a sculptor were hardly impressive, and a less perceptive official than Edmond Turquet would have said at once that Rodin did not have the credentials for a major public commission: he lacked the rigorous official training in such relevant skills as narration, he had worked for twenty years as an artisan and had failed consistently to submit and have work accepted in the Salons or to win any major open competitions, and the exhibition of his first two statues, after he was thirty-seven years of age, had aroused the critical displeasure of many leading sculptors, some of whom had been on the juries of artists that charged Rodin with sculptural malpractice. Surely M. Rodin was a dubious candidate for a major commission in 1880, one who could be taken on faith by only the most perceptive and courageous bureaucrat.

Edmond Turquet (Fig. 5) was a perceptive and courageous bureaucrat, who was not content just to sit in his office and read reports. Trained as a lawyer, under the Second Empire he had been a magistrate and as *procureur* had probably been involved in many official functions that took place at the now-ruined Cours des Comptes (Fig. 6). He owed his appointment as Under Secretary to the extremely able Secretary of Fine Arts, Antonin Proust, an astute art politician who had been one of the first defenders of Edouard Manet. It was Rodin's opinion, expressed some years later, that Turquet knew neither more nor less about art than other government officials, but Turquet at least liked art and artists and sought to surround himself with those he found most interesting, and

Fig. 5. Edmond Turquet, Under Secretary of Fine Arts in 1880. From a pastel.

to buy and commission the best art for his country.[3] He shared Proust's disdain for the Institute (the official Academy of France), as well as for the instruction given by the Ecole des Beaux-Arts, and he was not swayed by the attack of the mandarins on Rodin. Turquet seems to have been alerted by an artist to the controversy over *The Vanquished*, or as it came to be known, *The Age of Bronze*, and went to see it at the spring Salon. According to the American sculptor Truman H. Bartlett, Turquet even urged that the statue be bought by the State: "The Age of Bronze was accidentally discovered by a sculptor who was himself an example of School dislike. He saw its merits and cried its praises to his few friends, some of whom knew Turquet. That official was asked to go and see the figure, and

he did so, and was so struck with its unusual character, that, as acting minister of fine arts he urged its purchase by the buying committee of the state."[4]

Rodin had filled out the government forms by which artists automatically requested that the State purchase their exhibited work. When Turquet learned of the jury's opinion, out of his well-known sense of fairness and justice, he appointed a special committee to investigate the charges, asking former jury members to serve again and to be as objective as possible. His legal experience and political instincts may have also caused him to send an emissary to Brussels to talk with the model, Auguste Neyt, and the captain of this soldier's army platoon.[5] Despite the committee's findings that Rodin "probably" cast from

Fig. 6. The Cours des Comptes after its destruction during the Commune of 1871 (later the site of the Gare d'Orsay).

life, Turquet gave Rodin $300 and paid for a bronze cast made for the State. (It was assigned to the Museum of Modern Art in the Luxembourg Palace and placed in a corner of its garden.) When the same charges were lodged against the *St. John the Baptist* plaster, Turquet repeated the earlier procedure with the same result, the second purchase for the State of a work by Rodin that was confirmed by Antonin Proust.

Rodin was shy and quiet by nature, certainly not a paragon of the aggressive art politician, but after 1877 his ability continually attracted those who either had influence or knew others with power in the Paris art world. It is clear that whenever Rodin thought he needed someone to intervene on his behalf to further plans for his art, he did not hesitate to call on their services. In sum, Rodin was art smart. As evidence of Rodin's attraction to the influential, we have the testimony of Rodin's most knowledgeable biographer, Judith Cladel:

In the late 1870's they began to speak of him in that narrow Parisian milieu where . . . reputations are born. A friend desirous of creating useful connections introduced him to Mme. Edmond Adam in whose home he could meet the most striking personalities in the world of politics, letters, and the arts, especially Gambetta, the king of these gatherings. This politician wanted to see the man about whom he had heard so much praise. The meeting took place during a large soirée given by Madame Adam. Favorably impressed, Gambetta recommended him to his minister of fine arts, Antonin Proust, who became his effective protector and who began by causing the State to acquire the bronze of the St. John the Baptist when it was shown in the Salon of 1881. At the home of this celebrated woman of letters, Rodin met some politicians and eminent administrators in the entourage of Gambetta, among others, Waldeck-Rousseau, Eugene Spuller, several times minister of fine arts, Castagnary, an important art critic, of whom, because of his constant support, and to mark his gratitude, the sculptor executed a bust.[6]

It appears that Rodin actually met Turquet through Turquet's brother-in-law, a painter named Maurice Haquette, whom he had known since 1878 and who was working with Rodin at the Manufacture de Sèvres. Turquet must have been impressed with Haquette's extremely favorable judgment of Rodin's artistic abilities. In turn, eight months before actually receiving the commission, Rodin asked Haquette to write on his behalf to the Under Secretary of Fine Arts when he heard about the commission for the proposed new museum.[7] Rodin told Haquette that the conservative sculptor Paul Dubois, a medal win-

ner in the annual Salons, would be willing to sign such a letter, along with other well-known sculptors who had juried his work, such as Chapu, Falguière, and Moreau, as well as his employer, Carrier-Belleuse.[8] Rodin had enemies, but he also was able to make friends with a number of artists in what was then the establishment.

Thanks to the alert reporting of Truman Bartlett, who in 1887 determined to write a series of articles on Rodin, we have a valuable record, published and unpublished, of how the commission for *The Gates of Hell* came about as seen from three different viewpoints: those of an unnamed sculptor and acquaintance of Rodin (possibly Jules Desbois), Edmond Turquet, and Rodin himself. In Bartlett's files, housed in the Library of Congress, is a printed article, unsigned and lacking identification and date of the publication in which it appeared but presumably dating from before 1887, from which Bartlett quotes in his own published series of articles:

It needed an unusual independence on the part of Turquet to have anything to do with Rodin, as he ran the risk of offending all of our art authorities. Turquet was an independent in art matters, and acted for the interests of the best art. He did an immense deal of good; was a valiant friend of Rodin, and deserved all praise. The Salon jury would only give Rodin a third class medal, while he ought to have had the Medal of Honor when he exhibited "The Age of Brass" [*sic*] and the "St. John." But Turquet bought the statues all the same. It is perhaps not too much to say that Turquet created Rodin. [Bartlett adds a comment here: "I know Rodin thinks so."] . . . Rodin appeared with such surprising abruptness as a personage that it took nearly everyone off his feet, and opposition was all that was thought of. He has been more cruelly persecuted than any of his predecessors. His enemies were determined to kill him and they tried their best. I think they would have succeeded if it had not been for Turquet. He put on the committee to examine the "Age of Brass" the very men who opposed Rodin the strongest, and then they had to give an unbiased opinion.

A handwritten note by Bartlett also adds this explanation: "The majority of the jury was composed of the graduates of The School, Guillaume, the director of the school and one of its most eminent graduates, being its chairman. Dubois, now the director and regarded by popular opinion as the greatest modern French sculptor, was also a member of the jury. Turquet also rescued Rodin in the John the Baptist case, where it was argued by the jury that the work was life cast because Rodin used a big model."

Further amplification comes in a note made by Bartlett

after conversations he had with Rodin in November and December 1887:

No one outside of the little circle of Rodin's intimate friends had the slightest idea of the importance of the commission that he received from Turquet. And it is doubtful if anyone, save the sculptor himself, was aware of what he proposed to or could make of it. It is true that he explained to M. Turquet the plan he proposed to carry out, and this official had the most unlimited confidence in the sculptor, for he says, "I was sure that I had discovered a great artist, fully capable of executing any task confided to him."

A crucial question in the history of the commission is just whose idea was it for Rodin to use Dante's *Divine Comedy* as the subject for a decorative portal to go in front of a new museum of decorative arts? Most of the evidence points to Rodin as the one who came up with the idea, and Turquet gave it his assent. For example, it seems clear that Turquet arranged the commission for the doors solely for Rodin's benefit, and that there was no public announcement of a competition. If there had been public notice of a competition, tradition and convention would have dictated that the subject be set by the commissioner, in this case, the Ministry of Public Instruction. About the idea for the doors, Bartlett is contradictory. In his series of articles on Rodin in the *American Architect and Building News* in 1889 he says: "Imagine, then, his indescribable astonishment, when, on answering a note from M. Turquet, he appeared at that official's office in July, 1880, and heard these words: 'I wish to give you a commission to execute the model of a great door for the Museum of Decorative Arts, the subject to be taken from Dante's Inferno.'"[9] This statement does not correspond to the fact that Rodin knew by January of 1880 about the proposed commission, for which he seems to have been the only candidate, and to the wording on the commission, which specifies *Divine Comedy* but not *Inferno*; nor does it agree with the notes of Bartlett's conversations with Rodin. Therein Bartlett quotes the sculptor, "I was glad to take [Bartlett then crossed out this word and continued] accept the Inferno as a starting point." From what must have been the results of interviews with Turquet and Rodin we have the following in Bartlett's handwritten notes of 1887: "Turquet says, 'After the appearance of the Age of Brass and the St. John, and after I had bought them for the State, there was no doubt that I had discovered in Rodin a great artist. I had no hesitation in giving him a com-

mission for a great door for the Arts Décoratifs. This door will be a masterpiece. It is so considered by all the art world of France that admires it in his studio, and for me it was a real joy.'"

Elsewhere in his papers, however, Bartlett also wrote:

Turquet was certain that he had found in Rodin a genius of the first order and he determined, in the face of all organized opposition, to send him flying into fame and futurity. In July, '80 he sent for the sculptor and gave him an order for an immense door in bronze, destined for a proposed museum of Decorative Arts. The sculptor selected as a starting point for his design, his favorite work in literature, Dante's Inferno, adding to it any fancy of his own that seemed connected with the subject, and all to be executed from the almost imperceptible bas-relief up through all other grades of relief to the full round figure, and all smaller than life.[10]

Talking to a reporter in 1900, Rodin recalled the circumstances of his commission thus:

It is to M. Turquet that I owe this commission . . . and also M. Paul Dubois. After the ridiculous accusations of life casting that had been addressed to me, and after he was convinced that these were ridiculous, M. Turquet bought my Age of Bronze . . . and decided to give me a commission in the name of the state. They left it to me to choose my subject. As much as possible, I had decided to come up with a subject such that the lies thrown at me could not be repeated. At that moment it was a question of a palace of decorative arts that was to be constructed on the site of the former Cours des Comptes where the Gare d'Orsay is today. . . . They asked me to execute a monumental portal that had been planned for in the project of the engineer Berger. I accepted, and with the agreement of M. Turquet, I decided to make The Gates of Hell.[11]

Rodin's later comments, made in an interview with the writer Gustave Coquiot that was published in 1917, alter the tone though not the broad details of the circumstances:

The Age of Bronze had attracted the attention of Antonin Proust and then of his Under Secretary for Fine Arts, Turquet. They both dreamed of asking me to do "something," they didn't know what. And Turquet was wary. The story of the supposed life cast had bothered him a good deal. (He did not want to go into this like a blind man and he checked on me. If he was mistaken his minister would be out.) Turquet took the counsel of others. What was he risking, and what was he not risking? Being aware of these terrible perplexities . . . I decided to come to the aid of this politician. . . . I proposed to him that for a paltry sum and far from what people suppose even today I would model a gigantic door that would be The Gates of Hell—that is to say, all the most moving details of Dante's great poem. My listener thought I was crazy. (One usually did far fewer figures

in a commission.) He expressed his astonishment and stupefaction. Today he must regret having entered into negotiations with me at all and certainly he must privately curse the incomplete information that he had on me, none of which, I am sure, had represented me as a sort of strange, bizarre artist, given to hallucinations from which one could not draw anything reasonable. For an instant I was amused by his emotion: then, softly, slowly, I told him my idea of this Porte de l'Enfer. It was my salvation, my hope and chance of success. But certainly, I continued, though they have been able to accuse me of having cast from life a statue that is life-size, no one—not even the most obtuse of my enemies—will believe that I life cast these hundreds of statues in order to reduce them to the necessary dimensions for the ensemble of my door! Turquet did not take his eyes off of me. He listened, thought, then understood— without making allusion to the formidable enterprise that I would assume for a relatively minimal sum, he declared himself satisfied. That is the true story of my first commission.[12]

Judith Cladel's version of the fateful meeting between Rodin and his sponsor (as given in her 1917 book on Rodin) also mentions the numerous small figures: "In his genuine desire to atone for the wrong done to Rodin in the eyes of public opinion, he . . . ordered from him a great ornamental piece, a door destined for the Palais des Arts Décoratifs. . . . 'And what will you represent on the door?' enquired the Under Secretary of State. 'I'm sure I don't know,' replied the artist. 'But I shall make a quantity of little figures; then no one will say that there are casts taken from life.' "[13] A year later, in 1918, the excellent critic Camille Mauclair, who reliably printed many important conversations with Rodin, published a book in which he has Rodin responding to Turquet's query of what will be done: "I am ready for it. But, in order to really prove that I do not cast from nature, I will make small bas-reliefs, a vast work with small figures, and I think I will borrow the theme from Dante."[14]

Rodin and Turquet were friends for years, and the latter at times came to the sculptor's defense, notably during the difficult affairs of the *Monument to Balzac* and the installation of *The Thinker* before the Panthéon in 1906. At no time is there a record that Turquet claimed that he or Proust thought up the theme for the portal. (Bartlett seems to have been the only writer to assign to Turquet origination of the portal's theme, and even he is not consistent.) Somewhat curiously, though Rodin did portraits of Maurice Haquette and Antonin Proust out of friendship and in gratitude for their help, he never did a portrait of Edmond Turquet, who had done so much for him.

Fig. 7. *Dante*, by Jean-Paul Aubé, installed before the Collège de France in 1880.

Rodin's selection of Dante for the theme of his doors was obviously acceptable to a ministry that in 1880 had purchased for the State Jean Paul Aubé's statue of Dante, which still stands in public before the Collège de France (Fig. 7). Jules Ferry and other leaders of the Third Republic were strongly anticlerical, but Dante's Catholicism was not objected to, perhaps because his *Divine Comedy* had long been a favorite source for French artists.[15] Evidence from Rodin's biographers and reporters indicates that from at least 1875, the year Rodin visited Italy, he was an avid reader of Dante's poem. It provided him with a theme that was both epic in scope and well known to the people, two requirements that he believed were necessary for a public commission. As early as 1876, Rodin was working on a life-size sculpture of Dante's Ugolino, and while they are undated, his many drawings inspired by *The Inferno* could have included those that preceded the actual commission.

Judith Cladel is the only writer of Rodin's time who ventured to speculate on why the sculptor did not choose another literary source. In the 1917 volume she says:

Rising at four in the morning, as he had done in his youth, he studied the plans and details of his great work. He had announced a series of little figures. How was he to group them? Of what legendary theme, what theme of history or poetry, should he make use in order to realize his program? He had never ceased to be a passionate reader. He read especially the Greek poets and dramatists, the Roman historians, the old French chronicles, Dante, Shakespeare, Victor Hugo, and Baudelaire. He did not wish to draw the subject of his future work from Homer, Aeschylus or Sophocles; The School of the Beaux-Arts had so abused the theme of the antique . . . that it had entirely lost its freshness. The moderns attracted him less, but he was obsessed by the . . . "Divine Comedy" of Dante.[16]

In a later volume on Rodin, Cladel described Rodin's choice of Dante as reflecting his personal identification with the theme of human rebellion against divine authority:

[*The Divine Comedy*] haunted him from the time he first read it. . . . Between Dante and him there existed secret rapports, a wedding of imagination and realism, a conciseness of thought that regarding human passions retains only the essential. It was the eternal character of the Dantesque poem that seduced and subjugated the sculptor. . . . The monument that he was going to erect would be of an internal drama, the revolt of man against the supreme power—which in his youth had often obsessed his religious spirit. This would be *The Gates of Hell*.[17]

Rodin himself told Bartlett: "Dante is more profound and has more fire than I have been able to represent. He is a literary sculptor. He speaks in gestures as well as words; is precise and comprehensive not only in sentiment and idea, but in the movement of the body. I have always admired Dante and have read him a great deal, but it is very difficult for me to express in words just what I think of him or have done on the door."[18]

From several of the foregoing accounts it is clear that for Rodin the commission was above all the opportunity to vindicate himself as an artist, and the key to his future success. He needed an epic theme that provided the chance to work in relief on a large scale but with many small figures. These were his incentives rather than a burning sense of wanting to say something important to the world about life and the role of the artist in society. It tells us something important about Rodin that these incentives would evolve during the process of creating his monumental work. If he had succeeded in becoming an Ecole des Beaux-Arts student at seventeen, he would have proceeded differently, if indeed he had been able to attract Turquet to his art.

2

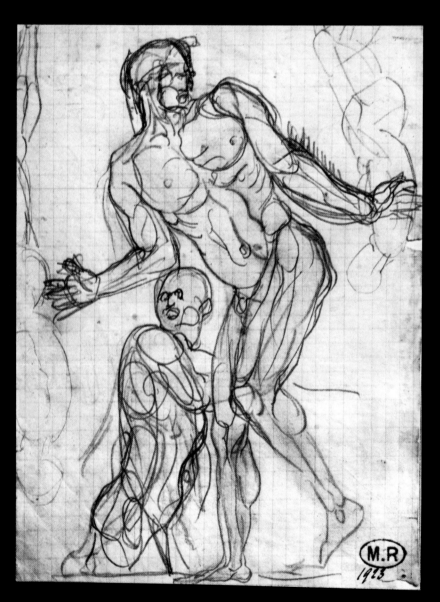

Fig. 8. Two male nudes,
c. 1880. Ecorché drawing mode,
pencil. Musée Rodin.

Living with Dante Through Drawing

By his own account, Rodin spent a whole year seeking to realize his vision of Dante in drawings. Whether that year began in January 1880, by which time it seems he could have been aware that he would get the commission, or in August, when the official document was signed, is hard to say. Reason dictates that the first of the drawings specifically inspired by the prospect of doing the doors would have come nearer to the former date, as Rodin was embarking on a new and awesome project, of a size that he had never before undertaken. In that year Rodin lived with Dante's *Inferno*.

Judith Cladel, Rodin's close friend and faithful but not infallible biographer, drew this picture about Rodin's subject: "He had read and reread it, and made a sort of commentary in the form of innumerable sketches which he jotted down mornings and evenings at table, while walking, stopping by the wayside to dash off attitudes and gestures on the leaves of his notebook."[1] She described how he began to work: "He examined hundreds of sketches that he had accumulated over the years, and made innumerable others. At night, even at the table, between his wife and son, he covered with drawings the least scraps of paper that came to hand. He filled copybooks and penny notebooks. . . . The ruled lines of the simple paper on which the drawings were done would show through the penciled lines and Chinese ink."[2] Rodin "stripped away the poet's synthesis of all transitory elements and attached himself solely to the representation of the world of feelings and passions of the human figure that Dante created. . . . His own art offered him only two means of translation: movement, and the expression of the living

form that the soul, the inner modeler, fashions in its resemblance."[3]

Cladel was much younger than Rodin (she was born about the time he began work on *The Gates of Hell*), but she had the advantage of extensive and direct access to him, and she was probably the first person to see all of the nearly eight thousand drawings he left to his museum. Until unfairly dismissed by Léonce Bénédite, who was the first director of the Musée Rodin, she was the first curator of Rodin's drawings, collecting and numbering them, and recovering some that had been illegally removed from his studios while he was alive.[4] Her writings contain many important points regarding not only the drawings in question but also Rodin's method of work.

Rodin always kept his drawings, and years after they had been made he would rework them. With rare exceptions, he did not date his drawings, perhaps because he generally did not regard a drawing as finished or unalterable.[5] This meant that they were susceptible not only to rectification and amplification but also to identification with ideas or names that occurred to him over time as he perused his albums or portfolios. Rodin began his drawings done from imagination as anatomical sketches (*écorchés*) that showed the figure in generalized outline with its most prominent musculature. In this first state there was no refining of facial features, for example, but only a fixing of the pose by establishing the location in space of the movable joints (Fig. 8). The reutilization of these first states is one reason why Cladel could refer to the Dante drawings as commentaries rather than as illustrations. After the first écorché sketch, Rodin might refine

the penciled outlines into more fluid inked contours, add hatchings to suggest shadows and directions of bodily planes, and apply watercolor shadows and white gouache highlights. His power to "generalize," as Cladel puts it, is a crucial concept, for it helps to explain why the same drawing or sculpture could receive so many different titles over the years from the artist and his friends. By reworking, Rodin thus was able to avoid what Cladel calls the transitory. He also omitted accessories such as costumes and objects, which tend to give figures specific identities. Even when he intended a final sculpture to be clothed, he would begin by drawing the nude figure and then "robe" it in shadows rather than costumes. To that generalizing capability might be added Rodin's inclination toward the equivocal in his story telling. Just as Picasso would later do, he would sometimes (as in *The Kiss* and *The Thinker*) set up a provocative pose or situation whose meaning or conclusion was not explicit. It would be susceptible to more than one interpretation depending upon the beholder's imagination.

Related to this power to generalize was Rodin's inclination with a complex subject such as Dante's *Inferno* to search out underlying and fundamental themes, notably those involving feelings and passions. He sought the timeless and universal (which he had been encouraged to do by his formal training), but instead of recourse to the standard or academic repertory of approved art poses, he preferred personal discoveries resulting from his study of the body. In turn, these studies focused on how movement gave expression to the figure. For Rodin, it was a matter of finding the eloquent movement first; a title could follow at any time. Unlike Blake, for example, Rodin did not have a literary imagination. One of his great gifts was for making études, studies of a disinterested nature for which a title was unnecessary. He believed that one should work and an idea or theme would come in the process, or after.

Rodin's own copy of Dante's *Divine Comedy*, translated by Rivarol in the eighteenth century, and the only one the artist ever used, has been lost (at least since 1949, when I was so informed by the late Marcel Aubert, then director of the Musée Rodin). In 1897, Rodin agreed to the facsimile publication of over one hundred drawings, many of which came from the time of his "living with Dante."[6] These, along with some that were published by contemporary writers as sources for the doors, and others in the

Fig. 9. *Dante and Virgil*, c. 1880. Pencil and ink. Musée Rodin.

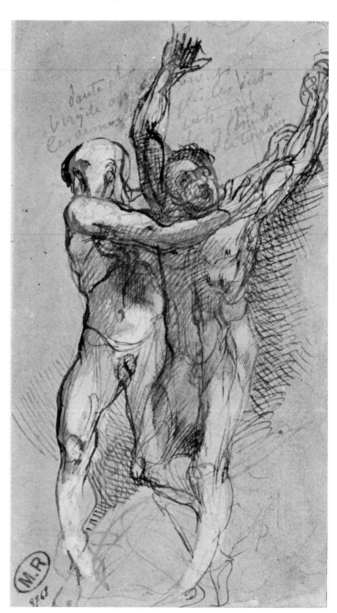

collection of the Musée Rodin, give us a good idea of what in the *Inferno* did and did not inspire Rodin.

For Dante the journey through Hell, Purgatory, and Paradise allegorized the achieving of salvation by ascending from the material world to an ultimate mystical union with God. Rodin's drawings do not indicate that he was concerned with the religious object of Dante's voyage: there are very few drawings that can be safely associated with *Purgatory* and *Paradise*, and no credible evidence exists to suggest that Rodin gave serious thought to interpreting all three parts of Dante's poem.

There are a few drawings whose theme is the isolated focus on Dante accompanied by Virgil in which Rodin's interest is in Dante's emotional reactions to his journey. Unlike Doré's fully staged illustrations, what inspired these dramatic responses is never shown by Rodin. In one drawing of two naked males in movement (Fig. 9), a determined Virgil pulls onward a frightened Dante whose arms are upraised. Rodin wrote on the drawing: "Dante et Virgile app[rochent?] les demons." (Much of the rest is not intelligible but it looks like "moment que les deux . . . le terrain.") In reworking the drawing Rodin drew over the words in some places. While this drawing shows two vigorous and athletic male figures, there are drawings titled by Rodin with the names of the two poets that are of a very different nature and suggest a homosexual relationship. One (Fig. 10), titled "Dante et Virgile" in the 1897 publication of Rodin's drawings, presumably shows the Roman guide carrying the limp and decidedly effeminate form of his companion, who faints frequently during the poetic voyage. In other instances, Rodin couples Dante and Virgil in the manner of lovers, and the drawings are interchangeable with the heterosexual studies presumably for Paolo and Francesca.[7] One of these in fact is inscribed on the margin "Françoise Paulo" and "Virgile et Dante," with the phrase "l'amour profond comme les tombeaux, Baudelaire" on the border (Fig. 11). This is one of the very rare drawings in which there is a comparable sculpture in *The Gates*: the couple at the bottom of the bas-relief on the right side of the frame (Fig. 174). The additional notation in the bottom margin of this drawing, "Abruzzesi trés beau," strongly suggests that it was done from life, as Mme. Abruzzesi was one of Rodin's favorite and most famous models for many years. Since the bas-relief was made probably between 1881 and 1882–83, one

can infer that even when Rodin had given up making drawings from Dante after that first year, he continued to imagine the poet and their "secret rapports."

Discussing the Dantean origins of the sculpture with Truman Bartlett in 1887, Rodin said: "I never so much as thought of Beatrice, though I know it is a beautiful subject. Perhaps I may include it yet, but it will be difficult to treat, because I only made nude figures for the door, and I don't feel like representing her nude. I can't think of her as a nude figure, and for the door she could not be made otherwise. Besides, she is an angel and I don't like angels as bodies, only as heads."[8]

Ten years after this statement, when the facsimile edition of Rodin's drawings appeared, no. 96 in the list of

Fig. 10. *Virgil Carrying Dante, Who Has Fainted*, c. 1880. Pencil, ink, and ink wash. Location unknown.

Fig. 11. *Virgil and Dante / Paolo and Francesca*, c. 1880. Pencil and ink wash. Musée Rodin.

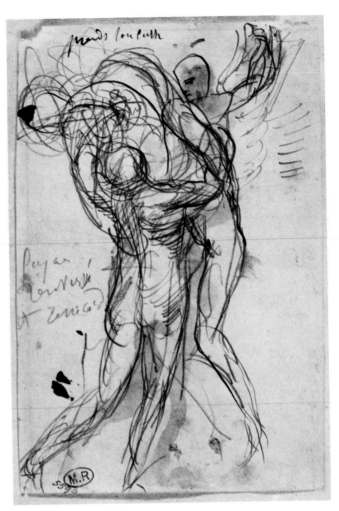

Fig. 12. *Dante and Beatrice*, c. 1880. Pencil and ink. Musée Rodin.

illustrations bore the title "Dante et Beatrice" (Fig. 12). It is a pencil drawing showing a man reaching up for a winged figure, over whose head is written (in ink): "Prends ton luth"—the opening words of the muse to the poet in Alfred de Musset's poem, *La Nuit de mai*. (Rodin inscribed an entire stanza from this poem on one of his carvings, *The Poet and His Muse*.) It seems probable that the title as listed was only applied in 1897, either by Rodin himself because it occurred to him at that point long after the drawing was made, or with Rodin's permission because, as advertised in the preface, the collection was intended to be a reflection of Rodin's early thoughts and work in preparation for the portal. It is quite possible that some of the drawings in the volume were begun before 1880 as problems in the anatomy and composition of two moving male figures, or simply as imagined paired expressive movements. Whatever the case for this particular drawing, some others seem to have been directly inspired by the poem. One drawing of a group of several drawings showing two or three passively posed men, similar to Dante and Virgil, is annotated, "Ombres parlant à Dante" (Fig. 13). *Ombres* (shades) are the souls of Dante's dead who speak to him during his journey, but unlike the poet, Rodin did not give them specific identities. Another notation on the drawing makes it clear that Rodin thought of this composition in connection with the portal: "Make a sketch with bas reliefs of 3 or 2 persons," and in parenthesis, "La porte." No such sketch has been found, but the postural unison of the male figures in the drawing anticipates, if it did not influence, Rodin's triplication of the same figure for *Three Shades* atop the final portal.

When Dante was about to enter Hell, he came to a gate over which was written the famous inscription:

> THROUGH ME YOU ENTER THE WOEFUL CITY,
> THROUGH ME YOU ENTER ETERNAL GRIEF,
> THROUGH ME YOU ENTER AMONG THE LOST.
> JUSTICE MOVED MY HIGH MAKER:
> THE DIVINE POWER MADE ME,
> THE SUPREME WISDOM, AND THE PRIMAL LOVE.
> BEFORE ME NOTHING WAS CREATED
> IF NOT ETERNAL, AND ETERNAL I ENDURE.
> ABANDON EVERY HOPE, YOU WHO ENTER.[9]

Whether or not Rodin thought of his commission as the poetic equivalent of the Dantean gateway is hard to say. Doré showed the entrance to Hell as a great cavelike

Fig. 13. *Shades Speaking to Dante*, c. 1880. Sepia, ink, and gouache, over pencil. Fogg Art Museum, Harvard University. Bequest of Grenville L. Winthrop.

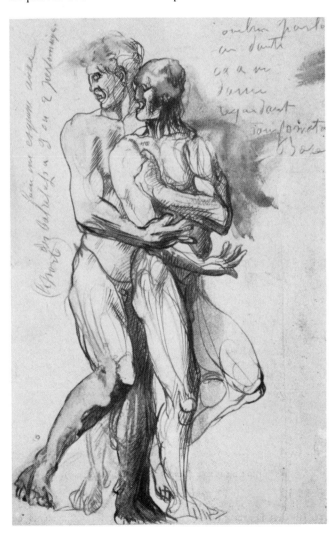

opening in a cliff with an inscription over it;[10] one contemporary commentator who saw the doors in Rodin's studio says that the words "Lasciate ogni speranza, voi ch'intrate" were in fact inscribed on the cornice of the doors in plaster. Other contemporary critics speak of the inscription as being embodied in the attitudes of *The Three Shades*, and certainly there is no trace of any inscription ever having been carved on or attached to the cornice or entablature of the original plaster portal. Indeed, the very design of these areas is good evidence that the dissenting commentator was mistaken. But certainly it can be said that Rodin was very mindful of Virgil's explanation of the inscription to Dante since it set the tone, expression, and movement for the figures in the medieval and modern infernos: "We have come to the place where I have told you you will see the wretched people who have lost the good of intellect." Perhaps Rodin used these last seven words to justify his intention to focus on movement motivated by strong feelings.

There are a number of drawings of single despairing or physically agitated figures who, although they are unnamed, invite comparison with those in Dante's Limbo as well as other circles. Rodin gives no indication of the external or internal cause of the figures' punishment; they lack both specific identities and traceable histories and are propelled by invisible forces. The drawing of a man running with upraised arms (Fig. 14) carries the notation "homme renversé à changer les jambes" (Man inverted to change the legs). Of all the figures in the sketches, this running man comes closest to having a counterpart in the final portal. It is the figure just above the head of Fortune in the lower left door panel who seems to be falling (Fig. 183). The position is reversed: the right leg no longer supports but is upraised and almost parallel to the left leg. In two other drawings—both perhaps dating to 1875 and very like Michelangelo—the arms are raised but are in different planes and are bent in a self-address that compacts against the muscular body. The positions are lunging and stationary but not static.

Though Dante describes crowd scenes, and the doors are in fact full of figures, there are few drawings of groups of women and children. The few crowd drawings are invariably of men sitting or standing despondently. An important exception to the sexually segregated crowd scenes in the drawings apparently relates to the entrance

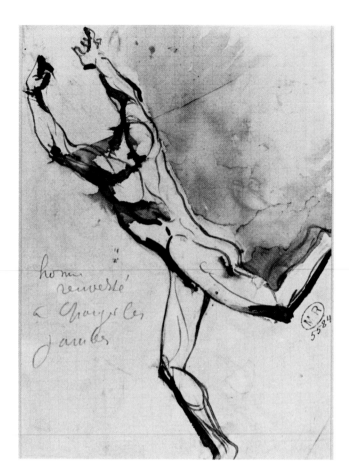

Fig. 14. Nude male running, c. 1880. Pencil, pen and ink, and ink wash. Musée Rodin.

to the Second Circle of the *Inferno*, which contains the souls of those guilty of carnal sin: "There stands Minos, horrible and snarling: upon the entrance he examines their offenses, and judges and dispatches them according as he entwines. I mean that when the ill-begotten soul comes before him, it confesses all; and that discerner of sins sees which shall be its place in Hell, then girds himself with his tail as many times as the grades he wills that it be sent down. Always before him stands a crowd of them; they go, each in his turn, to the judgment; they tell, and hear, and then are hurled below."[11] (Rodin used the eighteenth-century translation of Dante's *Inferno* by Rivarol, who has Minos seated: "Assis à la porte, il pèse les crimes."[12] It is thus that Rodin would have conceived the infernal judge.)

This drawing (Fig. 15) may have been one of the critical

Fig. 15. *Minos*, c. 1880. Pen and ink, and ink wash. Musée Rodin.

drawings done before Rodin worked on the portal as a whole, or at least on the upper section of the tympanum of *The Gates*, where *The Thinker* sits, and it would appear to be one of the few drawings in which Rodin roughed out an entire scene involving a setting and a large number of figures. The relatively shallow space and the dense packing of the figures in overlapping tiers relate the drawing to some of the reliefs the artist synopsized in his architectural sketches. The drawing is titled "Minos" in the 1897 volume, but the scene could represent any number of situations involving a fateful judgment—the Judgment of Solomon, for example—and it is perhaps significant that if the seated figure was indeed drawn as Minos, Rodin did not follow Dante in showing him as part serpent. In the foreground a nude woman is falling, her right arm upraised toward the confessor-jurist as if indicating the source of her despair. At the lower left sits a shaded nude figure, head resting on what looks like both hands. Rodin often used this sort of figure to anchor a group composition in one of its corners, but in this instance it curiously echoes the central seated figure and emphasizes the contrast with the movement of the other figures. The effect is carried even further in the tympanum. The drawing may have been intellectually crucial in the evolution of *The Gates of Hell*, for it shows Rodin equivocating when it comes to following Dante's view of the netherworld. It may have been a special case of Rodin's tendency to "generalize." He had to make a fundamental decision concerning fidelity to his literary source and Dante's personal theology. He appears to have opted for a less specifically medieval interpretation of humanity's fate beyond the tomb.

Virgil pointed out to Dante more than a thousand souls of carnal sinners in the Second Circle. Rodin seems never to have titled his drawings with such names as Semiramis, Helen and Paris, and Cleopatra, even though violence and tragedy attended their deaths. In the Second Circle, Rodin was taken with the story of Paolo and Francesca—Rodin's selection of this theme to the exclusion of many others was not uncommon in eighteenth- and nineteenth-century interpretations of *The Divine Comedy*[13]—but instead of showing the moment when the lovers first appeared to Dante "lashed by the black air," he chose to show them at an earlier time when, as they read of Lancelot together, they were overcome with love: "When we read

how the longed-for smile was kissed by so great a lover, this one, who never shall be parted from me, kissed my mouth all trembling . . . that day we read no farther in it."[14]

Doré and others before Rodin who illustrated the story of Paolo and Francesca liked to dramatize the scene with period costumes, and sometimes showed the jealous husband lurking in the background or emerging with a sword to dispatch his wife and his brother as they embraced. In a number of drawings Rodin imaginatively conjugated the various ways by which the naked lovers could couple as they kissed, such as Paolo at Francesca's side as in the previously cited drawing that also bore the caption "Virgile et Dante," and in the one here illustrated where the woman sits on her lover's lap with her right leg provocatively slung over his right thigh (Fig. 16). Either Rodin trusted that the public knew this story so well that no period reference was needed, or he was generalizing. As Rodin showed a lifelong interest in depicting all phases of love, it is possible that this sketch may even have been done before 1880; but it is the closest sketch to the sculpture that Paolo and Francesca inspired, *The Kiss* (Fig. 70), which was done in 1881, and we know that when Rodin had the opportunity to work from living models he did not rely upon earlier drawings for his final composition. What connects this particular drawing with the famous sculpture, and separates Rodin's interpretation from others, is that Francesca is made to be the more assertive of the two in manifesting her feelings with results that caused Dante to consign the lovers to the circle where reason was subject to lust.

The Third Circle of the *Inferno* is for gluttons and epicures, who are eternally exposed to rain and cold and must exist on a putrid-smelling ground: "Cerberus, monstrous beast and cruel, with three throats barks doglike over the people who are here submerged."[15] A drawing in the 1897 facsimile edition that shows a triple-headed seated man may have been at least partly inspired by Cerberus (Fig. 17). With few exceptions, notably his images of centaurs and serpents, and unlike Doré, Rodin was not given to depicting monsters. In this particular drawing it

Fig. 16 (*facing*). Embracing couple, c. 1880. Pencil, gouache, and ink. Musée Rodin.

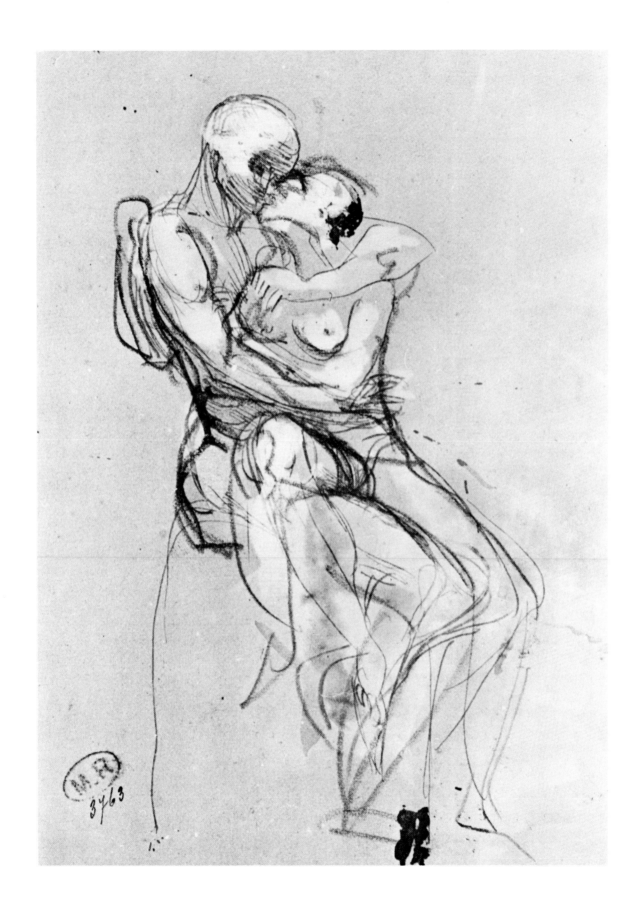

Fig. 17. *Cerberus*, c. 1880. Pencil and red ink. Location unknown.

is as if the three heads were later grafts, a not unusual operation for Rodin to perform with his sketches. The man's pensive posture belongs to a large repertory that includes another Dantean character, Ugolino, and out of which would come *The Thinker*.

Dante introduces the Fifth Circle: "I . . . saw a muddy people in that bog, all naked and with looks of rage. They were smiting each other not with hand only, but with head and chest and feet, and tearing each other piecemeal with their teeth."[16] In Rodin's recorded impressions, the Circle of the Wrathful seems to have been as important as that of the carnal sinners. Sketches of struggling figures are as numerous as those of lovers, and some seem even more inspired. Rodin's most forceful and imaginative expressions are to be found in situations of aggression against the body. Using his écorché, or flayed-figure method, Rodin constructed from imagination grappling pairs of males (Fig. 18). One example, a powerful ink and wash drawing (Fig. 19), shows a headless combatant tearing at the skin of his opponent. (In the 1897 publication this drawing is titled "Les Hérétiques.") The hands are overlarge, and as is often the case in Rodin's studies, not all the fingers are shown, but one has the sense of their being sunk into the other's body. Animated flesh, for example, is simulated by washes applied to rough paper with the colors allowed to run into each other to form provocative patterns inside and outside the contours. The resulting unnatural color and texture could suggest the skin of those condemned never again to see the sun. Whether intentional or not, liberal dosage of watercolor in the area of the legs resulted in the erasing of some of the contour lines, heightening the sense of the violent duo's existence in an inconstant ambiance. The outline of the figure at the left seems as much misshapen by combat or disease as by muscular development. Nothing in Rodin's extraordinary corpus of sculpture is its equivalent.

A few drawings may be assigned with some question to Dante's Fifth through Eighth circles. Some of the qualities of this portion of the *Inferno*, castigation by movement or the contorted body as a reflection of moral anguish, appear in annotated sketches. Rodin did a large number of drawings of centaurs, often coupled with women and never in poses that recall the threatening gestures of Dante's troop. Rodin's inspiration may have been Ovid's *Metamorphoses*.[17] He apparently never sketched

Fig. 18. Two male nudes struggling, c. 1880. Pen and ink.
Musée Rodin.

Fig. 19. *The Heretics*, c. 1880. Pencil, pen and ink, and ink
wash. Musée Rodin.

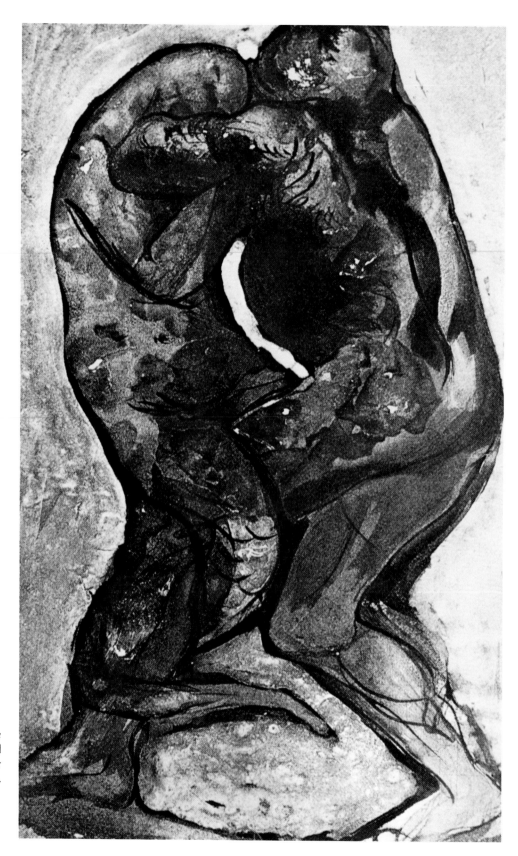

Fig. 20. *Thief Struggling with a Serpent*, c. 1880. Pen and ink, ink wash, and gouache, over pencil. Location unknown.

the ferrying of Dante and Virgil across the Styx by Phlegyas, with the burning city of Dis in the background. This subject had been made famous in the nineteenth century by Delacroix's great painting, which hung in the Luxembourg Museum and would surely have been known to the young sculptor.

The seventh chasm of the Eighth Circle provided a memorable experience for Rodin and clarifies his reference to Dante as a literary sculptor. A thief, Agnello, is being tormented by a serpent:

A serpent with six feet darts up in front of one and fastens on him all over. With the middle feet it clasped the belly, and with its fore feet took his arms, then struck its teeth in one and the other cheek; its hind feet it spread upon his thighs, and put its tail between them, and bent it upwards on his loins behind. Ivy was never so rooted to a tree as the horrid beast entwined its own limbs round the other's; then, as if they had been of hot wax, they stuck together and mixed their colors, and neither the one nor the other now seemed what it was at first.[18]

One of the greatest of Rodin's "black" drawings (Fig. 20) was inspired directly by this passage, or by the one that follows (or both):

[The pierced thief] eyed the reptile, the reptile him; the one from his wound, the other from its mouth, smoked violently, and their smoke met.

. . . They mutually responded in such a way that the reptile cleft its tail into a fork, and the wounded one drew his feet together. The legs and thighs so stuck together that soon no mark of the juncture could be seen; the cloven tail took on the shape that was lost in the other; and its skin grew soft, the other's hard. I saw the arms drawing in at the armpits, and the brute's two feet, which were short, lengthening out in proportion as the other's arms were shortening. Then the hind paws, twisted together, became the member that man conceals, and from his the wretch had put forth two feet.[19]

Rodin's drawing is a violent wedding of the sinner and the fork-tailed serpent, in which their silhouettes merge and the interlocked forms have a common texture. As in the left-hand figure in one previous drawing, the heads are little more than stumps. The figure on the right, presumably Agnello, has a scaly upper body that corresponds to the lower serpentine regions of the other. A strip of white gouache, like a searing light, separates the forms in the center. Although there are powerful movements throughout the composition, augmented by nondescriptive dark-toned brush strokes, the figures themselves seem

firmly rooted to the ground, which increases the appearance of body torsion. Much of the drawing's power and monumentality come from the way the struggling forms fill the field and the fact that Rodin does not trivialize the conception with unnecessary explanatory details. What may have exceptionally inspired Rodin was his fascination with the struggle between the human and the bestial, which was for him analogous with human nature.

In the ninth chasm of the Eighth Circle are those who were "in their lifetime sowers of scandal and of schism." "Truly a cask, through loss of mid-board . . . gapes not so wide as one I saw, cleft from the chin to the part that breaks wind; his entrails were hanging between his legs . . . he looked at me and with his hands pulled open his breast, saying, 'Now see how I rend myself, see how mangled is Mohammed!' "[20] Rodin's drawing with his handwritten notation, "Mahomet, intestins pendant" (Fig. 21), probably started out as a drawing of a figure in a contorted pose. It does not show the hands ripping open the breast, and the hanging intestines, rendered in inked lines and watercolor, are a later addition. The reworked sketch is a good example of how at different times, here at first in the upper part, and then in the abdominal area, Rodin would narrow his focus to just one area of the body, and not concern himself necessarily with making a finished figure. Rodin never made a sculpture whose theme was self-wounding with a display of inner organs, and it seems fair to conclude that, though he was obviously touched by Mahomet's punishment, he never seriously contemplated using the theme in sculpture.

By far the greatest number of drawings done by Rodin that can be traced to a theme in the *Inferno* were inspired by the story of Count Ugolino.[21] Ugolino is first seen by Dante in the last circle of Hell in a frozen waste:

I saw two frozen in one hole so close that the head of the one was a hood for the other; and as bread is devoured for hunger, so the upper one set his teeth upon the other where the brain joins with the nape. . . .

From his savage repast the sinner raised his mouth, wiping it on the hair of the head he had spoiled behind, then began . . . "You have to know that I was Count Ugolino, and this is the Archbishop Ruggieri . . . by effect of his ill devising, I, trusting in him, was taken and thereafter put to death."[22]

Rodin's drawing labeled "Ugolino" (Fig. 22) is one of those that he did on another theme and then, recognizing

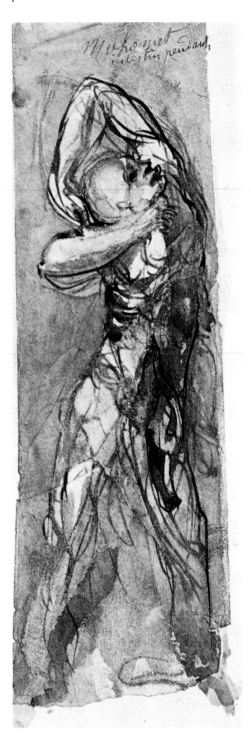

Fig. 21. *Mahomet*, c. 1880. Pen and ink, and ink wash, over pencil. Location unknown.

an association with Dante's text, altered in certain details. As Kirk Varnedoe has shown, this drawing was actually a sketch of a sixteenth-century Italian relief in the Louvre depicting the corpse of Count Guidon being fought over by St. Francis and devils.[23] By reworking the head of St. Francis at the left and opening the mouth, Rodin transformed a final embrace into the awful repast that was Ugolino's revenge on the Archbishop Ruggieri. He also canceled the arm gestures of the corpse that connoted peaceful repose, and a notation makes it clear that the attendant figures are now phantoms of the dead ("le repas d'Ugolin—les ombres regardent épouvantées"). Rodin probably made this sketch in the late seventies, when he was interested in obtaining commissions for funeral monuments to national heroes. The name of Victor Hugo, who died in 1885, appears along with those of Guidon and Ugolino on the base of the funeral slab. The shallow bas-relief conception of the scene with its uptilted perspective accords with the low relief panels that Rodin was considering in his first architectural drawings of *The Gates* (Fig. 36).

Another sketch (Fig. 23) shows Rodin's conversion of what started out as an écorché drawing of one figure standing over another (in older art this was a victory pose) into the Ugolino theme. The drawing in fact bears two notations: "Ugolin dévorant," at the top, and at the bottom, alongside a smaller sketch of a figure standing over a seated or kneeling figure, "Ugolin interromp son cruel repas." These both recall Dante's first sight of the count gnawing the head of the archbishop. Rodin perhaps also made a connection with the next canto, in which Ugolino tells his tale: what looks like an ink blot on the torso of the larger standing figure can also be read as the form of a child, upright with his legs astride the father's left thigh, grasping his body and looking up into his face. (When a photograph of this drawing was shown in 1950 to the late Jacques Lipchitz, he pointed out Rodin's daring use of spots of ink and watercolor that were like Rorschach blots to stimulate his imagination.) If Rodin did make the connection with Ugolino's tale, the figure lying between the legs of the upright Ugolino could then be a second and older child rather than the archbishop. Although this drawing is a remarkable example, many of the "black" drawings show how Rodin courted and capitalized on accidents. Rodin would have undoubtedly agreed with

Fig. 22. *Ugolino and Archbishop Ruggieri*, c. 1875–80. Pencil, pen and ink. Philadelphia Museum of Art.

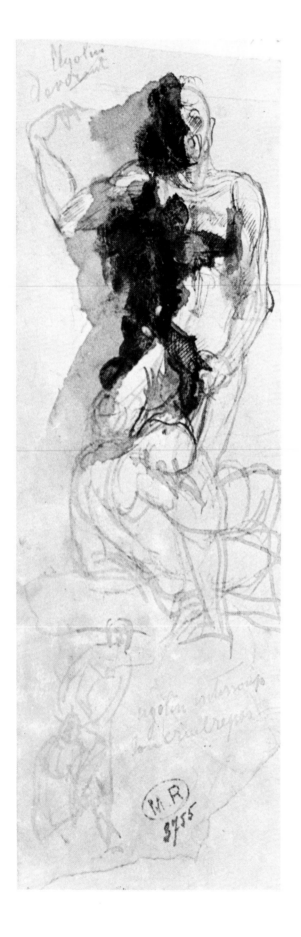

Louis Pasteur, with whom he was later to meet and compare methods, that chance discovery favors the prepared mind. In Rodin's case, part of his mental preparation was the early recognition that art must involve some form of exaggeration if it is to avoid the cold, dry, and lifeless.

Ugolino's account of how he came to be consigned to Hell is one of the most moving in the poem. He tells Dante that as punishment for betraying his native city of Pisa (which in medieval times was the equivalent of betraying one's own family), he and his four children were locked in a tower and left to die:

When I awoke before the dawn I heard my children, who were with me, crying in their sleep and asking for bread. . . . They were awake now, and the hour approached when our food was usually brought to us, and each was apprehensive because of his dream. And below I heard them nailing up the door of the horrible tower; whereat I looked in the faces of my children without a word. I did not weep, so was I turned to stone within me. They wept, and my poor little Anselm said, "You look so, father, what ails you?" I shed no tear for that, nor did I answer all that day, nor the night after, until the next sun came forth on the world. As soon as a little ray made its way into the woeful prison, and I discerned by their four faces the aspect of my own, I bit both my hands for grief. And they, thinking I did it for hunger, suddenly rose up and said, "Father, it will be far less painful to us if you eat of us; you did clothe us with this wretched flesh, and do you strip us of it!"
 Then I calmed myself in order not to make them sadder. . . . When we had come to the fourth day Gaddo threw himself outstretched at my feet, saying, "Father, why do you not help me?" There he died; and even as you see me, I saw the three fall, one by one, between the fifth day and the sixth; whence I betook me, already blind, to groping over each, and for two days I called them after they were dead. Then fasting did more than grief had done.[24]

In the more than thirty drawings by Rodin that can with varying degrees of certitude be associated with this story, it is apparent that Rodin made reference to its different episodes. The few here chosen are among the most extraordinarily powerful both as drawings and as drama. Most of the studies show a seated Ugolino, a few have him standing; only two show him on all fours. Related perhaps to the first day of their incarceration is a drawing that shows the seated Ugolino holding or supporting a child between his splayed legs while he averts his head

Fig. 23. *Ugolino Interrupts His Cruel Repast*, c. 1875–80. Ink wash and stain, over pencil. Musée Rodin.

(Fig. 24). Rodin subsequently and hurriedly penned with his own graphic code what looks like two other figures, standing with bowed heads before their father, so that the father now seems to be looking at as well as gesturing to them. (This recalls the line, "I looked in the faces of my children without a word.") There is a tragic tenderness in the positioning of the form of the father; it is one of the few examples of this type of drawing in which a figure is shown partly rotating in depth so that his form makes a right angle that ties him to his children. The drawing displays an astonishing gamut of Rodin's techniques, from a somewhat traditional outlining and shading of the big curving planes of the father and son, to the almost abstract linear conjuring of the human form. The aggregate effect of the nondescriptive inked lines suggests the standing children's posture expressing submission to their fate.

A drawing that may have been thought of as both Ugolino and Icarus (Fig. 25) is a splendid example of Rodin's basic postural situation that allowed him a wide latitude of associations. Rodin most certainly had in mind Ugolino's description of how his children offered him their own flesh for him to eat—the notation reads "reprend ces chairs que tu nous a données." But he also wrote "Icare" and "génie" (Icarus is consigned by Dante to the Circle of the Fraudulent). Close study of the child's head shows that when drawn in pencil the face was directed away from the parent. Later work in ink wash partly masks out the son's face and changes the upraised hand so that it seems to gesture to the father. The connection with Icarus was no doubt suggested by the movement of the boy falling away from the seated man—like the fatal plunge of Icarus for which Daedalus was largely responsible. This sketch is a model of how drawing can intimately reflect the thought processes of the artist, and how even when alternative subjects might be flooding into his mind, the artist never loses artistic consciousness. Look at the drawing as a whole to sense the overall free flow of the brush that succinctly establishes basic stable and unstable configurations in the composition and makes meaningful Rodin's view that "imprecision adds to the action."[25] The modern largeness of effect is due in great part to the way in which the composition fills the field, even to the extent that the upper part of the father's head is cut off, and this cropping of the father's upright head adds to the sense of his big scale and almost statuesque stillness.

It is such drawings that make orthodox distinctions

Fig. 24. *Ugolino and His Children*, c. 1875–80. Pen and ink, and ink wash, over pencil, with white gouache highlighting. Musée Rodin.

Fig. 25. *Ugolino/Icarus*, c. 1880. Pencil, pen and ink, and ink wash. Musée Rodin.

between those of painters and sculptors just plain silly. Rodin learned his basic technique in a school that taught the same system to all artists, whatever their medium; he learned additional devices from painters like Delacroix and possibly Géricault. Many of these "black" compositions defy projection into three dimensions. When, for example, Rodin used dark washes on his drawings, sometimes it was not to throw the figural form into relief or to clarify space and volume relationships, but rather to obscure them.

One example of the use of dark washes possibly to anticipate a sculptural effect in the portal is a drawing of the starving Ugolino staring at his dead or dying son cradled in his arms (Fig. 26). The drawing is both frightening and compelling. Perhaps because of its dramatic suspense and formal compactness, Rodin seems to have favored this conception as the basis for its rough sculptural counterpart in the last model for the doors (Fig. 46). Thematically Rodin is both most himself and often at his best when setting up an ambivalent situation. On the most obvious level, the drawing could be read simply as a grieving father mourning his child's death. But the artist could also count on the viewer's knowing of the possibility of a cannibalistic ending, and as if to foster that possibility Rodin has strongly highlighted the upturned sensual chest of the child while masking his head in shadow. The white spotting on Ugolino's form seems intended not as cast light but rather as highlight, to bring out the gauntness that comes with starvation. The downturned head is almost skeletal and the mouth is open. The exaggerated contrast of light and dark tonalities is like the polarization not just of good and evil but of life and death. In all, this is a striking example of Rodin's ability to express feeling in his drawings.

Ugolino's story closes with the provocative words "Then fasting did more than grief had done." The question of whether Dante was implying that the father had been dehumanized to the point of eating his children is not relevant here. Rather, the question is whether Rodin ever interpreted the story that way. Many artists in the eighteenth and nineteenth centuries did interpret the lines as meaning that the father ate his children.[26] One of Rodin's Ugolino drawings—having a not uncharacteristic ambiguity about it—suggests that Rodin considered showing Ugolino's unnatural repast (Fig. 27). The general

Fig. 26. *Ugolino Holding a Child on His Lap*, c. 1875–80. Pencil, pen and ink, ink wash, and white gouache. Location unknown.

pose of the figures in this drawing is much like that in the previous one, but the presumably dead child is held by the father, who has lifted his head and opened his mouth. (It also reminds us of Rubens's and Goya's great paintings of *Saturn Devouring His Children*.) Unquestionably, Rodin has transformed the former admiral of the Pisan fleet into a roaring famished beast, but is the painted white shape that hangs from the open mouth his tongue or is it the flesh bitten off from the white shoulder of his son?

It has been suggested that for "decency's sake" Rodin, like Dante, did not actually depict the father devouring the son.[27] Dante may have been purposely ambiguous because one of his friends was a grandson of Count Ugolino. But why should an artist who had shown Dante and Virgil as lovers be concerned about decency? Rodin did do a drawing showing Ugolino gnawing on the nape of the archbishop, and as these drawings were intensely private, not initially made or worked on with a view to their public display, why should he not have explored parental cannibalism in conjunction with infanticide? When he did the Ugolino drawings Rodin was a father. (His son, who was never given the artist's last name, was later to disappoint him as an artist, owing perhaps to a childhood brain injury, limited ability, and excessive parental expectations.) The great number of Ugolino drawings and the story itself deeply involved Rodin and had to have engaged his most private fears and fantasy. Was it not Rodin's instinct for personalizing themes from Dante that prohibited him from being "merely" an illustrator? Even this modest sampling of Rodin's drawings from Dante argues that Rodin lived with Dante in terms of his own life, temperament, and "tortured imagination."

The answer to the question of whether these drawings would have provided Rodin with sufficient inspiration to create enough sculpture for a monumental door must be yes, even though some of his greatest drawings could not have been translated into three dimensions. If Rodin had based his portal on the drawings from Dante it would have been recognized as an original and personal contribution to the history of art. If Rodin had been survived by only his "black" drawings, he would be reckoned still as an important artist. Even though he had not systematically illustrated Dante, he had enough important and well-known themes to have modeled an impressive Dantean portal, fulfilling the spirit and letter of the commission. Rodin showed no interest in the physical structure or environment of the *Inferno*, nor would the public have necessarily expected this of a sculptor. Rarely in the drawings do we find demons inflicting pain upon the spirits. Snakes and centaurs outnumber the rare demon, just as they do in Romanticist art and poetry. Like the French public of the time, Rodin was more interested in self-inflicted punishment. In the drawings, violent subjects about equal more restrained ones. Rodin's drawings are populated predominantly by men. If a census is made, the masculine majority is strong. For both Dante and Rodin, the nude male form permitted the most emphatic and dramatic expressions of life. Whether the strong preponderance of male forms had any personal sexual implications for Rodin we may never know. (There is no evidence that he was bisexual.) But it is reasonable to assume that this passionate man who was a spiritual and artistic rebel, lover, and sinner could have enacted his own torments, including feelings of guilt, through his self-wounding creations. Certainly the great attraction of the *Inferno* to Rodin was its sweeping presentation of a range of passions, tensions, and conflicts, lugubrious moods of anguished despair and melancholy introspection. These human qualities and conditions, not theological constructions and considerations, connect the drawings and weave the fabric of Rodin's thought for his first conception of *The Gates*.

It may have been that Rodin's drawings after Dante helped convince him that, as he told Bartlett, he was not as profound as the poet, but that in sculpture he should be like a modern Dante to his own age by treating its spiritual drama. Rodin did not become a sculptor when he was young because he had something to say to the world. He had a natural love and aptitude for shaping and joining forms. By the age of forty, however, and having been exposed both to a hard personal existence and great examplars from art and letters, Rodin had the means, incentive, and confidence to make a strong statement about sculpture and life on his own terms. It didn't take Dante to convince Rodin that he was not a philosopher. The sculptor knew that he thought best with his hands while drawing or modeling. The Dante drawings seem to have convinced him that his view of humanity's fate could be better expressed in sculpture that was inspired by the natural poetry of the living human form.

Fig. 27. *Ugolino with a Child*, c. 1880. Pen and ink, ink wash, and gouache. Musée Rodin.

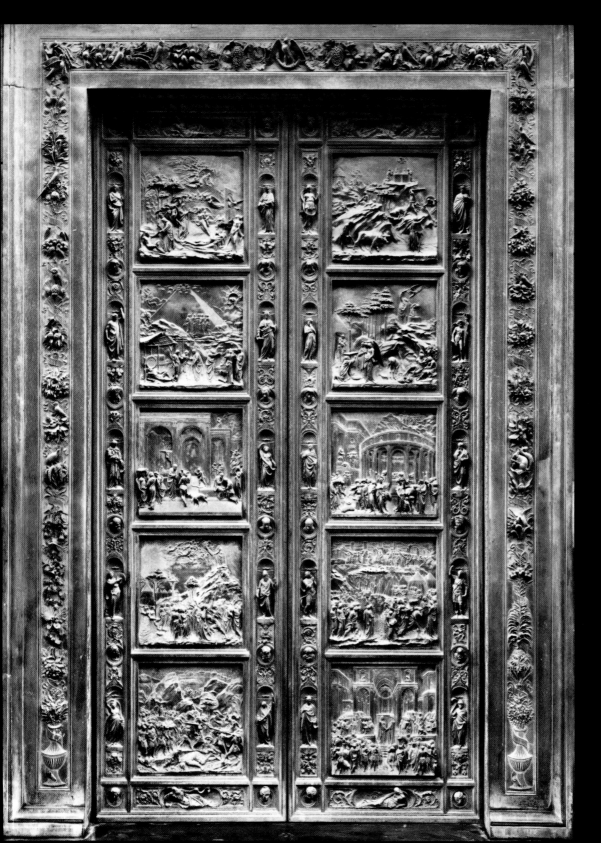
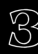

The Architectural Genesis of 'The Gates of Hell'

Just as Rodin had to establish through drawings his working relationship to a medieval epic poem, so too did drawings and sculptural models allow him to come to terms with a Renaissance architectural prototype for the actual design of his doors. To paraphrase Rodin's own statement, he was glad to accept Dante as a starting point for the theme of his work; so too did it please him to take the format of Ghiberti's *Gates of Paradise* (Fig. 28) as a basis for his first attempt at relating sculpture to architecture. There have been attempts to downgrade Ghiberti's initial importance because there were other models accessible in Paris before 1880, notably Henri de Triqueti's bronze doors of the Ten Commandments for the Church of the Madeleine made in the 1830's (Fig. 29) and a portal by the architect Percier built in 1811 to contain Renaissance reliefs by Andrea Riccio that stood in the Louvre until the early 1850's (Fig. 30). Kirk Varnedoe has shown persuasively that Rodin did draw from and was influenced by Riccio's reliefs in the Louvre.[1] These new suggestions for the architectural source of *The Gates of Hell*, however, are unseconded not only by Rodin but also by that considerable number of artistically aware contemporaries who wrote about the doors. Contemporary commentators repeatedly compared Rodin's portal to Ghiberti's and not to French sources. The Church of the Madeleine, for example, stood nearby across the Seine from Rodin's studio on the Rue de l'Université. Many of the artist's visitors must have passed it going to and from his studio to view

the portal. In 1880, its ten-meter-high cold and dry neoclassical doors would have epitomized all that Rodin detested in the relief sculpture approved by The School. Both the Percier and de Triqueti designs ultimately derived from that of Ghiberti, of course, and Rodin, who saw *The Gates of Paradise* in Florence during his Italian trip of 1875, is known to us as an original artist of great ambition who always sought out sources rather than commentaries or derivations. But neither Rodin nor other artists of his time had the expectation that they could produce a major public commission beyond comparison with great public art of the past. The challenge to sculptors, and particularly to Rodin, was not to reject tradition, but to extend it. Intellectually Rodin had set himself the problem in his portal of matching himself with Dante, Michelangelo, Ghiberti, and perhaps Andrea Riccio, but not Percier and de Triqueti.

As with the drawings from Dante, we cannot precisely pinpoint the date when Rodin began to make preliminary designs for the doors. He could have begun thinking about the overall design as early as January 1880, so that he could either show or explain to his commissioners what he would do. If there had been an open competition, Rodin, in view of his inexperience, would have been obliged to make at least presentation drawings. By one of his own accounts, to the writer Coquiot, Rodin explained to Turquet how he would go about fulfilling the commission, and it is possible that he brought drawings with him for such a purpose. Turquet was taking a great personal gamble in granting such an important project to this controversial middle-aged man who had spent more time

Fig. 28 (*facing*). *The Gates of Paradise*, by Ghiberti, fifteenth century. Florence. Photo Alinari.

Fig. 29. *The Ten Commandments*, by Henri de Triqueti, 1834–41. Bronze doors. Church of the Madeleine, Paris. Horst W. Janson Photographic Archive.

being an artisan than being an artist. Despite the absence of factual confirmation, it strains credibility to try and imagine that a high but untenured government official and former magistrate did not require some sketches at least—either on that occasion or soon after—to supplement Rodin's description of what he had in mind. It seems logical to think that Rodin, too, who prided himself on being a conscientious workman, would have had good reasons for presenting his ideas graphically rather than solely in words.

We know neither the exact dates nor sequence of the preliminary architectural studies. As with the drawings from Dante, many of the sketches on paper show re-working at various times. It is possible that Rodin worked out his first idea for *The Gates*, not in a pencil sketch, but on a ten-inch-high clay slab (Fig. 31). By quickly thumbing and dragging his finger across the slab, Rodin established the schema of a tall rectangular portal. Vertically divided in the center, four or five pairs of mostly square panels rise almost from the ground in emulation of Ghiberti's design. (Whether or not Rodin intended two panels at the very bottom is not clear.) The relief panels project forward from the surface of the doors, but not quite as far as the external frame that comes slightly farther forward on three sides and that Rodin seems to have built up from the original flat slab. Proportionately, the frame at the top is larger than those on the sides, as in the Florentine model. Otherwise, there is no additional elaboration. It is not so much a study in simplicity itself but rather a study an artist would make who wanted to know his future work in its most fundamental aspect, or who wanted to recall the basic character of a Renaissance prototype.

What may have been one of the first architectural sketches made by Rodin is on a half sheet of paper over which he later pasted a drawing (Fig. 32). Apparently he was dissatisfied with it, perhaps because it came at such an early moment when he was preoccupied with the unfamiliar exercise of designing a door with moldings, and he had thought of subdividing the relief panels into three sections. The sketch is of the upper section of the door, but curiously there is no central dividing line that would have marked where the two panels met, leaving the impression that in its most primitive form Rodin may have thought of a single door hinged on one side, which was unusual for monumental portals. The traced lines in the

THE ARCHITECTURAL GENESIS OF 'THE GATES OF HELL'

Fig. 30. Project sketch for the
Portal of the Salle des Cary-
atids in the Louvre by Charles
Percier, c. 1811. The Louvre.

Fig. 31. Architectural maquette for *The Gates of Hell*, 1880. Clay, 10 in. high. Musée Rodin. Photo Louis-Frédéric.

Fig. 32. Tracing, by the author, of one of the first architectural sketches (1880) for *The Gates*. Present whereabouts unknown.

illustration show the tentative nature of Rodin's drawing, but the asymmetry of the moldings is typical of his frugality in testing different possibilities within one sketch. The flat moldings are characteristic of the Italian Renaissance style, and Rodin would later devote years to studying more complex and sensuous French medieval sources of this architectural element.

Ghiberti's model is even more clearly apparent in a small drawing done on copybook graph paper of the sort that French students still use (Fig. 33). For the moment, try to imagine the pencil design before the addition of the three figures in dark ink. The penciled outline of the portal seems tentative for Rodin, as if from unfamiliarity with the subject he was drawing, especially in the area of the cornices, which he later would master and model with confident subtlety. From Ghiberti's ten panels Rodin has gone to eight, perhaps thinking of the number of circles in Dante's *Inferno*. These panels would have contained figural reliefs, not rendered in the Albertian perspective on which Ghiberti drew so extensively, but with dense groups filling the field and brought close to the surface by a tilted-up perspective. (The drawings of Minos and Ugolino with the archbishop give us a good sense of Rodin's ideas.) It is the sculptural rather than architectural design that links this drawing with the Percier doors made for Riccio's panels, which noticeably do not extend to the ground as do those in Rodin's plan. None of the schematically rendered panels betrays a recognizable Dantean motif, and the fact that all eight are not filled indicates that Rodin may not have had any particular subjects in mind at the time of this drawing. The side panels, containing mostly single figures, separate this schema from possible French sources and suggest a connection with Ghiberti, although Rodin made the flanking niches rectangular and of the same height as the squared central panels. (In Bologna Rodin could have seen and been impressed by the side panels of the central door of the basilica of St. Petronius, whose story of Adam and Eve was carved by Jacobo della Quercia.) Ghiberti treats his niche figures, as well as the figures in the foreground of the main panels, almost entirely in the round. Thus when Rodin was to tell others that he sought in his portal to work in all forms of relief, he was again placing himself in line with the Italian Renaissance master.

Rodin drew a horizontal vine that not only separated

Fig. 33. Drawing for the architecture of *The Gates*, with notations for sculpture, 1880. Pencil and ink on graph paper. Musée Rodin.

the panels from one another but separated his design from that of Ghiberti. Percier had used horizontal and symmetrically disposed garlands between rectangular panels, a form of neoclassical ornamentation that by 1880 Rodin would have disliked intensely. It is likely that his idea for using the vines to help divide the panels in an infernal portal came from having seen the medieval reliefs of the Last Judgment on the facade of the Cathedral of Orvieto during his Italian trip (Fig. 34). We do not know whether Rodin was aware of the symbolism of the vine and its relation to Christ ("I am the true vine," John 15:1), who sits at the top of the Orvieto Judgment. The motif was a fruitful one, however, and it will appear in an unexpected manner in the final doors.

What may be a second drawing that developed the ideas of the first shows even less patience with figural notations for the squared central panels and more interest in using a wash to evoke the overall tonal effect of the doors and the widening of their external frame (Fig. 35). At some point after studying the first result, Rodin came back to this drawing and edited certain areas with a darker wash. The stronger reworked shadows around the niche figures suggest that they would have been in higher relief. The use of ruled paper that would have helped him establish proportions also suggests that Rodin may have been deciding between squared and rectangular formats for the central panels. Compared to his thinking about light and dark, the *effet* as the French called it, this was a minor consideration at best.

The largest of what seem to have been the first four architectural drawings showing the entire portal (although they may not necessarily have come in the order presented, in view of Rodin's unpredictable way of working) shifts the focus to the central relief panels (Fig. 36). He has stripped the doors of side panels, even canceling out with a vertical stroke two such shapes introduced after the drawing was first done. Foliate decoration is absent, perhaps because he was now bringing figures to the outer corners of what are consistently rectangular relief panels. This new format, coupled with the notations for strenuously posed figures at the corners, invites comparison with Michelangelo's design for the Sistine Ceiling, but at some later time Rodin used a white gouache to line or mask out some of the border figures on the right. The sketched relief narratives are the most detailed Rodin

drew in these models, and they show rough designs familiar from his "black" drawings: a horizontal figure stretched across the center as in the funeral motifs, or suggesting the torturing or carrying of a body by two others; figures seated or standing in the corners, off-centered pairing of a large with a small figure evoking parental themes like those of Ugolino; strenuously active and passively posed group situations, all of which completely fill the field from bottom to top and left to right and give no hint of settings.

In the light of Rodin's strong preoccupation with the figural reliefs of the preceding drawing, a second sculptural maquette (Fig. 37) may have allowed him to carry these ideas further. The two bottom scenes cannot be read in terms of specific themes (the one at the right suggests the pairing of a man and woman and could have been an early idea for Paolo and Francesca),[2] but they are interesting as Rodin's sculptural notes to himself, the mashed balls of clay sometimes etched with knife or nail. The purpose of this maquette does not seem to have been to work out narrative compositions but rather to try out an idea that broke with the Renaissance format. This modest model, only ten inches high, shows what might be construed as Rodin's new idea for the upper portion of his doors. In the upper register he has eliminated the vertical division that separates the two lower panels. It is as if Rodin had decided upon a frieze for the top of his doors, and that in fact is exactly what he did when he came to build and model them. The paired figures at the extreme left of the frieze seem reminiscent of drawings that show Dante and Virgil, especially those in which the poet's guide is urging Dante on (Fig. 9). At the far right is what seems to be a group of figures moving away from those entering at the left. The central area is devoid of a recognizable figure: *The Thinker* has not yet made his appearance.

At some time after the preceding maquettes and the original states of the three drawings, Rodin determined to introduce one or more large figures into his overall composition. The second architectural drawing (Fig. 33) shows inked notations for a vertical figure, in all probability his own statue of *Eve* (Fig. 64), to be placed in the up-

Fig. 34. *The Last Judgment*, fourteenth century. Cathedral of Orvieto. Photo Alinari.

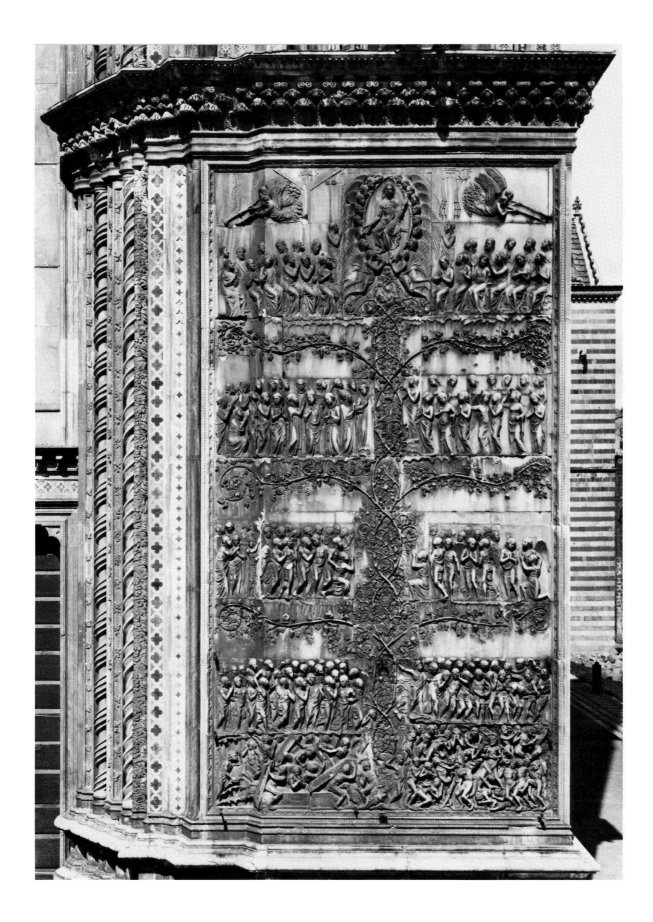

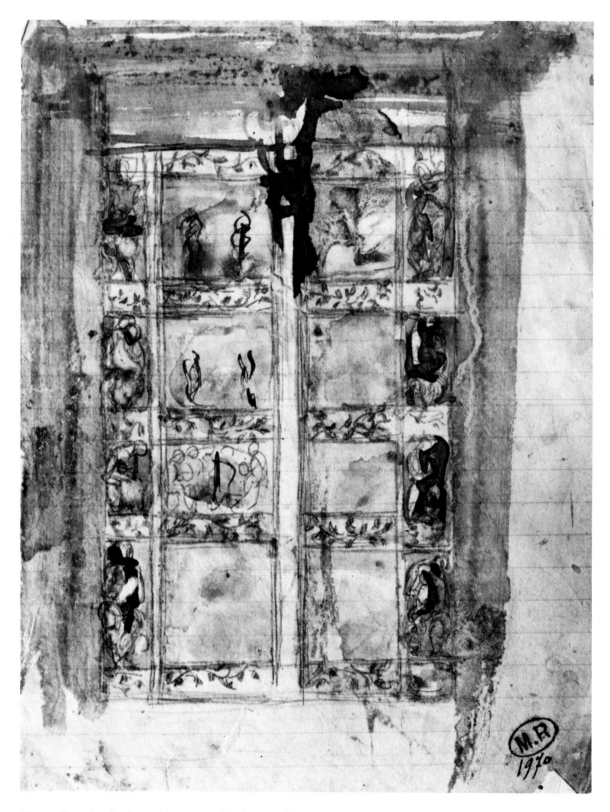

Fig. 35. Drawing for the architecture and sculpture of *The Gates*, 1880. Ink wash over pencil on ruled paper. Musée Rodin.

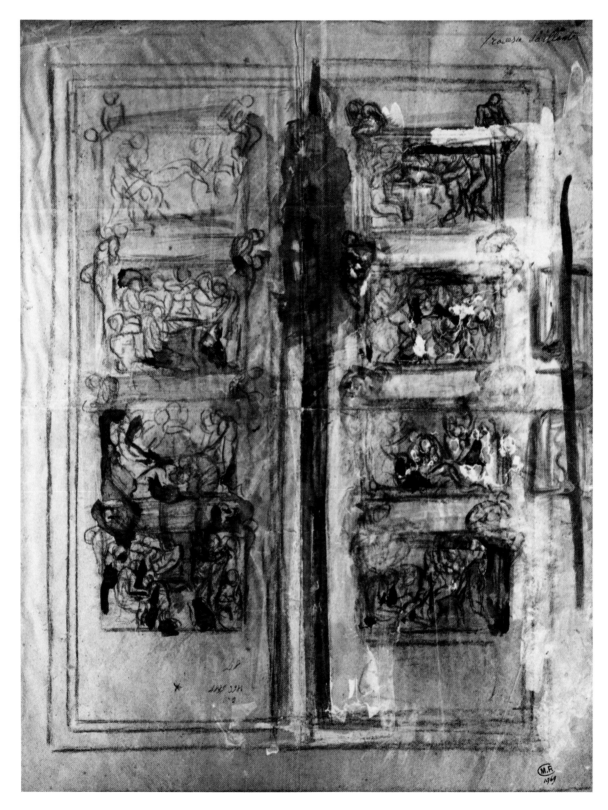

Fig. 36. Architectural sketch, 1880. Pencil, ink wash, and white
gouache. Musée Rodin.

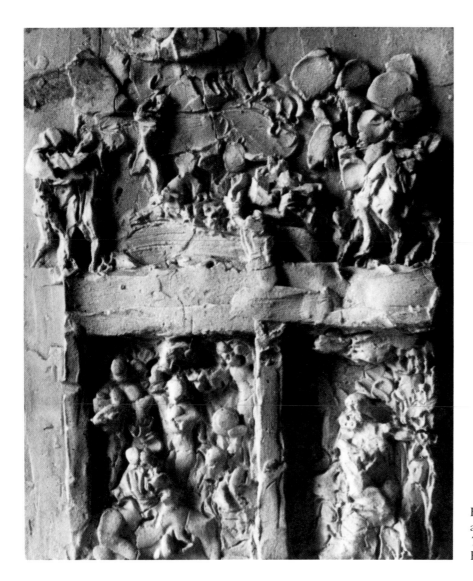

Fig. 37. Maquette for the architecture and sculpture of *The Gates*, 1880. Clay. Musée Rodin. Photo Louis-Frédéric.

per center between the two door panels. Above her are what look like two seated figures whose identities are not known. (They were possibly "Shades," or Dante's tortured spirits of the dead.) As we will see, Rodin tended to think in terms of trios of figures that were outsize in comparison with the relief panels. It is also possible that in the fourth architectural drawing (Fig. 36) Rodin had blocked in with a dark wash the idea of a vertical figure between the doors. A precedent for this raised and centralized location of Eve would have been the statues of the Virgin similarly placed in the portals of Gothic cathedrals with which Rodin was already familiar, and which may have inspired

him to shift from an Italianate to a more French source for his ideas. In his travels to Rouen, he could have seen the transept portal dedicated to the Virgin of the Church of Saint-Maclou, which in the artist's day was believed to have been carved in wood by the great sixteenth-century French sculptor Jean Goujon, who was much admired by Rodin (Fig. 38). Just above the middle of the portal and in its center is a statue in the round of the Virgin. Other aspects of its design, notably the decorative use of numerous consoles alternating with masks, successive zones of reliefs, figures in the round, and two lower door panels through which one could enter the church, have echoes in

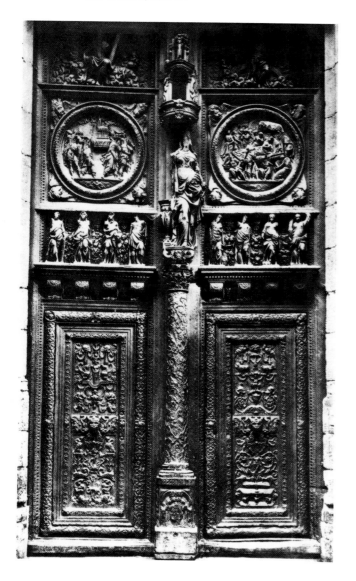

Fig. 38. Portal with statue of the Virgin, sixteenth century. The Church of Saint-Maclou, Rouen.

Rodin's later work on *The Gates*. In fact, there is a drawing from one of Rodin's notebooks containing other sketches for the portal that shows vertical interior panel divisions for the doors somewhat like those at Saint-Maclou (Fig. 39).

This notebook drawing is more interesting, however, for the sketchy figure at the top of the doors (but still within its overall frame), and for the flanking statues of *Adam* and *Eve*. These last drawings may not have been the first in which *The Thinker* appears. His debut may have been in other somewhat simpler sketches in the same notebook. Figure 40 shows a simple, almost egglike form above the three-part relief panels (vertical panels flanking circular ones) that could have been Rodin's hasty cipher for the compacted silhouette and overall curving gesture of the seated man. More cryptic is the inked notation at the top of the third architectural sketch (Fig. 35), where one cannot make out whether Rodin is suggesting a seated or standing figure, if a figure at all. Much clearer as to *The Thinker*'s identity is another from the same notebook (Fig. 41). Rodin was definitely establishing a triad of large figures, life-size and half life-size, to increase the visual and sculptural interest of his project, as well as radically changing its theme from being an illustrative one entirely dependent upon Dante. Adam and Eve do not appear in the *Inferno*.

A fourth drawing from the same notebook shows four ideas for the portal, three of which involve this new trio of large sculptures (Fig. 42). The large central drawing, furthermore, shows for the first time the indication of a figure or figures to stand atop the doors. Whether this fluid configuration augured the presence of *Eve*, *Adam* and *Eve*, or *The Three Shades* is hard to tell. According to the critic Camille Mauclair, "[The gate] at first was to have been surmounted by the two figures of Adam and Eve, and Rodin rejected it."³ In a box at the upper right on the notebook page, Rodin repeated the same seemingly abstract configuration three times. This may have been one of his first ideas for tripling the same figure as a crowning sculptural element, and from which might have come *The Three Shades*. The central drawing was vehemently reworked so that one has a sense of the door's depth. It also appears that Rodin was thinking of a forward extension of the lower portion of the frame. Such a projection might have been to accommodate a dramatic change in

Fig. 39. Sketch for *The Gates* from a notebook, showing *Adam* and *Eve* and *The Thinker*, 1880. Pen and ink. Musée Rodin. Photo Bruno Jarret.

Fig. 40. Sketch for *The Gates* from a notebook, showing a notation for *The Thinker*, 1880. Pen and ink. Musée Rodin. Photo Bruno Jarret.

the forward projection of the relief sculpture on the central panels. The roughly circular configuration above the broadened base may have been Rodin's note to himself to heighten the relief of the figures on the panels so that they would seem to be spilling out of the doors. This reworked drawing could have been made in 1881, when Rodin was ready to build the first frame for *The Gates*

The last sculptural maquette for *The Gates* is a forty-inch-high study built up out of blocks and slabs of clay that in many areas Rodin excavated with his fingers (Fig. 43). It is a marvelously raw and rugged sculptural object. Originally, the maquette may have been shallower and completely circumscribed by flat moldings, some of which remain, but then Rodin seems to have brought forward the sides and upper section as he began to add figures. This deepening of the portal was still another move away

Fig. 41. Another sketch for *The Gates* from a notebook, show-
ing *Adam* and *Eve* and *The Thinker*, 1880. Pen and ink. Musée
Rodin. Photo Bruno Jarret.

Fig. 42. Page of sketches for *The Gates* from a notebook, 1880.
Pen and ink. Musée Rodin. Photo Bruno Jarret.

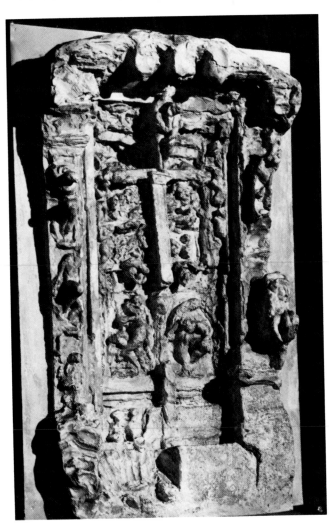

Fig. 43. The last sculptural maquette for the portal, 1880.
Terra-cotta, 39½ in. high. Musée Rodin. Photo Louis-Frédéric.

Fig. 44. Drawing of *The Gates* above another drawing of a
reclining woman and child, 1880. Pen and ink, and ink wash.
Musée Rodin. Photo Bruno Jarret.

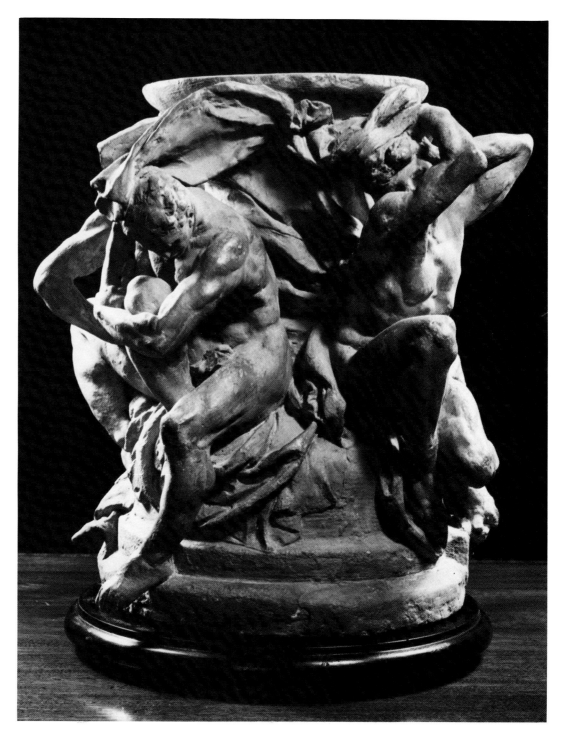

Fig. 45. *The Vase of the Titans*, by Rodin, 1878–80. Terra-cotta.
Musée Rodin.

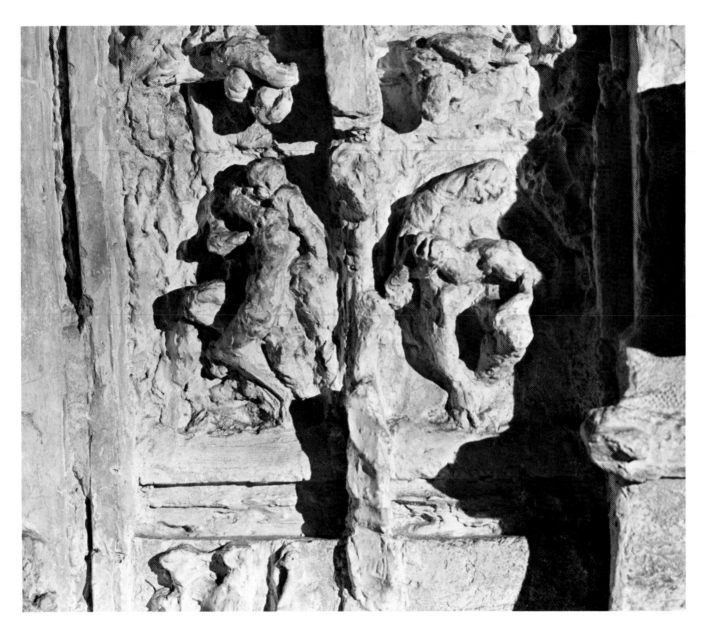

Fig. 46. Detail of the last sculptural maquette, showing *Paolo and Francesca* on the left and *Ugolino* with one of his children on the right, 1880. Photo Louis-Frédéric.

from the shallower Renaissance prototype, and Rodin may even have had in mind Gothic portals, which allowed both reliefs and sculpture in the round seen under strong contrasts of light and shadow. We can see his ideas for deepening the doors in a small drawing (Fig. 44). The contorted Michelangelesque figures in the external reliefs on the maquette recall those Rodin did on *The Vase of the Titans* just a short time earlier while working for Carrier Belleuse (Fig. 45). They also equal in size the figures of *Paolo and Francesca* seen on the lower left door panel, and *Ugolino* with one of his sons at the right (detail, Fig. 46). *The Thinker*, whose distinctive crossover gesture of his right arm now appears for the first time, has been set into his final place (Fig. 43). Rodin felt the need to deepen and build up the cornice above him by adding three big blocks or dentils. (They would be replaced by four brackets and above them *The Three Shades* in the final doors.) Above Paolo and Francesca and Ugolino with his son there remain two registers of reliefs, each half the height of the lower zone with the aforementioned characters. It does not appear that Rodin intended large crowd compositions for any of them. This intermediate zone seems to have given Rodin more trouble in *The Gates* than any other, and he was not to resolve the problems until 1899–1900.

When this maquette was made it is uncertain that Rodin knew whether or not his plan for the flanking statues of Adam and Eve had been rejected by his commissioner. This final preliminary sculptural design does show that Rodin had a plan for an anchoring triad of big sculptures inside the frame of the doors. The lovers and the dying father and son provided the base of a triangular design with *The Thinker* at the apex. As yet there is no frieze of figures behind *The Thinker*, and in fact his form seems to have been put in front of what was originally the upper horizontal molding of a paneled arrangement similar to those in the drawings. Rodin had also decided that he wanted his lowest figures to be higher off the ground, closer to eye level, which meant a higher molding at the bottom. This decision would have influenced his thinking on the physical size of the doors when it came to building the actual frame, and it accounts for their considerable height right from the beginning.

Far from being the result of inexperience, Rodin's unwillingness to work out in detail all that he would do came from confidence. This valuable maquette tells us that Ro-

Fig. 47. Old photograph of the last architectural maquette, mounted on cardboard with penciled lines, 1880–81. Musée Rodin.

din was coming close to the solving of certain problems. The regular arrangement of equal-sized narrative panels has broken down, and the distinct architectural boundaries between the figures are disappearing. Between Paolo and Francesca and Ugolino, Rodin has ripped out much of the central molding. The figures in the remaining paneled registers begin to overflow their borders. As in the final *Gates*, *The Thinker* projects well beyond the vertical central divider, and the figures in the flanking vertical reliefs are neither of the same number nor in horizontal alignment. The vertical relief at the left has become a sculptured pilaster by being given a capital, while that on the right has none. Rodin wasted no effort on duplication. Almost from the start, he had no patience with strict symmetry and architectural consistency. Incomplete as this model may seem to us, for the artist it had answered enough questions for him to take the big step of moving to full scale. He had simply decided to make fewer and bigger figures. Overall harmony would depend upon a shifting equilibrium. When he got his hands into the clay he molded the project, especially the architecture, to his evolving thought. The undulating sides of the maquette look more like Rodin's rendering of a woman's profile than architecture. One of the joys of pondering this last preliminary work is to see the vigor with which Rodin solved his problems by means of clay, the energy with which he tore away the unformed, the passion by which he formed, and the frugality by which he ignored the repetitious and unessential.

In the archives of old photographs at the Musée Rodin there is a photograph, mounted on cardboard, of the last big maquette, with some hastily penciled lines (Fig. 47). Looking at the door this way, Rodin noted the need to square off the top and increase the height and presumably the depth as well. As a historical document the photograph is especially interesting because it shows the maquette posed in front of the large wooden box frame of the portal (the horizontal planking is visible behind the maquette and to the right), as if Rodin were using the model to give him ideas on the portal's superstructure. Photographs allowed Rodin a way of standing back and looking at his work, of detaching himself from what was done passionately or instinctively, and perhaps in haste. Historically this is a marvelous document, for it shows a connection between stages of *The Gates'* development that was otherwise unavailable to us.

Fig. 48. Rodin in 1880, when he began work on *The Gates of Hell*. Photographer unknown.

"Give More Liberty to Your Timid Imagination, M. Rodin": The Sculptor's Gamble

At some moment either in the latter part of 1880 or early in 1881, Rodin made the fateful decision to depart from the literal illustration of Dante's *Inferno* as well as from the traditional method of creating and presenting a monumental sculptural portal. Rodin's choice had no historical precedent. On a heroic scale he would *improvise* an epic, a personal, modern vision of hell. Perhaps because he won his gamble, not only we but Rodin's contemporaries seem to have forgotten that this forty-year-old artist who had won a small and controversial reputation in the Paris art world was staking his entire career on his ability to accomplish something by ways and means no other sculptor in history had tried on such a scale (Fig. 48).

First of all, his was an official government commission that called for him to interpret a specific subject. Secondly, it is fair to assume that his commissioner, Edmond Turquet, expected Rodin to follow the traditional episodic panel format in the Renaissance manner, such as de Triqueti's doors for the Church of the Madeleine that were done earlier in the century. Rodin knew that government inspectors would be visiting his studio to assure the ministry not only that the work was of good quality, but also that he was fulfilling the commission. Thus he would not have been able to confront and surprise Turquet or his successor with an accomplished fact.

Concerning this momentous decision, Rodin had little to say, but he made it sound perfectly normal. To the writer Serge Basset, Rodin recalled in 1900, "I lived a whole year with Dante—living only with him, and drawing the eight circles of his Hell. . . . At the end of a year, I saw that while my drawings rendered my vision of Dante, they were not close enough to reality. And I began all over again, after nature, working with my models. . . . I had abandoned my drawings after Dante."[4] What Rodin meant by "reality" we can judge only in retrospect by looking at *The Gates*.

Given what was at risk with this first great public commission, Rodin could not have made this decision casually. His reflective nature and temperamental sobriety assure us that he pondered the decision at length. Unquestionably he relied on Turquet's confidence in his ability as an artist, but this bureaucrat did not have tenure and was vulnerable to art world pressures. If Rodin had known privately that Turquet would not object to the change in theme—and we cannot confirm this—then he would have somewhat reduced the stakes. After all, the commission was for a work to be seen in conjunction with an art museum rather than a church or governmental building, in which case the theme would have reflected on the Third Republic. It seems unlikely that Rodin informed his commissioner of a change of mind because those who visited Rodin's studio, including government inspectors, and wrote about the portal always referred to its thematic source in Dante. That Rodin never seems to have contradicted this general assumption strongly suggests that he was quite happy to leave matters as they were instead of raising the question with Turquet, hoping that by his artistic skill he could impose his vision on others. What he could not conceal was the radical departure from tradition in the portal's form that his new vision of hell demanded, and at least one government inspector recognized the departure.

Why did Rodin change his mind and what in his background reinforced or inspired the decision? When Rodin experienced strong negative critical reaction to his *Age of Bronze* and *St. John the Baptist*, not only his integrity as a modeler from life was questioned, but he was faulted for being unimaginative. Among the notes taken by Truman Bartlett on both of his conversations with Rodin and from press clippings the artist may have shown him, there is the comment by a hostile critic: "Give more liberty to your timid imagination, M. Rodin."[5] The commission for the portal was the chance for Rodin to vindicate himself against the life-casting charges and to prove that his imagination was far from timid. That he rejected his vision of Dante's poem on the grounds of remoteness from reality is not a contradiction, for it was his experience of living human forms —his criterion of the real—that fired his imagination.

Looking back at Rodin's art from the time of his death to 1880, and considering what he was to do on major commissions such as *The Burghers of Calais*, *The Monument to Balzac*, and *The Monuments to Victor Hugo*, we realize the extent to which, after he had matured as an artist, as seen in *The Vanquished* and *St. John the Baptist Preaching*, Rodin felt compelled to be true to his own thought, feeling, and vision, hence *original*. It was recognized by Rodin's most famous and exact sculptor contemporary, Jules Dalou, that his colleague's genius had not been stifled by training at the Ecole des Beaux-Arts.[6]

Fig. 49. Scene from the French Revolution, c. 1880. Black wax, 8 in. high. The Philadelphia Museum of Art. Purchased with funds contributed by a private donor and general museum funds.

Dalou may have been implying not only that Rodin had not been indoctrinated into certain rules governing public sculpture but also that he was not committed to literal illustration and making his sculpture from drawings. (By the late 1870's and 1880's, "illustrator" had begun to acquire the pejorative meaning it still has today when applied to a figural artist, for it signified abdication of intellectual responsibility for one's own work and dependence on the word of another.) Further, as we have seen, there were crucial expressive qualities in Rodin's "black" drawings that would have resisted even this great artist's translation into sculpture. These drawings had been made free to Rodin's fantasy and passion, and hence were of an extremely private nature, which, it is possible, Rodin's own sense of decorum may have then considered unsuitable for a public sculpture. What he came to have in mind

for his portal, which, as he told Serge Basset, had to be more faithful to "reality," would come less from his fantasy and more from observing the living model. His two publicly exhibited statues had not grown out of drawings. A comparison of the few relevant drawings that survive with Rodin's ceramic designs shows that at the Sèvres factory he worked largely by improvisation or from imagination, since no models were available. Rodin continued to work at Sèvres for two years more, at an hourly wage, even after he received the commission in 1880. (Turquet was very much aware of the nature of Rodin's work in ceramic, as he intervened on the artist's behalf to see that he obtained a certain vase he wanted.)[7]

Dalou's remark perhaps was also meant to suggest that Rodin did not have the inclination, training, or experience to produce complex and extensive narrative relief compo-

sitions, such as Ecole des Beaux-Arts students were trained to do. This may have been true, but it was certainly not beyond Rodin's skill and capacity to make narrative episodic panels. There survives in the Philadelphia Rodin Museum a wax compositional sketch of a very extensive and complex historical narrative that he did around 1880 (Fig. 49). The subject, as interpreted by John Tancock, appears to be a scene from the French Revolution showing enrollment of volunteers.[8] The synoptic modeling of this presentation sketch for a public competition is exactly comparable to that done by Rodin in his second sculptural model for the portal (Fig. 37). That Rodin did not win the competition is not as important as the fact that he knew he could compete and carry out a large-scale narrative relief in 1879 or 1880. On the basis of this relief, for example, it is not unreasonable to assume that if Rodin had chosen to make a series of similar reliefs based on the *Inferno* for his portal he could have produced a very satisfactory portal—and with far less trouble.

Rodin must have been certain that his decision to break with historiated relief panels would give him greater scope as an artist to show what he could do by combining figures in the round with those in all degrees of relief. While we have tended to stress the modernity of Rodin's theme, a necessary counterbalance to this emphasis must be his artistic drive to revitalize and modernize sculpture. The commission for a great work that would be seen, presumably, in front of a museum of decorative art must have fueled his fancy even more than the desire to create his own life attitude in sculpture. Rodin never wanted to totally break with tradition. He sought to perpetuate it by giving to sculpture new ideas, vitality, and dramatic credibility. As one contemporary critic, Mauclair, put it, "The Door corresponds to the period when Rodin was preoccupied . . . with creating by the intensity of movement and the originality of figural attitudes and silhouettes, a new drama in his art that the taste of his time had fixed in a false 'neo-Greek' nobility obtained by immobility, the inertia of silhouettes, the fear of seeing too lively movement break the general harmony. To look for a new harmony in the study of movement, to create instead of static art, a dynamic art, that was . . . Rodin's idea."[9] In abandoning the long-standard paneled format Rodin was taking on the perilous freedom of moving into unexplored territory. The making of Rodin's *Gates of Hell* gives

meaning and tangibility to the idea of artistic creation as an adventure.

Rodin's decision to gamble on the making of *The Gates of Hell* was an important moment in the history of modern sculpture. Without as yet having developed a strong and influential buffer of writers and critics to explain and defend his work, Rodin set out on an adventure that is by now familiar to many modern sculptors: the creation of a public sculpture, paid for by taxpayers but based on personal rather than collectively held values. No one knew better than Rodin that there were many powerful figures in the art world who wanted him to fail, notably the artists on the juries that had rejected his competition entries and had accused him of casting from life.

The resources that confirmed and sustained him in his decision both at the time it was made and in the long years thereafter had to include not only extraordinary self-confidence but a profound understanding of the history of art and what was needed in the art of his time. In retrospect we can also see that it was from his self-acquired understanding of literature as well as art that Rodin drew comfort and inspiration. He had knowledge of the precedents of great writers he admired, such as Victor Hugo, Balzac, and Baudelaire, who themselves had modernized Dante's *Inferno*. Had not Baudelaire broken with narrative poetry? So far as art was concerned, Rodin had studied firsthand the great painting and sculpture of the Italian Renaissance, but he had also come to know intimately and to admire French medieval and sixteenth-century sculpture that was ignored in Beaux-Arts instruction. Rodin's whole previous life of self-education in word and image had been a great investment for the future and a high-risk adventure.

4

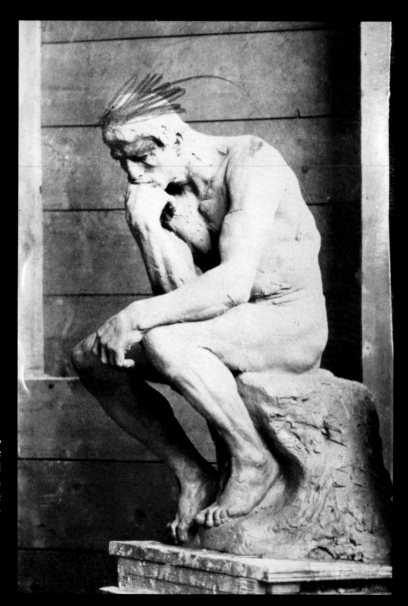

Fig. 50. *The Thinker*, in clay, before the wooden box frame of *The Gates*, 1881. Pencil notations on the old photograph indicate that Rodin may have been dissatisfied with the treatment of the head. Old photograph in the Musée Rodin.

How 'The Gates of Hell' Were Made: The First Campaign, 1880-1889

No working drawings for *The Gates* have been found (if indeed they exist) from the time, probably in late 1880, when Rodin had the first wooden frame of the doors constructed in his government-owned studio at the Dépôt des Marbres on the rue de l'Université. We now have a very good idea of what that original frame looked like, and it is clear why drawings, at least detailed drawings, may not have been required. Photographs taken at the studio in late 1880 or 1881 when Rodin was modeling *The Thinker* and the *Ugolino* group in clay (Figs. 50, 51, 52) show these sculptures in front of what looks like a wall of horizontal pine planks and vertical joists; this is in fact the first wooden armature of *The Gates of Hell*, against which Rodin was testing his sculpture. Photographs assisted in this process. Although there is no photograph that shows this wooden structure in its entirety, what is visible indicates that it was like a huge box, of a simple symmetrical design in five parts. It could have been built by Rodin and his assistants but was probably the work of a carpenter named Guichard, in whose dossier at the Musée Rodin is a bill dated January 6, 1881, for the "making of a door."

Within a simple rectangular frame, the two doors had recessed individual panels above their bases and were terminated at the top by a lintel. The cruciform design of the portal resulted from the vertical divider that separated the door panels and continued up through the lintel to divide the tympanum into two compartments. The back wall of the tympanum area appears to curve upward to meet the cornice at the top. (Rodin in later communications with the government refers to this whole upper area

as the "entablature.") The two outer sides of the portal, which were to receive the panel reliefs, were plain vertical planks about one foot wide. The door panels seem to have been recessed only about six inches, much less than the width of *Ugolino* and other groups set in front of them for photographing (Fig. 51). Below the recessed door panels was a broad molding, which meant that the lowest reliefs set into the recessed panels would have been about three feet above the ground. The vertical center board in the entablature area would have left no room for *The Thinker* in that location. Old photographs show this sculpture still in clay raised on a scaffolding for viewing from below, but the sculpture appears not yet to have been situated in the center (Fig. 52). In the early months of the work Rodin seems to have explored the possibility of putting *The Thinker* in front of the doors at ground level. He has a note to that effect on an old photograph of the plaster seated *Ugolino*, which was the immediate formal ancestor of *The Thinker* (Fig. 53).

It is hard to judge the exact size of the wooden framework from the photographs, but a letter from Rodin to the government dated October 20, 1881, gives approximate measurements that suggest the size of the armature: "Your having given me the commission and the first subsidy has made it possible for me to lay the foundations of this large work. I must say large since this door will be at least 4.5 × 3.5 m [14.8 × 11.5 ft.] in size and comprise, besides the bas-reliefs, many figures almost in the round. In addition, two colossal figures will stand at either side of the gates. . . . I need at least three years to complete this work."[1]

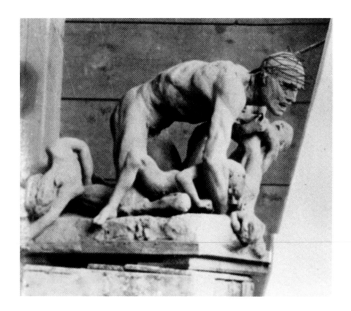

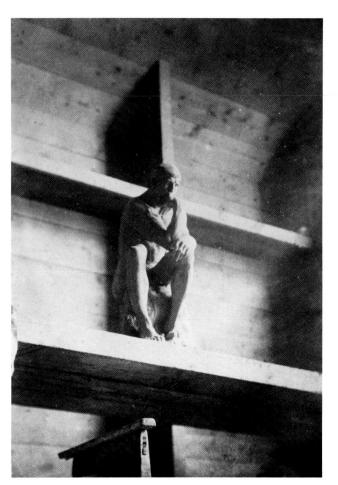

Fig. 51 (*left*). *Ugolino and His Children*, in clay, set before the wooden box frame of *The Gates*, 1881. Old photograph on which Rodin has drawn across the top of Ugolino's head. Musée Rodin.

Fig. 52 (*below*). *The Thinker*, in clay, set upon a scaffolding in front of the wooden box frame of *The Gates*, 1881. Old photograph in the Musée Rodin.

Just how Rodin arrived at these measurements is not clear. It appears that an engineer named Georges Berger was charged with the rebuilding of the ruined Cours des Comptes. Though it seems logical to assume that Berger and Rodin met and consulted with each other, no archival evidence has been found to show that it was Berger who gave Rodin the dimensions for the proposed portal. The written commission Rodin received from Turquet the previous year says nothing about size. The fact that Rodin gives approximate dimensions suggests that they were his decision. This also implies either that Rodin believed Berger could accommodate such a large doorway in his reconstruction (or that there had been such a large door to the old building) or else that Rodin may have already had a sense that his work might not be an integral part of the new museum's architecture. (The decision not to build the new museum on this site was made by 1887.)

The "two colossal figures" to which Rodin referred in his letter to the government were his *Adam* and *Eve*. The former was a descendant of two earlier projects, a monument to Lord Byron that Rodin had worked on in Belgium in 1875 shortly after returning from Italy, and a work Rodin reportedly destroyed that was titled *Creation of Man*.[2] *Adam* was exhibited in the Paris Salon of 1881. (A half life-size version of *Eve* was shown in London in 1883, but the full-size version was not exhibited until 1898.) In 1881, Rodin sent a note to his friend Maurice Haquette,

Fig. 53. Seated *Ugolino*, 1876–77.
Old photograph on which Rodin
has sketched an indication
of the frame of *The Gates*
behind the figure. Musée Rodin.

who had been helpful before on his behalf: "I learn that M. Turquet might resign one of these days. . . . Do me a service and speak to him, if you can (day or night), of the two figures that are around my Door that are not officially commissioned, nor authorized. You see, it is a very serious matter for me and you are the only one who can bring this about."[3] Despite Haquette's presumed intervention and the *Adam*'s successful exhibition in terms of critical praise, the government did not agree to finance their casting so that they could be placed flanking the portal. How they would have looked is suggested in Rodin's drawings (Fig. 41): *Adam* would have been on the left and *Eve* on the right.

On the basis of Guichard's carpentry bill and Rodin's communication to his commissioner on December 11, 1881, it seems safe to think that by this date the wooden armature had been constructed:

I have the honor to solicit the commission to execute in bronze the door that the administration has charged me with carrying out. The work of casting by *cire perdue*, the only method that can render my sculpture, will be very long. It will be done in five pieces—two pilasters, two doors, and the entablature. Each piece will come to me from the founder in prepared wax and I will retouch it, the founder and the sculptor alternating. . . . I am hastening to complete the work to which I consecrate all my efforts and all my time. What is more, bronze alone will be able to give the effect of this door which is so chiseled and so hollowed out.[4]

To these first years of the portal's creation there are very rare eyewitness reports. One such account is valuable because the writer actually visited Rodin's government-owned studio and saw the wooden armature. On April 30, 1882, Henri Thurat wrote in *L'Art Populaire*:

[On the] Rue de l'Université, in the Dépôt des Marbres, he works quietly. His studio, which is marked with the letter M (you translate it as Master!), is modestly sheltered under the great shadows of the studios of Guillaume and Fremiet. Here, nothing is a concession to luxury. It is poor, severe, great. No refinement. One would think one was in a monk's cell. This ascetic lair seizes you with respect and superstitious terror. You are introduced with an air of mystery. You are soon assailed with fantastic visions. What are those veiled shadows that are arranged along the wall? What masterpieces are covered under those damp cloths? And this immense wooden box that rises almost to the roof and takes up all the floor, what is that? Rodin replies to you tranquilly, "It is my door." . . . Despite the promise that I made to the artist to remain discreet, I cannot prevent

myself from saying to him alone that this colossal conception will remain as a secular monument. When this door in bronze, commissioned by Turquet, is installed on the Trocadero heights, at the entrance to our museum of decorative arts, when these immortal episodes of Dante's poem are suspended above our heads in their fantastic unfolding, we will believe that with Virgil we are penetrating the circles of Hell. All the genius of Dante is there, in this sculptural page. It is not a new translation: it is an evocation.

From Thurat's account (which may have confused the proposed new museum of decorative arts with the old), it seems clear that Rodin had not begun to mount his sculptures on "the wooden box." This suggests that Rodin was using it in this first stage as a guide, as something against which to calculate the size of his works as they emerged in clay. This assumption seems to be corroborated by the fact that some of the first figures for the portal were photographed against the wooden frame while still in clay. (It is interesting that Thurat does not report on the presence of plasters in the studio.) Little more than a month after Thurat's article appeared, Turquet sent one of the government's fine arts inspectors, Roger Ballu, to studio M, in response to a request by Rodin for more funds. His report was as follows:

I hasten to inform you . . . that the work already executed fully justifies M. Rodin's application and I consider that a sum of three thousand francs may at present be placed at his disposal. As to pronouncing a considered judgment on the work as a whole, I hope you will allow me, Monsieur le Ministre, not to commit myself. In the artist's studio I had the opportunity of seeing only isolated groups from which wet protective cloths were successively removed as they were shown to me. I cannot anticipate the effect that these compositions, all done in high relief, will have on the great portal as a whole. In order to give an opinion based on full knowledge, I should have had to see all the groups in place. This notwithstanding, M. Rodin's work is extremely interesting. This young sculptor reveals a really astonishing originality and power of expression with overtones of anguish. Beneath the energy of the attitudes, beneath the vehemence of the poses expressive of movement, he conceals his disdain for, or rather indifference to, a coldly sculptural style. M. Rodin is haunted by Michelangelesque visions: he may astound, he will never leave the viewer indifferent . . . and while I reserve my judgment as to the whole, I have nothing but praise for the parts already completed.[5]

At some time between January and November of 1883, Rodin began to mount his figures and reliefs on their armature, possibly the "wooden box," but more probably its

plaster replacement. Roger Ballu wrote a second report on November 13 that clearly indicates the *montage* has taken place: "The artist pursues his work with a care and solicitude that render it increasingly interesting. With nature before his eyes, he models his small figures piece by piece. These he then adjusts into an ensemble which he arranges in the groups laid out on the panels of the door." Now having the opportunity to make a judgment on the effect of the whole composition, Ballu continues:

I believe the conception of the work will be striking. The execution is carefully done, energetic, and strong. The personality of M. Rodin, already revealed in his earlier works, is here affirmed, and takes on power. The artist has understood the poet of *The Divine Comedy.* . . . When it is finished, this door will have certain strange aspects, but it will testify to the author's audacity; it will impress as an original creation; it will be criticized in the name of sacred principles and rules; it will be admired for the willful energy of style responsible for its creation. It will be really and in every sense of the word a work of art. M. Rodin asks for 4,000 francs. The work justifies this legitimate request.[6]

Ballu's report succeeded in obtaining for Rodin the requested sum of money. We gain a sense of the intensity and productivity of the sculptor during the years 1883 and 1884 by the fact that three months after Ballu's report, at Rodin's request, his fellow sculptor Jules Dalou wrote a very supportive letter seconding his colleague's request for additional funds.[7] Although this letter adds nothing to our knowledge of how *The Gates* were made, it is important in showing the respect Rodin was winning from a leading artist of his own generation.

While Rodin's lowliest *garcon d'atelier* would have known how he applied his sculpture to the doorway, today we are still groping for information. We know from the foregoing accounts that individual figures and groups were generally modeled in clay and separately, although one account refers to groups in "high relief." The side reliefs, with some notable exceptions (*I Am Beautiful*, *The Old Woman*), were possibly modeled as reliefs on a horizontal surface before being vertically installed. Because of their size, each of these two side reliefs may have been modeled in two or more sections where marks indicate joints. Another old photograph, this one of *Eternal Spring* in clay, shows in the background what is probably the lower section of the portal (Fig. 54). From what we can see it appears that clay may have been directly applied to

Fig. 54. *Eternal Spring*, in clay, with the wooden frame of *The Gates of Hell* in the background with traces of clay on it, 1881. Old photograph in the Musée Rodin.

the rough wooden planking. Molds would then have been taken, after which the clay could have been cut away and replaced by plaster casts. On this whole question we get some help from Bartlett's articles and the unpublished notes that record his observations in Rodin's studio in 1887 and Rodin's answers to his questions. Bartlett's comment in an article, "The whole thing was first modelled in clay and cast in pieces in plaster,"[8] is amplified in one of the unpublished notes: "The architectural part is constructed in plaster. The sculptor then modelled on it in clay in a greater or less degree of perfection—cast in plaster, in pieces and sections and then replaced. It was at first the intention of the sculptor to model in wax but for various reasons this process was abandoned. None of the sculpture, properly speaking, has any background."[9]

Just how Rodin got from the wooden armature to the architectural portions in plaster that Bartlett saw in late 1887 is still not clear. From what Bartlett has written it is possible to speculate that Rodin may have roughed out a background in clay on the two recessed wooden door panels, cut it off in sections, and cast it in plaster. But the doorway that Bartlett saw seems to have been larger than the one Rodin described in his October 1881 letter to the government. The manuscript of a talk Bartlett gave in 1894 includes the following details: "The frame of the door is about 18 feet high and 12 feet wide. . . . All the sculpture was modelled in clay and finished, save the extremities of the figures, hands, feet and heads. Each figure, or section of relief, was then cut off, cast in plaster and replaced in its proper position."[10]

The decision by Rodin to enlarge the doorway may have come in 1883 or 1884 when he was working on the tympanum, which we know was made separately from the portal because it exists as such in plaster (Figs. 55, 56). Its considerable size in Rodin's view might have made it disproportionately large for the original scale of the "wooden box." When the door was enlarged, that would have been the time for Rodin to cast in plaster the door panels with their relief backgrounds. Even though the whole frame of the portal was in plaster (supported by a new wooden skeletal armature) this obviously did not prevent Rodin from working on it, as he could simply put clay figures on the plaster to test their appropriateness, and, if he was satisfied with them, mark their positions, have them cast in plaster, and put them in place. (In Ro-

din's time, as today, it was not difficult to get plaster to adhere to plaster by means of a liquid adhesive.)

In a four-year period, from late 1880 to 1884, Rodin must have completed much of what we see today in *The Gates of Hell*. In 1883 he began to exhibit figures publicly, starting with the marble version of *The Fallen Caryatid* and a bronze of the *Meditation*, from what reporters were already calling by 1885 *"la porte de l'Enfer."*[11] His exhibited "morceaux" of 1884 were probably from *The Gates*. In the winter of 1885–86, exhibiting with Monet and others at the Galeries Georges Petit in Paris, Rodin showed *I Am Beautiful*, *The Kiss*, and other couples from the doors, half a dozen plasters and marbles whose character caused the writer Emile Michel to comment that Rodin's art had "this new shiver" comparable to the poetry of Baudelaire.[12]

By June of 1884, Rodin had progressed to the point where he could ask the bronze founder, Eugène Gonon, who had made some casts for him in 1883, to estimate the cost of reproducing the portal in bronze by the lost-wax method.[13] On June 15, Gonon replied that he had estimated the weight of the door to be "four thousand kilos" (roughly half the weight of the eight-ton bronze portals cast after Rodin's death) and that the cost for the work would be 40,000 francs. In the event that the State furnished the metal, estimated at 8,000 francs, the cost would be reduced to 32,000 francs for the "good execution" by Gonon. Perhaps at the request of the government, which wanted a second estimate, or because of Rodin's eagerness to see his work in bronze at least expense to the government, in 1885 the Bingen Foundry gave an estimate of 35,000 francs for casting by lost wax. This figure was accepted by the government and set aside in Rodin's account, indicating that this foundry was to do the work.[14]

From the estimated weight and Rodin's previously approximated measurements, it would seem that by 1884 the doors were about two-thirds their present height, if not overall size. (As we know them today, *The Gates* are 7.5 × 3.96 m [24.6 × 13.0 ft.], and it is possible Bartlett may not have included *The Shades* in his estimate of the portal's height.) Presumably the founder's estimates were made from a substantially mounted portal, one that certainly must have included the tympanum and full entablature. Although *The Three Shades* are not mentioned, Octave Mirbeau may have confirmed this substantial mounting in the first detailed description of the portal, published

Fig. 55. The plaster tympanum without *The Thinker* and separate from *The Gates*, c. 1881–84. Viewed from the left. Musée Rodin.

Fig. 56. The plaster tympanum without *The Thinker* and separate from *The Gates*, c. 1881–84. Viewed from the right. Musée Rodin.

in *La France* in February 1885. (*The Three Shades* were mentioned in 1886 by Félicien Champsaur.) These founder's estimates, always contingent on there being no major changes by the artist, lead us to assume that Rodin had settled on the dimensions. That they were not determined by the engineer Berger is suggested by Mirbeau's statement in the *La France* article: "It is not known whether *The Gates* will be set inside or outside the new museum."[15]

Rodin may have believed in 1884 that he was so close to completing the museum commission that in good conscience he could compete for a major new assignment. In October of 1884 he was successful in obtaining the municipal commission for a *Monument to the Burghers of Calais*. (Rodin had more than one studio and had taken on more assistants, for which he could be reimbursed by his commissioner.)

As another possible sign that from at least the standpoint of the sculpture, Rodin believed that he had nearly completed his work on the portal, he entered into a contract with an architect named Nanier for a sum of 2,400 francs, to work on the architecture of the doorway. The Musée Rodin files do not show Nanier's receipts for the full amount, but in a letter of February 24, 1885, Nanier complains that as of December 31, 1884, he had only received 1,000 francs out of a total of 1,414 francs incurred in expenses. We do not know what Nanier charged as an hourly fee, but Rodin's most skilled assistants were getting about one franc an hour at the time. Even at four times that sum, Nanier would have put in a considerable number of hours on the architectural details. The interesting and still unanswered question is just how much of the architectural design that we see today did Nanier devise in consultation with Rodin, and how much stems from the sculptor? Further evidence suggests that the answer to the first question is, little if any, and to the second, most if not all.

There is a long and detailed bill in the Musée Rodin archives from Guichard simply dated 1884, but presumably coming at the end of the year, as was the custom, for work done at the Dépôt des Marbres. In the margins of this itemized account are sketches of the moldings and capitals executed by Guichard's carpenters in pine "pour un modèle de porte" (Fig. 57). (The terms accompanying these sketches are "Moulures à l'outil detaché," "Chapiteaux," "Cadres volants," or "montants" and "traverses.")

We cannot be sure if these architectural details were designed by Nanier in 1884, but they do not accord with those in *The Gates* as we see them today. Nanier's letter to Rodin hints not only that the sculptor was slow in paying the full account but also that he may not have been pleased with the architect's interpretation of his intentions. It is likely, judging by the final portal, that Rodin tried Nanier's designs and decided they were too intricate or too colorful.

The outside framing of the central panels and those of the flanking reliefs on the final version of *The Gates* look as if they were made of simple flat wooden planks set at varying depths to each other. Similarly, much of the horizontal molding at the bottom of the central panels is achieved by a stepped arrangement of flat boards. The profiles of the cornices and bases below the side reliefs do not coincide with those in Guichard's invoice. In the final portal, the most intricate moldings are those that frame the upper sides of the tympanum but are cut off and merge

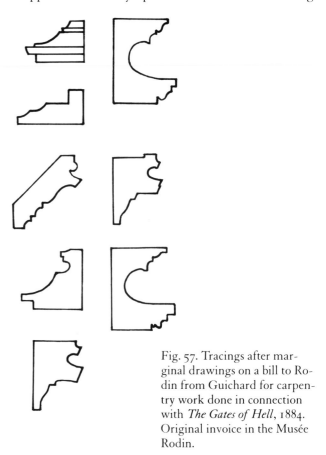

Fig. 57. Tracings after marginal drawings on a bill to Rodin from Guichard for carpentry work done in connection with *The Gates of Hell*, 1884. Original invoice in the Musée Rodin.

with winged figures, those at the very bottom which would have been their termination, and those on the underside of the tympanum itself (Figs. 152, 153, 176). Old photographs indicate that these deep vertical or flanking moldings did exist at one time and ran continuously from tympanum to base.[16] The meager historical evidence argues an evolution from the elaborate to the simple. For all Rodin's study of older architecture and drawings of moldings, much of the final portal's frame consists of flat planes and relatively simple cornices and capitals.[17] This simplification may have resulted from Rodin's intense and prolonged reflection on modifying the interaction of sculpture and architecture. Rodin may also have wanted fewer references to period styles in order to achieve an effect of greater timelessness. As we now see the portal, and as it was in 1900, the areas in which there are the most obvious architectural inconsistencies are the side moldings of the tympanum, their truncated equivalents or continuations below at the base, and the presence of two differently stepped and decorated pilasters on the outer sides of the doorway.

Rodin's only specific comments on *The Gates* that refer to its architectural deficiencies were written on a photograph taken by Druet in 1900 of the disassembled plaster portal in his exhibition pavilion of that year (Fig. 136): "Dimensions less bulky. Moldings less colorful and finer." Rodin may at least have momentarily regretted the pilasters added to the sides of the doors, but it would not have been difficult for him to have had them removed by his assistants, thereby reducing the "bulky" dimensions.

To the extent that the French government's payments to Rodin for the expense of making the plaster model tell us when and how long and extensively he worked on it, it seems that the period of greatest activity before 1899 was from the summer of 1880 to the winter of 1888. The government's list of payments[18] was itemized by year:

October 14, 1880	2,700
January 27, 1883	3,000
November 17, 1883	4,000
August 22, 1884	2,500
January 14, 1885	2,500
July 20, 1885	4,000
October 11, 1886	3,000
March 31, 1888	4,000
Total	25,700

Rodin was never again personally to request funds from the government's account of 30,000 francs, and it was not until July 1917 that the curator of his museum, Léonce Bénédite, asked for the remainder of the allocation. Unexplained is why in 1900 Rodin did not ask for the 4,300 francs due him. By that time he had spent far more than the above total in working on the portal. Finally, on the basis of the statistics and absence of eyewitness commentaries to the contrary, it is probable that Rodin did little or no work on the project between 1888 or 1889 and June 1899. If this supposition is true, how may we account for this? By 1887 Rodin may have been aware that the new museum of decorative arts would go into an existing building, the Marsan Pavilion of the Louvre, that was to be remodeled. (It is the present location of the Musée des Arts Décoratifs.) Perhaps he had hopes that *The Gates* would be cast in bronze and housed in the museum. He could also have known that the remodeling would take years, and in fact, the Marsan Pavilion, if indeed the remodeling had been done, seems to have been empty as late as 1900. There is absolutely no evidence that the government ever gave any indication that the portal would go to any other building or museum. Thus, there might have been a lack of incentive on Rodin's part to push the work to completion. On July 20, 1885, Rodin had written the government, "I have the honor to inform you that the model in plaster will be finished in about six months."[19] With the full knowledge of the government, he was taking on a number of major commissions in the late 1880's and early 1890's that would have occupied all his time.

5

How Rodin Worked on the Sculpture

All his life, Rodin was known as a prodigious worker. Bartlett called him "A terrible worker and a night worker."[1] Before 1880, and for over twenty years, he had led a double existence. On weekdays during the daylight hours he was employed by other artists in making everything from jewelry to ornamental decoration to large decorative compositions to adorn buildings. In Bartlett's words, "Night and Sunday work saved him from artistic and intellectual ruin."[2] The irony was that during the day, although working in ways that he detested but that were dictated by his employers, Rodin was often obliged to draw on his imagination for themes and composition. (This was particularly true in his work at the Manufacture de Sèvres, where he applied decorations to plates and vases.) Rodin's individuality manifested itself not just in the quality of his work but in his penchant for invention, for trying the unorthodox, as shown at Sèvres when he introduced (not always successfully) the practice of engraving designs, and of modeling in a different material from that of the fired vase he was to decorate.[3] (Rodin used the same technique later on when he modeled clay figures on a plaster background of the emerging *Gates*.) From Rodin's own accounts, it appears that although he rarely received any praise from his employers, they respected his speed and the quality of his work, by which they profited financially and in terms of their reputation.

Not surprisingly, Rodin was prone to dismiss his years as an artisan, but they helped develop his astounding stamina and patience, and they gave him certain types of valuable experience. Often to his financial detriment, he developed a strong sense of artistic judgment of what was right and wrong even when engaged in ornamental art. While working for Carrier-Belleuse and during his years of decorative work in Belgium, Rodin had ample time to ponder the secrets and requirements of composition by which two or more figures are joined. "Though I was making poor sculpture for Belleuse," he told Truman Bartlett, "I was always thinking to myself about the composition of figures, and this helped me later on."[4] Rodin was particularly interested in the compositions of Carpeaux, a graduate of the Ecole des Beaux-Arts, because of the way he broke with academic rules and put life into his compositions with several figures.[5]

At night and on Sundays, Rodin was able to indulge his passion for study. In the early years he followed the custom of drawing from plaster casts of ancient sculptures that he had purchased from the Department of Casts at the Louvre. Later on he would criticize the sculptors of his time for having relied more on this indirect experience of the human form than on the living model. Since adolescence when he was a student at the Petite Ecole, he had developed a reliable memory so that he could draw paintings at night that he had seen in the Louvre during the day. In Belgium he drew Rubens's paintings from memory, and during his Italian trip he used nocturnal hours to analyze the structures of Michelangelo's sculptures he had seen during the day. This discipline nourished his imagination, and fortified by extraordinary knowledge of craft and the mechanics of the human form, the experience served him first in earning his bread, and then on the doors.

When he was on his own time, Sundays and evenings,

Rodin chose to work directly from the model, and to make pure, and for him realistic, sculpture. (This private study began probably even before *The Man with the Broken Nose*, on which he worked in 1863.) Without thinking of a subject, or *poésie*, as one was taught to do in academic training, he would set the model in a pose of "correct design" to study its profiles and the joining of the body's planes. It was disciplined self-study in observation of anatomy and its "masses" and the achievement of firmness of modeling that made his figures hardy and vigorous and gave the correct "drawing" of the contours in clay so that they were "right and just." His search was always for what could give his sculptures the quality and appearance of life.

Of the time before *The Age of Bronze* Rodin could say, "My studies had been a blind search after movement."[6] Movement for Rodin was the highest achievement of sculpture and its crucial life-imparting ingredient. From years of study on his own as well as from the teaching of at least one fine instructor at the Petite Ecole, Horace Lecoq de Boisbaudran, Rodin developed an ingrained moral commitment to criticize and constantly strive to improve his own work: to commit himself to a life of self-surpassing effort. This helps us to understand why no matter what he did, Rodin could never be totally satisfied with *The Gates of Hell*. In some ways their commission brought together two aspects of his previous dual existence, working directly from life as well as imagination. While for the most part he detested his commercial employment, it had given him extensive practice in all modes of sculpture, particularly of a decorative sort, and he was no novice at relating sculpture to architecture and a variety of variously sized and shaped fields.

Concerning the beginnings of *The Gates of Hell*, Cladel wrote, "The first years he worked with a kind of concentrated fury. He rose at six A.M., was in the studio an hour later, and, interrupted only by lunch, he worked until night. He even modeled by candlelight."[7] Edmond de Goncourt noted in his journal on February 26, 1886, "After dinner I spoke with Rodin who recounted to me his life of toil, his rising at seven o'clock, his entry into the studio at eight, and his work which continues until night, interrupted only by lunch: work standing or perched on a ladder, this crushing labor caused him to retire to his bed at night after an hour of reading."[8]

After the commission in 1880, Rodin did not experience a dramatic change in terms of physical toil, as he recalled how, many years before, when he worked at night on a life-size sculpture of a Bacchante, he was often so tired that others had to help him home. A fellow worker at Sèvres, Taxile Doat, recalled that when he stopped by Rodin's studio to go with him to lunch, Rodin emerged as if out of a deep trancelike state.[9] No question but that Rodin was robust and gifted with extraordinary powers of endurance. We can understand why his self-image was always as a worker. And he was a shrewd as well as skilled worker, who, even when he was hired by others in Belgium, was able to employ assistants for his own work, since there were at that time many sculptors poorer than Rodin. When the government gave Rodin a rent-free studio and an advance against expenses on the portal, in all likelihood he was able to hire one or more assistants to help him. The government advance was against expenses, and Rodin had to continue doing other projects to support himself, his mistress Rose, and their child. This meant that as late as 1882, Rodin put in occasional hours at the Sèvres ceramic factory, and we know he did decorations for an elaborate carved bed for a fine furniture maker named Ginsbach in that same year.[10] Rodin was probably not financially secure until around 1889 with his second exhibition at the Galeries Georges Petit.

Solving the Initial Sculpture Problem

Neither by disposition, nor by training, nor by previous experience was Rodin what one might call a systematic thinker in a philosophical sense. He was an empiricist, one who solved problems as they came along by trial and error, and he does not seem to have been governed by conceptualizing and grand theories. He had a few fundamental beliefs, notably that art should be soundly based on craft and drawn from life, and that he should trust his artistic judgment. These convictions stood him in good stead throughout his career.

When it came to actually working on *The Gates of Hell*, Rodin did not tie himself to a clear and consistent blueprint. He solved the basic problems in part by common sense, his common sense to be sure, always leaving details to be worked out in the future, relying upon his experience and judgment won over twenty years of hard work. Take

as an example the sculptural program of the portal. Given the fact that his project was to be a large door, he naturally resorted to his big wooden box frame. Given his determination to employ various types of sculpture, which by itself was no doubt stronger than his desire to illustrate Dante, Rodin's solution was characteristically simple and logical: the box was divided up into five zones; the upper zone with its tympanum would have sculpture in the round, the external side panels would be in bas-relief, and the two door panels would be a mixture of both. The third architectural model tells us what Rodin considered to be the principal or anchor sculptures for his composition: a triad of large forms consisting of *The Thinker*, *Ugolino*, and *Paolo and Francesca*, or *The Kiss*. By 1881 he had decided on life-size free-standing statues of Adam and Eve to go in front of and frame the doorway. These five figures gave a somewhat inexperienced monument maker his big asymmetrical sculptures in a symmetrical and roughly pyramidal design. Rodin would also have foreseen that the tympanum and its figures behind *The Thinker* would give him a strong horizontal composition across the top of the doors, and that the vertical framing of the whole would be taken care of by the lateral reliefs.

A rough drawing that shows humanity's parents framing the portal, probably from late 1880 or 1881, also shows *The Three Shades* on its top, but no *Thinker* is indicated in the tympanum area (Fig. 58). In this sketch, Rodin seems concerned with weighting the full-size flanking figures with the half life-size crowning trio. The idea for placing *The Shades* above the doors, thereby juxtaposing radically different figural sizes, could have been inspired by the Baptistry door in Florence—where Ghiberti's bronze *Gates of Paradise* are surmounted by Andrea Sansovino's triad of the sixteenth century, the *Baptism of Christ* (Fig. 59).[11] This was undoubtedly one of the objects of Rodin's study on his Italian trip in 1875. The drawing is also interesting because it reveals that Rodin foresaw his portal at the top of a flight of steps and possibly framed within an arch.

According to written accounts—and some time after the third architectural model—Rodin modified his design for the two door panels to emphasize the horizontal elements: the two major sculptural motifs would be framed top and bottom by reliefs, that is, a line of masks above, and panels with allegorical masks flanked by rampant

Fig. 58. Drawing of *The Gates*, with *Adam* and *Eve* and *The Three Shades*, in an architectural setting, c. 1880–81. Pencil. Musée Rodin. Photo Bruno Jarret.

Fig. 59. *Baptism of Christ* (c. 1540), by Andrea Sansovino, over Ghiberti's *Gates of Paradise*. Florence. Photo Alinari.

centaurs and women below. (This did not preclude there being small groups of figures around and above *Ugolino* and *Paolo and Francesca*.) This simple but original schema favored artistic objectives—and precluded the systematic illustration of Dante—and because it seemed a satisfactory answer to the major artistic problem, it allowed Rodin to focus for many years on the execution. It was not until probably the late 1890's that Rodin would give up the anchoring figures and tripartite division of the two door panels, but by then he had established the general artistic harmony of the big portal around its periphery. The daring and quality of the result were evident to studio visitors before 1887. Bartlett quotes an unnamed artist, probably Jules Desbois, who saw them: "What a combination is the upper part! and the panels on each side! outside of their originality they are divine as a piece of color . . . he owes nothing to any school; or professional authority. He is greater than them all."[12]

From an artist-worker's viewpoint, at the outset he had two life-size sculptures to model and four compositions in which the figures were half life-size or less. The remainder of the figures would be at the secondary scale or smaller. In terms of the considerable time they would take, it thus seems logical that Rodin began with his six most critical figural compositions. (Ironically, three of them would not be used in the final version: *Adam* and *Eve* and *The Kiss*.)

Four of the figures in this sextet are the most Michelangelesque sculptures Rodin ever made. *Adam* and *Eve* are direct derivatives from their counterparts in the Sistine Ceiling, and *The Shades* derive from Rodin's *Adam*. *The Thinker* grew from memories of the Medici tomb in the church of San Lorenzo and perhaps from prophets such as Jeremiah in the Sistine Ceiling. (Although many attempts have been made to show other sources, Blake, Carpeaux, Duret, etc., these were all themselves inspired by Michelangelo, and Rodin consistently sought the original.)[13] Ever since Rodin's trip to Italy, the primary intention of which was the firsthand analysis of Michelangelo's work, he had been pondering his ancestor's "secrets" and seeking the differences between the two of them in order to discover himself. In *The Gates* Rodin was intent on personalizing and modernizing not only Dante but also Michelangelo. *The Thinker* and *Adam* and *Eve* tell us what he learned from Michelangelo about how to achieve

drama through the human form by means of compacting and expressive structuring of the limbs, and by exaggeration in body type and pose. Rodin's discovery, which allowed him to come to terms with his ideal, was that, although Michelangelo's principles of composition and expression could be found in nature, Michelangelo had not worked from the living model. Rodin could therefore set himself the task of naturalizing or humanizing Michelangelo by putting live models into the poses of his exemplar and modeling them from life. The oft-repeated story[14] told by the artist himself of his dismissing the model for *Eve* because, unknown to him, she had become pregnant, causing him to constantly redo the abdomen, reminds us of his way of working:

I believed before that movement was the whole secret of his [Michelangelo's] art, and I put my models into positions like those of Michelangelo. But as I went on observing the free attitudes of my models, I perceived that they possessed these naturally, and that Michelangelo had not preconceived them, but merely transcribed them according to the personal inspiration of human beings moved by the need of action. I went to Rome to look for what may be found everywhere, the latent heroism of every natural movement.[15]

'The Thinker'

The Thinker (Fig. 60) was probably the first sculpture that Rodin made for the portal.[16] In many ways it is the most crucial figure, and its presence in the earlier architectural drawings as well as in the last architectural model indicates that it was important from the start. Thematically and compositionally *The Thinker* was to represent the center of the conception, the equivalent of Christ in older images of the Last Judgment. As often happens with great artists, this one sculpture was a kind of summation of the artist's past, a measure of his growth, and proof of the emergence of his individuality. *The Thinker*'s genealogy descends primarily from the Medici tomb, that is, the effigies of Giuliano and Lorenzo and the allegorical figure of *Night* with the crossover arm motif, but it also bears some relationship to Goujon's relief showing the seated Euclid and Archimedes on the facade of the Pavilion of Henry II in a court of the Louvre (Fig. 61) as well as to Carpeaux's statue of Ugolino with his children, itself inspired by Michelangelo. Within Rodin's own art, this ancestry begins with the *Belvedere Torso* (Fig. 62), a plaster

Fig. 60. *The Thinker*, in clay, in Rodin's studio, 1880–81. Old photograph in the Musée Rodin.

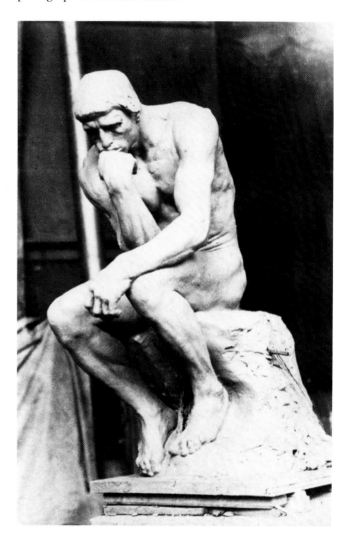

Fig. 61. Decorative reliefs, by Jean Goujon, on the Pavilion of Henri II in a court of the Louvre, showing Mercury (at the top), Archimedes (at the left), and Euclid (at the right), sixteenth century.

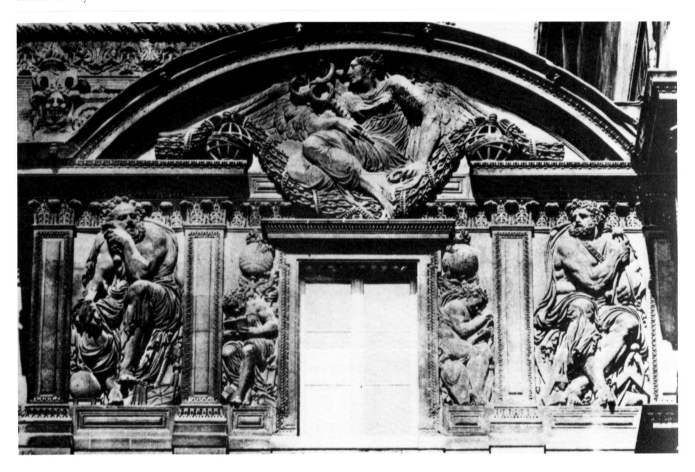

cast of which Rodin had copied by a stone carver in Brussels for his *Trophy of the Arts* in front of the Palais des Academies.[17] This famous ancient torso, which was to influence his later work with the partial figure, taught Rodin much about the expressiveness of the body without head and hands and about how to build a figure from the center outwards. In fact, the pose and proportions of the torso and thighs of *The Thinker* are unthinkable without Rodin's study of this eloquent Roman fragment. The genealogy continues in the large seated allegorical figures of the Antwerp *Monument to Burgermeister Loos*,[18] and to these should be added the many drawings of the seated Ugolino, inspired by Dante.

Crucial for Rodin's transforming rather than synthesizing his sources was the fact that for the actual modeling of *The Thinker* Rodin used a live subject. Since no preparatory sketch closer than the figure in the third architectural maquette survives, it is probable that Rodin worked out his final design in the posing of the model. His use of a powerfully muscled well-proportioned model may have been the lesson from Michelangelo that such a form, especially when its strength seems turned against itself, magnifies the internal drama of the subject. A strong physical type, composed compactly within an imagined cube, also solved Rodin's problem of creating a central character high up in the doors whose still and ample form would stand out against the surrounding turbulence and project from a distance. Finally, the figural type used by Rodin for *The Thinker* may be explained by what he stands for. In 1904, when the enlarged version of this sculpture was first exhibited in Paris, Rodin had this to say about how *The Thinker* came about and who he is:

The Thinker has a story. In the days long gone by, I conceived the idea of "The Gates of Hell." Before the door, seated on a rock, Dante, thinking of the plan of his poem. Behind him, Ugolino, Francesca, Paolo, all the characters of the Divine Comedy. This project was not realized. Thin, ascetic, in his narrow robe, Dante separated from the whole would have been without meaning. Guided by my first inspiration I conceived another thinker, a naked man, seated upon a rock, his feet drawn under him, his fist against his teeth, he dreams. The fertile thought slowly elaborates itself within his brain. He is no longer dreamer, he is creator.[19]

When Rodin first made *The Thinker* less than half life-size, he may still have considered putting it before the doors. (He could have enlarged the figure, as he did with

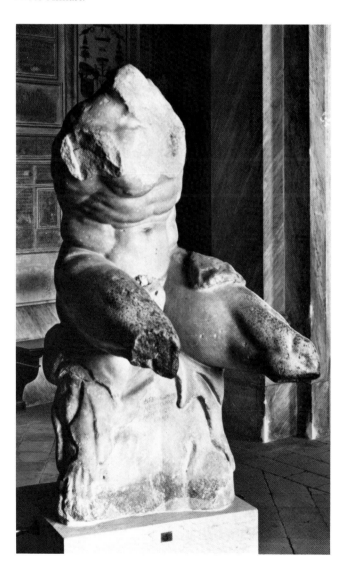

Fig. 62. *The Belvedere Torso*, first century B.C. Vatican Museum. Photo Alinari.

that of *Eve*.) But his idea of having *Adam* and *Eve* precede and flank the portal could have discouraged this, and encouraged him to move the seated man up and into the gates, as an old photograph shows it on a scaffolding before the wooden armature (Fig. 50). Notations for *The Thinker* on several previous architectural drawings were supplemental rather than integral to the original architectural design, as Rodin pondered its placement. *The Thinker*'s location in the third architectural model, however, does not mean that Rodin had made his decision before the armature was built, as the upper section of the tympanum had a vertical divider that would not have allowed his centralized location. What caused Rodin to make the decision on final placement will become apparent subsequently when *The Thinker* is viewed in different contexts within the doors.

'Adam' and 'Eve' and the Lessons of Michelangelo

The poses of *Adam* and *Eve* (Figs. 63, 64) are, as many have pointed out, variations on those used by Michelangelo on the Sistine Ceiling (Figs. 65, 66). The compactness of the *Adam*, his upraised leg and violent twist of the head to the side, also speaks of Rodin's study of Michelangelo's *St. Matthew* (Fig. 67). According to Cladel, the *Adam* or its first version was made by Rodin shortly after his return from Italy in 1875.[20] More obviously, for the pose of the statue of Adam, Rodin turned upright the reclining figure from the Sistine Chapel's *Creation of Adam*. (For Rodin the positioning of the navel area rather than the dictates of gravity was the expressive law for his sculptures.) He transferred the life-receiving gesture of the frescoed figure's left arm and hand to his *Adam*'s right side. The pronated attitude of *Adam*'s left arm came from that of Michelangelo's dead Christ in the *Pietà* in Florence (Fig. 68). Rodin knew how to read the meaning of Michelangelo's gestures, and in his mind *Adam* may have come to summarize the whole theme of *The Gates of Hell*. Thus this single figure enacts gestures of life and death, while his agonized body dramatizes the suffering of earthly existence between its beginning and end.

This dramatic use of gestures having an important history in art would seem to have made Rodin a symbolist. It was at the moment that Rodin discovered in his study of Michelangelo's art what he called "the heroism latent

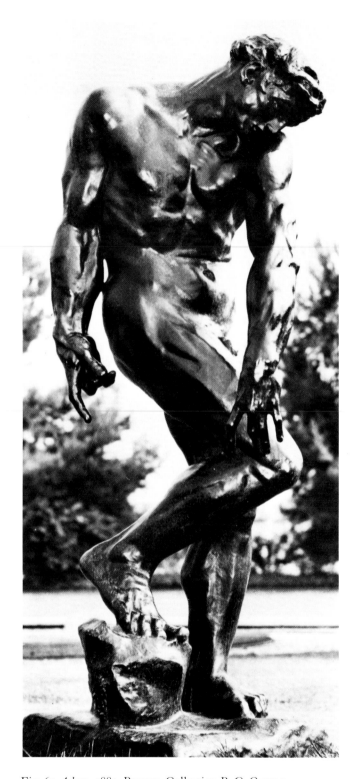

Fig. 63. *Adam*, 1880. Bronze. Collection B. G. Cantor.

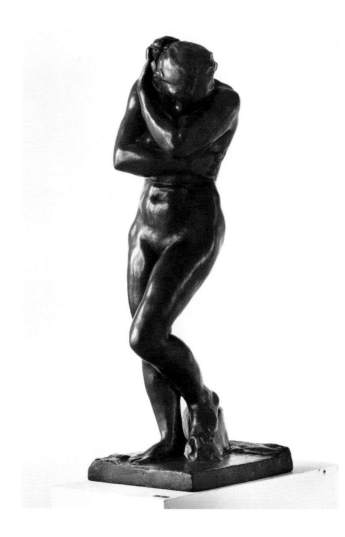

Fig. 64. *Eve*, 1881. Bronze. Collection B. G. Cantor.

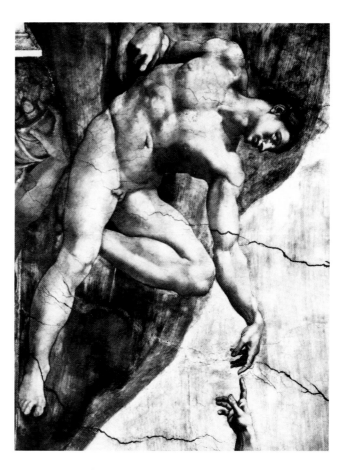

Fig. 65. *Adam*, from *The Creation of Adam*, by Michelangelo, 1508–12, in the Sistine Ceiling. Photo Anderson.

in every natural movement," that by his own account "I perceived the elements of what one calls my symbolism." "I understand nothing of theories," he said, "but I am a symbolist if that must designate the ideas suggested to me by Michelangelo. That is to say, that the essential is modeling, the plane, which alone renders intensity, the supple variety of movement and of character."[21]

No better explanation of how Rodin made sculpture can be found than in his own recitation of principles derived from his years of studying Michelangelo, and the figure of *Adam* makes an ideal illustration:

What is the principle of my figures? . . . Equilibrium is the pivot of my art. Not inertia: but the opposition of volumes that produces movement. Here is the flagrant fact of art . . . the essential are the planes. Respect them from all sides: movement inter-

venes, displaces volumes, creates a new equilibrium. The human body is a walking temple. It contains a central point around which the volumes distribute themselves. . . . He [Michelangelo] understood that the human body can create an architecture, and that in order to obtain an harmonious volume, one must inscribe a figure or a group in a cube, a pyramid, a cone, a simple geometrical figure. . . . I say that the sense of the cube is the mistress of things, not appearances. . . . I feel the sense of the cube everywhere. . . . Am I a symbolist, metaphysician? No, I am a realist and sculptor. Unity oppresses and haunts me.[22]

Rodin was able to apply those same principles to the overall form of *The Gates of Hell*, and they were crucial to solving the problem of order that haunted him. One could look at the portal as being a gigantic cube within which Rodin inscribed his figural and architectural composition. The cubelike form of *Adam* placed before the portal would have allowed the viewer to make the analogy between the two, and the figure is thus a microcosm of the sculptural world's artistic order.

Rodin was so anxious for Turquet's approval to add this figure to the original commission that he exhibited

Fig. 66. *Adam and Eve and the Expulsion from the Garden*, by Michelangelo, 1508–12, in the Sistine Ceiling. Photo Alinari.

Fig. 67. *St. Matthew*, by Michelangelo, 1504–6. Accademia, Florence. Photo Alinari.

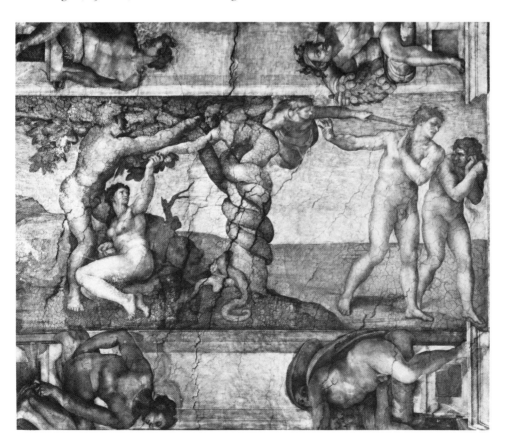

Fig. 68. *Pietà*, by Michelangelo, 1548–55. Florence, Museo del Duomo. Photo Alinari.

Fig. 69. *Eve*, by Falguière, 1880. Marble. Ny Carlsberg Glyptothek, Copenhagen.

the statue in the Salon of 1881, where it won praise for its "power and intensity of life," but to no avail.[23] This lesson may explain why Rodin did not go to the time and expense of enlarging his statue of Eve until long after its first exhibition in London in 1883, when it was shown in the half life-size version. Rodin's *Eve* is a more deliberate departure from her ancestor in the Sistine Ceiling, and a small surviving study of the upper portion of the figure shows Rodin's interest in deepening the psychological drama of the first woman as she realizes the consequences of her act. Where other sculptors such as Falguière (Fig. 69) and Guilbert[24] had shown Eve before the fall as Venus or a nineteenth-century beauty queen, Rodin astonished his viewers by depicting a woman who guiltily buries her head

in her arms, and with one hand tries to ward off the wrath of God in the form of the angel who expels her from paradise, while the other hand remorsefully claws at her side. Unquestionably Michelangelo opened Rodin to the dramatic possibilities of showing simultaneously in a single figure two strong and opposed states of being, which was crucial for the drama and meaning of *The Gates of Hell*.

Eve is a critical figure in Rodin's development, for she may have been the last figure fully inspired by Michelangelo's art and the means by which Rodin worked back to the study of the profiles, proportions, and movements of less statuesquely endowed living models. In this process he realized not only how strong but how personal Michelangelo's style was, and he saw that anatomical exactitude was not artistic truth. The lesson included the crucial requirement that the artist exaggerate his modeling in accord with and in order to realize his individuality. Whether or not Rodin was historically correct, he was consistent in going to the source—life itself—which he believed Michelangelo had started from. Rodin recapitulated his own development as follows: "I began by the most faithful studies of nature, as in *The Age of Bronze*. . . . I looked for the forms of vases for the manufacture de Sèvres. I did not succeed in finding a beauty of proportions and of lines that satisfied me because I only based my research on imagination. . . . Then [after reflecting on Michelangelo], I understood that one must rise above to a higher reality, which is the interpretation of nature by a temperament."[25] (It seems ironic that Michelangelo should have led Rodin to a view of realism shared by Emile Zola.) Not the least importance of *The Gates* was that during the early years of their creation Rodin found himself by learning how to fuse his technical and imaginative gifts.

'The Kiss' and 'Ugolino'

In *The Kiss* (Fig. 70), which could have been made by 1881, Rodin was still trying to show the official art world that he could compose with the best of the Prix de Rome winners. In fact, he not only outdid them in the sincerity of the lovers' expressions of mutual awareness and love, he even revived an old gesture of sexual appropriation by having the more assertive Francesca sling her leg over that of the hesitant Paolo.[26] It was not, however, this sexually symbolic gesture that surprised and in some cases shocked the critics when the work was first shown in public (it seems to have gone unnoticed to this day) but rather the nudity of the lovers. This was a popular couple in the nineteenth century, and in their numerous portrayals—such as Aristide Croisy's plaster of 1875 (Fig. 71)—they are usually shown in Florentine dress. Croisy's lovers are the model of youthful innocence. Rodin's couple are adults, and no longer innocent. Though he retained the book in Paolo's left hand behind Francesca's back (most viewers tend to overlook this), by showing the figures in the nude he offended public expectations and sensibility and found himself accused of vulgarity and obscenity. (Many teenagers, however, have written to the Tate Gallery over the years telling how the marble version of *The Kiss* showed them the purity and beauty of love and how important it was to their sex education.) Within the context of *The Gates*, Rodin had early determined to eliminate any reference to time and place such as costume would have provided. Rodin not only wanted to show that he could interlace limbs with the best of sculptors, but was also determined to tell a passionate story in the round and with all the subtlety at his command. Rodin had his models pose so that they do not actually kiss, and the man's right hand rests tentatively on the woman's left thigh. His back is still dutifully erect, as if mindful of the fact that he is the brother of his lover's husband and has been hired by him as her tutor. (His double tragedy is as a brother and teacher.)

Rodin seems to have first tried the half life-size initial version of this sculpture in the portal. Dissatisfied with its scale, he reduced it, and it was seen in that state in the left door panel by Bartlett and others until at least 1889. At some point Rodin removed it from the doors. Although pleased with its simplified vigor, Rodin later implied that the couple was too isolated from the rest of the composition: "Without doubt the interlacing of The Kiss is pretty, but in this group I did not find anything. It is a theme treated according to the tradition of The School [The Ecole des Beaux-Arts]; a subject complete in itself and artificially isolated from the world that surrounds it."[27]

The Kiss and the *Ugolino* group both trace their ancestry to an extensive number of drawings by Rodin, though none of these provided the exact guide to the final sculpture. Rodin had explained why he turned from his drawings inspired by Dante, saying that he wanted his work to

Fig. 70. *The Kiss*, 1881.
Bronze. Stanford University
Art Museum, gift of
B. G. Cantor.

Fig. 71. *Paolo and Francesca*, by Croisy, 1876. Plaster. Musée de l'Ardenne et Musée Arthur Rimbaud, Charleville-Mézières. H. W. Janson Photographic Archives.

come closer to reality. With funds provided by the government, Rodin was able to hire a number of professional as well as nonprofessional models to work for him and to "multiply the modeling sessions."[28] He preferred the nonprofessionals because they had not been trained to assume poses from art and were more natural. In a conversation with Bartlett, he recounted what the living model gave to him:

A model may suggest, or awaken and bring to a conclusion, by a movement or position, a composition that lies dormant in the mind of the artist. And such a composition may or may not represent a defined subject, yet be an agreeable and harmonious whole, suggesting to different minds as many names. The physical and mental character of a model regulates, to a degree, this affinity. A model is, therefore, more than a means whereby the artist expresses a sentiment, thought or experience; it is a correlative inspiration to him. They work together as a productive force.[29]

Talking of his models on another occasion, Rodin explained: "I constantly note the association of their feelings and the line of their bodies, and by this observation I accustom myself to discover the expression of the soul, not only in the features of the face, but in the entire human form. . . . It is very rare that they [the sketches] serve me as preparatory models for more advanced works."[30] Rodin's practice of having the models move naturally about the studio is well known today. He began to use the method in the early 1880's. When he was working on *The Gates*, Rodin would study his models, at rest or in movement, and then have them assume a pose he felt was in character with their mood or nature. It is thus possible that Pignatelli, who came to Rodin untrained as a model, and whose wild Abruzzi peasant character had inspired Rodin to use him for the *St. John*, may also have inspired the sculptor to have him model as the Pisan count whom hunger and grief almost turned into an animal. As we see him in the doors, Ugolino is on all fours, his stomach contracted and mouth open as if crying out in pain or horror (Fig. 72). Such poses as those of *Ugolino and His Sons*, *The Kiss*, *The Thinker*, *Adam*, and *Eve*, which models could have helped to inspire, nevertheless came from Rodin's imagination and are what Edmond de Goncourt characterized as his "poetic humanity."

For visitors to Rodin's studio, *The Kiss* epitomized the portal's focus on love, whereas the *Ugolino* group epitomized for Bartlett "the horror of the door." Bartlett recognized what today is apparent to anyone who compares Rodin's interpretation of the theme with that of Carpeaux (Fig. 73): "Rodin's power of seizing the most dramatic point of a subject. . . . [He] goes at once to the depths of the whole tragedy."[31] Rodin was not only a better modeler than all other nineteenth-century sculptors, he surpassed them in imagination, profundity, and dramatic judgment. Though his sculptures appear to have been done effortlessly, we know that as with *The Kiss*, he had to make many changes with *Ugolino*, notably in the area of the agonized head as shown in an old photograph (Fig. 51). Rodin was not only a superb dramatist, the best in sculpture since

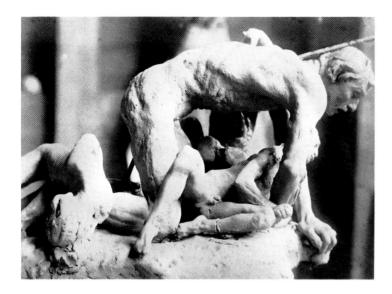

Fig. 72. *Ugolino and His Children*, 1881. Clay. Old photograph in the Musée Rodin.

Fig. 73. *Ugolino*, by Carpeaux, c. 1861. Photo Ruth Butler.

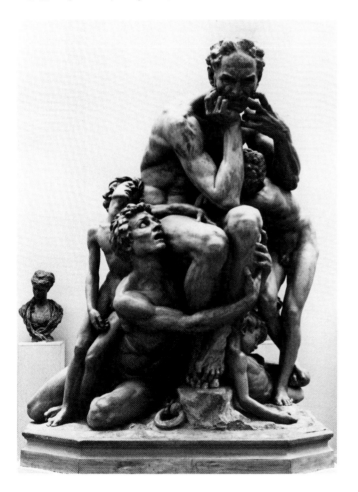

Bernini, but he could also be as meticulous in his characterizations and staging as the most bemedaled academician.

Both *The Kiss* and the *Ugolino* group, like the statue of *St. John the Baptist*, were made so that sections of figures could be removed for study and reworking. A photograph of the final *St. John* in plaster, standing in Rodin's studio, shows a somewhat dismantled *Kiss* in the corner (Fig. 4). Rodin was a patient and thoughtful worker who did not rely upon momentary inspiration but would consider his sculptures scattered around the studio in all stages of realization for months or years on end before completing them. This practice of using time as an ally sometimes gave Rodin the inspiration and inclination to completely rework a composition, such as the *Ugolino* group, even after it had been finally set into *The Gates*. In the case of the *Ugolino* group, Rodin made still a third version showing the father seated, surrounded by his dying offspring, that is the closest to the general conception of the original drawings. This third version (Fig. 74), never cast in bronze or exhibited to my knowledge, is in the Musée Rodin reserve, and it is a hybrid montage of plaster figures and figural parts cannibalized, culled, or recycled from other works as well as from the version on the portal. Rodin also recycled parts of his *Ugolino* group in the doors, notably the body and head of the son clinging to his father's back, for parts of other figures. The boy's head is also used on that of the woman just below the *Ugolino* group in the final doors, and that couple is titled *Paolo and Francesca*.

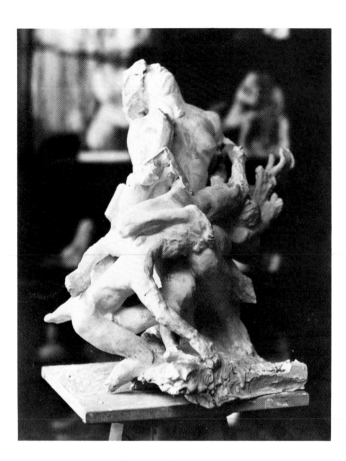

Fig. 74. Rodin's third version of *Ugolino and His Children*, date unknown. Plaster. The children are from the second version. Ugolino is a hybrid: the body is that of a seated woman, at times called Cybèle, and the male head is from a different source. Musée Rodin, Meudon. Photo Bruno Jarret.

The Serious Play of Sculptural Matchmaking

Rodin told Bartlett that it was not until he had reached the age of thirty-five that he felt confident enough to work entirely from nature. This is no doubt true, but Rodin did not make all his art thereafter directly from the model. One of the important influences on Rodin's method of creation that resulted from his years of work on the portal was that of making sculpture from his own sculpture. He created a vast repertory troupe, one that visitors commented on as filling the floor, walls, shelves, and furniture of his studio, "this battlefield covered with twisted bodies in the strangest poses."[32] Rodin's sequence of sculptures did not come about systematically, but at times derived from his moods, as well as from those of the models he chanced to have. Like Balzac, he was inspired more by emotions than by ideas. He knew, like his fellow poets and writers, that for his great work he would create more than he could use, and that he would have to make difficult decisions when it came to constructing the "architecture" and order of the sculpture. Some of the prolific production Rodin's guests saw in the studio was caused by there being more than one cast of a given work, as well as many casts of figural parts.

When the models had left, or when he was not modeling from the memory of a particularly inspired model, Rodin had still another means of creating that produced some of his most poetic couplings in sculpture. Like a dramatist or choreographer, he could sit or stand among his plaster progeny and audition them by pairing separately made figures to see if by chance an electric spark of form and drama would result. This practice was possible because almost all his figures were made in the round, "without background" as someone observed. It was also grounded in Rodin's compositional discoveries that if two figures were well modeled from every profile, and if their points of contact seemed to catch fire, such things as difference in modeling mode, scale, or sex were unimportant. The fact that their bodies had been shaped according to a given orientation to gravity that differed from the new orientation he had given the figures was dismissed by Rodin as insufficient to force him to either give up or rework what he had found and that delighted him. The couple that apart from the doors came to be known as *Fugit Amor* is a splendid example of this sort of reuse of figures. They

occur in two different orientations near each other in the lower center and corner of the right door panel (Fig. 89). Neither of the angles from which we see this couple in the portal coincides with the position of the models when Rodin first modeled them separately. Rodin manipulated the two plaster forms in his hands until he decided that placing them back to back was the most provocative coupling. But Rodin, who also thought of the human body as a "polyhedron," liked to create compositions that could be visualized within a simple geometric form. In this regard, *Fugit Amor* may have satisfied Rodin's own cubism. By this practice Rodin effected otherwise impossible unions of men and women, and he became an artistic matchmaker without peer or precedent.

Rodin's technical insouciance and compositional daring were predicated on the simple assumption that a wise sculptor never lets a good piece of modeling or sculptural idea go to waste—something that stems from the attraction of genius to frugality as much as the lesson of years of poverty. He had been sporadically synthesizing figures from differently made parts since the time of the mask of *The Man with the Broken Nose*, and he liked to tell how often he had tried that first real piece of modeling he ever did on such figures as the lost *Bacchante*, as well as *The Age of Bronze*. (This is a good example of Rodin's indifference to gender consistency in a hybrid work.) His second version of the more aged model for that mask came to be used twice, once for a figure in the tympanum and again at the extreme right as the last in the line of heads just above *The Thinker* (Fig. 108). The portion of the portal that gave free rein to this practice must have been the two door panels, for in them he had a larger field and space in which to allow his imagination and figures like *Fugit Amor* to soar (Fig. 92).

No better example exists of Rodin's frugality, matchmaking, and unorthodoxy than *The Three Shades* atop the portal (Fig. 77). The first preliminary architectural drawings do not clearly show that there were to be three closely grouped figures above the doors. Nor is it clear when Rodin made notations on these drawings about installing one or more figures in that location. At one point he seems to have thought of putting humanity's parents on top of the doors. There is only one drawing, probably the last, in which Rodin's drawing code indicates the triple-figured crown for the doors, and they appear along

with the full-size flanking figures (Fig. 58). In their form and emotional state, the three figures were to be *Adam's* descendants. Using the one-third life-size version of the statue, Rodin changed the arms by removing and replacing them with different gestures and bringing the arms out from the body and cutting off the hands. (This amputation was not casual, and one should read the surviving edges in conjunction with the silhouette of the torso.) Rodin could have effected this change either by breaking the arms and resetting them or by making a clay duplicate instead of plaster, which would have been easier to rework as the arms are now disposed. Then Rodin would have had, as was his custom, more than one plaster cast of the figure that came to be known as *The Shade*. During those hours of matchmaking Rodin might have pushed together first two and then three casts to judge their effect, and being satisfied, he might then have thought of trying their appropriateness atop the portal. In that location, and having lost their identity as Adam, the figures became Dantean shadows, or spirits of the living or dead, an ambiguity that instinctively appealed to Rodin. Thematically, triplication magnified the figures' dolorous mood. Compositionally he had won a dynamic yet almost emblematic symmetry with no touching or interlace. Sculpturally, what would have pleased him was the fact that, even though set against a wall, the trio offered three different views of his modeling including the back, of which Rodin was so proud that he had it especially photographed.[33]

One of the most striking unions of Rodin's matchmaking is the couple known as *Je suis belle* (I Am Beautiful) (Fig. 75). It appears in the upper right-hand external bas-relief (Fig. 100). The male can be found elsewhere clinging to the floor of the tympanum to the left of *The Thinker* (Fig. 86). Not far away, just to *The Thinker*'s left, is the second partner, *The Crouching Woman* (Fig. 76). All that Rodin had to do to achieve their union was to break off and reposition the arms of the male. Here too he might have pressed clay into the mold made for a plaster, giving him a second work in that malleable medium, and working again in clay he could effect gesticular changes. (Rodin used this technique also to restore movement to a figure that time showed him had been lost.) He loved the expressiveness of the male's back so much that he used the figure from the waist up, inverted, and clutching a different woman, also from the tympanum, next to the tomb

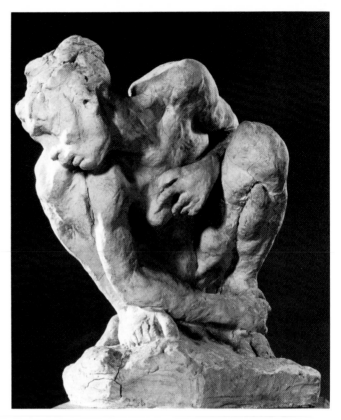

Fig. 76. *The Crouching Woman*, 1881. Clay. Musée Rodin.

Fig. 75. *I Am Beautiful*, c. 1881–82. Plaster. On this old photograph Rodin made some notations in ink, perhaps to indicate how he would have treated the work in stone. Musée Rodin.

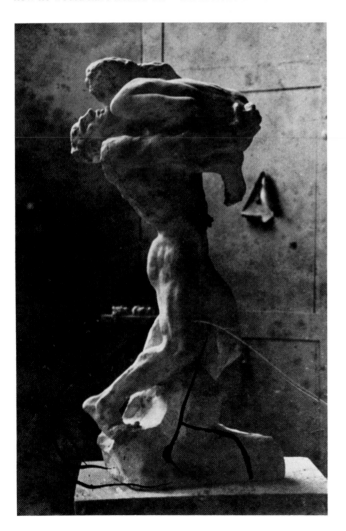

in the right door panel (Fig. 78). At some time before 1887, Rodin inscribed a verse from Baudelaire's poem, *La Beauté*, on the base of the couple at the top, but we can see from the history of these figures that they were not inspired by the poem.[34] Rather, Rodin seems on occasion to have read poetry in terms of his sculpture. Since so much of his sculpture had been made with no titles or names in mind, like his friends Rodin enjoyed baptizing his creations with identities that at a given time struck him as apt, but not irrevocable.

The Beauty of Sculptural Line and Color: The External Bas-Reliefs

The portion of the doors that seems to have received the largest amount of approval from visitors to Rodin's studio while he was working on the commission was the reliefs on the pilasters (Figs. 77, 96, 102). In different ways these reliefs show the variety and ingenuity of Rodin's

text continued on page 110

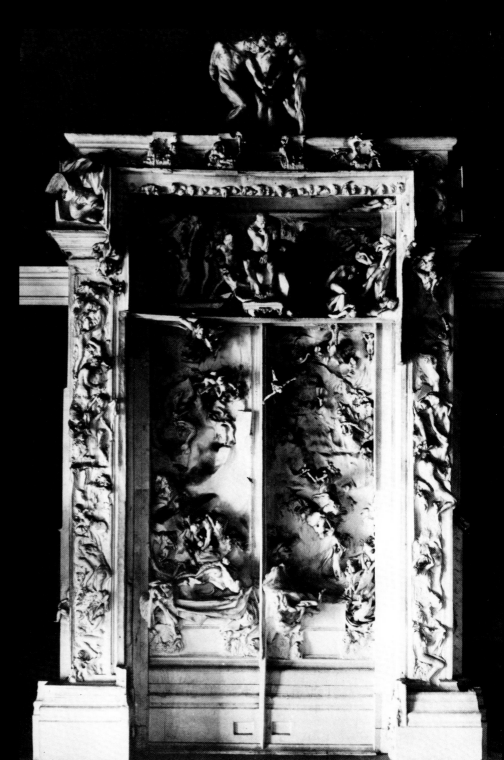

Fig. 77. *The Gates*, fully assembled in plaster, 1917. Photographed by Bulloz in the same year. Musée Rodin.

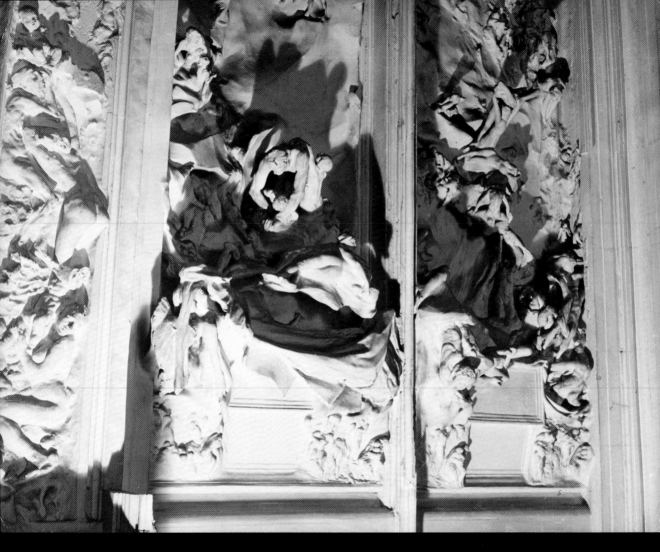

Fig. 78. Lower half of *The Gates*, in plaster. Photo Louis-Frédéric.

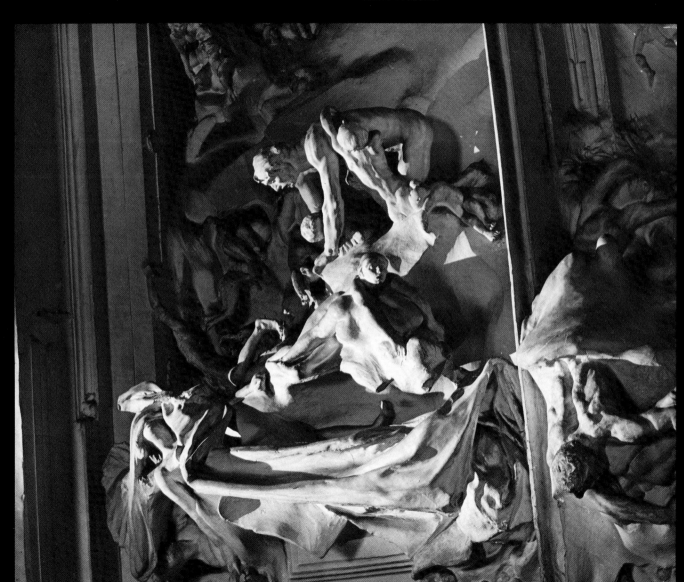

Fig. 81. *Paolo and Francesca*. Photo Louis-Frédéric.

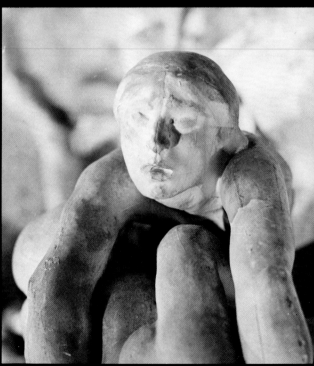

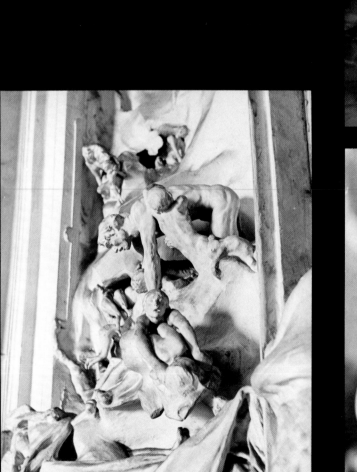

Fig. 80. Lower section of the left door panel, seen in daylight. Photo Louis-Frédéric.

Fig. 82. Head of Paolo. When separated from the doors this became *The Head of Sorrow*. Photo Louis-Frédéric.

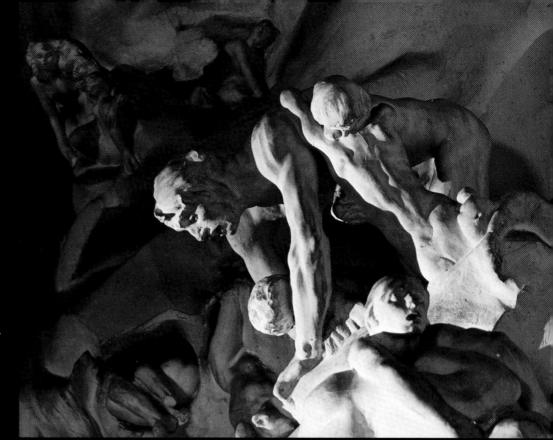

Fig. 83. *Ugolino and His Children*. Photo Louis-Frédéric.

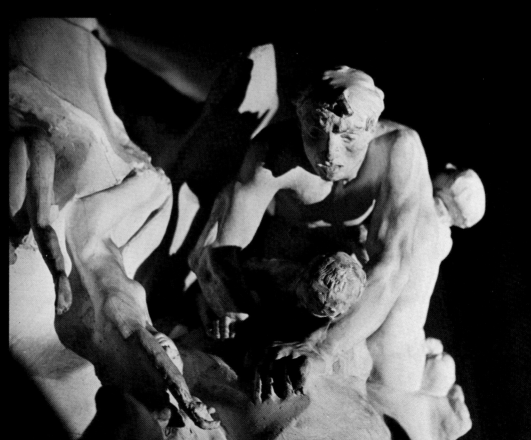

Fig. 84. *Ugolino*, front view. Photo Louis-Frédéric.

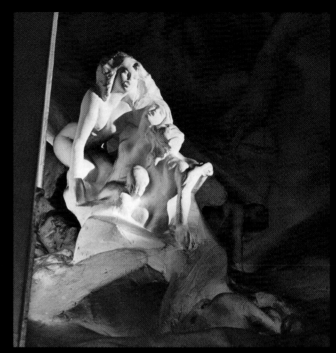

Fig. 85. Left door panel, group known as *The Sirens*. Photo Louis-Frédéric.

Fig. 86. View from below of the upper left door panel, with *The Falling Man* clinging to the tympanum. Photo Louis-Frédéric.

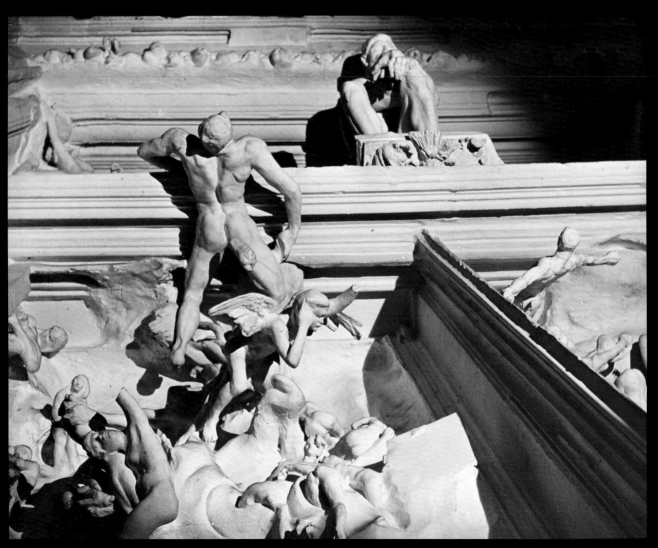

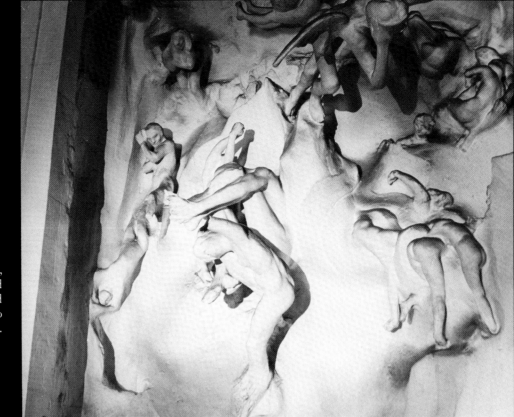

Fig. 87. Upper left door panel, with serpent coiled around figures at the right, and falling angel above. Photo Louis-Frédéric.

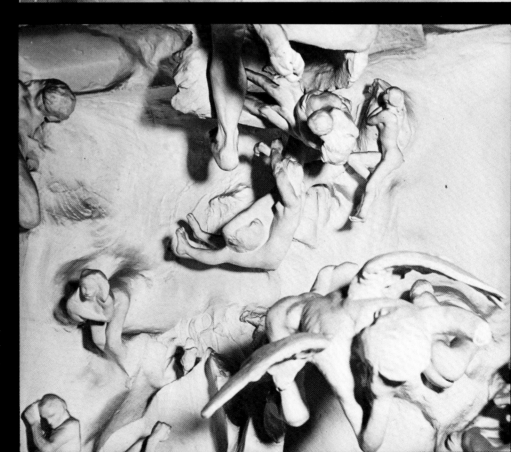

Fig. 88. Top of the left door panel just below *The Falling Man*. Photo Louis-Frédéric.

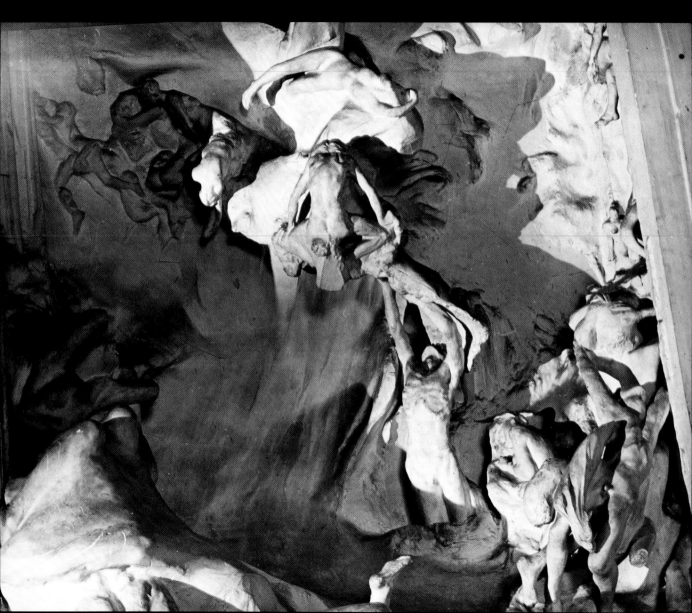

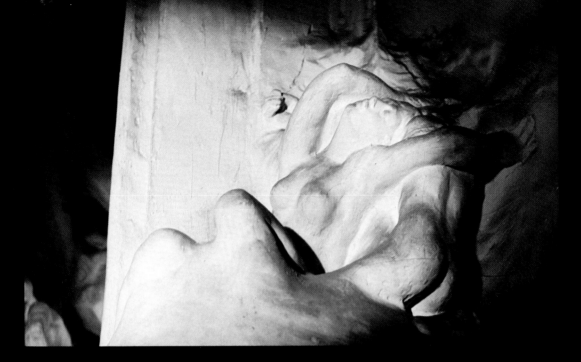

Fig. 90. Lower left corner of
the left door panel, showing
two figures in soft ground.
Photo Louis-Frédéric.

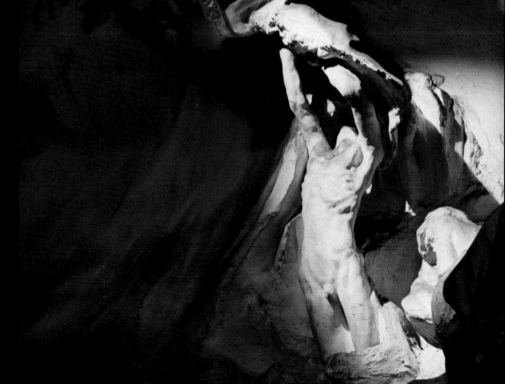

Fig. 91. Detail of the lower left
corner of the left door panel,
showing a nude male on his
knees. Photo Louis-Frédéric.

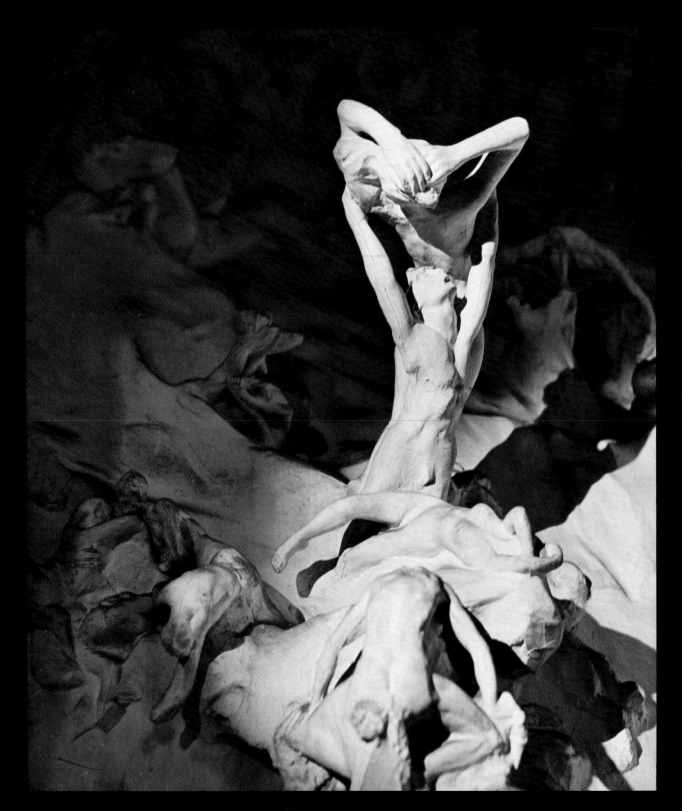

Fig. 92. Midsection of the right door panel, showing the couple
known as *Fugit Amor*. Photo Louis-Frédéric.

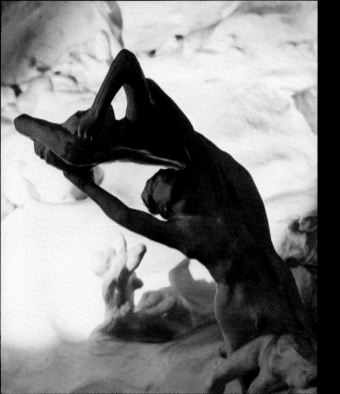

Fig. 93. *Fugit Amor* from a different lighting and viewing angle. Photo Louis-Frédéric.

Fig. 94. Right-hand area of the midsection of the right do
panel. Photo Louis-Frédéric.

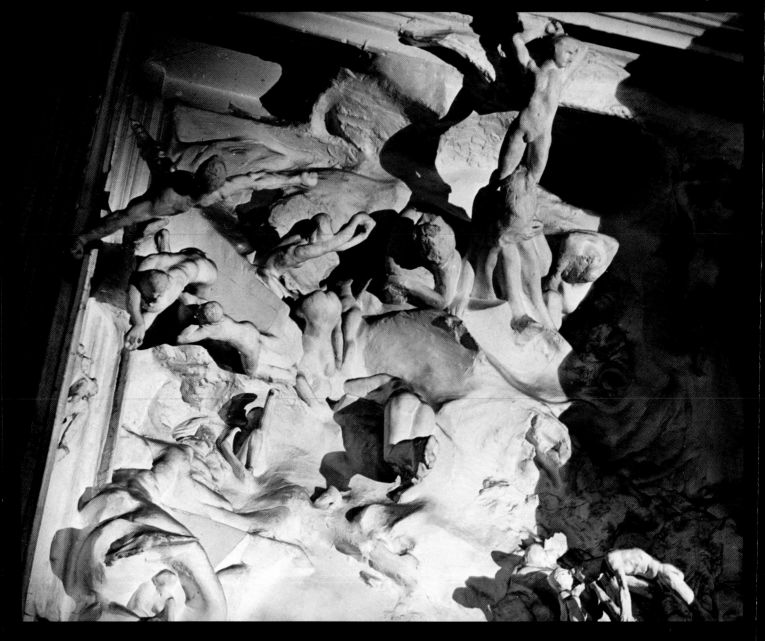

Fig. 95. Upper section of the right door panel. Photo Louis-
Frédéric.

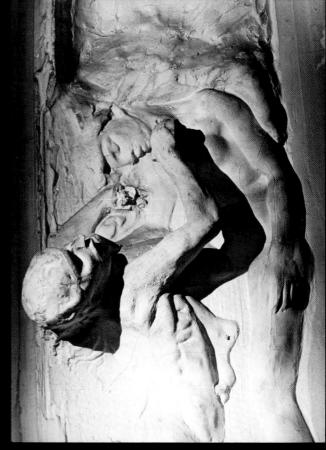

Fig. 97. Second couple from the bottom of the right external bas-relief. Photo Louis-Frédéric.

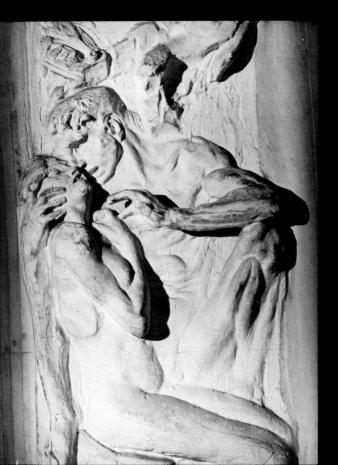

Fig. 96. Couple at the bottom of the right external bas-relief. Photo Louis-Frédéric.

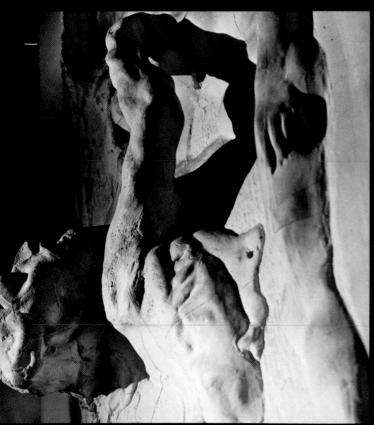

Fig. 98. Detail and side view of the male in the second couple from the bottom of the right external bas-relief (Fig. 97). Photo Louis-Frédéric.

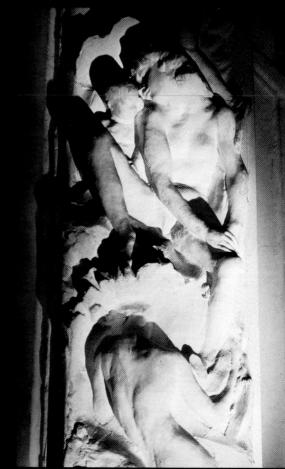

Fig. 99. Women and children in the middle section of the right external bas-relief. Photo Louis-Frédéric.

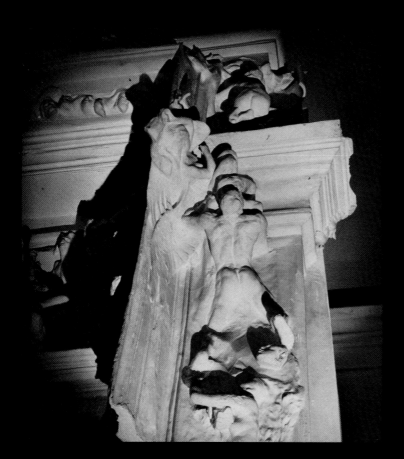

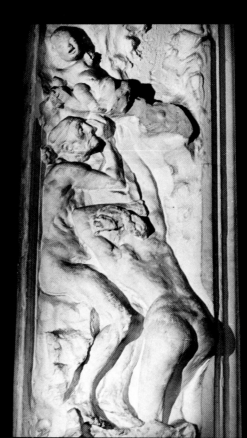

Fig. 100. Upper section of the right external bas-relief, showing the couple known as *I Am Beautiful*, the male of whom is also *The Falling Man*. Photo Louis-Frédéric.

Fig. 101. Lower left section of the left external bas-relief. Photo Louis-Frédéric.

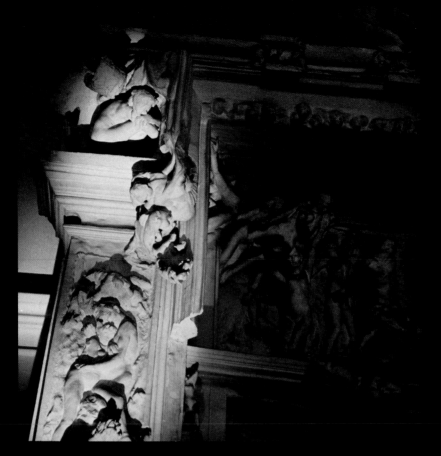

Fig. 102. Upper section of the left external bas-relief, above which are the giant leaf and angel whose wings fuse with the left molding of the tympanum, and in the top left corner *The Fallen Caryatid*. Photo Louis-Frédéric.

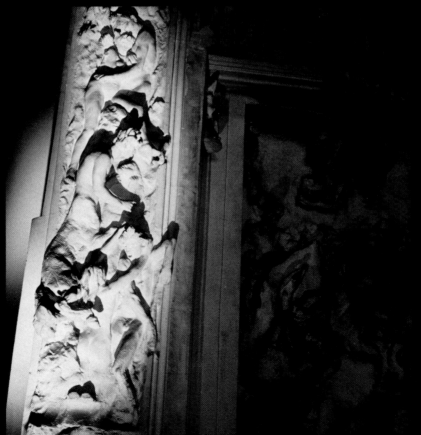

Fig. 103. Midsection of the left external bas-relief. Photo Louis-Frédéric.

Fig. 164. *The Thinker*, in the tympanum. Photo Louis-Frédéric.

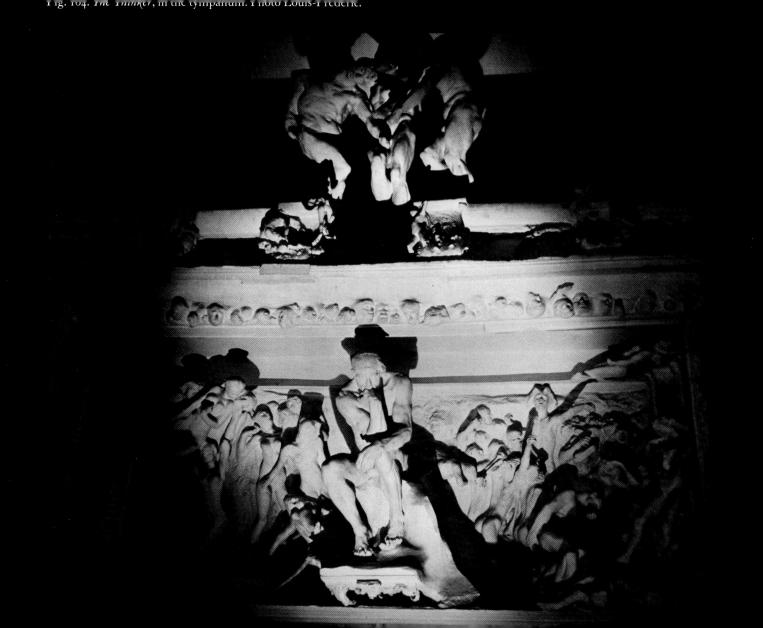

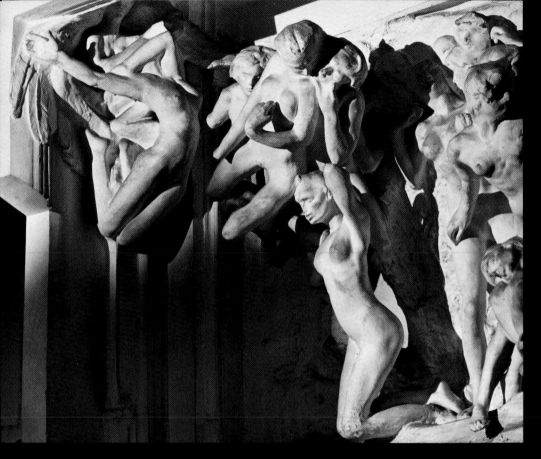

Fig. 105. The left side of the tympanum detached from
The Gates. Photo Louis-Frédéric.

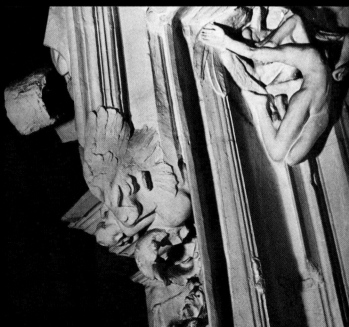

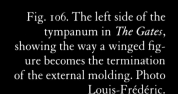

Fig. 106. The left side of the
tympanum in *The Gates*,
showing the way a winged fig-
ure becomes the termination
of the external molding. Photo
Louis-Frédéric.

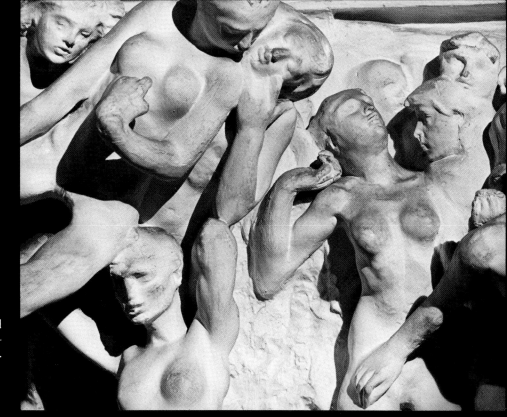

Fig. 107. Detail of the crowd
in the left side of the tympa-
num. Photo Louis-Frédéric.

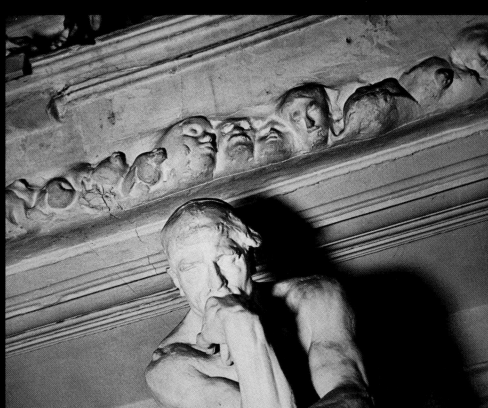

Fig. 108. Head of *The Thinker*
and line of heads above. Photo
Louis-Frédéric.

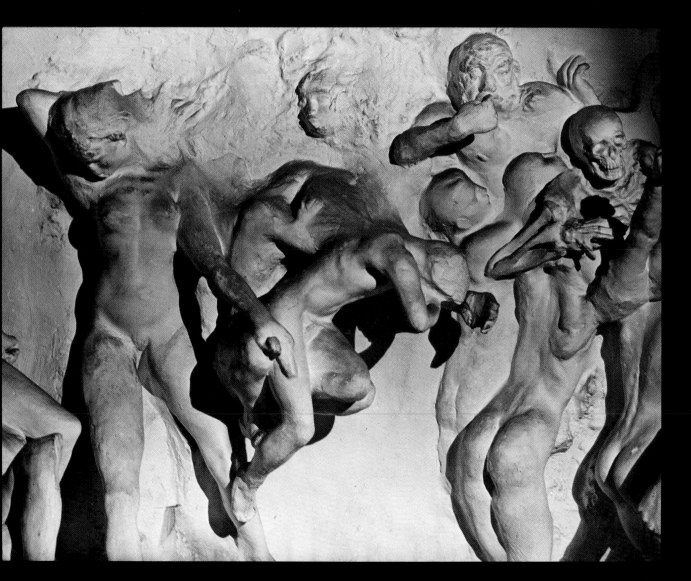

Fig. 109. Figures behind *The Thinker* in the tympanum. Photo
Louis-Frédéric.

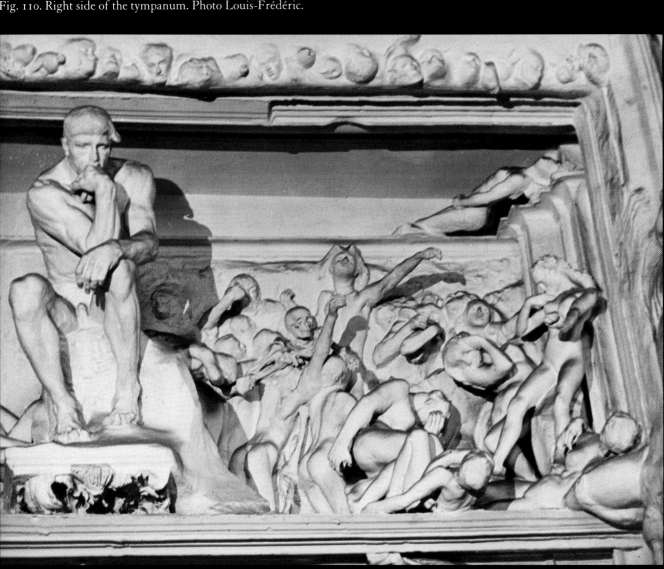

Fig. 110. Right side of the tympanum. Photo Louis-Frédéric.

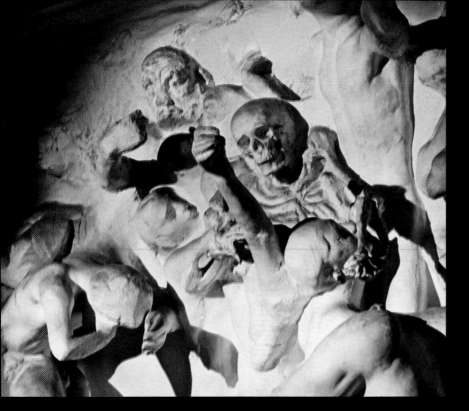

Fig. 111. Right side of the tympanum, showing a crowd that
includes a skeleton and the aged version of *The Man with the
Broken Nose*. Photo Louis-Frédéric.

Fig. 112. Right-hand section of the line of heads along the top
of the tympanum, with the head of the older *Man with the
Broken Nose* at the far right. Photo Louis-Frédéric.

Fig. 113. The top of *The Gates*, and *The Three Shades*. Photo
Louis-Frédéric.

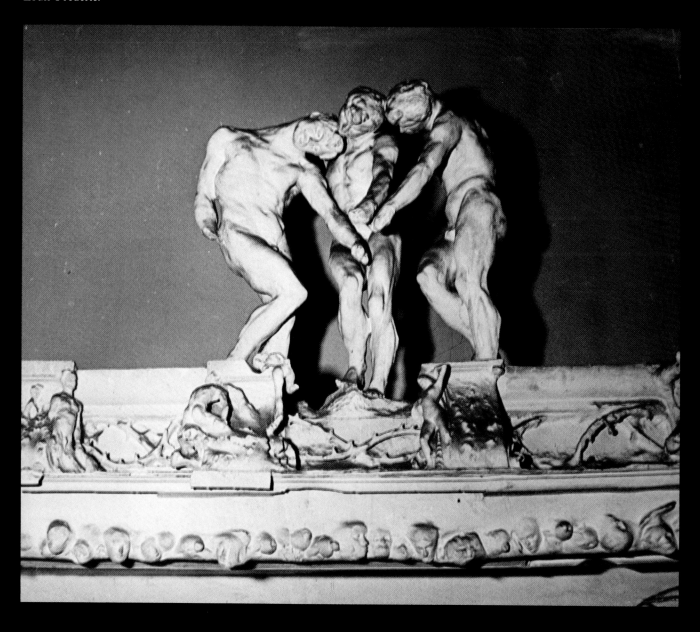

Fig. 114. Looking down into
the lower right door panel.
Photo Louis-Frédéric.

Fig. 115. Looking down into
the lower left door panel.
Photo Louis-Frédéric.

Fig. 116. Looking down at the midsections of the two door panels. Photo Louis-Frédéric.

methods as well as his gifts as a composer. Some of the figures were made directly from models, and were probably only made in relief. Others, notably the centaur in the left panel, came from his imagination. Still others came from sculptures in the round, such as the couple at the top of the right panel, and may have been remembrances of drawings, such as the two lowest couples in the right-hand relief (Figs. 11, 96, 97). Whether or not the conjoined old and young women in the left panel were made before or after the Sèvres vase bearing their forms we may never know, but assuredly the designs Rodin made for ceramic decoration influenced his thinking.[35]

Rodin's unorthodoxy at Sèvres, which so dismayed his supervisor, signaled his impatience with the conventions by which reliefs were made in his time and also reflected his dissatisfaction with official art school teaching that taught students to study the model as if she were a relief. Bartlett reported that Rodin opposed the practice of students looking at the model for a single line or from only one angle (which he felt was the influence of Ingres), as he wanted "the fact, not the effect," of the figure in its full roundness.[36] The side reliefs of the doors show Rodin's own personally evolved principles, starting with what might be called that of figural rotation. No two figures in the panels are shown from the same point of view. They are often partially if not largely in high relief, and that as well as Rodin's method of working from all the profiles would have made them susceptible to rotation. In fact, when Rodin made several of these figures in the round, he may not have known from which angle or how much of the body would be shown until he actually tried them on the panels. The "color" so approvingly referred to in these reliefs derived from the light and shadow cast by the varying degrees of relief, which Rodin could control not by having initial and arbitrary surface planes but by trial and error.

A second principle was that of compositional continuity or linkage between figures rather than the compartmentalizing of motifs. It is apparent that Rodin wanted his composition to flow upward and downward. By overlapping and staggering the figures he avoided a tiered effect and brought the bodies into surprising relationships of attraction and repulsion (Fig. 77). By this means he also gained the beauty of line sculptors admired in the 1880's. Except for the figures at the top and bottom of the reliefs (whose silhouettes seem roughly squared off), figures tend not to have their lower limbs aligned on the same level, and symmetry in the bodies is also avoided. The vertical rhythms of the panels are not predictable or continuous, and there are breaks or pauses, as when Rodin removed a woman from just below the middle of the left relief. The rhythms are achieved by irregular spacing and rough rhyming of bodily gestures, notably the raised diagonals made by torsos and limbs in the right side panel. These sequences, like those that are coarse and smooth, are not obvious, but they are nevertheless deducible. Rodin showed his extraordinary compositional sense in the way he related the parts and the whole to the vertical rectangular shape of these two fields. One has the sense that the rectangularity is not imposed on but rather is given by the figural arrangement. This derives from Rodin's beliefs about nature and what it taught him as a composer, and it also shows that he did not have an architect's view of the subordinate relation of figure to frame. As we shall see in the chapter on touring *The Gates*, Rodin had no hesitation about overlapping or cutting away the architecturally defined edge of the field if his figural movement so required.

Looked at against one another and as the outermost boundaries of the portal, the side reliefs suggest some of Rodin's compositional thinking (Fig. 77). The two reliefs, while somewhat similar in overall effect of light and dark and general movement, are substantially different. There are six motifs on the right and five on the left. (The removal of one figure must have established this asymmetry as intentional.) Starting from the top or bottom, one can see that there is no horizontal alignment of respective figural sequences. The composition on the right extends higher, actually overlapping the cornice, than its companion. (Adding to that impression is the exposed back of the figure in the upper right-hand corner.) In the left relief, not only do the figures not rise as high, but the crouching figure in the upper corner above them is partly concealed by drapery (Fig. 102). Perhaps Rodin felt that with our habit of looking from left to right, he needed more visual weight on the right side. The postures of the figures in the right relief tend to turn them to the left, away from the outer edge of the door frame. But in connection with that frame, we can see that by contrast with their counterparts, the diagonal movements in the right relief are

picked up in the diagonally stepped external pilaster, as opposed to horizontally on the left side.

By avoiding repetition and regularity, Rodin achieved in the side reliefs compositional unpredictability, with an absence of figural self-conscious posing and adaptation to the field, and above all, the look of the natural. For all that the reliefs appear on first sight to have been casually arranged or even unarranged, they have a rigorous coherence, and it is in part this coherence that endows their astonishing variety with inexhaustible interest. Though Rodin's personal compositional principles seen in the side reliefs were in fact applied throughout the doors, he seems to have been so pleased with these reliefs that after 1900 he had them reduced in size and recast so that they were available to collectors.

The Improvisations

Just how Rodin worked on the central door panels is less clear, although there is an account by the French writer Camille Mauclair that suggests he had observed Rodin working in this area:

He is continually putting in little figures which replace others. Plastered into the niches left by unfinished figures, he places everything that he improvises, everything that seems to him to correspond in character and subject with that vast confusion of human passions. . . . He will be forever improvising form, and this he plants in his door, studies it against the other figures, then takes it out again, and, if need be, breaks it up and uses the fragments for other attempts. . . . If it [the doors] were to be carried out, it could not contain all the figures destined for it by the artist. There they stand, innumerable, ranged on shelves beside the rough model of the door, representing the entire evolution of Rodin's inspiration, and forming what I call, with his consent, "the diary of his life as a sculptor."[37]

Mauclair reminds us that Rodin did not always model with a living subject before his eyes, and from the artist himself, at a later period, we have an account of his improvisations and how he was open to the promptings of memory and imagination:

I often begin with one intention and finish with another. While fashioning my clay I see in fancy something that had been lying dormant in my memory and which rises up before me in what seems to be a vision created by myself. I know it is not this but a suggested combination of forms which I must have already perceived in nature and which has never before roused in me

the image that corresponds to it. And then as I go on, and the execution becomes more complete, there is a sort of reverse process in my mind and I find resemblances and fresh analogies which fill me with joy.[38]

Another commentator observed: "Countless damned women were born from a rapidity of spontaneous creation. They palpitated under his fingers, with some living for only an hour before returning to the coarseness of the clay and being remodeled again."[39]

Undoubtedly there were times when Rodin set out to model a figure for his doors and another idea or purpose came to him. One gains a sense of Rodin's frustration over his inability to include in the portal all that he desired by his comment to Dutch visitors in 1891: "All of life has passed through my mind while I studied this work. Often and only for myself I have executed apart [from the doors] the ideas that came to me while working. . . . To think of how many days of crushing study are not represented there."[40]

When, after 1887, Rodin knew that the new museum of decorative arts would not be built and that his doors might not literally serve as the entrance to a building, he may have extended the introduction of his improvisations into the jambs, or corners of the central panels. (Foundrymen tell me, however, that with a few small changes, the central doors as we see them today could have been made to open.)

The Nocturnal Netherworld

As a notorious night worker, Rodin would have spent considerable time working on and studying his portal by artificial light. Judith Cladel told me in 1949 that Rodin hoped to have *The Gates* lighted from below. Uplighted with artificial light, the plaster portal acquires a totally different dimension than when seen by overhead daylight (Figs. 79, 80). By candlelight or oil lamps, the plaster could have appeared more like marble, and this nocturnal experience of seeing the doors may have contributed to Rodin's hope of carving the sides and upper section in marble, with the central doors cast in bronze.

By nocturnal illumination the plaster portal becomes almost hallucinatory as well as more personally intimate (Figs. 114, 115, 116)—hallucinatory because one's orientation in the doors is most vulnerable when they are only

partially lighted in a larger surrounding area of darkness. One loses the ability to estimate the size and limits of the work as a whole, and the lighted area becomes an intimate world unto itself, in which the limited radius of candle or lamp light forces one consistently closer to the figures than in the daytime. With the aid of the ladder always kept near *The Gates* in his studio, and with the artist playing the role of a Virgilian guide, one could have made a nocturnal Dantean voyage through Rodin's netherworld. There would have been a succession of dramatically lighted individual encounters, and the broader panorama of suffering would have been obscured. Much of the pleasure and astonishment to be derived from such a voyage would have come not just from the figures themselves but from the evocative power of their upward-cast shadows (Figs. 89, 92). Always expressive because they are the true black projections of the marvelous white figural silhouettes, the shadows often become strangely distorted or warped by being thrown onto modeled rather than flat surfaces (Fig. 95). The presence of the projected shadows doubles the gestures, enhancing the impression of figures in movement. An inconstant candle flame would have made the flickering uplighting more infernal.

Viewing the doors by artificial light suggests that among other things Rodin could have studied the size and placement of his relatively open spaces in the central section. These spaces become receptacles for shadows, throwing into greater relief the most salient figures on the door panels. Many of the faces in the portal are downturned; they can be better seen when uplighted, and relationships between figures and groups take on a new character. One can imagine Rodin holding a candle or lamp and touring a visitor through at least the lower regions of the doors, and how he could have spotlighted Ugolino, whose shadowed environment enhanced the sense of imprisonment (Figs. 83, 84). Rodin could have used candlelight to demonstrate to a visitor how he "fought the cold and dry" in sculpture, and how his side reliefs had the blond or transparent shadows he so admired in the sixteenth-century sculpture of Goujon.[41]

Night viewing of the great portal could have inspired many visitors, as well as the artist himself, with analogies to the poetry of Baudelaire, whose verses are filled with evocations of tenebrous environments and tormented figures. When Rodin received the commission by Paul Gal-limard in 1887 to illustrate Baudelaire's *Les Fleurs du Mal*, these poems must have been more strongly in Rodin's mind than ever, and the dimly lighted portal would have been most susceptible to the poet's influence, as well as helping to bring the words to life in Rodin's thought. In 1889, Hugues le Roux wrote of Rodin's public exhibition of works from the doors and how he remembered them in the artist's studio: "I knew the time when the walls, the studio floor, the sculpture stands, the furniture was covered by these small bodies of naked women, twisted in poses of passion and despair. Rodin was then under the influence of Baudelaire's book. He seemed intoxicated with it."[42]

Rodin's Illustrations for 'Les Fleurs du Mal'

Rodin's illustrations for Baudelaire's poems consisted of twenty-two pen and ink drawings done directly on Gallimard's personal beautifully bound copy of the first edition, and five full-page insertions.[43] These drawings—done mostly in a fine drypoint technique—have an appearance of great spontaneity, but they took Rodin over a year to finish, and even then he was not wholly satisfied. Part of this protracted time was due to work on *The Gates of Hell* and such other projects as the readying of *The Burghers of Calais* for exhibition in 1889. Rodin needed money to support his family even modestly, and his studio expenses were considerable. As he told Edmond de Goncourt in 1887, when the writer asked him to do some illustrations, "I am a naked man, not one with draperies" (Je suis un homme du nu et non de draperies).[44] Rodin had done only one other illustrated book, and that consisted of supplying two drawings for Emile Bergerat's *Enguerrande*, published in 1884.[45] Gallimard's project was in principle a far greater challenge, but in fact the client made it more difficult for the artist to rise to it. On December 29, 1887, Edmond de Goncourt wrote in his journal, "[Rodin] spoke to me of the illustrations for Baudelaire's poems that he was in the midst of executing for a collector and into the depths of which he would have liked to descend but the remuneration does not permit him to give it enough time. Thus, for this book, which will not have publicity and must remain confined in the study of the collector, he does not feel the warmth, the fire of an illustration, demanded by an editor." (The first facsimile

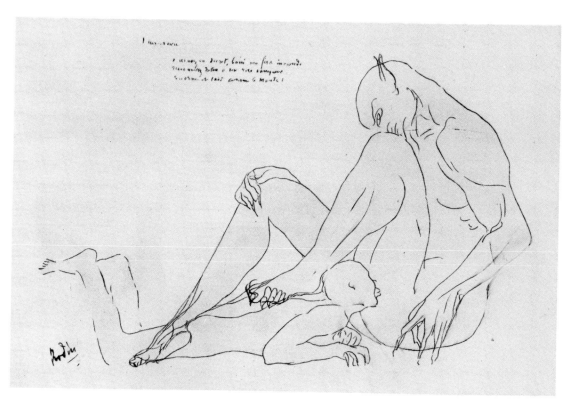

Fig. 117. *L'Imprévu* (The Unexpected), 1887–88, frontispiece for *Les Fleurs du Mal*. Pen and ink. Musée Rodin. Photo Bruno Jarret.

Fig. 118. *Au Lecteur* (To the Reader), 1887–88, from *Les Fleurs du Mal*. Pen and ink. Musée Rodin. Photo Bruno Jarret.

Fig. 119. *Le Guignon* (Bad Luck), 1887–88, from *Les Fleurs du Mal*. Pen and ink. Musée Rodin. Photo Bruno Jarret.

Fig. 120. *La Beauté*, 1887–88, from *Les Fleurs du Mal*. Pen and ink. Musée Rodin. Photo Bruno Jarret.

edition of Gallimard's copy illustrated by Rodin was not published until 1918.) Even though these drawings do not represent Rodin's best sustained effort in interpreting a poet who was so important to him, they are revealing about how he made art and thought about Baudelaire.

What Rodin chose to respond to in the 1857 edition of twenty-five poems of *Les Fleurs du Mal* were above all the themes of the *femme fatale* and male remorse, despair, and violence. Seductive but unattainable women embody the beauty after which artists vainly strive (*Le Guignon*, *La Beauté*; Figs. 119, 120, 121). They engage in lesbian love (*Femmes Damnées*), lure and reject male partners (*De Profundis Clamavi*, Fig. 122), and they are responsible for the deaths of their lovers (*Le Poison*). Rodin shows women

Elle était donc couchée, et se laissait aimer,
Et du haut du divan elle souriait d'aise
A mon amour profond et doux comme la mer
Qui vers elle montait comme vers sa falaise.

Les yeux fixés sur moi, comme un tigre dompté,
D'un air vague et rêveur elle essayait des poses,
Et la candeur unie à la lubricité
Donnait un charme neuf à ses métamorphoses.

Et son bras et sa jambe, et sa cuisse et ses reins,
Polis comme de l'huile, onduleux comme un cygne,
Passaient devant mes yeux clairvoyants et sereins ;
Et son ventre et ses seins, ces grappes de ma vigne,

S'avançaient plus câlins que les anges du mal,
Pour troubler le repos où mon âme était mise,
Et pour la déranger du rocher de cristal,
Où calme et solitaire elle s'était assise.

Je croyais voir unis par un nouveau dessin
Les hanches de l'Antiope au buste d'un imberbe
Tant sa taille faisait ressortir son bassin.
Sur ce teint fauve et brun le fard était superbe !

— Et la lampe s'étant résignée à mourir,
Comme le foyer seul illuminait la chambre,
Chaque fois qu'il poussait un flamboyant soupir,
Il inondait de sang cette peau couleur d'ambre !

Fig. 121. *The Thinker*, 1887–88, illustrating *Les Bijoux* (The Jewels), from *Les Fleurs du Mal*. Pen and ink. Musée Rodin. Photo Bruno Jarret.

Fig. 122. *De Profundis Clamavi* (Out of the Depths Have I Cried), 1887–88, from *Les Fleurs du Mal*. Pen and ink wash. Musée Rodin. Photo Bruno Jarret.

dying or dead (*Une Charogne*, *Remord Posthume*, *Une Martyre*, Figs. 123, 124, 125), but never rotting or turning into skeletons as does Baudelaire. Woman is shown enjoying the embrace of a skeleton (*Les Deux Bonnes Soeurs*, Fig. 126), and the company of demons (*La Béatrice*, Figs. 127, 128). Men are tortured by remorse (*L'Irrémédiable*, *L'Irréparable*, Fig. 129, *Réversibilité*), compose disconsolate groups (*L'Aube Spirituelle*, *Causerie*), enact violence on one another (*La Destruction*, Fig. 130), and long for death (*La Mort des Pauvres*, Fig. 131). Rodin even introduced an illustration for a poem not in Gallimard's volume that shows the devil. The book's frontispiece, taken from *L'Imprévu*, shows a sinner kissing Satan's arse (Fig. 117). A quizzical demon stands beside *Tout Entière*. Opposite

Fig. 124. *Remord Posthume* (Remorse after Death), 1887–88, from *Les Fleurs du Mal*. Pen and ink. Musée Rodin. Photo Bruno Jarret.

Fig. 123. *Une Charogne* (A Carrion), 1887–88, from *Les Fleurs du Mal*. Pen and ink. Musée Rodin. Photo Bruno Jarret.

Le tombeau, confident de mon rêve infini,
— Car le tombeau toujours comprendra le poète, —
Durant ces grandes nuits d'où le somme est banni,

Te dira : « Que vous sert, courtisane imparfaite,
De n'avoir pas connu ce que pleurent les morts? »
— Et le ver rongera ta peau comme un remords.

LES FLEURS DU MAL 49

Ce qu'il faut à ce cœur profond comme un abîme,
C'est vous, Lady Macbeth, âme puissante au crime,
Rêve d'Eschyle éclos au climat des autans;

Ou bien toi, grande Nuit, fille de Michel-Ange,
Qui tors paisiblement dans une pose étrange
Tes appas façonnés aux bouches des Titans!

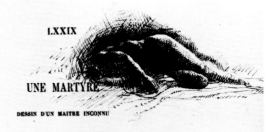

LXXIX

UNE MARTYRE

DESSIN D'UN MAITRE INCONNU

Au milieu des flacons, des étoffes lamées
 Et des meubles voluptueux,
Des marbres, des tableaux, des robes parfumées
 Qui traînent à plis paresseux,

Dans une chambre tiède où, comme en une serre,
 L'air est dangereux et fatal,
Où des bouquets mourants dans leurs cercueils de verre
 Exhalent leur soupir final,

Fig. 125. *Une Martyre*, 1887–88, from *Les Fleurs du Mal*. Pen and ink. Musée Rodin. Photo Bruno Jarret.

Et la bière et l'alcôve en blasphèmes fécondes
Nous offrent tour à tour, comme deux bonnes sœurs,
De terribles plaisirs et d'affreuses douceurs.

Quand veux-tu m'enterrer, Débauche aux bras immondes?
O Mort, quand viendras-tu, sa rivale en attraits,
Sur ses myrtes infects enter tes noirs cyprès?

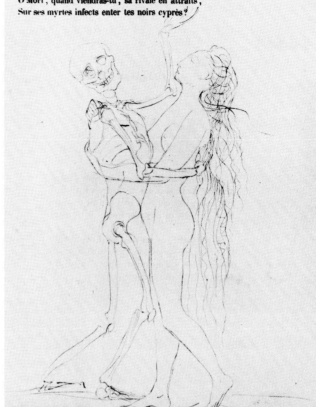

Fig. 126. *Les Deux Bonnes Soeurs* (The Two Good Sisters), 1887–88, from *Les Fleurs du Mal*. Pen and ink. Musée Rodin. Photo Bruno Jarret.

LXXXVI

LA BÉATRICE

—

Dans des terrains cendreux, calcinés, sans verdure,
Comme je me plaignais un jour à la nature,
Et que de ma pensée, en vaguant au hasard,
J'aiguisais lentement sur mon cœur le poignard,
Je vis en plein midi descendre sur ma tête
Un nuage funèbre et gros d'une tempête,
Qui portait un troupeau de démons vicieux,
Semblables à des nains cruels et curieux.
A me considérer froidement ils se mirent,

Fig. 127. *La Béatrice*, 1887–88, from *Les Fleurs du Mal*. Pen and ink. Musée Rodin. Photo Bruno Jarret.

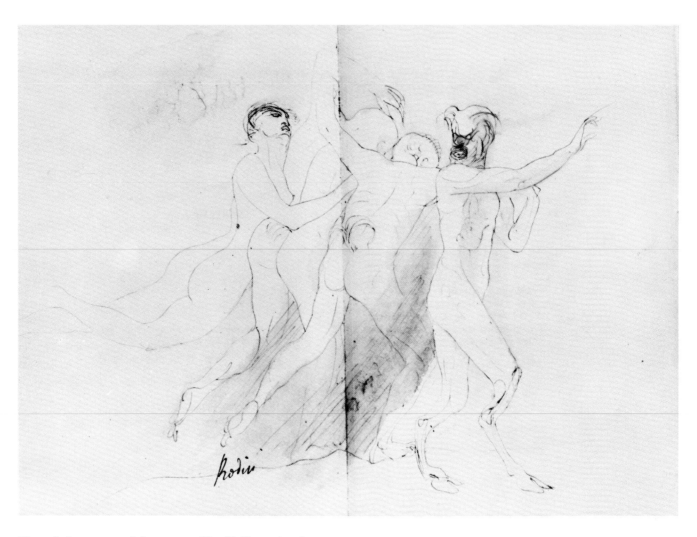

Fig. 128. A woman and three men, 1887–88, illustrating *La Béatrice*, from *Les Fleurs du Mal*. Pen and ink. Musée Rodin. Photo Bruno Jarret.

Fig. 129. *L'Irréparable* (The Irreparable), 1887–88, from *Les Fleurs du Mal*. Pen and ink wash. Musée Rodin. Photo Bruno Jarret.

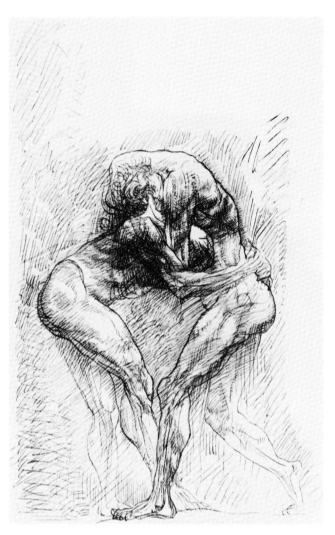

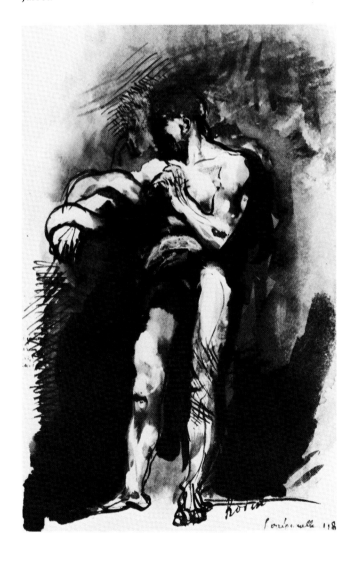

Fig. 130. *La Destruction*, 1887–88, from *Les Fleurs du Mal*. Pen and ink. Musée Rodin. Photo Bruno Jarret.

the dedication page, Rodin drew a naked, striding, and beckoning male figure who incarnates the invitation in *Au Lecteur* for readers to follow and see their own vices in the poems (Fig. 118). One of the most intriguing juxtapositions of drawing and text is that of *The Thinker*, shown as if in a dark cave, opposite the poem *Les Bijoux* (Fig. 121). Instead of showing the evil seductress of the poem, Rodin has *The Thinker* incarnate the poet's resistance to her attempt to disturb the "quiet in which my soul found itself and to dislodge it from the crystal rock where calm, solitary, it was seated." *The Thinker* is thereby cast in the role of the poet's soul, detached from but exposed to sexual temptation. (In 1888, when this sculpture was first exhibited in Copenhagen, Rodin titled the work *Le Poète*.)

Rodin's drawings came from a mixture of sources. About half a dozen were renderings of new motifs that were literally illustrations. Several were of existing sculptures from his existing repertory (the male figure in *Orpheus and Eurydice*) and *The Gates* (*The Thinker, Kneeling Fauness, The Martyr, Meditation*). These latter were from the tympanum of the portal, and he also included the woman from *Lust and Greed*, who is in the arms of the inverted man to the left of the tomb in the right door panel. Many were reworkings of previous *écorché* drawings (*La Destruction, Réversibilité*), some of which were associated with his interpretations of Dante (the demon next to the poem *La Béatrice*), and the rest were utilizations of already existing sketches that accompanied but did not literally interpret the text (*De Profundis Clamavi, L'Irréparable, L'Irrémédiable*).

In the same manner as *The Gates of Hell*, Rodin's drawings for *Les Fleurs du Mal* stand between traditional and modern art. The literal illustrations were of one or two lines in a poem. Others, including some of those *hors de texte*, already existed and had general but not specific reference to the verses. (For example, *L'Irréparable*, Fig. 129, speaks of a remorseful man tormented by worms, and Rodin's figure has a serpent wrapped around his arm.) In *La Beauté*, the woman's open eyes are important, but Rodin's figure, drawn from *The Gates*, is shown with eyes closed. (Although done before 1888, Rodin decided not to draw his sculpture *I Am Beautiful*, on whose base he had engraved a verse from *La Beauté*.) Except for the title, *La Destruction*, Rodin's combat of two naked males has

Fig. 131. *La Mort des Pauvres* (The Death of the Destitute), 1887–88, from *Les Fleurs du Mal*. Pen and ink. Musée Rodin. Photo Bruno Jarret.

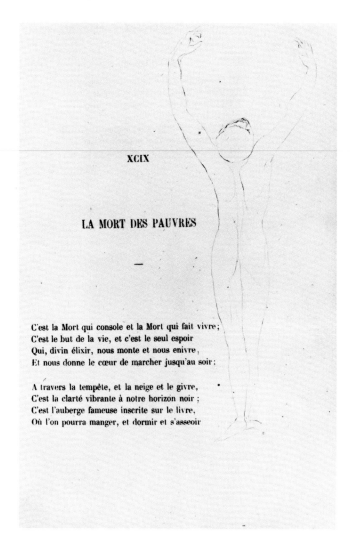

XCIX

LA MORT DES PAUVRES

—

C'est la Mort qui console et la Mort qui fait vivre;
C'est le but de la vie, et c'est le seul espoir
Qui, divin élixir, nous monte et nous enivre,
Et nous donne le cœur de marcher jusqu'au soir:

A travers la tempête, et la neige et le givre,
C'est la clarté vibrante à notre horizon noir;
C'est l'auberge fameuse inscrite sur le livre,
Où l'on pourra manger, et dormir et s'asseoir

nothing to do with the poem. Where Rodin's work connects with modern book illustration in France is when his drawings are more in the vein of an homage to the poet and are associated with the spirit of his poetry rather than its literal illustration. Secondly, and even taking into account the lack of time and inspiration the artist complained of to de Goncourt, it is obvious that in many instances Rodin read Baudelaire's poems in terms of his own drawing and sculpture.

The Baudelaire project reveals an important aspect of Rodin's imagination as a composer. Drawing directly on Gallimard's book, Rodin started with several givens: the size and rectangular shape of the page, and the irregularly shaped and disposed blocks of print. But Rodin could no more think of repetitively boxing in a drawing below or above the text and treating it as something physically apart than he could zonally and symmetrically compose his figures in the side reliefs of the doors. His drawings, in a surprising range of size, not only occur above, below, and on either side of the text but often intrude into it. The amiable skeleton of *Les Deux Bonnes Soeurs* seems to support the text with an upraised hand (Fig. 126). The shoulder of a decapitated body rests on the last letter of the title *Une Martyre* (Fig. 125). Occasionally the bottom of the page serves as a ground line for figures, and in some drawings the setting runs off the sheet. The free formal relationship of image to text reminds us of medieval manuscript marginalia, before the Renaissance framed illusionistic illustration came into being, as well as the way the sculptor related sculpture to architecture in the portal. There is no uniformity or progression of scale from large to small from one drawing to the next, any more than there is with the sculptures in *The Gates*. This condition is like Baudelaire's verses in which there is an abrupt juxtaposition of intimate scenes with vast melancholy landscapes.

Rodin simply treated the entire page as something to be animated and brought into a new harmony by his drawing. The typographer's imaginative layout of the poems certainly inspired him. The former unwittingly supplied diverse fields and challenges for the artist, who had been taking up similar challenges in the portal of his own design. As in the doors, there is never any sense that the drawn figures self-consciously conform to the shape of the field in which they are located. Leafing through the book is like perusing *The Gates*. Both are a visual and intellectual delight having unpredictable and refreshing changes of pace, size, texture, light and dark, and order.

There was much in common between the respective evolutions and structures of *Les Fleurs du Mal* and *The Gates of Hell*. Poet and sculptor wanted to free their respective art forms from the bonds of older aesthetics.[46] They began certain poems and sculptures (*Ugolino, Adam*) without knowing that they would eventually be part of larger works. Neither created in a planned or chronological sequence, and both responded to moods and unexpected experiences. Most important for Rodin, especially at the time in 1880 when he took his great gamble, must have been the precedent that, unlike Dante and Victor Hugo, Baudelaire did not write long narrative poems. Rodin, too, preferred contrasts, juxtapositions, the disjunctive, as evidences not only of his temperament but also of modernity and his crediting the viewer with greater sophistication. Poems and sculptural images are artful montages, and Rodin's work showed that a single figural fragment can have all the expressiveness and self-sufficiency of a single line by a poet.

The Commentators, 1885-1889

In the absence of photographs of the evolution of *The Gates of Hell* in the 1880's and 1890's, we must rely on the accounts of writers who visited Rodin's studio. Unfortunately, few of these accounts contain observations that are helpful in visualizing the whole work. Customarily, writers coming to see the gateway for the first time would be overwhelmed, unable to systematically record what they saw or what Rodin said. At times they would promise their readers to be more extensive in future articles that never appeared. The few exceptions are worth quoting. (Additional comments made by these and other writers concerning the importance of the work, its thematic and formal character, will be given and commented on in later sections of this book.)

Octave Mirbeau's article on Rodin that appeared in *La France* on February 18, 1885, gave the first full description of *The Gates* as he saw them in Rodin's studio:

Above the capitals of the door, in a panel with a slightly curved vault, there figures Dante, who very much stands out and who detaches himself completely from the background which is covered with reliefs that represent the arrival in hell. . . . The levels of the door are divided into two panels, each one separated by a group. . . . On the panel at the right, Ugolino and his sons; on the one to the left, Paolo and Francesca da Rimini. Nothing is more frightening than the Ugolino group. Thin, stripped of flesh, bones projecting under the skin . . . the mouth empty and the lip soft, from which seems to fall, at the contact with flesh, the bay of a famished wild beast. He crawls like a hyena who has unearthed corpses, on the overturned bodies of his sons whose inert arms and legs are hanging here and there in the abyss. To the left, Francesca da Rimini, intertwined with the body of Paolo, makes the most tender contrast to the group that synthesizes the horrors of hunger. Her young body is charming where the artist has reunited . . . all the delicate and sensual feminine beauties. Her arms knotted around the neck of her lover, in a movement at once passionate and chaste, she abandons herself to the embrace of Paolo, whose flesh shivers with pleasure and whose young athletic strength appears in the elegant and powerful musculature—the same type of male beauty of which Francesca da Rimini is the type of feminine grace.

Below these groups, Rodin had composed bas-reliefs in which free-standing figures detach themselves from scenes in half-relief, all of which gives to this work an extraordinary perspective. Each door panel is crowned by tragic masks, heads of furies, or of terrible or graceful allegories of guilty passions.

Below these groups, still more bas-reliefs, on which project masks of sadness. All along a river of mud gallop centaurs carrying the bodies of women who struggle, turn, and twist on the prancing rumps; other centaurs shoot arrows at those unfortunate ones who want to escape, and one sees women, prostitutes, carried away in the rapid falls, hurl and fall—the head in the fiery mud.

The wings are also formed of admirable bas-reliefs; that of the right expresses cursed lovers who entwine forever and who are never satisfied; that to the left, limbo, where one sees in a sort of mysterious vapor the downfall of the children, mixed in with the horrible figures of old women. Admittedly Rodin has been inspired by the Italian poem, but one cannot calculate the personal imagination the artist has deployed in order to impart to each head and body a different expression and attitude. There is in these compositions a sweep and grandeur of action that astonishes and captivates.

In those days before photographs were widely published in art magazines and authors relied upon descriptions, a writer of Mirbeau's stature carried considerable weight. Unless their readings of the doors were actually corroborated by Rodin, those who came after Mirbeau in describ-

ing *The Gates* seem to have followed his interpretations of the meaning of the portal's various zones.

Although Mirbeau notes the "curved vault" above "Dante," he does not mention *The Three Shades*, whose weight on the cornice must have caused that curvature. Mirbeau then reads the tympanum as the arrival of the damned in hell, and he sees the right bas-relief as embodying episodes from Dante's Circle of Lovers, while Limbo is assigned to the left external bas-relief. The line of "tragic masks" that he describes at the top may have prefigured the line of heads that appeared on the cornice, above the head of *The Thinker*, in 1900. Just what they looked like in 1885 we cannot say for sure, but in a caricature by Charles Paillet done in 1884, showing Rodin carrying *The Gates of Hell* on his back, we can see a row of large heads just below the lintel (Fig. 132). Paillet, who worked at Sèvres, may have known or been a friend of Rodin (his caricature is a very good likeness); he was certainly aware of the burden the big project had become for the sculptor in four years. Whether Paillet had actually seen the doors is questionable: he could have drawn the door on the basis of descriptions and his imagination, as the most obvious figures in the portal—*The Thinker*, *Paolo and Francesca*, and *Ugolino*—are not present.

Mirbeau seems to have seen *Paolo and Francesca* in the early version known as *The Kiss*. Unless Rodin had made a smaller version, their original almost half life-size would explain how they and the *Ugolino* group dominated respectively the left and right central sections of the two doors. The bottom reliefs with their "masks of sadness" and rampant centaurs would remain in the portal until 1899 or 1900 (Figs. 133, 134).

The second detailed description of *The Gates* appeared about a year later than Mirbeau's, in the January 16, 1886, *Supplément du Figaro*. The article, entitled "He Who Returns from Hell: Auguste Rodin," and written by Félicien Champsaur, emphasized the interpretation of the *Inferno*:

This door is about the development of the frightening circles of the Italian poem. Dominating the whole, three figures, which seem to incarnate the phrase that they show written on the pediment, "Leave all hope you who enter." [Champsaur is the only writer to say that this inscription was actually written on the doorway. All others indicate that *The Three Shades* incarnate the inscription, or point to where it might have been written.] The length of the capitals, among the bubbling lava, mouths sneer, arms menace, hands clench, torsos shiver, faces contracted

Fig. 132. Caricature of Rodin carrying *The Gates of Hell* on his back, by Charles Paillet, 1884. Watercolor. Manufacture de Sèvres, Bibliothèque. Photo Gabe Weisberg.

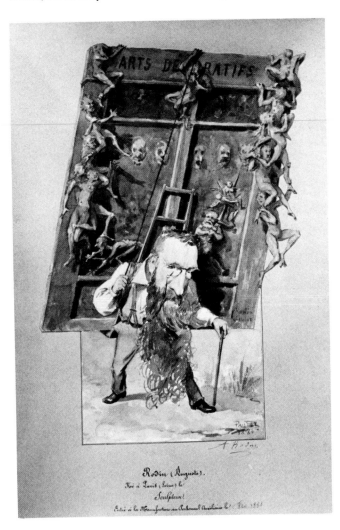

by anguish are moistened by tears. . . . Standing out on a bas-relief, the arrival in hell, is a thoughtful Dante Alighieri, chest forward, elbow on a leg, chin resting on his hand, his inspired gaze seems to plunge to the bottom of the abyss where are mixed the grinding of teeth and kisses. On the right relief, souls of the damned intertwine, unusual couples that are never sated: it is the unknown that their bodies want to embrace and penetrate. To the left, in the middle of the vapors of Limbo, children fall. It is a veritable epic, complex and harmonious. Each movable door panel is divided into two panels separated by a group. On one side, Ugolino; on the other Francesca da Rimini. Emaciated like a starving animal, Ugolino crawls over the bodies of his sons. Opposite, as an antithesis, Francesca, into whom her creator has put all of woman's graceful sensuality, wraps her arms tenderly around the neck of her lover. Then, above, a pile of furies, of tragic masks, terrible or delicious allegories; and below, on a bas-relief, centaurs abduct naked women who struggle or twist on the buttocks of horses. . . . It is violently superb. . . . There remains only to cast it in bronze.

Edmond de Goncourt described *The Gates* in an entry in his diary on April 17, 1886, after a visit to Rodin's studio:

There is on the two immense panels, a jumble, a tangle, something like the formation of a coral bank. Then, at the end of several seconds, the eye perceives that what in the first moment seemed like coral, has projections and cavities, forms leaping outward and inward, a world of delicious small nude figure studies, turbulent, so to speak, giving Rodin's sculpture the appearance of borrowing from the epic fall of Michelangelo's *Last Judgment*, and even of certain crowd scenes in the paintings of Delacroix, and all that with an unprecedented relief that only he and Dalou have dared.[1]

It is curious that such an observant writer as Edmond de Goncourt makes no mention of the three major works cited by his predecessors; also he either did not notice the tripartite division of the central panels or else chose to write about their overall effect. This division was certainly still in place when Truman Bartlett saw *The Gates* a year later.

Since Bartlett was a sculptor himself and was looking with a trained eye, he seems to have observed more details than others who saw *The Gates*, and his articles are strikingly free of the poetic associations that fill the French accounts. Bartlett's articles on Rodin and his art that were published in the *American Architect and Building News* in 1889 constituted the most detailed coverage of Rodin's art and thought to that time and still rank as the single most important documentation on the great artist before 1890. Bartlett in effect carried on a series of interviews not only with Rodin but also with sculptors who knew him, and he read all that had previously been written on his subject. The 1889 articles may be the first in the history of art actually based on interviews with a sculptor, if not an artist in general. Fortunately, Bartlett's notes for these articles survive and are housed in the Library of Congress. They are helpful in checking the published text in order to see either what the writer or his editors changed. Further, the notes show us that contrary to the extensive printed paragraphs in which Rodin seems to have expounded at length on *The Gates*, Bartlett appears to have stitched together the artist's answers to questions and reflections given at different times. In the notes we also find a more extensive description of what Rodin's studio with the doors was like than in the articles.

"The writer first saw the door and its author in November, 1887," Bartlett's first article begins. "On entering the studio, a large barnlike looking place, he saw an enormous structure in plaster reaching nearly to the ceiling." Bartlett's notes add the further information that the studio was "nearly 30′ square and high in proportion." On the right was "a structure in plaster that appeared to be about eighteen feet high and twelve feet wide, the face of which was at right angles with instead of fronting the light." The printed article goes on:

The first impression is one of astonishment and bewilderment: astonishment at the size of the doors and the style of its design, and bewilderment at the extent and variety of the forms that compose it. If possible this impression is heightened by a glance at the floor, for half of it, as well as every available place on the walls of the studio, is covered with plaster figures, in every conceivable position, that are destined to complete the work. It is like looking into another and strange world.[2] [The notes are more poetic on this last point:] It is like looking into the teeming brain of a genius. [One could imagine the editor of the *Architect and Building News* balking at printing that metaphor.]

Although he may not have been the first to ask for them, it was Bartlett who had the good historical sense to write down and publish Rodin's views concerning his intentions for *The Gates of Hell*: "Although the door is generally understood and popularly called, for description's sake, an illustration of Dante's *Inferno*," Bartlett pointed out, "it is true only to a limited degree." He then went on to quote Rodin directly on the thoughts and sentiments that actuated him:

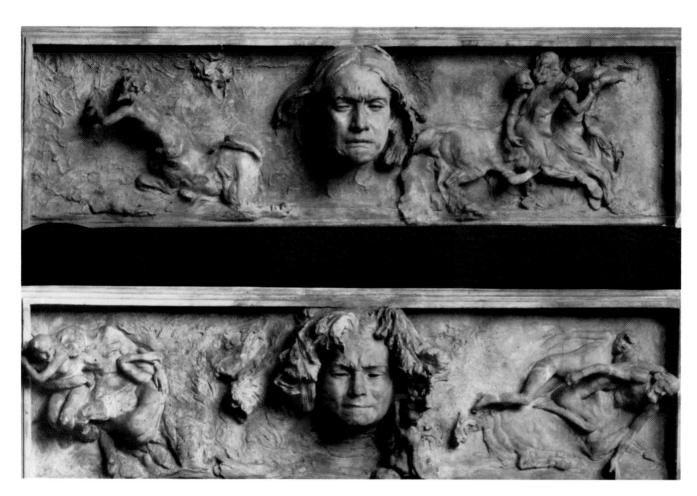

Fig. 133 (*above*). Relief showing a crying woman's head flanked by centaurs and other figures. Removed from *The Gates* by Rodin c. 1899. Musée Rodin.

Fig. 134 (*below*). Relief showing a crying woman's head flanked by agitated figures. Removed from *The Gates* by Rodin c. 1899. Musée Rodin.

I had no idea of interpreting Dante, though I was glad to accept [here the notes show the word "take" lined out] the *Inferno* as a starting point, because I wished to do something in small, nude figures. I had been accused of using casts from nature in the execution of my work, and I made the St. John to refute this but it only partially succeeded. To prove completely that I could model from life as well as other sculptors, I determined, simple as I was, to make the sculpture on the door of figures smaller than life. My sole idea is simply one of color and effect. There is no intention of classification or method of subject, no scheme of illustration or intended moral purpose. I followed my imagination, my own sense of arrangement, movement and composition. It has been from the beginning, and will be to the end, simply and solely a matter of personal pleasure. Dante is more profound and has more fire than I have been able to represent.[3]

Bartlett's interpretation followed Rodin in viewing the doors as at the same time the *Inferno* and a personal sculptural vision, and in his account he speaks of the dominant figure as Dante but also *The Thinker*:[4]

And the Dante, he that looks down upon hell. For an expression of a deep understanding of and a penetration into the very soul of him who walked through the abodes of the cursed and saw its endless grief, what could be more complete than this statue? This awful Thinker: seen from his left, he looks like a bird of prey contented with the vengeance he has meted out to the vile of the earth, a composition of physical and mental dominance, an effect of personality seemingly without rival in all the sculpture of the world. . . . Of Rodin's power of seizing the most dramatic point of a subject, the group of Ugolino and his sons is a terribly real example. Various artists have tried this subject at the moment when the father is in the act of biting his fingers in the first scene of his agony and when his sons are suffering the first pangs of hunger. [Bartlett is obviously referring to Carpeaux's interpretation of this subject.] Rodin goes at once to the depths of the whole tragedy. The youths have fallen to the ground, and Ugolino seeing them so, and feeling the full terror of his situation, throws his own emaciated carcass down and crawls over the bodies of his offspring like a beast benumbed with rage and famine. . . .

The other important subject . . . is the group of Paolo and Francesca da Rimini, the first study of which was too large for the purpose intended, it being over half life-size. . . .

Of the many studies which the sculptor has made of this subject, the one that will go on the door represents the figure of a powerful man holding to his breast and neck, with all the desperation of undying love, the folded together form of a woman. [This is the work that was more familiarly known as *I Am Beautiful*.] . . .

The whole structure is about eighteen feet high and twelve feet wide. The door itself, which is immediately under where Dante sits, is not divided into a series of panels, each containing a special subject and treated independently, as great doors gen-

erally are, but represents a perpendicular section of the damned world, without apparent background, and with a slight moulding running through the center from top to bottom.

The formations of rock, sea, fire and cloud are peopled with the phantoms of human beings, sirens, harpies, fauns, furies, and monsters; all in more or less movement, according to the desires, emotions, or propensities of their natures while on earth, and as affected by their present surroundings. They sail through the air, dive into the sea, dart here and there as though they were possessed, or stand as motionless as death.

The spectator looks through the framework of the door into this indescribable scene. Many of the groups and figures are in full relief, and are placed well in advance of the surface line of the door, and from them the relief gradually lessens until the dimmest perceived distance shows the vanishing forms in delicate mass or outline.

The frame of the door, composed of small mouldings setting well out from it, is also covered in the most surprisingly ingenious manner with figures of every kind, age, sex, making it appear like the shores of an overflowing sea of uneasy souls impossible to keep within the stately authority of an architectural form. The sculptor, more pitiful than the poet, grants a little respite to the unfortunates, and permits them to leave their direful abode. Or carried away with the endless procession he has unguardedly set in motion, and in no way restricted by the arbitrary topography of the poet, he . . . lets Hell loose, and the limits of that locality are bounded only by the imagination of the artist. . . .

The large unfinished panel, or the tympanum of the door before which Dante sits in silent state, contains two subjects, that on his right, "The Arrival," and the one on his left, "The Judgment" [Fig. 135]. The first represents a crowd of spirits pushed on by relentless destiny in hurried disorder to the bank of the Styx, where they await the arrival of Charon's boat. The central figure of this part of the panel is a kneeling female satyr clasping her hands behind her head. She personifies sensual passion, and expresses in her position the consciousness of her condition and readiness to accept the coming punishment.

The principal figure of "The Judgment" is a young girl whose right hand is raised to her chin, the latter meeting it at the shoulder, while her left arm is extended near her body. . . . It may be selected as an excellent example of the character of Rodin's art temperament. He works from the force of the sentiment that possesses him, that he lives, and not from the motive of any given name or outwardly defined subject. The Ugolino group is the chief point of interest of the right hand part of the door, and is placed on a line with the eyes of the observer.

At its left there will be a group of human and half-human figures surrounding "The Three Sirens." These sirens, unearthly creatures, weird and seductive in every form and movement, make perhaps the most subtle composition on the door. . . . It is just praise to say that they are beyond the reach of the camera.

Just behind them stands a splendid youth, in full relief, with

his hands clasped over his head, looking in wonder at a kneeling female figure at his feet, and perfectly unconscious of his woeful surroundings. Above him is a group, also in full relief, of the noble figure of a man, and three equally fine ones of women, the latter expressing fear and uncontrollable grief. A short distance below Ugolino, a narrow panel begins, which has two central pieces of masks of those who have died in misery, and the spaces on each side are filled with an illustration of the festival of Thetis and Peleus when invaded by Centaurs. Thoughtless pleasure is personified by a youth borne on the back of a siren, who is about to dive into the sea carrying her joyful and unconscious victim with her. . . .

The sculpture of the pilasters of the door is in low relief, and treated with extraordinary reach of line. As pieces of color they are almost beyond praise. The one on the right of the door represents souls in limbo, and is composed of figures of all ages and sexes who have sinned in ignorance. The sculptor chose to treat this preliminary region in order that he might introduce infants and children, and thus give greater variety of form and interest to the art effect. [It is apparent from the descriptions of Mirbeau and Champsaur, as well as the external reliefs as we see them today, that Bartlett had confused the left relief with the right. This may have happened when he wrote the articles in America and did not have access to the doors to check his memory.] And here are scenes of the most touching dramatic interest. Half-awakened mothers pressing their long-lost infants to their emaciated and milkless breasts; children in sweetest innocence calling in vain for some affectionate recognition from the now insensible, but once loving arms of their parents, and aged souls gathering to themselves in tender and comforting embrace some young and saddened spirit.

The other pilaster illustrates the circle of love, and has for its principal subject the group of "Paolo and Francesca," already described. [Today, just as Bartlett described them, this couple is at the top of the external side reliefs at the right as we face the doors.] It is placed at the top, with the back of the lover toward the observer, thus emphasizing, like a crowning capital, this saddest of all heart tragedies.

The molded exterior sides of the frame of the door, running back from the pilasters to its surface line, are also decorated with figures, "Flowers of Evil," in low, high, and full relief. All arranged with surprising grace and masterly sense of decoration. [The doors as we see them today have a few figures on their sides, but what Bartlett saw, figures in presumably some profusion, probably was later replaced by the stepped pilasters now visible.] . . .

The high relief group of "Mother and Child" occupies a small panel above one pilaster, while its corresponding panel is filled by two young female forms embracing each other. [Presumably the mother and child were in the upper left-hand corner of the entablature where today one sees *The Fallen Caryatid*, almost concealed by drapery.]

In a subsequent paragraph, but without indicating where or if she is on the door, Bartlett describes *The Fallen Caryatid*, which at that time may have been known to the writer by a different name: " 'Sorrow,' a young girl pressed down by a weight upon her shoulder. . . . This supple little creature, not more than eighteen inches high, is regarded by the sculptor and his friends as one of his very best compositions, and many copies of it have been made . . . in both marble and bronze."[5] *The Fallen Caryatid* was, in fact, the first figure from the portal that Rodin exhibited publicly.

We can tell from Bartlett's careful description that he saw the portal pretty much as it is today, with some important exceptions in the area of the two door panels. His notes mention the thorn vines below *The Three Shades*, but the lithograph of the upper portion of the doorway shows that the vines were preceded by twisted heavy ropes, which Rodin later covered over with clay (Fig. 135). *The Kiss* was no longer in the portal, and the *Ugolino* group was still in the right door panel. The notes also indicate that as of December 1887 there was no projected date for completion. Despite the numerous articles written on *The Gates of Hell* after Bartlett's, and to the time of their assemblage in 1900, no other account of their design is as complete and clearly descriptive as his and as free from personal interpretation.

More than just critics visited Rodin's studio to view the portal before 1889. As articles began to appear about the doors, the number of visitors swelled. Rodin exhibited works from *The Gates* in the Georges Petit Galleries in 1885–86. Bartlett commented in 1889:

Before the close of 1887 the most distinguished art lovers, litterateurs, and critics of Paris, as well as many from Belgium and England, had visited his studio and seen the door. As its general composition was defined, its principal groups and figures decided upon in sketches, parts of the work completed and nearly all of the hundreds of subjects in process of execution, its immense scope of design, startling originality, and copious art expression were enthusiastically recognized. It was declared to be the most important piece of sculpture of the nineteenth century, and nothing since Michelangelo could give any idea of its magnificence.[6]

As more attention was brought to his work, there were two criticisms that disturbed Rodin. The first was that he was a literary sculptor, one who relied upon literature

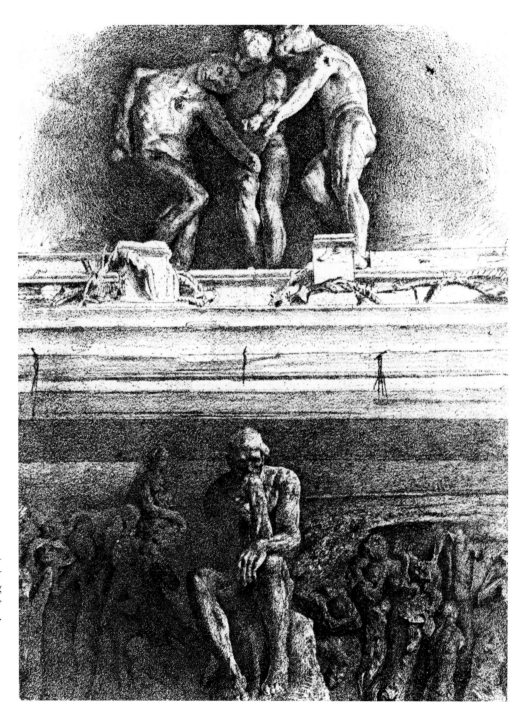

Fig. 135. Lithograph reproduced by Bartlett of the upper section of the doors, showing *The Thinker* and *The Three Shades*, 1889.

rather than on "plasticity" for inspiration. The second was that his art was vulgar or obscene. In the late nineteenth century, for a sculptor to be called "literary" did not carry with it quite the stigma associated with the term in this century. After Romanticism, with the coming of various forms of realism and Impressionism, there were many in the French art world who expected the artist to eschew the word in favor of personal experience of life and art as sources of inspiration. Bartlett, who was aware of those who tried to detract from Rodin's achievement on this basis, made a point of saying, "He works from the force of the sentiment that possesses him, that he lives, and not from the motive of any given name or outwardly defined subject."[7]

Camille Mauclair was the critic most interested in probing Rodin's way of working in relation to literature and symbolism. In 1905 he published notes from a conversation with the artist in which Rodin said the following: "I do not deny that I think I have a taste for symbols and synthesis, but I do not take them from literature in order to interpret them sculpturally. Nature gives them to me." The way he elaborated the point makes us think of artists before Rodin such as Leonardo, and those that followed, such as Henry Moore and Paul Klee, who many times responded to unexpected sources of stimulation in the materials they worked with rather than the word: "Nature offers symbols and synthesis on the breast of the strictest reality. It suffices to know how to read them. Sometimes a knot of wood, a block of marble, by their configuration, have given me an idea, the direction of a movement; it seemed that a figure was already enclosed there and my work consisted of breaking off all the rough stone [gangue] that hid it from me."[8]

Rodin was always disturbed that others could not share his vision of how, by means of analogy, the artist could find in the living model an "infinity" of ideas and did not have to depend upon writers. In the same sessions with Mauclair, published in 1905, Rodin said: "When one follows nature with a faithful love, one obtains everything from it. When I have a beautiful body of a woman as a model, the drawings that I make of it give me images of insects, birds, fish. . . . I have drawn the bodies of women, and one of them has given me in its synthesis a superb form of a vase. . . . Everything is in all that surrounds us.

Everything is held in nature, everything is a continuous movement."[9]

Rodin's own published response to characterizations and charges that he was literary shows him, once again, as being a figure who, like Picasso later on, wanted to continue certain aspects of tradition but also work in new areas. Further, Rodin believed that sculpture and painting could rival theater, for example, and that he might occasionally draw an idea or a title from what he read.[10] Rodin always wanted to be free to choose as he liked. Here is his famous response, given many years after the first criticisms were leveled at him:

If my modeling is bad . . . if I commit anatomical faults, if I badly interpret the figure's movements . . . these critics are a hundred times right. But if my figures are correct and living what is there to change? And by what right would they prevent me from attaching to these figures certain intentions? What can they complain of if, additionally in my professional work, I offer them ideas, and if I enrich the significance of forms capable of seducing the eye? One is mistaken if one imagines that true artists are content to be simply skillful workers and that intelligence is not necessary to them.[11]

Bartlett's articles are valuable for bringing together insinuations and actual charges that certain of Rodin's works were obscene. The first exhibition of *The Kiss*, in Holland, raised protests against the lovers' nudity. When Rodin showed works from the doors in 1885–86, Bartlett says, "an occasional allusion was made in regard to the unusual freedom of their composition and action, and the slightest hint was given that too susceptible minds might not look at them with as chaste a feeling as the sculpture intended to convey."[12] Bartlett seemed to have forgotten the story of Paolo and Francesca or that Rodin was not intending to show chaste feelings. Later in his series of articles, Bartlett filled out the censure of Rodin's treatment of love:

The fault of a too free representation of the passion of love was first found at the time of the exhibition at Petit's Galleries of some groups and sketches of the figures made for the door, and again referred to by some English artists who visited Rodin's studio. The pleasing terms used to designate these works were "vulgar," "indecent," "illogical," "exaggerated effects." Private criticism has denominated their author as "crazy," and a "fool.". . . It is certain that the early Puritans would have burned Rodin at the stake. . . .

Rodin was accused of too faithful a reproduction of the

model, a too free representation of the divine passion of love
. . . for having a contempt of the merely agreeable . . . to express
his conceptions in forms expressive rather than in themselves
beautiful by means of gestures and attitudes passionate and
significant, rather than attuned to rhythmical harmony.[13]

Rodin's most important printed rejoinder to the accu-
sation that he was immoral and that his art was obscene
appeared in the journal *Antée* in 1907:

[The artist] must celebrate that poignant struggle that is the
basis of our existence and that brings to grips the body and soul.
Nothing is more moving than the maddened beast, perishing
in lust and begging vainly for mercy from an insatiable passion.
In art, immorality cannot exist. Art is always sacred even when
it takes for a subject the worst excesses of desire; since it has in
view only the sincerity of observation, it cannot debase itself. A
true work of art is always noble, even when it translates the
stirrings of the brute, for at that moment the artist who has
produced it had as his only objective the most conscientious
rendering possible of the impression he has felt.[14]

Rodin's defense came down to the assurance of his sin-
cerity, a defense that is still crucial in art obscenity cases
today. His choice of example makes us think of the subject
of *The Gates of Hell*, and in many ways this may be one
of the sculptor's most revealing although indirect state-
ments about the portal's theme.

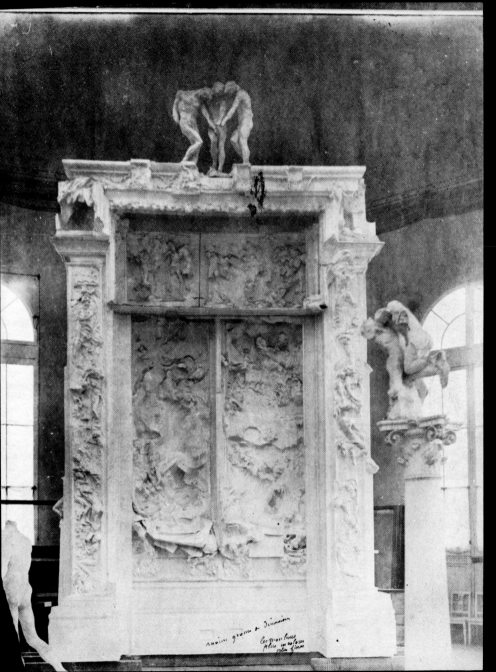

Fig. 136. *The Gates of Hell*, in plaster, as they appeared in Rodin's 1900 exhibition. From an old photograph in the Musée Rodin.

The Last Campaign, 1899-1900

The last period of concentrated effort by Rodin to complete *The Gates of Hell* came in the year preceding its first intended public exhibition in the spring of 1900. This exhibition was to be an important historical event, not just because the greatest living sculptor, by critical acclaim, was having his largest showing simultaneously with a great world's fair in Paris but also because it was the first large-scale retrospective of a living sculptor and was being paid for by the artist. Rodin had been planning this event for some time and deemed it the appropriate situation in which to give his portal its first public showing. The exhibition was not to be held in an art gallery but in a new pavilion built in a small park facing the Place de l'Alma, not far from the main entrance of the world's fair. The triangular design was determined by the site, and Rodin's views were communicated to his architects.

In the Musée Rodin archives is a large chart, done in pen and ink in all probability by Rodin's secretary, and titled "Porte de l'Enfer—Moulage—13 Juin 1899 à 1er Juin 1900." Besides carrying the portal's title, as we know it today, the chart records the names of twenty assistants who were skilled in casting plaster from clay figures. Also listed is the amount that each earned in two-week periods. Eugène Guiochet, Jr. did the most work, a truly astonishing amount, and he must have been Rodin's most trusted assistant or *chef d'atelier*, both in casting plaster and *montage*, or assembly of the plaster figures on the doors. Four other Guiochet brothers, Gaston, Dieudonné, Auguste, and Ernest also did work in varying amounts.[1] Even assuming that Eugène Guiochet obtained twice the one-franc-an-hour customary wage for studio assistants, there

were long periods when the column under his name showed bimonthly earnings of over 275 francs, and from March 1899 until the end of May, he was billing Rodin for well over 300 francs each period.[2] In one two-week stretch, April 29–May 12, as the deadline for the show approached, Guiochet earned 410 francs. Ten-hour work days and six-day work weeks were the norm in Rodin's era. Guiochet must have worked around the clock seven days a week. The labor costs of preparing the fully mounted plaster version of *The Gates of Hell* for the 1900 exhibition came to 32,438.85 francs. This expense, well above all the previously allocated funds by the government, was borne by the artist out of pocket, along with the even greater costs of the show that included building his own pavilion, for which he had obtained private loans of 60,000 francs.

The obvious and important question is, on just what areas of the portal was all that work done? Rodin had repeatedly affirmed to the government and visitors from 1884 on that the project was nearly ready for casting. In 1899, at about the time Rodin began this last great campaign, his biographer Léon Maillard, in the first book entirely devoted to the sculptor, made the statement "Already for many long years *La Porte de l'Enfer* . . . has been completely finished."[3] Unfortunately we lack not only a photograph of the fully assembled *Gates* before June 1899 but also one of its frame alone without the sculptures in high relief, such as we have for June 1900 (Fig. 136). What information we have before 1899 comes from previously quoted verbal descriptions, the reproduction of photographs of individual figures and couples, and drawings

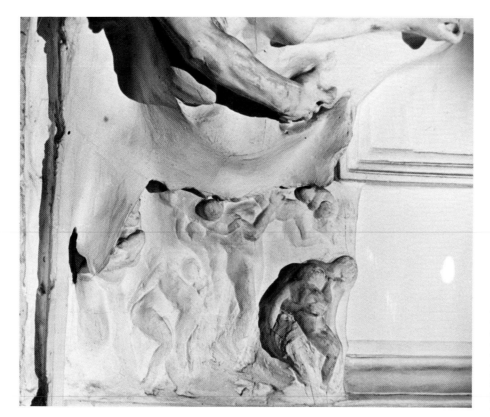

Fig. 137. Relief of mothers and children to the left of the tomb in the right door panel. Photograph taken from the plaster cast made in 1917, Musée Rodin. Photo Louis-Frédéric.

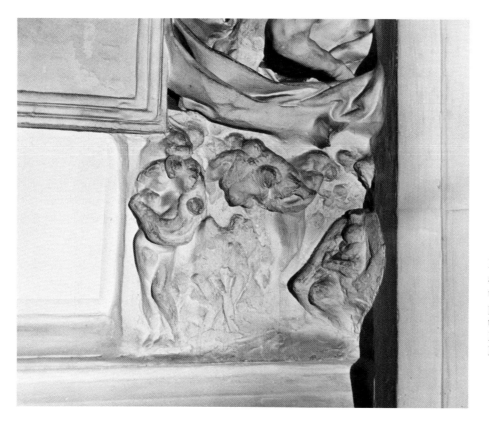

Fig. 138. Relief of mothers and children to the right of the tomb in the right door panel. Photograph taken from the plaster cast made in 1917, Musée Rodin. Photo Louis-Frédéric.

and lithographs made from photographs of parts of the doors.

Rodin had probably not made any additions to the sculpture of the portal after 1888 or 1889. Since at least 1887 he was aware that the new museum of decorative arts would not be housed in a new building that could have accommodated his portal as an integral part of its architecture. *The Gates* were thus destined to be self-sufficient and a symbolical rather than actual doorway. Rodin had therefore turned his attention to other projects, except, perhaps, for reflecting on the architectural aspect of the portal, especially the moldings. In 1890, for example, he wrote to Rose: "I am becoming an architect and this is necessary in order that I complete that which is lacking in my door."[4]

From what one can tell, it would seem that in this critical last year of the nineteenth century, Rodin set about redoing most of the two doors' panels and also made some changes in the entablature. For example, he seems to have moved the *Ugolino* group from the right to the left door panel, locating these figures where the group known as *The Three Sirens* had been, and moving the latter to another location slightly higher and to the left in the same door panel. The two reliefs having symbolic grieving heads in their midst and flanked by rampant centaurs were removed entirely, and replaced not only by the tombs but also by the low reliefs of mothers and children that frame them (Figs. 137, 138). Directly above the tombs were added the fallen figure of *Fortune* at the left, and the couple known as *Avarice and Lust* at the right (Figs. 139, 140).

What earlier writers such as Mirbeau and Champsaur had described as "tragic masks" above the two groups from Dante may have been transferred to or redone on the tympanum's cornice, directly above the head of *The Thinker* (Fig. 104). In an old photograph in the Musée Rodin archives and in the lithograph made from it that Bartlett reproduced in 1889, that same cornice is shown devoid of sculptural decoration. In Druet's photograph of the same area that appeared in the catalogue of the 1900 exhibition, the line of heads appears where we see it today (Fig. 141). Otherwise, with a few small exceptions, the central section of the tympanum and the cornice with its decoration above it that includes the thorn vines and *The Three Shades* are as we see them today. (Whether or not at this time, rather than earlier, Rodin replaced the mother

Fig. 139. *Fortune* atop the tomb in the left door panel. Photograph taken from the plaster cast made in 1917, Musée Rodin. Photo Louis-Frédéric.

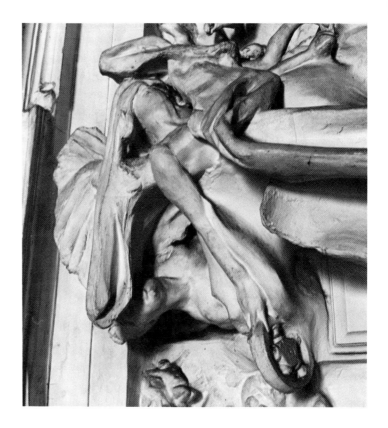

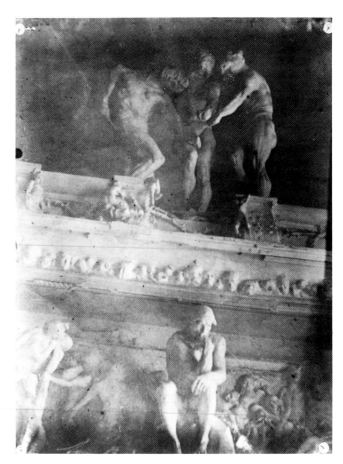

Fig. 140. The figures known as *Avarice and Lust*, to the left of the tomb in the right door panel. Photo Louis-Frédéric.

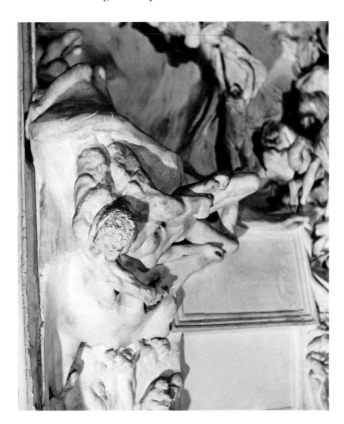

Fig. 141. The assembled tympanum of *The Gates* in 1899 or 1900. Photo Druet.

Fig. 142. Lower two-thirds of *The Gates* being installed in
Rodin's 1900 pavilion. Below the scaffolding in the lower right-
hand corner or jamb of the portal can be seen the relief of
Rodin's self-portrait. Old photograph in the Musée Rodin.
Photo Bulloz?

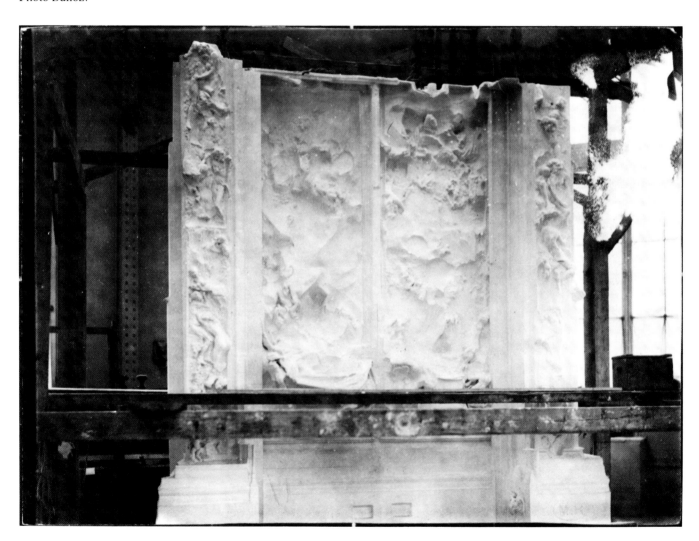

and child in the upper left-hand corner, as described by Bartlett, with *The Fallen Caryatid* we cannot say.) It seems certain that Rodin did redo the upper halves of the two door panels from which he had removed the line of heads. (It is possible that at this time he actually increased the total height of the portal to twenty-one feet from what may have been eighteen feet when Bartlett saw it in 1887. Bartlett may have been only estimating the height, and we do not know whether he was including *The Three Shades*.) If Rodin did enlarge the entire frame, however, he would have had to add to the side bas-reliefs, and internal evidence does not clearly support the theory. Enlarging the frame could have caused Rodin to cut back the vertical moldings that separated the external reliefs from the two door panels, but this could also have been done for other reasons: Rodin may have felt that the extruded vertical moldings threw too great a shadow onto the door panels.

Two other additions that may be described as belonging almost certainly to—and certainly no later than—this period are the two reliefs of *Eve* or *The Siren* and the sculptor's self-portrait at the bottom of the doors respectively on the left and right inside panels of the jambs (Figs. 190, 191). Their existence in this location by 1900, along with the aforementioned changes, is confirmed by photographs taken of the portal during its first public exhibition (Fig. 142). It would have been fitting for Rodin to have "signed" his work with his own image in 1900 if he, at that point, considered the whole enterprise finished, which I believe he did.[5]

Part of the expense incurred by Rodin's assistants resulted from the necessity of cleaning the plasters that had acquired studio dust and marks from their handling over many years. This was more easily done with those plasters already detached from the frame. It was more difficult working on the portal itself. One of the eyewitnesses to this work was Judith Cladel, who noted, "We were looking at . . . *La Porte de l'Enfer* before which . . . was a scaffolding because the workers were taking moulds of this unique work."[6] Many of the plasters required new casting because the first ones had been used for making bronzes when Rodin exhibited them separately. Rodin may even have used this as an excuse when explaining to reporters why the exhibited portal was not fully assembled. On June 18, 1900, for example, Francis Warrington Dawson re-

Fig. 143. The first plaster version of *The Gates*, at Rodin's death in 1917. Musée Rodin, Meudon. Photograph taken in 1949 by Louis-Frédéric.

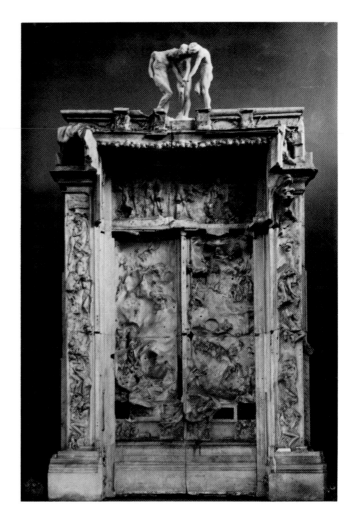

ported in *The News and Courier*, "Twenty years of cease-less toil have completed the apotheosis of suffering. But many of the fragments already tinted did not harmonize with the plaster model and had to be detached." The "tinting" would have been caused either by a plaster having been colored to make it look like a bronze, as was often done in Rodin's day for exhibition purposes, or by varnish applied to the plaster when molds for bronze casting were taken from it.

Not only did Rodin have to pay a considerable sum to his assistants for mounting the high relief plasters onto the doors, he also had to pay for their dismounting when the time came to ship the portal to the exhibition pavilion. A photograph showing just the lower two-thirds of the doorway being set up in the pavilion proves that it was cut into at least two horizontal sections, and from that same doorway, now at Meudon, we can see that the tympanum area was cut vertically and roughly in half (Figs. 142, 143).

The firm of Léon Autin, which did much of Rodin's shipping, spent 509 hours between May 13 and June 6 (the opening date had been originally scheduled for April 15) working on the installation of all the sculptures for the exhibition and building their bases and scaffoldings. The wooden platform on which *The Gates* stood, and the wooden armature behind it, were built in that period at a cost of 161.20 francs. The ropes that are to be seen on the sides of the portal today may have been put there in the spring of 1900 by Rodin for purposes of facilitating the lifting of the portal during shipment; they remained on the plaster version throughout Rodin's lifetime, but it is not clear that he intended them to be cast in bronze, as they were from the time of the first bronze casting which, of course, came after Rodin's death.

Unfortunately, the exact date of the delivery of *The Gates* to the pavilion does not show in Autin's accounts. Judith Cladel wrote in 1917, "The day of the opening arrived before the master had been able to have placed on the tympanum and on the panels of his monument the hundreds of great and small figures destined for their ornamentation."[7] For weeks before the May 13 opening, Rodin had been tremendously busy selecting and preparing more than 150 sculptures and a large number of drawings and having them moved and installed, and he clearly misjudged the time and work that had to be done

to have everything ready for the *vernissage*. This is how *The Gates* looked to a reporter for the *New York Tribune Supplement*, who wrote on September 2, 1900, "The plaster model in the pavilion is a weird object with some parts apparently finished and others indicated only by numbers scrawled in pencil on the white surface." (Today one can still see the graphite numbers on the Meudon plaster of the doorway, Figs. 144, 145.)

All evidence indicates that the incomplete showing of *The Gates of Hell* in 1900 was not intentional but probably resulted from bad timing. The arrival of *The Gates* at the pavilion, presumably just before the public opening, as Cladel implies, must have meant that Rodin did not have the time for his assistants to build a scaffolding to remount the high relief figures. From what he had told others, this would have required at least two weeks, during which time visitors to the pavilion would have had the distraction of workers and scaffolding at the end and center of the pie-shaped hall, right behind the plaster *Monument to Balzac*. Rodin was showing this controversial sculpture in public for the first time since he withdrew it from the Salon of 1898 after its rejection by its commissioners and the great critical and public outcry against it. No question but that Rodin wanted vindication for his *Balzac*, and it must have seemed far better to him to have the unadorned portal near or behind the statue as a backdrop than twenty feet of wooden scaffolding and workmen in their smocks reconstituting *The Gates of Hell*.

We should also remember that Rodin had a very considerable financial stake in this exhibition that he hoped to recover by admission fees and commissions as well as purchases. The last thing he needed, after his previous encounters with scandal, was to give even more ammunition to his critics and create a disturbed public. In interviews with the press, Rodin played down the financial risk. On April 8, a week before the scheduled opening, Rodin told a writer from *Le Gaulois*, "My exhibition has no financial purpose, as I wanted to expose my work in the belief that it could interest the young artists, and that is all." (In this same interview he commented, speaking of *The Gates*, "I could not begin to mount it in less time than two weeks.") He then went on to say, "The small plasters constitute an element of the étude that will perhaps render some service to the young." Rodin was totally sincere regarding his hopes that his exhibition would influence

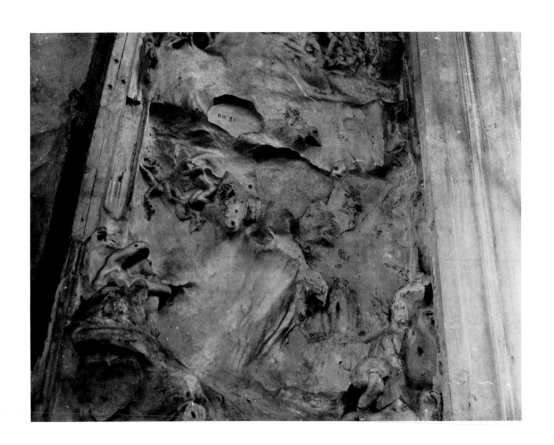

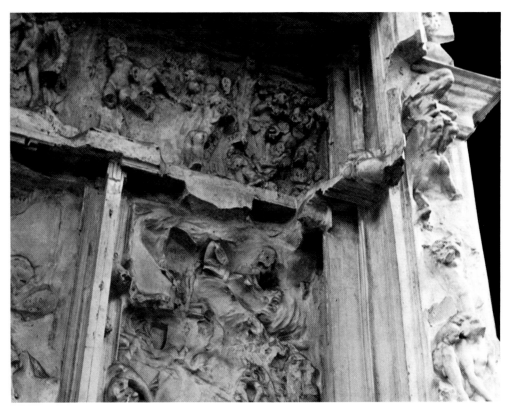

younger artists, and he audaciously sought to give the étude parity with "finished" art. The fact is, however, that if Rodin had not at least recovered his costs, he would have faced financial ruin. *The Gates* were the only work not for sale.

After 1900 there emerged other explanations of why the doors were not completely assembled in the exhibition hall. Judith Cladel, who was closer to Rodin than other and later commentators, wrote that when the show opened "The artist felt worn out from overwork," and she added, "he had seen it too much during the twenty years in which it had been before his eyes. He was tired of it, weary of it."[8] For the most part Cladel was a reliable reporter with regard to the artist's views, and what she wrote was probably true in terms of Rodin's attitude long after 1900. The difficulty with her statement, written more than a decade after the fact, is that as an explanation it implies that Rodin personally would have gone to the trouble of remounting the sculpture on the doors, whereas at the time he already had the skilled assistants at hand who were prepared to do the job, and none later could have done it as quickly or as well. Rodin also knew that at the exhibition's close, no matter how *The Gates* were received, including the possibility of the government's ordering their casting in bronze, they would have to be moved again, hence dismounted, to go either to the Bingen foundry or back to his studio. As it was, the portal was taken back to Rodin's studio at the Dépôt des Marbres when the exhibition was over, and in 1901 the pavilion was dismantled and transported to Rodin's home at Meudon. It was not until some years later that the cast of the portal was moved to Meudon.

Rodin the perfectionist was of course extremely sensitive to critical comments about the denuded as well as fully dressed portal. Much of the favorable criticism had been written by writers who had presumably seen the full composition in the sculptor's studio before it was dismantled. Whether Rodin agreed with Bourdelle that *The Gates* were "too full of holes" is hard to say.[9] Cladel wrote, "According to Rodin, the work had a breadth and unity which was spoiled by the ornamentation that previously covered it."[10]

There were more years in which Rodin saw his epic dismounted than intact (see frontispiece). Keeping in mind that in the first nineteen years he had probably removed many of the high relief figures from the frame to protect them from studio damage, he may thus have only seen the final fully assembled portal for at best a few months or weeks in the winter and spring of 1900. Supporting Cladel's report about Rodin's preference for the denuded version of the doors is the fact that it was the 1900 exhibition at which, by their numbers and even placement in the exhibition, Rodin proclaimed to the art world his belief in the artistic self-sufficiency of the partial figure. To those who came to the pavilion near the Pont de l'Alma, Rodin presented many fragmented versions of not just unfamiliar older sculptures such as the life-size seated *Ugolino* but also familiar major works, notably one of *The Burghers of Calais*, which served as the frontispiece for the show by being placed outside under the entry portico. In time for the big exhibition, Rodin reworked the torso and legs of the earlier successful *St. John the Baptist* in the new form of *The Walking Man*. Given Rodin's frame of mind on this subject, it is conceivable that he could have rationalized not remounting the portal on the grounds that it was an étude, and aesthetically complete. Recognizing Rodin's complexity as well as his attitude toward such an important work, I do not believe, however, that they were the necessary and sufficient cause of his inaction with regard to reassembling *The Gates of Hell* when he had hopes of their acceptance by the government.

Fig. 144 (*facing, above*). Detail of the first plaster cast of *The Gates* as they were at Rodin's death in 1917, showing his system of removing works in high relief and marking their locations. This detail is of the lower right door panel. Musée Rodin, Meudon. Photo Louis-Frédéric.

Fig. 145 (*facing, below*). Detail of the upper right section of the first plaster cast of *The Gates*, showing Rodin's system for removing works in high relief and numbering their locations. Musée Rodin, Meudon. Photo Louis-Frédéric.

'The Gates of Hell,' 1900-1917: Complete But Not "Finished"

An important and interesting question that still confronts us is: did Rodin regard the plaster cast of *The Gates of Hell* he exhibited in 1900 as complete, or as unfinished? To answer this question is difficult because the information we have from various sources, including Rodin himself, is contradictory. One may first ask, would Rodin have spent such an impressive sum of his own money and made such a determined effort to show his work of twenty years to the public and the government if it had not been ready for casting? In his 1899 book on Rodin, for the writing of which he had talked at length with the sculptor, Léon Maillard wrote, "La Porte de L'Enfer is now ready to be cast in bronze."[1]

While we have no archival record of the fact, there is little doubt that Rodin's 1900 exhibition was visited and the plaster portal viewed by government officials including the Minister of Fine Arts. We also know that Rodin met with one of its architects, Georges Berger, who had been connected with the original project for the museum of decorative arts since at least 1880. On January 10, 1901, Rodin told a reporter for *L'Echo de Paris* with the *nom de plume* of Le Nain Jaune, "A few months ago, Monsieur Georges Berger asked me to go to the Pavilion de Marsan in order to study the place that would be suitable for my door. But I believe that the official architects show little enthusiasm for the project. And when the officials don't want it, there is nothing to do. It is a 'cammora' [a cabal of Neopolitan malefactors], like the one that killed Carpeaux."

Rodin thus did not put off Berger or the reporter by pleading that his work was unfinished. Berger may have been disturbed by, among other things, the great height of *The Gates*, which would have caused severe problems architecturally if the portal were to have been integrated into the museum's exterior. But there is evidence that the government, or Berger, had decided that the portal was not to be an integral part of the building in the sense of serving either as its actual or as its symbolic entrance. By not calling for *The Gates'* casting, the State in effect caused the public to think that Rodin was at fault for not finishing the commission. On October 19, 1901, in an article titled "Le Louvre s'achève," Fernand Hauser interviewed an unidentified "future curator of the future Museum of Decorative Arts," who showed him the renovated but still empty Marsan Pavilion. Hauser asked, "And *The Gates of Hell*?" He was told, "The Gate of Rodin? But it is not yet finished?" Hauser: "Are you not destined to receive it?" Reply: "I know nothing about it. It is the State that commissioned this portal of Rodin. One hears that the State will give us this masterpiece as a gift, but it is necessary that Rodin finish it. Then there is the casting that will be very expensive. When Rodin will be ready, and when the State will decide to give us *The Gates of Hell*, we will open all the great halls of our museum to him, and Rodin will choose the placement that seems best to him."[2]

Although the door had been made in his studio, one wonders just how much enthusiasm Rodin would have had for the placement of the bronze cast of *The Gates* indoors. According to Maillard in his book of 1899, Rodin was determined to leave nothing to chance concerning how his portal would look in the open air.[3] From the

sculptor's standpoint, locating *The Gates* indoors might have commended keeping the work in plaster where its lighter surface would be more hospitable to side or incidental lighting. The State could have accepted the full plaster version of the doors for their interior location in the Marsan Pavilion, but either this did not occur to anyone or else the convention of paying for a bronze cast, as stipulated in this case by contract, was compelling. (Ironically, when it is finished the new Musée d'Orsay will exhibit permanently the fully assembled plaster, which since 1917 has stood in the former chapel of the Musée Rodin; because it was paid for by the government, the government can locate the portal wherever it wants.)

Whether or not Rodin assembled the plaster in the pavilion for his 1900 exhibition did not seem to have influenced the decision by the government not to call for its immediate casting in bronze. There were many who had seen the fully assembled portal in Rodin's studio on the rue de l'Université in the years and months preceding its disassemblage for shipment to the Place de l'Alma pavilion, and some had published their enthusiastic reactions. In view of the attraction that Rodin and his studio had for those of influence in the official art world of Paris at that time, it is not unreasonable to speculate that the Minister of Fine Arts had been unofficially kept aware of Rodin's progress and accomplishment. The government must have had every reason to assume that Rodin had finished the commission. Berger's invitation to Rodin seems to confirm that.

What do we know of Rodin's own attitude toward the 1900 state of his plaster portal? Although we cannot be certain of its date, from Rodin's own handwritten note on a photograph of the portal, it would seem that he wanted modifications, but this was a reaction not untypical of the artist to his work seen in photographic reproduction. What he had written on the photograph by Druet was, "Moins grosses de dimensions / Les mouleurs plus incolorés, plus fines." (Dimensions less bulky. Moldings less colorful and finer.) A close comparison of this photograph with the portal as we know it today does not reveal any evidence that Rodin ever acted on his own observation in the next seventeen years before his death. This was not unusual in terms of what he had similarly done with photographs of other sculptures. (Rodin even occasionally sold an expensive marble sculpture with some of his

graphite editing marks still on it, much to the annoyance of at least one client.) All this is by way of saying that if the government in 1900 had called for the bronze casting of *The Gates of Hell*, Rodin would have complied, with or without modifications. The same could be said, in my view, if the government had called for the casting in 1889 or 1885.

Rodin's reputation for not being able to finish large commissions was largely unjustified. After *The Gates of Hell*, his next largest public commission was *The Burghers of Calais*. He had finished it by 1889, but the installation was delayed another six years for lack of funds. He finished the first version of his *Monument to Victor Hugo*, and it was installed in the Palais Royale courtyard in 1892, the same year as the inauguration in Nancy of his *Monument to Claude Lorrain*. That the second Hugo monument for the Panthéon was not carried out was not his fault but that of the commissioners. Although it took him seven years, Rodin did finish his *Monument to Balzac*, but it was rejected by the commissioners. In 1900 the *Monument to President Sarmiento* was unveiled in Argentina. Fulfilling public or private commissions was a matter of pride, not indifference, to Rodin, and he turned down many more than he accepted. Moreover, there is no documentary proof that the French government ever actually pressed Rodin to deliver *The Gates of Hell* for casting.

Despite a few dissenting views,[4] the strongest case seems to be that Rodin never made any significant changes on the doors before their final assemblage in 1917, and that was carried out by the first curator of the Musée Rodin, Léonce Bénédite. In his 1903 essay on Rodin, Rilke mentioned that the casting of the gates was imminent.[5] In 1904, Rodin's secretary Réné Chéruy wrote that Rodin wanted a molding that would be "precise enough to act as a frame to his composition, but which would be soft enough in tone to connect it with the surrounding atmosphere, and his mind was not set on his last experiment."[6] A year later, the critic Kenyon Cox affirmed that "if ever the government should require him to deliver his work, he would be able to do so without delay."[7]

Rodin as Lucifer the Diabolic Tradesman

After the 1900 exhibition, Rodin had begun to enlarge figures from the portal that in 1891 the critic Gille had

referred to as a "gigantic cupboard" and the sculptor called his "Noah's Ark." *The Three Shades* were made life-size and shown in 1902; *The Thinker* was enlarged and exhibited by 1904; *Ugolino and His Sons* and other figures from the portal were also enlarged at about this time. At Rodin's death two versions of *The Fallen Caryatid* were in the process of enlargement. This activity around the portal, so to speak, did not prevent Rodin's detractors from voicing their discontent. On June 26, 1904, in an article entitled "Les deux penseurs: Michel-ange et Rodin," published in *Le Journal des Arts*, L. Augé de Lassus wrote: "Florence closes its Baptistery with radiant, charming doors that Michelangelo proclaimed entirely divine, and that he dreamed announced paradise. Alas! We will never have in their entirety Rodin's gates of hell. The Church assures us that it is easier to win hell than it is to conquer paradise. It is the same thing with the doors, at least if one must believe that diabolic Lucifer, Rodin."

Some critics suggested that a scandal was involved with the nondelivery of *The Gates* and Rodin's selling of works derived from it. Charges of this sort were made in an unsigned article called "Un Scandale" that appeared in *La Gazette de la Capitale et du Parlement* on October 6, 1912:

What has become of the 'Porte de l'Enfer'? This name alone no longer evokes anything in your memories.... You will recall that it was a monument commissioned by the State of master Rodin thirty years ago. It was destined for the Museum of Decorative Arts, a project, like so many others, that remains in the state of a proposal. Doubtlessly in the spirit of imitation the work of the sculptor did the same. Well now, he had been entirely paid for it. In all equity, Rodin should repay the sum or deliver the monument. For many years, and it is here that the affair becomes complicated, he sells by the piece that which he had never finished—whether to private persons or the State; this last therefore repurchases at high prices the fragments that must have constituted a work paid for as a whole. In commerce, such operations have a name that we do not wish to recall. We will be less discreet with regard to the pieces; they are *The Thinker*, *The Fallen Caryatid*, *The Hand of God*, *The Kiss*, etc., and all have to have been part of the ensemble of *The Gates of Hell*, which will never be delivered. If Rodin is a great sculptor, one sees that his artistic faculties have not obliterated those of the tradesman.

The Last Inspection: Morand's Report

Even though Rodin's project was not accepted and cast in bronze for the Marsan Pavilion of the Louvre, the gov-ernment still owned it, and one more recorded inspection of the portal was made in 1904 in order to find out when it might be ready for casting. The French National Archives dossier on Rodin makes reference to a brief report by a M. Morand, a member of the Commission des Travaux d'Art. As there is no indication in the dossier or the report of where the bronze door was to go, it is reasonable to believe that the government had not definitely decided on the Marsan Pavilion and had no specific plans for it. Rather than as a result of the government's impatience with Rodin, as some have indicated, Morand was sent on a routine inspection tour of all state-sponsored projects, as part of the government's requirement of an accounting of all funds being held for various artists. On February 9, 1904, Morand reported that the work at Meudon was "advanced," but that its author had "manifested the intention of making diverse modifications" and he did not foresee its completion "before 3 or 4 years."

In August of 1885, the government had set aside 35,000 francs for the portal's casting, but in 1904 it was decided after Morand's report that this sum could not be withheld from other projects. The Ministry of Public Instruction and Arts therefore annulled the 1885 award, while in principle maintaining the commission and Rodin's obligation to supervise the eventual casting by the lost-wax method. A separate award for casting costs at such a future time was contemplated. It was in fact this financial annulment that delayed the bronze casting of *The Gates* until after Rodin's death. In 1925 Jules Mastbaum commissioned a cast for his new Rodin Museum in Philadelphia, and in 1928 the Japanese industrialist M. K. Matsukata paid for the Paris Musée Rodin bronze and one for himself that is now in the Museum of Western Art in Tokyo.[8]

There was never any question of Rodin's repaying the government, acquiring all rights to the plaster model, and casting it himself. There was the staggering cost, even for a man of Rodin's means after 1900, and where the bronze portal would have been located was another question. After 1900 Rodin knew that he would have his own museum, and the pavilion, relocated from its original Paris site to Meudon, came quickly to be known to those who worked for Rodin and others as the Musée Rodin. The cover of the printed speech given July 31, 1900, in Rodin's pavilion at the Place de l'Alma by Camille Mauclair reads, "Au Musée Rodin." The artist may have comforted him-

self at times with the thought that the plaster portal would stand in his museum forever as a gigantic étude.

Fair question is why did not the government *demand* that Rodin deliver his plaster model for bronze casting? Under French law, even in Rodin's day, the artist alone has the right of divulgation, which means that only Rodin could have decided when his work was finished.

Rodin's Ambivalent Attitude Toward the Doors

There still remains the question of whether or not Rodin believed that he had done all that he could on the doorway and considered the work complete, if not finished by conventional standards. That he did not reassemble the doors when they were removed to his studio argues that he still had reservations about the architecture, or the sculpture, or both. One answer is that Rodin and his most skilled assistants were terribly busy fulfilling orders for his work that resulted from the financially successful retrospective. Another is that a project that was as unprecedented, of such a magnitude, undertaken over a twenty-year period by an artist for whom the conventional idea of "finish" was anathema and who reflexively always saw other ways of extending his own art, could never have been realized to Rodin's permanent and total satisfaction. "And were the cathedrals finished?" he would ask when challenged on *The Gates'* unfinished state.[9] We must remember that Rodin's art was intimately tied to his life, to his growth and change as a person. He never considered any work that he had done, even when bronze cast, as unalterable. Being cast in bronze was just a more permanent state, but still a state of a work that was for the artist in perpetual evolution. How could Rodin, of all artists, have lived with his plaster *Gates of Hell* for the last seventeen years of his life without seeing changes that could be made, or having second thoughts? The point is, that there is no real hard evidence that he carried out any of those changes on the door itself.

As an example of recorded incidents where Rodin agreed with a visitor that his work could be changed, we have an article of January 20, 1919, in the *New York Herald Tribune*, in which Eugène Rudier, the head of the Alexis Rudier foundry that cast the bronze *Gates* for Jules Mastbaum, was interviewed. Rudier recalled a visit with Rodin

at Meudon: "We were lunching together. I remarked to the master, 'You said you wanted to work again on some parts of the door. Why not do it now that spring is so beautiful? An opportunity may soon come and you will be ready.' Rodin gazed at me silently, and then said, 'You are right. Have the cornice set under the portico.' " Just when this incident occurred is not clear, but Rodin seems to have had spurts of interest that faded before anything was really done. Judith Cladel wrote, "Around 1912, as the project to create a museum of the Hôtel Biron took form, I spoke to him about the admirable panels destined to be his master work. 'That doesn't interest me any more,' he said." Cladel then told him she regretted his renunciation of a work "that symbolized one of the most ardent periods of his career. . . . I felt a reanimation of his interest for The Door and he decided to look at it again and to finish it."[10]

Not all the reports about Rodin's thoughts on the door are necessarily true, of course. Léonce Bénédite's efforts are particularly suspect. For example, he says (in an article written in 1918), "When all was finished after twenty years of patient effort, Rodin was disgusted with his work, abandoned it, and only made use of it as a sort of reservoir from which he drew isolated elements. 'The door has too many holes,' he wrote. . . . In later times he amused himself with his older work by filling the holes with plastilene."[11] But this is not corroborated by contemporary witnesses, contemporary photographs, or examination of the plaster portal at Meudon.

Proposed Sites for 'The Gates'

Even while he was working on the plaster model of the portal before 1900, Rodin was dreaming of having a version that was both carved and cast. Henri Frantz wrote in 1898, "The artist's dream is to have the jambs carried out in marble and the two doors in bronze."[12] In the Musée Rodin archives is a sketch on thin, partially transparent paper, as well as a cost estimate of this project. The frame, tympanum, and *The Three Shades* were to have been executed in marble at an estimated cost of 96,000 francs. The door panels were to be in bronze. There is no date on the rough sketch, which was really a tracing from a photograph made of the reassembled portal in the chapel of

the Musée Rodin and taken near the end of 1917. This argues that Bénédite, who wrote about Rodin's dream, made the sketch, probably after Rodin's death.

There were other plans for *The Gates*, conceived by Rodin and his friends. Kenyon Cox noted in his 1907 essay that "Rodin is credited with an intention of bringing up all other figures to the same dimensions [as the enlarged *Thinker*] which would represent an unheard of outlay and a gate nearly a hundred feet high." At one point the sculptor had the idea of setting up the portal as the entrance to the crypt of his proposed *Tower of Labor*. Dujardin-Beaumetz, who as Under Secretary of State for Fine Arts had presided at the inauguration of *The Thinker* before the Panthéon in 1906, never gave any hint of dissatisfaction with Rodin's work on the portal. In fact it was this man who not only recorded some of the most important conversations on art by Rodin but also proposed that the artist install the portal in a deconsecrated chapel surrounded by frescoes of his own creation. This was related to the project to move the whole collection of modern art from the Luxembourg Palace. Bénédite tried to claim some of the credit for this project when he wrote in 1918:

In 1908 . . . he considered its reconstruction in its integrity. "A door must be open or shut," I said to him, "and yours will be shut." In fact there was a question at the time of setting it up in the secularized Chapel of the Seminary of St. Sulpice, then given over to the Luxembourg [the museum then headed by Bénédite]. . . . And I suggested to him the idea, which was carried some steps toward execution, of surrounding it with a fresco illustrating the Purgatorio and Paradiso, since the Under Secretary of State, Dujardin-Beaumetz, wanting to encourage Rodin's work on the fresco, had given him an order for one without restriction of subject.[13]

The Portal's Final Assembly

Rodin's last recorded words on *The Gates* may have been those given to Gustave Coquiot in an interview published in 1917. During the course of their conversation the subject turned to *The Gates*, and Coquiot said, "But one remains astonished that you did not deliver it." Rodin replied:

That does not surprise me. No one can suppose what a large sum of money would be required in order to terminate this difficult work! I assure you, as for me, I am not in arrears with

the State. I have worked far beyond the funds they have given me, because I have never measured my work in terms of money received. But it is always the same thing. They become impatient and find that I do not go fast enough, despite a life dedicated to work. . . . They have always found that I do not finish on time. For a long time it has been repeated that I work slowly. . . . Will I terminate this Door one day? It is truly improbable. And, moreover, I need only a few months, perhaps two or three, to achieve it. You know that all the casts [*moulages*] are ready, labeled for the day when it pleases them to demand its complete achievement. But will that day ever come? . . . I have dispersed the details of my door in different places. . . . In any case, I leave my work to the State. My account is therefore largely squared with them.[14]

When Rodin signed the will bequeathing his work to the State in 1916, he in effect put everything into the hands of the first director of his museum, Léonce Bénédite. In 1921 Bénédite claimed that he had Rodin's consent and supervision in the final assembling of the plaster of *The Gates of Hell* in 1917. But from what we know of Rodin's health in the last months of his life, the latter is extremely doubtful. If the montage was done at the Dépôt des Marbres, it is even more doubtful, as Rodin was very much restricted to Meudon during the last year of his life. The first director of the Musée Rodin was not a paragon of truthful reporting or ethical conduct, according to Judith Cladel, who worked with him for some time. An article that appeared on December 16, 1917—a month after Rodin's death—stated: "M. Bénédite and Mademoiselle Cladel work without rest to arrange the Musée Rodin. They have begun by restoring the chapel of the Hôtel Biron where a selection of the master's works will be installed. They will set up a plaster cast of the *Porte de l'Enfer*."[15] In this article, Bénédite makes no mention of Rodin's having given the authorization for or supervising the assembly of the portal. In fact, the article states, "During Rodin's last days, M. Bénédite gathered in the studio of the rue de l'Université all the morceaux of the *Porte de l'Enfer*, and he was greatly surprised to notice that the monument was complete. It was not lacking one piece. It was a question of joining together and superposing the parts of the portal in order to set it up in its radiant ensemble." If Rodin had initiated the final assembly, his first director would surely have so indicated to the world in 1917 rather than have waited until 1921. Bénédite took a great number of initiatives without Rodin's knowledge

and consent, and, ethics aside, he seems to have had the legal authority to do so.

On May 18, 1917, acting as the curator of the Musée Rodin, which had been officially established by the State the previous year, and as Rodin's surrogate, Bénédite wrote to the government requesting the remaining 4,300 francs in Rodin's account:

In 1880 M. Rodin was commissioned by the Fine Arts Administration to produce the model of *The Gates of Hell* inspired by Dante's *Divine Comedy*, originally intended for the Museum of Decorative Arts. The fee to be paid for this model was 30,000 francs and M. Rodin received 25,700 francs of this total. This work, while it could in a sense be said to have been already delivered to the State, in the studios of the Dépôt des Marbres, had remained unfinished, and M. Rodin had not put in a claim for the balance of the sum contracted for.

Today . . . I have the honor of informing you that I have had the various parts that compose *The Gates of Hell* assembled in their entirety, in a completed form, in the choir of the chapel of the Hôtel Biron, and I therefore respectfully request, in the name of M. Rodin, the settlement of this balance, amounting to the sum of 4,300 francs.[16]

We know that from some time in 1916 until his death, Rodin was physically incapable of doing even the smallest amount of work with his hands, owing probably to a series of strokes. Even though Bénédite had control over the finished works of Rodin that had been given to the State, in view of the French recognition of the artist's right of divulgation (to determine when a work is finished and ready for public showing), it would have been a daring act by Bénédite to order the reassembly of *The Gates of Hell* without Rodin's consent. Some writers, notably Judith Cladel, have viewed Bénédite as unscrupulous. As events after Rodin's death were to prove, Bénédite did overstep his authority on certain occasions.[17] In the matter of the final reassembly of the doorway, Judith Cladel, who was dismissed by Bénédite as a curator at the Musée Rodin, wrote during the years 1933–36 that workmen told her in 1917 that Bénédite edited their efforts on at least one occasion in a way they felt Rodin would not have approved:

Some of Rodin's scandalized assistants who cast his plasters made it known to me that, charged with the reassembly of *The Gates of Hell*, they received orders to place certain figures in a different arrangement than that which the artist wanted, because "that would be better," or because the figure of a woman representing a spring "must have the head below." "The sense of the cube is the mistress of things and not appearances," Rodin used to say. But does a shockingly brusque functionary have the time to meditate on such an axiom?[18]

While *The Gates* give the impression of being susceptible to various ways of mounting the figures, close inspection of the Meudon cast without the high relief sculptures shows that this is not the case. When I watched skilled foundrymen restoring the plaster high relief figures to the Hôtel Biron cast after it was used in the making of the molds for the fifth bronze cast, I concluded that the margin for error, or for misinterpreting or even changing Rodin, was restricted to the orientation of limbs that had been removed at the joints. In his études Rodin would sometimes position an arm in such a way that it was at variance with the orientation of the shoulder and the torso. Whole figures could not have been altered. Cladel's report is therefore not necessarily untrue, but it may be more alarming in tone than in consequences.

We come back, then, to the question of whether Rodin regarded the plaster cast of *The Gates of Hell* he exhibited in 1900 as incomplete or as unfinished. Our answer depends upon its being given at various times in his life between 1900 and 1917. For example, when it was fully assembled in the spring of 1900 and ready for shipment to the exhibition pavilion, Rodin thought his work was complete. Both Cladel and Bénédite concur that Rodin worked on the doors for twenty years, from 1880 to 1900. Rodin never would have thought the work finished by conventional standards, meaning unalterable in every detail. At different times after 1900 he seems to have expressed feelings that the work required certain modifications, chiefly with respect to the architectural frame. That these were not carried out, so far as the evidence goes, indicates that if called for delivery by the government, Rodin would have complied at any time after 1900.

'The Gates of Hell' Viewed by Rodin's Contemporaries

The Hell in Rodin's 'Gates' as Seen by His Peers

Those who wrote about *The Gates of Hell* in Rodin's lifetime never showed any doubt about what they were seeing. Critics in his era felt their professional justification was in their personal interpretation of art, not in documenting the artist's intentions. Rare was the writer like Bartlett who even raised a question about Rodin's intention. Perhaps because they often read their predecessors' articles, and because of the availability of the artist himself, the critics strongly agreed on the meaning of the sculpture. What emerges from these contemporary readings are certain themes and variations. There is no written evidence that Rodin objected to or contradicted his guests' interpretations of the portal, but this is consistent with Rodin's tact toward visitors, and it could be said about any of his major works.

Understandably, the earliest interpretations of the doors, made even before they were fully mounted in the early 1880's, focused almost exclusively on their source in Dante. From the start, every writer stressed to his readers that Rodin was not a "banal illustrator" but had "understood" Dante or been "inspired" by him or used the *Inferno* as a "frame." Even when confronted with the still empty wooden box of the doors, and from only his inspection of individual figures and groups, Roger Ballu did not hesitate in his report to the government to affirm, "This young sculptor reveals a really astonishing originality and power of expression with overtones of anguish." In the most extensive and influential early reading of the portal, Octave Mirbeau wrote in 1885, "Admittedly Rodin

has been inspired by the Italian poem, but one cannot calculate the personal imagination the artist has deployed in order to impart to each head and body a different expression and attitude."

After they were mounted atop Rodin's portal (at least by 1884), *The Three Shades* were seen by numerous writers as incarnating the line, "Abandon every hope, you who enter." Some wrote of how the left arms of *The Shades* point downward in unison as if to an implied inscription on the cornice below. Bartlett saw *The Shades* as "phantoms" and a "trio of despair" who tell "the story of the whole door." Léon Maillard was most moved by these "robust beings, in the fullness of their virility, their bodies drawn together as in mutual support, for destiny has struck them equally. The abyss of despair that opens below calls them. . . . Their strength cannot save them from the frightening fall; their muscles tighten for one instant more in a last constraint, because thereafter they will wander the circles of eternal suffering, one by one."[1]

The tympanum was read by some writers in the 1880's as incarnating Dante's Second Circle of Hell, but after Bartlett commentators do not continue the reading of the tympanum as a place of judgment. Arthur Symons saw it as a "Dance of Death." Somewhat more persistent is viewing the flanking sculptured pilasters or external reliefs as vaguely embodying circles of Dante's Hell—though the writers did not agree on which side is that of Limbo and which is that of lovers whose sin was "criminal love." The first to give them a reading from Dante was Mirbeau in 1885: "The wings are also formed of admirable bas-reliefs; that of the right expresses cursed lovers who en-

twine forever and who are never satisfied; that to the left, limbo, where one sees in a sort of mysterious vapor the downfall of the children, mixed in with the horrible figures of old women."[2] Until Rodin removed *The Kiss* from his doors between 1885 and 1887, visitors such as Mirbeau had no problem in identifying Paolo and Francesca. Thereafter, Bartlett assigned these lovers to the couple known as *I Am Beautiful*, located at the top of the right external relief as we have read. There was never any ambiguity about the identity of Ugolino and his sons, only about their location, whether in the right or left door panels.

The physical background of the side reliefs and the two door panels was often described as "bubbling lava," or "vapors," or "mud," or "ice," but no one saw Rodin as literally illustrating Dante's infernal geography. Several writers, including Maillard and Bartlett, saw Rodin's infernal population shading off from sources in Dante to ancient mythology, notably in the relief panels that once were placed at the bottom of the door panels, in the center of which were masks of "grief" or "sadness" flanked by lusty rampant centaurs. In his unpublished notes, Bartlett wrote, "It is only after repeated visits that the necessity of a more classified examination claims its right." To his credit, Bartlett made these repeated visits and developed the most thorough and systematic analysis of Rodin's improvised "program" that we have from one of the artist's contemporaries:

1. Those who have just arrived, and express in their actions fear, horror, indifference, or mute surprise. Some stand erect, others roll themselves together like a ball, in concentric agony, and still others grasp a foot or leg in utter desperation, as though that member were the cause of or could ameliorate their woe.

2. Those who seek, in all the haste of wild and unguided eagerness, the friends that have preceded them. They rush through every nook and corner, over rock and under sea, blindly feeling, falling, and crawling after some never-to-be-forgotten loved one. The pathos exhibited by some of these beings is touching beyond measure. Eyes filled with ever-flowing tears, and cheeks cast in everlasting agony. Not all the pains of Hell can quench this angelic sentiment.

3. Those phantoms who have become accustomed to the place. Of these, some are continually affected by their surroundings, while others vainly and persistently grope around in the attempt to re-enact their lives on earth. Here and there is seen an isolated spirit, like the kneeling harpy, who, perched on the point of a projecting rock, peers down, with the most impertinent curiosity, into the whirling circles below her. Another,

a robust figure of a man, throws his arms around his body, as if to hold himself from bursting with indignation at the awful sights which meet his protesting eyes. A third raises his head and hands upward in cursing reproof of the punishment of faults for which those who committed them were not responsible.

. . . In some retired spot a majestic shadow stands in quiet contemplation of a flock of delightful little male figures, who flit about and come and go, like so many fairies. . . . The grave old being that sits with his legs well apart and rests his hands on his knees represents a man turning into a tree. On the door his back is toward the observer, and while going through this peacefully transforming process, he contentedly views the agitated panorama that stretches out in an endless vista before him. Nearby, a hideous female monster has caught within the slimy meshes of her serpent arms and legs, a gay and handsome youth, whom she presses to her breasts with an evidently mutual satisfaction.[3]

It was from this thoughtful inspection that Bartlett was to develop his sense of just how Rodin's epic differed from that of Dante. Perhaps the single most important figure in *The Gates of Hell* that tells us of Rodin's personalized vision of Dante and hell itself, and that reflects his decision not to be simply an illustrator, is that of *The Thinker*. From almost the first writing on *The Gates* through that of Edouard Rod in 1898, there is a continuous, but not exclusive, identification of *The Thinker* as Dante. The first mention of this figure in connection with the doors is in 1883 in an unsigned article in the English *Magazine of Art*: "Some parts of it exist already in the round:—a superhuman 'Dante.'" In 1886, Champsaur saw this seated figure in the tympanum as "Dante Alighieri . . . his inspired look seems to plunge to the bottom of the abyss."[4] Bartlett saw his "Dante" as looking "down on hell," but he also called him "This awful Thinker" who "seen from the left . . . looks like a bird of prey contented with the vengeance he has meted out to the vile of the earth." W. C. Brownell also saw in Rodin's "Dante" the "rapt and sinister countenance of the beholder of visions."[5] Frantz summarized him as "absorbed and thoughtful, his eyes fixed on the infinite," and Rod likened him to Michelangelo's "Il Pensieroso" (the tomb effigy of Lorenzo de' Medici).[6]

Although it begins in 1889, the alternative identification to that of Dante is more frequently found, probably influenced by the fact that in Paris Rodin first exhibited this sculpture by itself in 1889 as *Le Penseur: Le Poète*. In not one of its exhibitions during the sculptor's lifetime was

the sculpture we today know as *The Thinker* titled "Dante." For reasons already discussed in the section on Rodin's Gamble, it is not hard to understand why Rodin would not have objected to having this muscular nude referred to as the Florentine poet. The very title chosen by Rodin, *Le Poète*, in the nineteenth century encompassed not simply writers but also artists. In the single most influential article written by a French critic during Rodin's life, Gustave Geffroy evoked the agitated crowds of the tympanum (which for him constituted the "first circle of hell") in front of which "a Dante, or rather 'Le Poète,' naked, having no signs that allow us to recognize a time and nationality, meditates in the manner of a man of action in repose."[7]

In 1889 a writer named d'Auray, who had seen not only Rodin's exhibition of figures separated from the doors, but also *The Gates* themselves, told his readers, "Above, at the summit, as if frightened by his own work, the artist, the poet, the creator is crouching, his head in his hands [*sic*], pressing his brain to the limit.... Rodin names this figure 'Le Penseur.' "[8] (This is the first recorded instance in which Rodin is credited with titling the sculpture as we know it today, although in 1884 one of his English clients uses it in a letter acknowledging receipt of the sculpture.)[9] The Belgian poet Georges Rodenbach, coming to write about "the great figure that is at the summit," declared, "[he] represents not Dante, but the eternal poet, thoughtful and nude."[10] Arthur Symons's notes of his visit to Rodin's studio in 1892 show: "on the frieze, around Le Penseur." Mauclair's interpretation (1898) was: "This prophetic statue can carry in itself the attributes of the author of the Divine Comedy, but it is still more completely the representation of the Penseur. Freed of clothing that would have made it a slave to a fixed time, it is nothing more, in its severe nudity, than the image of the reflexion of man on things human."[11] In 1900, Serge Basset described the figure as "seated on a broken column," and a "symbol of the ambitions never satisfied, a thinker, proud and sad, dreams."[12] Judith Cladel in her book of 1903 referred to "the somber, thickset Poet in his meditation." Not surprisingly, the most poetic interpretation was that of Rilke in his 1903 essay: "Before the silent closed room of this surface is placed the figure of 'The Thinker,' the man who realizes the greatness and terror of the spectacle about him, because he thinks it."[13]

Rodin's own view of *The Thinker* in relation to *The Gates of Hell* as expressed in 1904 has already been cited: "I conceived another thinker ... he is no longer dreamer, he is creator." The moment Rodin chose literally to replace Dante with his image of *The Thinker*, *The Gates of Hell* became his personalized vision of humanity's fear. His departure from the medieval epic in favor of a modern vision was early recognized and extensively analyzed. This can be seen even in Bartlett, who despite his lengthy explication of the portal as the hell of Dante, wrote:

The predominant emotion expressed on the door is that of love, in all its unnumbered degrees, phases, and characteristics, and by every kind and degree of humanity, both high and low. Some of its expressions find here their appropriate environment, while others evidence, in their every breath, that where love is there is Heaven. If sweet submission and helplessness had any effect in softening punishment, the very rocks themselves would melt in pity and forgiveness before the appealing forms of the female spirits with which the sculptor has blossomed his inferno. Perhaps he means to suggest that Heaven and Hell are individual rather than collective localities.[14]

Bartlett's indecision about Rodin's intent indicates that either Rodin had not discussed his theme extensively with him, or Bartlett had not pressed for elucidation. The questioning of Hell as an impersonal world for all was prophetic of later readings. With his focus on the importance of love in *The Gates*, Bartlett was neither the first nor the last contemporary commentator to find in it the portal's central theme. A few years after Bartlett's visits, Rodin talked to a visitor from Holland about his work on the doors: "All of life has passed through my mind while I studied this work. Often I have executed a part from the Porte only for myself, the ideas that came to me while working. See these lovers, condemned to eternal suffering; they have given me the inspiration to represent love in different phases and poses as they would appear in our imagination: I would say passion, because, above all, the work must be living."[15]

Even more than love, passion was seen by many writers as Rodin's obsession in his *Gates*. Mirbeau saw "the more than 300 figures" as "each one expressing in a synthesizing way, a form of passion, of sadness and of those things by which humans are cursed.... Each body responds to the passion by which it is animated." Concomitant with passion, many such as Mirbeau saw revolt as another eternal human curse: "Even in the strangest contortions and in

the most twisted forms, the personages are logically shown in the destiny the artist has marked for their rebelliousness and punished humanity."[16] In Champsaur's words, the doors portrayed "pitiful humanity, with its revolts, its despairs, its ugliness of conscience, its passionate troubles, its frenzies and curses, its coarse appetites, at the same time that it appeals to the infinity of the ideal."[17]

Edmond de Goncourt saw *The Gates* just after having visited another studio in which Rodin was working on *The Burghers of Calais*. In Rodin's treatment of *The Burghers*, de Goncourt saw "real humanity," whereas in the doors he saw "the home of poetic humanity."[18] On the other hand, in 1889, M. D'Auray made the strongest connection to that date of Rodin's *Gates of Hell* with modern life: "Dante's name is just a pretext, it is not his Hell, it is not his Paradise, and it is not his Purgatory, it is us, it is you, it is this time, it is this city, it is our sad humanity."[19] Writing at about the same moment, Roger-Milès said: "The subject of this monumental door is the Hell of Dante. But Rodin has not wanted to make himself into the banal illustrator of the Ghibeline poet; that which he has seen in the divine epic is the great journey of love and sadness . . . it is humanity made great by mystery where it renews itself, and it is humanity vanquished by the abandon that exhausts it; it is the poem of the flesh in harmony with the poem of the soul . . . it is life and it is death."[20]

By 1889, helped perhaps by a large Paris exhibition of études for *The Gates*, writers such as Roger-Milès were stressing the eternal aspect of their meaning: "The episodes are timeless; the actors have cast off their costumes." Georges Rodenbach also dismissed any thought that the portal's "scenes" were "contemporary with Dante's time." He evaluated Rodin's "picture of human passions" as the artist having wanted "to construct an examination of the conscience of humanity."[21] That September, in *Les Lettres et les Arts*, Gustave Geffroy observed, in a subsequently much quoted statement: "The Ghibeline poem has not preserved any of its local color, has lost all of its Florentine significance. One might say it has been denuded, expressed in a synthetic significance, as a collection of the unchanging aspects of the humanity of all countries and all times."[22]

The internalized character of Rodin's hell and the sculptor's compassionate treatment of his subject were eloquently voiced in 1900 by one of the nation's most celebrated contemporary writers, Anatole France. His article, "La Porte de l'Enfer," appeared in *L'Echo de Semaine* in June, a month after *The Gates* went on public view for the first time:

But Rodin's Hell no more resembles that of Dante than the thought of our time resembles that of the 13th century. . . . Compare this modern Hell to the Hell painted on the walls of the Campo Santo in Pisa or in the chapel of Santa Maria Novella in Florence by the Tuscan painters who took inspiration from The Divine Comedy. Recall the damned placed to the left of God on the beautiful portal of Bourges. In these theological representations of Hell, the sinners are tormented by horned devils who have two faces. . . . You will not find these monsters in the Hell of Rodin.

There are no more demons, or at least the demons hide themselves inside the damned. The bad angels who cause the suffering of men and women are their passions, their loves and their hates, it is their flesh and their thoughts. These couples who pass "so lightly on the wind" cry: Our eternal tormentors are within us. We carry within ourselves the fires that burn us. Hell is the earth, it is human existence, it is the flight of time, it is the life during which one dies without cease. The Hell of the lovers is the desperate effort to put infinity in an hour, to stop life in one of their kisses which on the contrary announces the end; the Hell of the voluptuaries is the decadence of their flesh in the midst of eternal joy. . . .

And I discover with sympathy that the Hell of Rodin is no longer a Hell of vengeances and that it is a Hell of tenderness and pity.[23]

One of the most succinct and apt commentaries on *The Gates* was given in one sentence by a friend of Judith Cladel, a poet identified simply as Claire, who accompanied her to the artist's studio and saw work being done on the plaster portal in 1899 or 1900. Claire commented, "It is the hell of Dante, but above all it is life."[24] Stuart Merrill spoke for many when he characterized Rodin as "The poet of sadness and passion."[25] Standing before the denuded portal in the exhibition of 1900, Mauclair gave a public lecture in which he pointed out that Rodin "has a subject, humanity. He has general ideas. . . . He is a symbolist without being aware of it. . . . He sculpts passions."[26]

Overall, Rodin's portal was considered equal to Dante's poem by Bartlett; Thurat saw it as a "secular monument"; Guigou saw the reliefs as Rodin's "Panathenaic procession of the sadness of tortured bodies"; Geffroy was unequivocal when he called the doors "the equivalent of a profound book . . . a work of great observation and high

metaphysics." Many writers used Victor Hugo's response to the poetry of Baudelaire as evoking a "new shiver" to characterize what they found in *The Gates of Hell*: "a tragic shiver"; "the shiver of anguish and anxiety"; and "the shiver of sovereign passion."

Some of the commentators seemed concerned that there might be those who would see Rodin's passionate drama as obscene, and they tried to forestall such criticism. Roger-Milès wrote, "The beings appear without hypocrisy and without indecency, but living with an intense life. . . . Rodin's characteristic mark is the power of passion . . . with him everything is under the influence of passion. . . . Rodin has created nothing for voyeurs and searchers of the obscene. . . . He shows . . . passion in love, not in vice."[27] These last sentiments were expressed more specifically by D'Auray at almost the same time: "Félicien Rops etches vice, Rodin shows vice; under his fingers two beings embrace and that becomes 'L'Amour.' Two women kiss, and this is not Lesbos, this is not Sodom, it is the 'damned women' and that is explained by the bones, the muscles, by the nerves, by all of the organism, the entire body concurring with the intense rendering; his lovers are exhausted, his lovers are unsatisfied, their flesh crackles with desire."[28]

One of several writers to link the portal with Baudelaire's poems was Theodore Child, who expressed his views in 1891:

To the superficial observer and to the Puritan eye, Rodin's work may often appear dangerously sensual, but in reality it is only intensely pitiful. In *The Gates of Hell* Rodin has rendered the ferocious battle of the sexes with a force and eloquence that no other sculptor has hitherto equalled; but at the same time that which is uppermost in his mind is that other battle of man against the ideal, the struggle . . . which symbolizes our never-to-be-attained aspirations . . . all the sins that Dante had mentioned, completed by more sins referred to by Baudelaire in his *Fleurs du Mal*. . . . Rodin . . . has sought his sensual and more modern inspiration in Baudelaire and in the corruption of contemporary humanity.[29]

A few of those who looked at and thought about *The Gates* saw their intimate relation to the artist himself. Mirbeau called Rodin "A man of our time, filled with moral maladies, betrayed hopes, sarcasms, angers and tears," and Mauclair called him a "gloomy psychologist of passion, [who] understands the disease of the age, and at the same time pities it."[30] Guigou wrote in 1885: "Rodin

has a marvelous subject for his temperament. Torturer of form, ardent lover of muscular convulsions and contractions and the violent, the rugged master has been able to abandon himself to the somber passion of his nature."[31] Bartlett was convinced that "Rodin works from the force of the sentiment that possesses him, that he lives, and not from the motive of any given name or outwardly defined subject."[32]

The observation of Judith Cladel is perhaps most interesting because she, more than the critics, had the opportunity and time to know how far Rodin's life *was* related to his work on the portal. To her, the connection was implicit, and intimately bound up with his affair with Camille Claudel. *The Gates* were, she said, "an immense carnal poem, a work of lovers who desire, possess, and devour each other, a mirror of lustful nature." Referring to the years of the 1880's when Rodin worked most continuously and intensely on the commission, Cladel wrote after her friend's death, "This phase of his extraordinary production was naturally concordant with the culminating period of his life under the influence of the passions of love. . . . A great love occupied him, becoming one with his work as an artist, and was happily echoed in his thought. He would not speak of it until a long time afterwards at the time of the inevitable breakup."[33]

Color and Effect: The Form of "The Gates" as Judged by Rodin's Peers

From those who wrote about *The Gates* between 1880 and 1900 there were more compliments than criticism concerning its form. As was to be expected, the most severe adverse critiques came during and after its 1900 showing. At no time, however, were the assays of the portal's form ever as extensive as the readings of its theme. Seldom did a writer take the time, in the form of several visits, to actually study the great doors in terms of their composition. (Since many were journalists and more adept at literary criticism, this is not particularly surprising.) Most visitors—including the critics—were so overwhelmed by the scale and scope of the emerging epic that in their articles they chose to stress what it was about. As most of the visitors to the artist's studios who wrote about their experiences were writers and not artists, the imbalance is not surprising. Even after the advent of abstract art and for-

malist criticism, still today little attention is paid to the formal aspect of *The Gates of Hell*.

It was not unusual to find Rodin's conception of his commission referred to as "colossal" or "grandiose" (that in the late nineteenth century, unlike today, was a positive term). Mirbeau, for example, said, "There is in these compositions a movement, a sweep and grandeur of action that astonishes and captivates." For Dargenty, the doors were "an extraordinary work where the material execution equals the majesty of the conception"; and this writer was not alone in calling the still unfinished project "the capital artistic event of the age."[34] Rodenbach, writing in 1889, proclaimed, "This will be a capital work of modern sculpture, an uncontested masterpiece."

I have already said a good deal about the articles by the one sculptor who wrote about the doors before 1900, Truman Bartlett, in which he describes the sculpture with an obviously sensitive artistic understanding of form and mass—telling us, for example, that the low relief of the pilasters is "treated with extraordinary reach of line." In his notes, Bartlett wrote, "As pieces of low relief color, the pilasters . . . are regarded by all who see them as complete masterpieces." Bartlett was not the only one to compare Rodin's conjoining of sculpture and architecture in the area of the frame's moldings with medieval art, and frequently Rodin was likened to a Gothic sculptor, even the reincarnation of a medieval carver who worked on the cathedrals. As Bartlett wrote, "Rodin is a great admirer of Gothic sculpture and it has often been affirmed, because of his piercing way of seeing and reproducing nature, that he was an ancient Gothic artist come to life again."[35] Bartlett's comparison of the design of *The Gates* with those of Ghiberti was not unique: "Of the character of the design, in comparison with that of Ghiberti, it must be said that it is more original and more varied."

The most informative judgment, however, came from Léon Maillard, who, like Bartlett, was able to talk at length with Rodin and observe him at work. In his study of Rodin that was published in 1899 he says: "The decorative unity such as Rodin conceives it, and such as the most famous monuments resulted from, he obtained not by additions but by systematic subtractions. He has been wise in going so far as to eliminate exquisite things, and this voluntary elimination leads the ensemble of the planes to their true harmonic value."[36] When Maillard wrote this,

probably the year before his book was published, the doors were probably not fully assembled, for he added: "Now that the Door is only constructed in his thoughts, he can permit himself this compositional debauchery, whereas the definitive construction must lead the elements back to a synthetic vision." Above all, Maillard recognized the decorative aspect of the doors:

The decor is not only the fact of an intellectual search . . . it is born not from long sought for assemblage but from a happy meeting of lines, of forms, and of aspects. This truly gifted artist is imbued to the highest point with that harmony that constitutes the truly decorative. . . . The least of his figures is destined to produce that immediate perception of decor, by the mass of shadows and the light . . . because with his figures the selection of the planes lends direction as much to the profiles as to the ensembles . . . causing them to enter into an ambient unity. The Gates of Hell amply give the certitude of a decorative work, par excellence, by the absolute superiority of its constitutive elements and by its majesty.[37]

Not all critics agreed on the total effect of the composition. For Henri Frantz, the most memorable experience of the portal's formal realization seemed to be its unity: "The beauty of detail is never impaired by the grandeur of the whole, and never sacrificed to it. The artist adheres to the geometrical scheme of the masses, the essential and primordial structural forms on which nature insists."[38]

Never criticized for his handling of individual sculptures, or "fragments" of the portal, Rodin did receive low grades from some as a composer. Roger Marx, a critic who was otherwise an ardent and long-time champion of Rodin's work, lamented, "I wish Rodin would give us his Gates of Hell. It is a matter of great regret to me that he does not. My opinion is that he has worked at it too much, has put too much into it, has overloaded it . . . and if I may venture to say so, has gone beyond his architectural construction. The door has been finished for some time. It is a pity he does not acknowledge it."[39] Marx's questioning of Rodin's capacity to balance sculpture and architecture was done in the most tactful way. There was no such restraint from the critics Brownell and Cox:

If Rodin had been as instinctively drawn to the ensemble as he was to its elements, he would not have been so long in executing it. . . . It is the belief that Rodin is not only not a designer by nature, but that he has an innate incapacity for design on a large scale, and lack of architectonic faculty, an inability to think except in fragments, that leads some of us to imagine that the

gates will never be completed, that they are incapable of completion because they have never been really conceived as a whole.[40]

In his *Portraits of a Lifetime*, the painter and friend of Rodin, Jacques-Emile Blanche, wrote: "Now there was a burning question to which . . . I should like to have found an answer; Rodin had a thousand moulds of miniature figures for his Porte de L'Enfer in his museum at Meudon. . . . Was he aware of his incapacity to design a monument? As far as we were concerned . . . though he excelled in the composition and modelling of a figure, his conceptions of groups are weak."[41]

Rodin never replied to his critics in print, but when he talked about what he had found or achieved in *The Gates*, it is fair to assume that he had their words in mind or was even anticipating their criticisms. In 1883, Roger Ballu foresaw that Rodin would be accused of violating certain sacred rules, by which he apparently meant the way sculpture was supposed to relate to architecture. Bartlett, for example, notes a story that is revealing of Rodin's views on what constitutes sculpture appropriate to architecture: "Rodin went to see Garnier, the architect of the new Opera. The latter showed him his first sketches of the building, and then began to inveigh against Carpeaux's group saying that it did not go well with the building as the others did, and was not architectural. . . . To which Rodin answered that the fact was that it was the only one that went well with the building, the only one that was architectural, that applied to the building. It was the only one that had any architecture about it."[42]

The group being referred to was of course *The Dance*, whose unveiling was greeted by a torrent of critical abuse that included the publication of broadsides against it. Unlike Garnier and most critics, including Bourdelle, Rodin did not believe that figural sculpture had to repeat or even echo the major lines of a building in order to be architectural. The body had its own architecture, and as implied in Bartlett's anecdote, the fitting relationship between the two art forms was that of high quality of execution and contrast in their respective constructive possibilities and logic.

Years after the denuded portal was exposed in 1900, Judith Cladel wrote that someone had said to Rodin, "Your doorway is much more beautiful like that, in no circumstances do anything more to it." (This person may well have been Bourdelle.) Cladel goes on:

This absurd advice befell at an evil moment: the artist felt worn out from overwork and anxieties of all kinds. . . . Had he been in better health, more the master of himself physically and morally, he would have replied to the prattling of these excited parrots and guinea hens, "Take more room to examine my Gate from a little further off, and you will see at once the effect of the whole, the effect of unity which charms you when it is deprived of its ornamentation. You must understand that my sculpture is so calculated as to melt into the principal masses. For that matter, it completes them by modeling them into light. The essential designs are there: it is possible that in the course of the final work I may find it necessary to diminish such or such a projection, to fill out such or such a pool of shadow; nevertheless leave this difficulty to my fifty years of artisanship and experience, and you may be sure that quite by myself I shall find the best way of finishing my work."[43]

Aside from his oldest and most skilled assistants, there was probably no one in Rodin's lifetime who knew the artist and his thoughts on *The Gates* better than Judith Cladel, or who would have had the temerity while the sculptor could read what was written to speak on his behalf as she did. Rodin was in fact silent on such comments regarding the superiority of the naked portal, but Cladel's response on his behalf may be the closest we will ever come to knowing what he thought.

In 1917, without seeking to paraphrase Rodin but nevertheless informed by her experiences with him, Cladel gave her own reading of the doors. It is one of the very best in terms of a grasp of the whole and its sensitivity to the interaction of the plaster with light:

The powerful frame is furrowed with deep depressions. It rests on the ground upon a strong base from which rise the two doorposts, as robust as pillars and mounting together toward the summit. A pediment, in the shape of an entablature, overhangs the entire monument, casting over it deep shadow full of nuances; and it is this shadow, skillfully graduated, that gives to the work its rich, soft color. The body of the portal is divided into two panels; a vast tympanum surmounts them transversally. This tympanum, surmounted by a cornice, dominates the work. Without weighing it down, it gives it its mass, it attracts, obsesses the eye; it is the soul of the edifice, its intellect. No word can more justly describe it than the word brow, for it is magnetic, haunting, mysterious, like the forehead of a man of genius.

The panels sink deep into a shadow that is heavy, but not harsh, while in the foreground the pillars advance into the light; the delicate bas-reliefs that cover them in a silvery atmosphere,

the source of the great softness which envelops the work, otherwise severe and tragic, the source of the fugitive lightness of the lines, which strike up from the earth toward the somber and tormented regions.[44]

More than his critics such as Bourdelle, Brownell, and Cox, Rodin seems to have had a broader and deeper historical awareness of various traditions for relating sculpture and architecture. Rather than received theories or opinions, Rodin's decorative sense was informed by first-hand study of architectural history and the human form. In talking to Cladel around 1899 or 1900, for example, Rodin discussed how he worked from living models moving freely in the studio: "It is by this patient study that I have rediscovered the procedures of the Greeks, thanks to work itself and not by imitating their statues; it is their method that came to me, as in The Gates, where I brought back to light the means employed by the artists of the Renaissance, for example, this mélange of figures, some in bas-reliefs, others in the round, in order to obtain the beautiful blond shadows that convey such softness. . . . It came from my models, the same as it had been revealed to the sculptors of the sixteenth century by their models also."[45]

What contributes to the conviction that to all intents and purposes *The Gates of Hell* were completed in terms of their form by May of 1900 is a statement made by Rodin in which he spoke in the past tense of what he sought to achieve formally in the doors. It was recorded by Frederick Lawton when he was Rodin's secretary around 1903: "I used to think that movement was the chief thing in sculpture, and in all that I have tried to attain. My 'Hell Gate' is the record of those strivings. It contains the whole history. There I have made movement yield all that it can. I have come gradually to feel that sculptural expression is the essence of the statuary art, expression through modelling."[46]

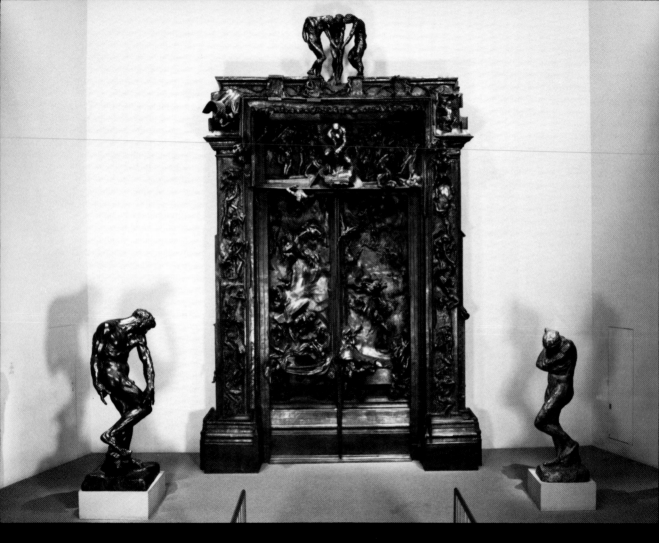

Fig. 146. *The Gates* seen as a whole, with *Adam* and *Eve*. Photo
Bill Schaefer.

A Tour of 'The Gates of Hell'

Today, we can examine *The Gates* from top to bottom by means of photographs, studying every detail in a way that was not possible even for critics and others who visited Rodin's studio during the years of their creation and montage in 1900. Certainly from Rodin's lifetime there is no detailed photographic record of the assembled portal such as we can present now. The photographs here reproduced permit a tour of Rodin's hell that includes views such as the entire upper section that are unavailable to the beholder standing at ground level looking up at the doors. The reader is thus better able to weigh the interpretations of *The Gates* made by Rodin's contemporaries, as well as the author, against the art itself.

The presence of *Adam* and *Eve* shown after the Fall, flanking the doors, to which Rodin unsuccessfully tried to have his commissioner agree, gives the theme of the portal the prologue of original sin (Figs. 146, 147) and reveals the assumptions on which Rodin's life attitude expressed in the portal was based. It is as if we are looking between humanity's parents at the spectacle of their legacy. The derivation of each of *The Three Shades* from the figure of *Adam* helps to foster this ancestry. Rodin would have immediately established the beginning and source of universal and timeless human suffering.

Artistically, the presence of these two life-size figures would have completed or extended the range of figural scale; the large size of *The Three Shades* atop the doors would not have been as noticeable as it is otherwise. The Michelangelesque proportions of the framing figures allow them to project and hold their own against the powerful doors. They enforce a basic symmetry in depth to the overall plan, as well as establish the base for an implied pyramidal design with *The Shades* at the apex. Having established such a formal general design, Rodin then set out to work against it (not unlike Picasso in the way he countered the final pyramidal design of *Guernica*). The self-contorted postures of *Adam* and *Eve* show Rodin's will to animate and dramatize a type of formal balance that otherwise would have been too cold or inert for his taste.

Having the *Adam* at ground level would have also helped the beholder to sense the analogous compositional principles shared between the figure and the portal, both of which are based on a shifting equilibrium of masses. Rodin's thinking about the order in his doors was rooted in his ideas about composing the figure. Compare the overall design of *The Gates* with its counterpart in the structure of *Adam*. Start with the solid horizontal base and its architectural equivalent, and in like manner then consider the vertical framing action of the arms and external bas-reliefs. Look for the roughly horizontal line of the shoulders, neck, and head that squares off the body's outline and its correspondence atop the doors. Finally, as Rodin worked by shifting balances and contrasts between stable and unstable forms, compare the zigzag path made by *Adam*'s right leg and torso with the placement of figural groups on the door panels and tympanum. It is only from this distant perspective that the nature, and success or failure, of Rodin's system of harmony can be perceived and understood as a whole.

In some ways the three-quarter views of the portal (Figs. 148, 149) are preferable to the head-on view. As with

text continued on page 208

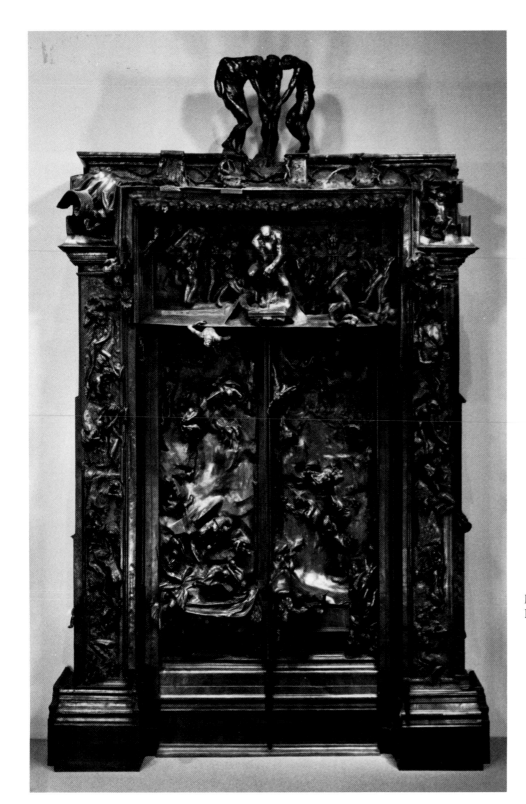

Fig. 147. *The Gates of Hell*.
Photo Bill Schaefer.

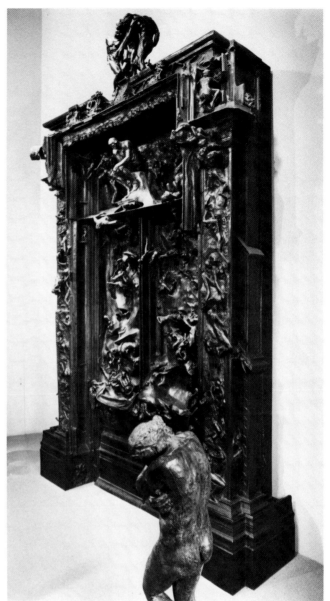

Fig. 148. *The Gates* seen from a left three-quarter view. *Adam* is in the foreground. Photo Bill Schaefer.

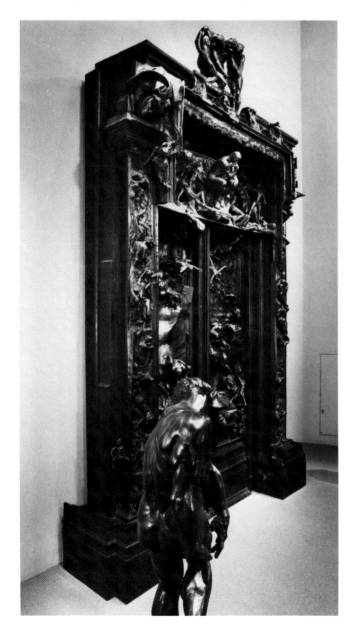

Fig. 149. *The Gates* seen from a right three-quarter view. *Eve* is in the foreground. Photo Bill Schaefer.

163

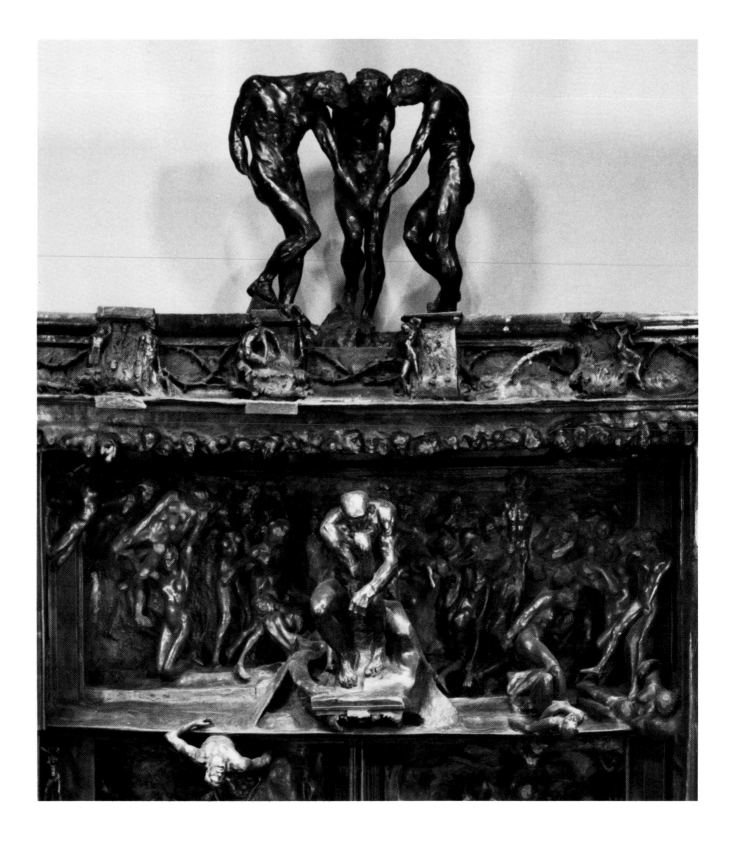

Fig. 150 (*facing*). Front view of the upper central section of
The Gates. Photo Bill Schaefer.

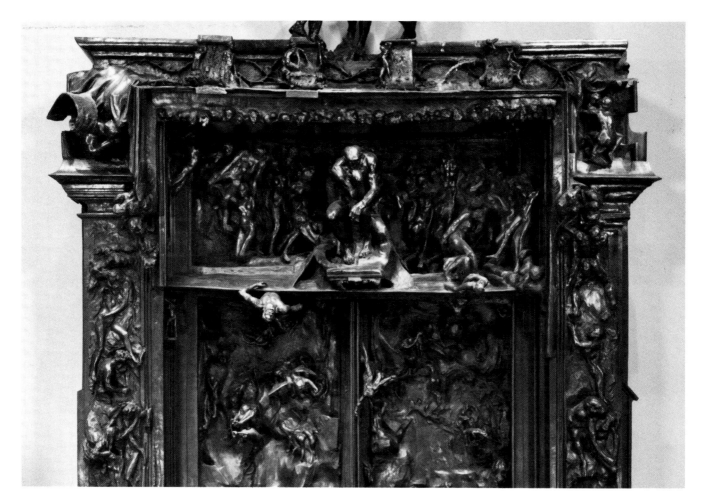

Fig. 151. Front view of the tympanum and entablature. Photo
Bill Schaefer.

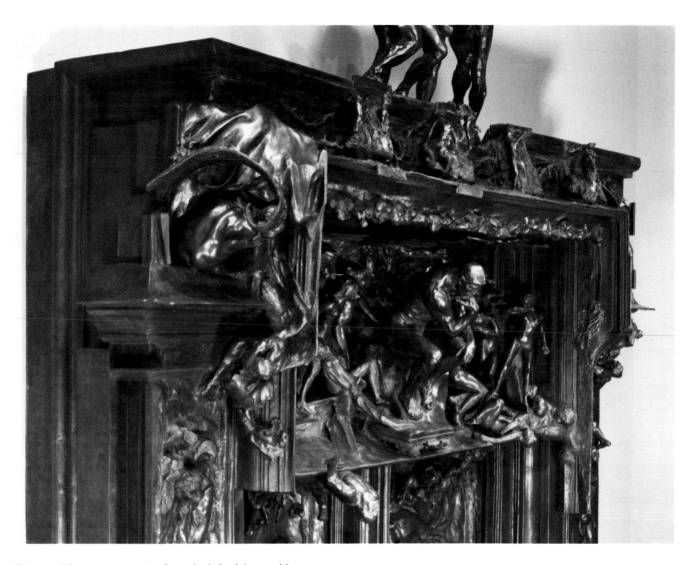

Fig. 152. Three-quarter view from the left of the entablature
and tympanum of *The Gates*. Photo Bill Schaefer.

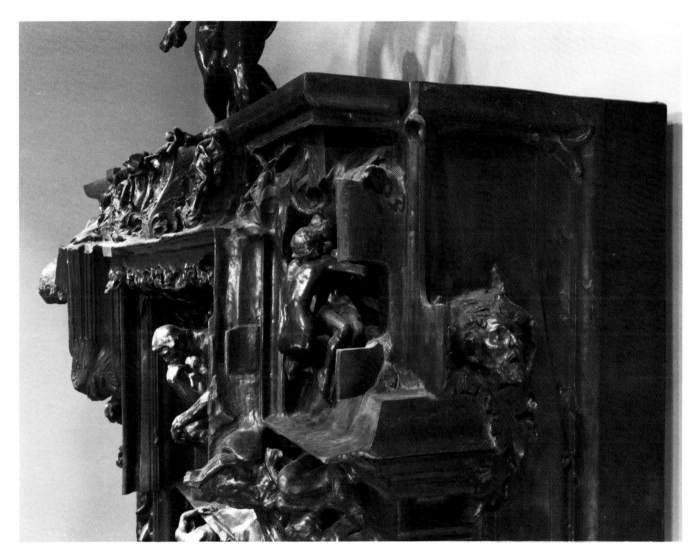

Fig. 153. Three-quarter view from the right of the entablature and tympanum of *The Gates*. Photo Bill Schaefer.

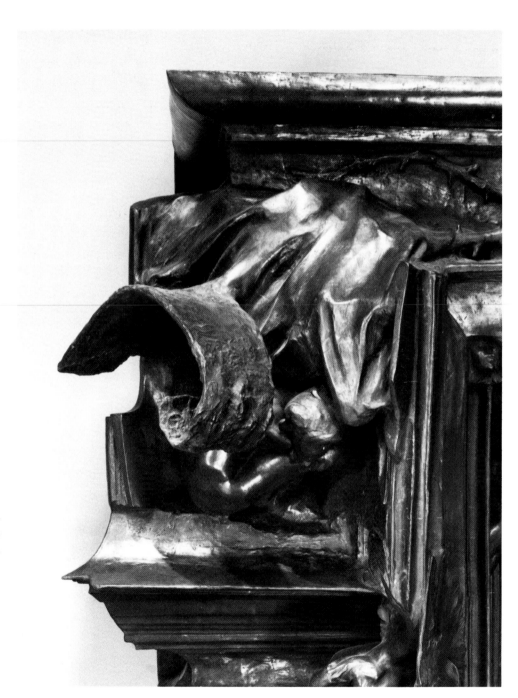

Fig. 154. The upper left corner figure known as *The Fallen Caryatid*. Photo Bill Schaefer.

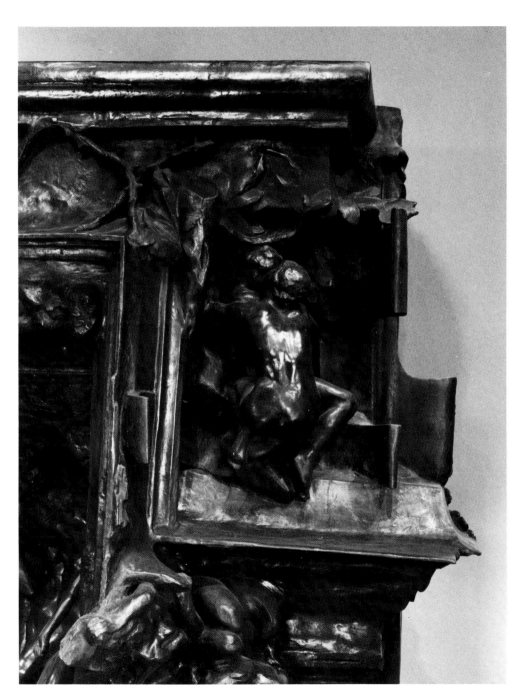

Fig. 155. The upper right corner figures known as *The Damned Women*. Note the beginnings of the thorn vine in this area. Photo Bill Schaefer.

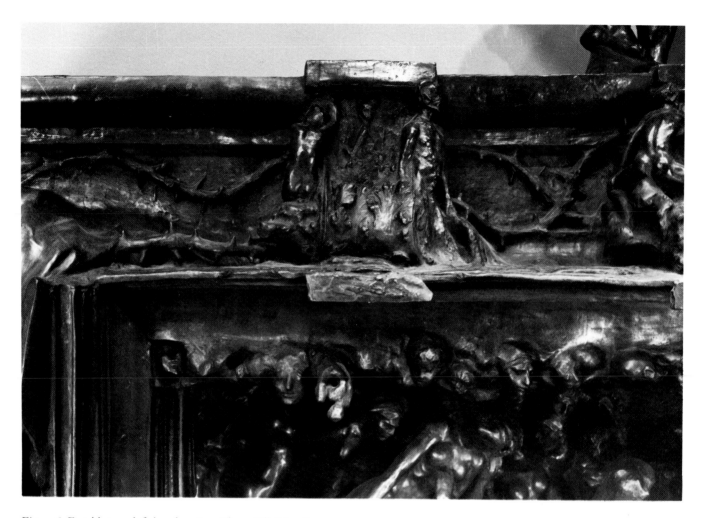

Fig. 156. Entablature, left-hand section. Photo Bill Schaefer.

Fig. 157. Entablature, section to the left of center. Photo Bill
Schaefer.

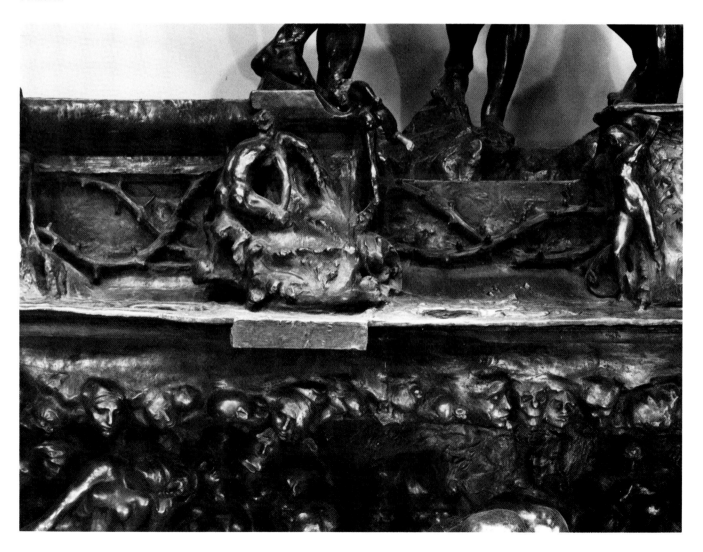

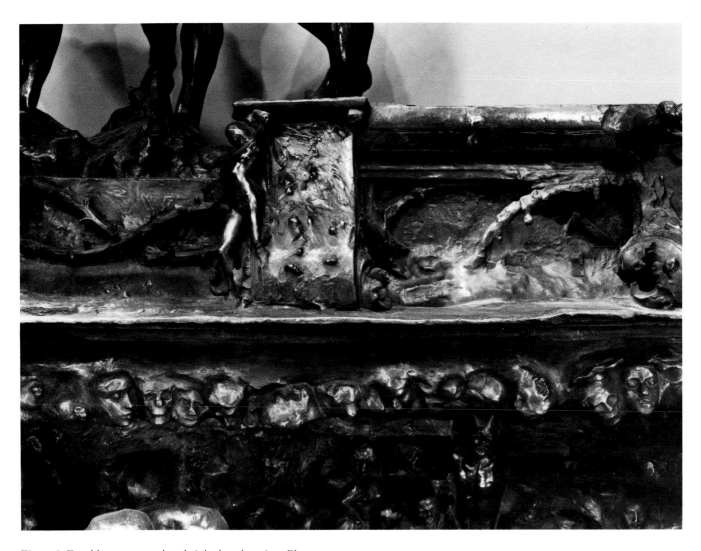

Fig. 158. Entablature, central and right-hand section. Photo
Bill Schaefer.

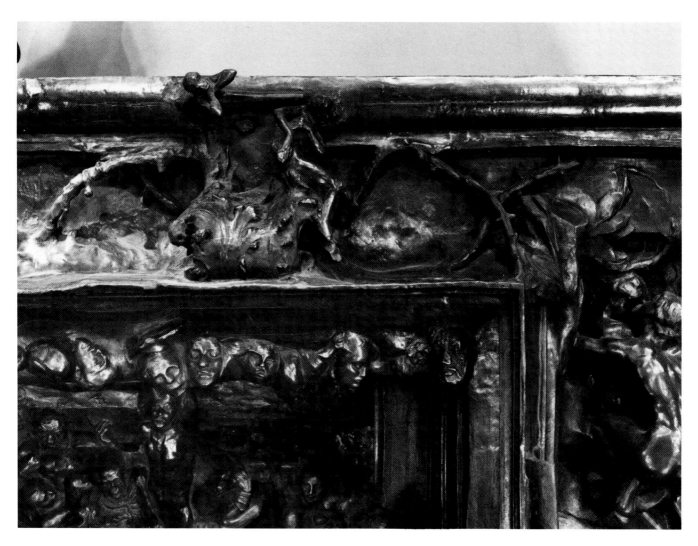

Fig. 159. Entablature, right-hand section. Photo Bill Schaefer.

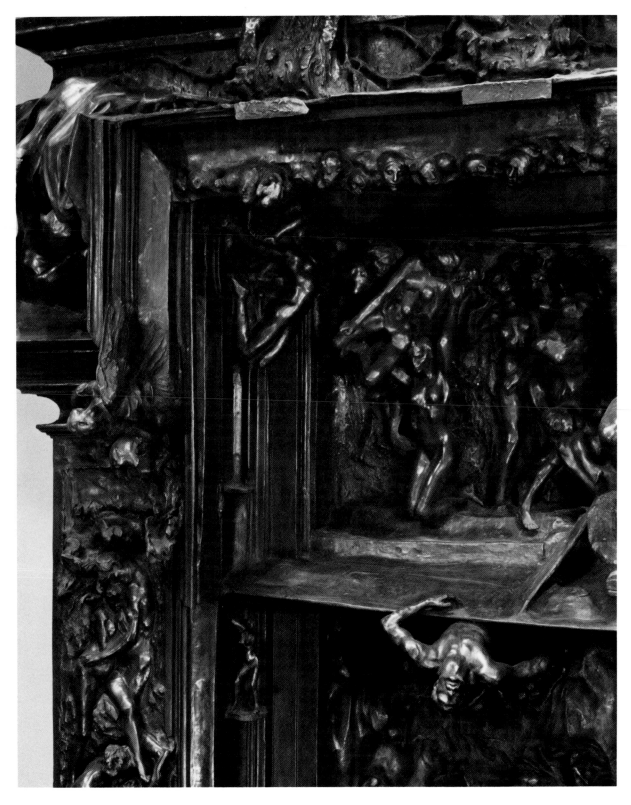

Fig. 160. Left side of the tympanum seen from an angle. Photo
Bill Schaefer.

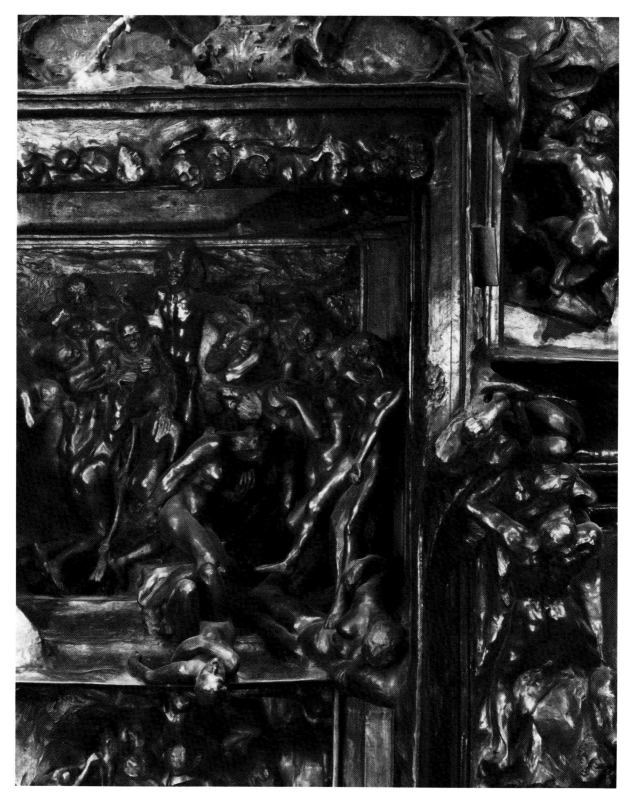

Fig. 161. Right side of the tympanum seen from an angle.
Photo Bill Schaefer.

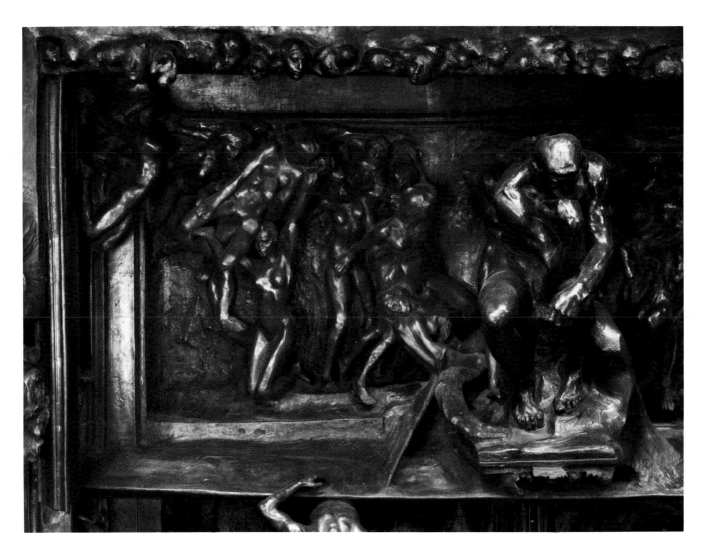

Fig. 162. Front view of the left side of the tympanum. Photo
Bill Schaefer.

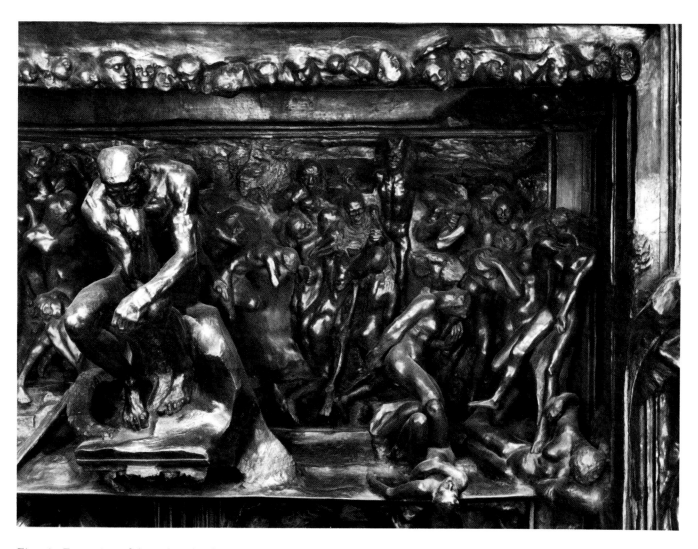

Fig. 163. Front view of the right side of the tympanum. Photo
Bill Schaefer.

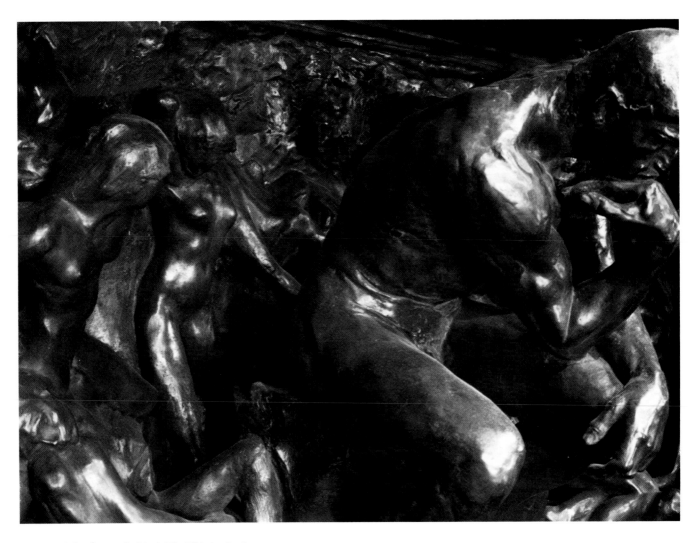

Fig. 164. The figures behind *The Thinker* in the tympanum,
seen from the left. Photo Bill Schaefer.

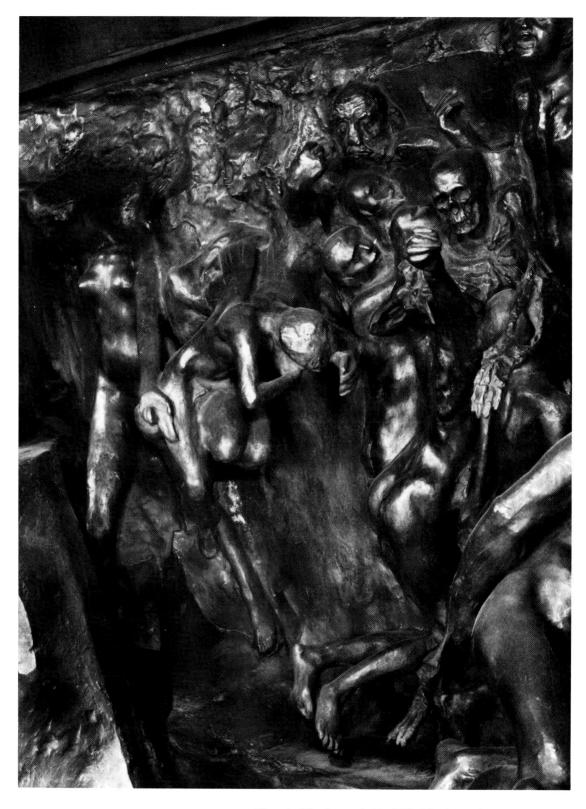

Fig. 165. The figures behind *The Thinker* in the tympanum, seen from the right. Photo Bill Schaefer.

Fig. 166. The crowd in the right rear of the tympanum. Photo
Bill Schaefer.

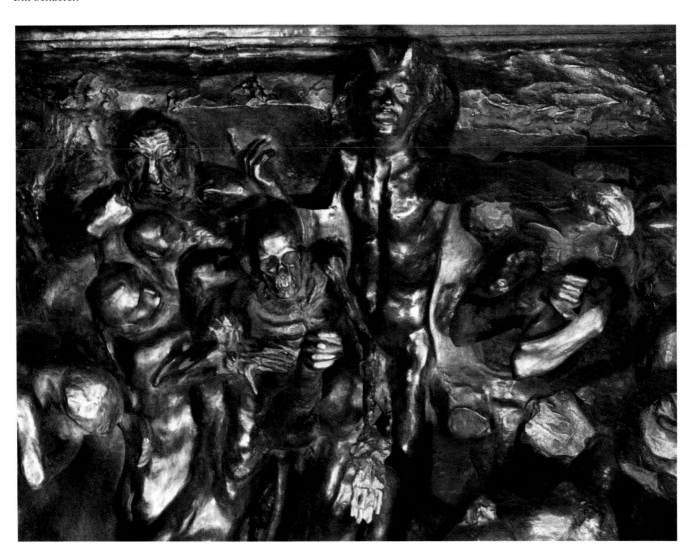

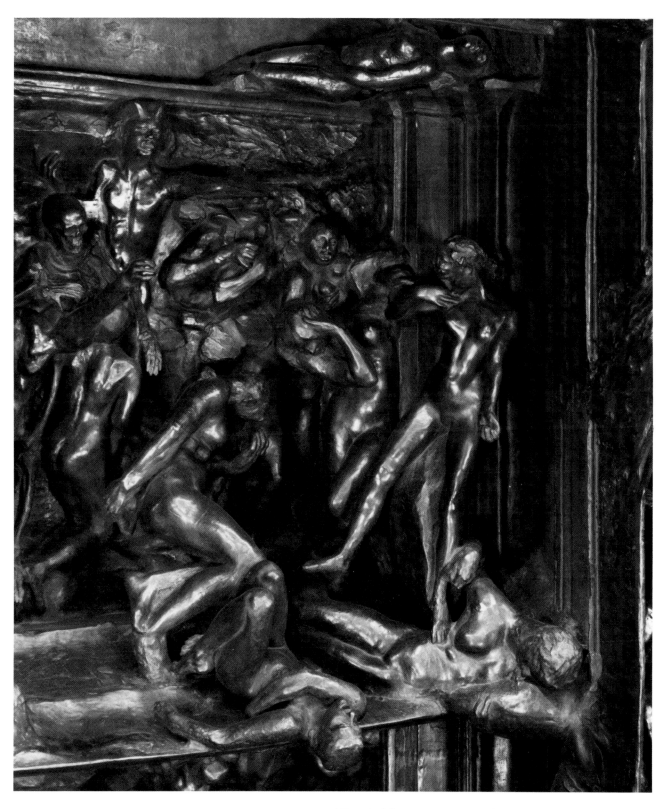

Fig. 167. Three-quarter view of the right side of the tympa-
num. Photo Bill Schaefer.

Fig. 168. Upper section of the
left external bas-relief. Photo
Bill Schaefer.

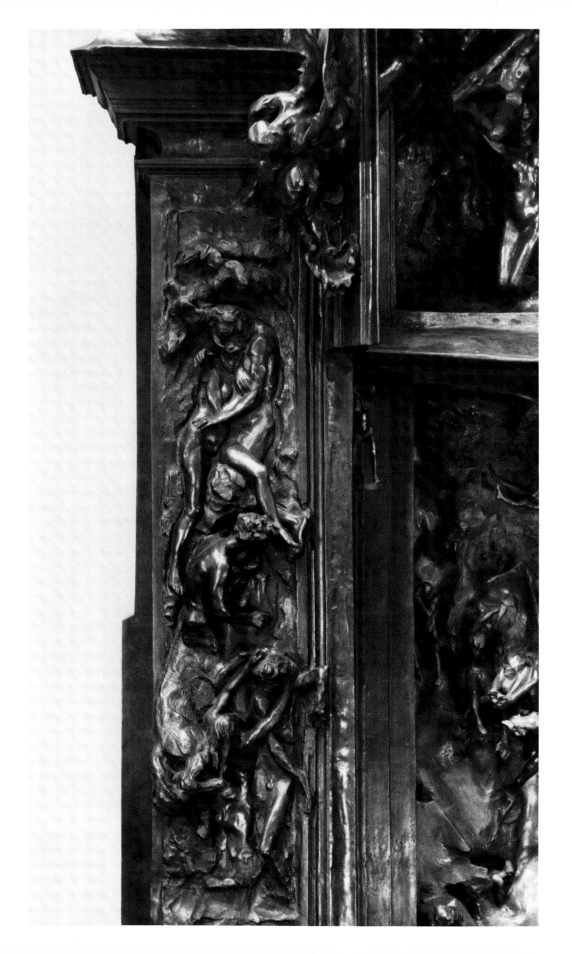

Fig. 169. Lower portion of the
left external bas-relief. Photo
Bill Schaefer.

Fig. 170. Three-quarter view of the lower left corner of the doors. Photo Bill Schaefer.

185

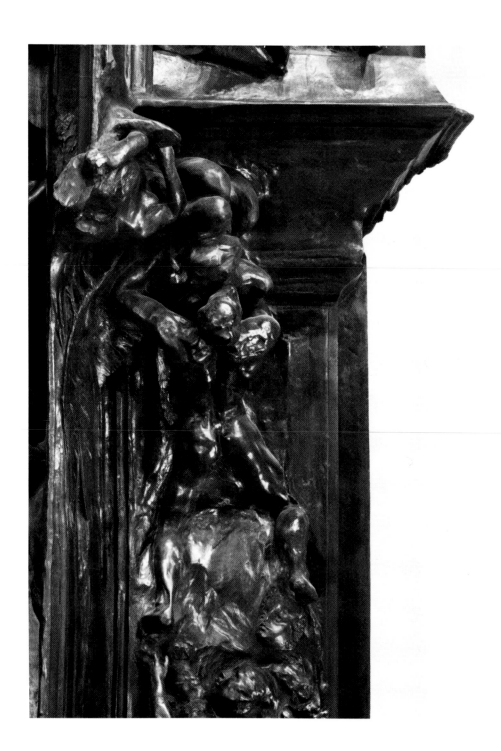

Fig. 171. Top portion of the right external bas-relief. Photo Bill Schaefer.

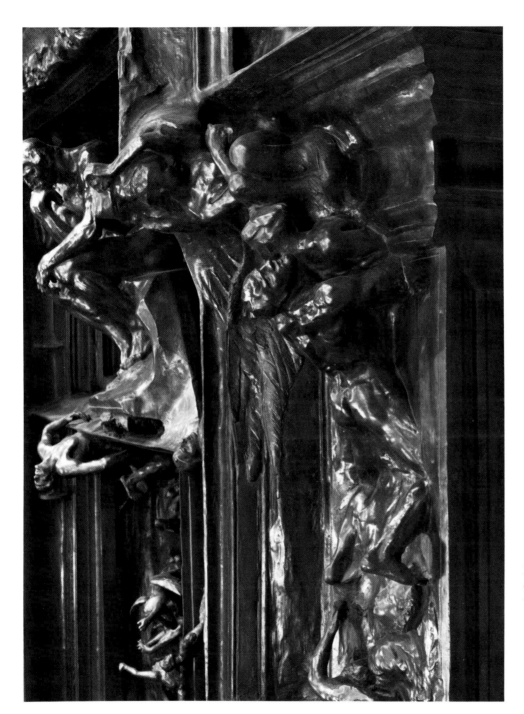

Fig. 172. Three-quarter view
of the upper right section of
the doors. Photo Bill Schaefer.

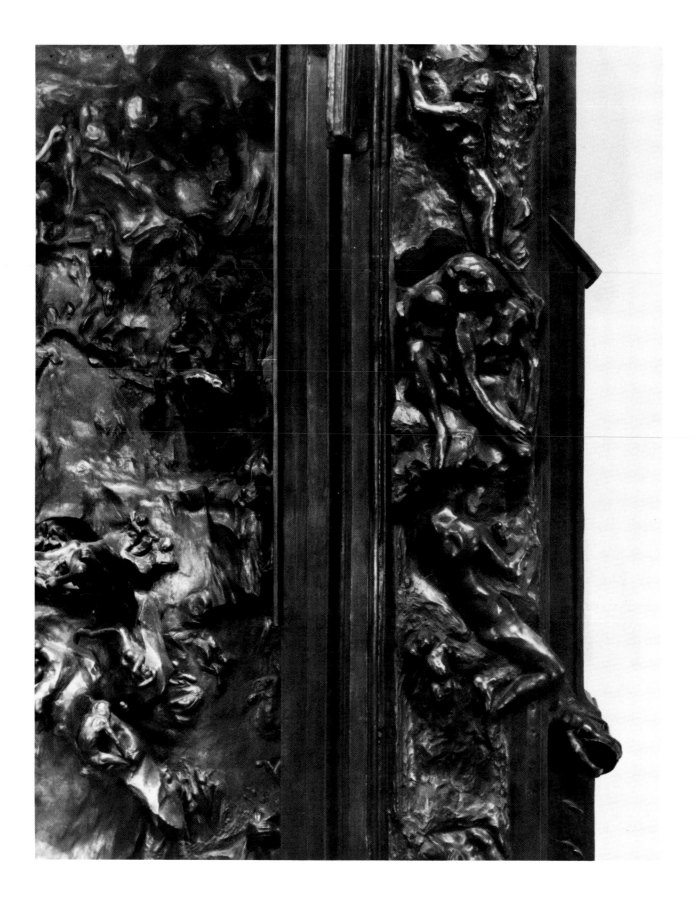

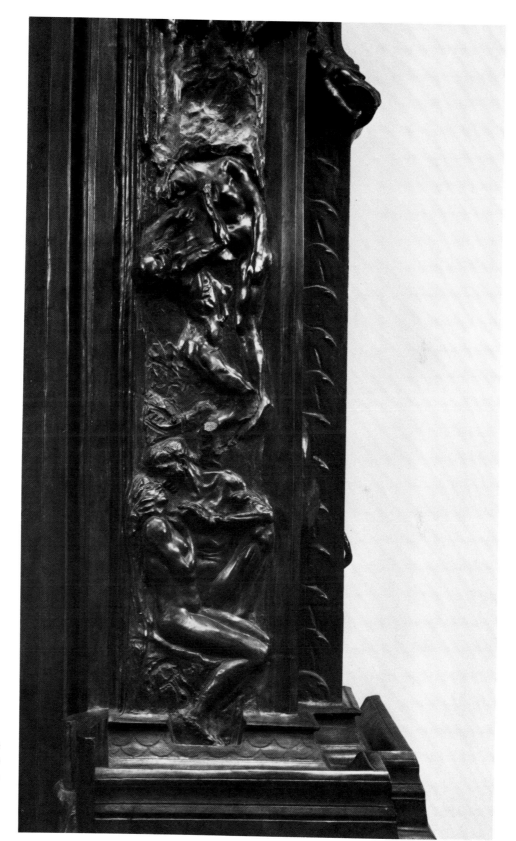

Fig. 173 (*facing*). Midsection of the right external bas-relief. Photo Bill Schaefer.

Fig. 174. Lower section of the right external bas-relief. Photo Bill Schaefer.

Fig. 175. The two central
doors. Photo Bill Schaefer.

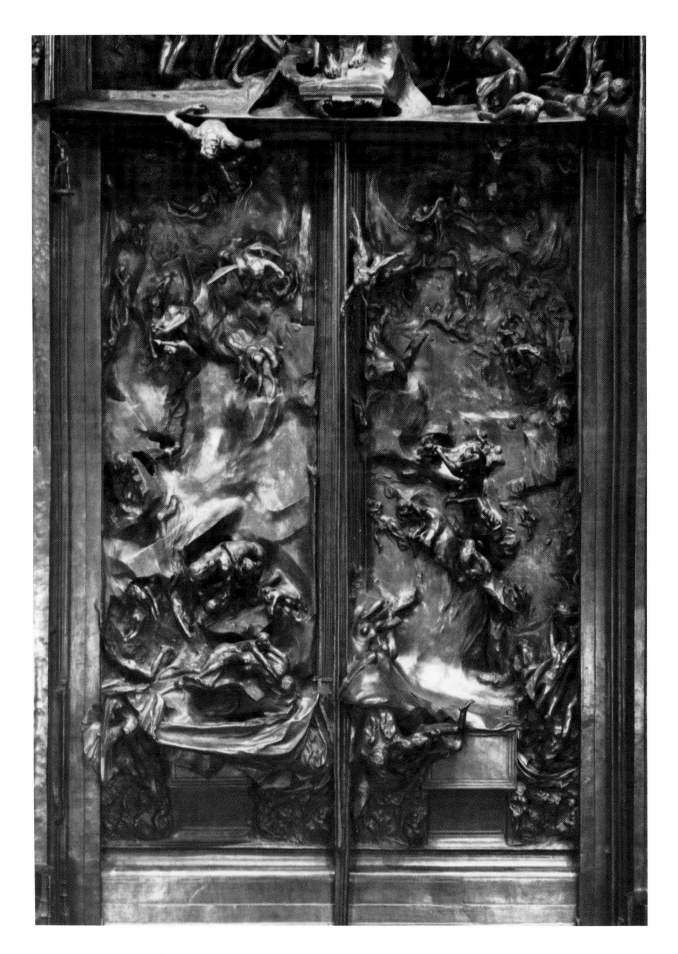

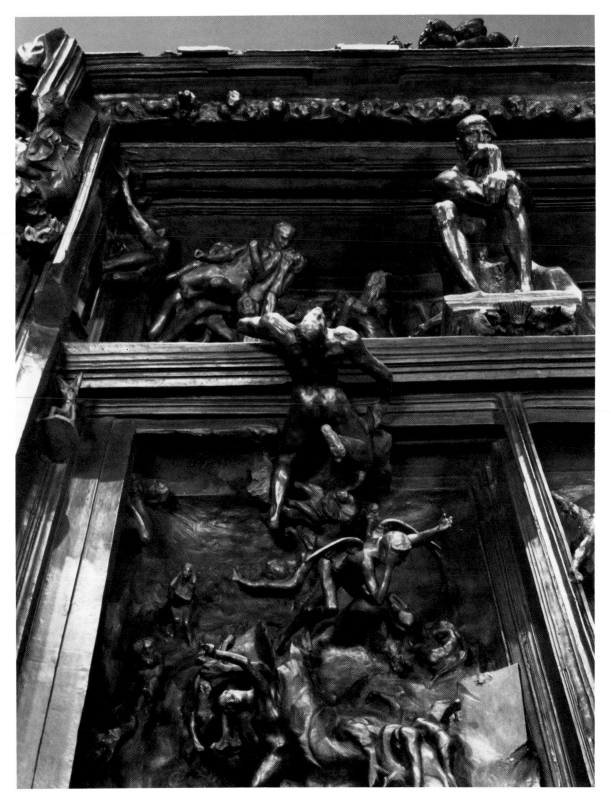

Fig. 176. View from below of the upper left door panel. Photo
Bill Schaefer.

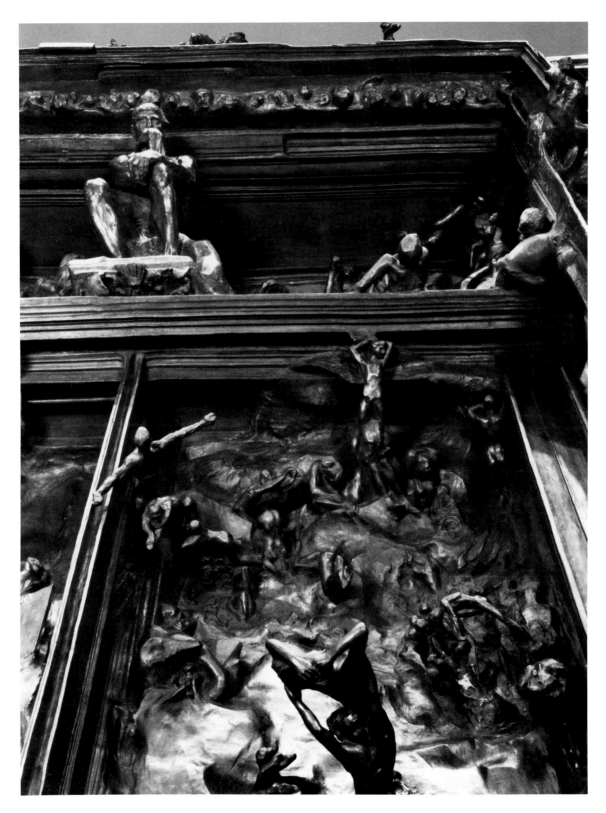

Fig. 177. View from below of the upper right door panel.
Photo Bill Schaefer.

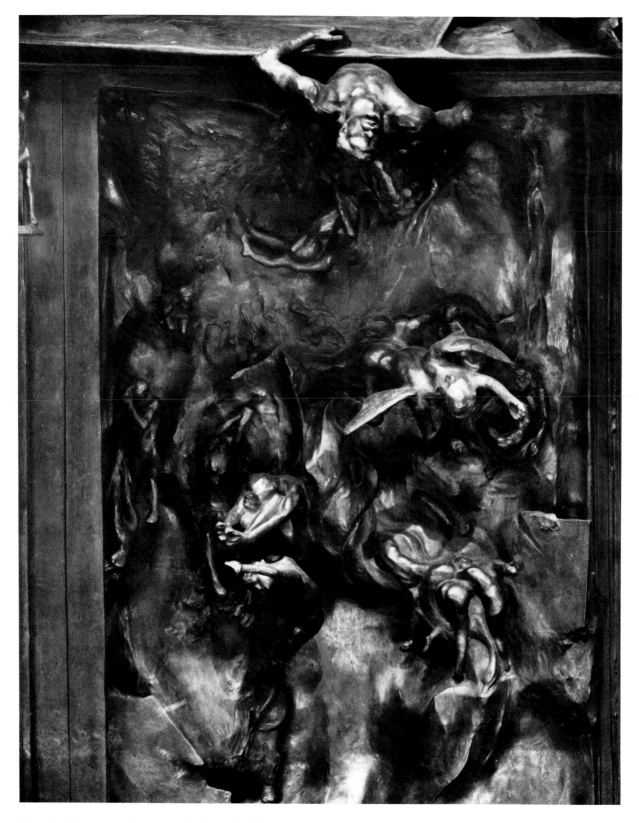

Fig. 178. The upper left door panel. Photo Bill Schaef

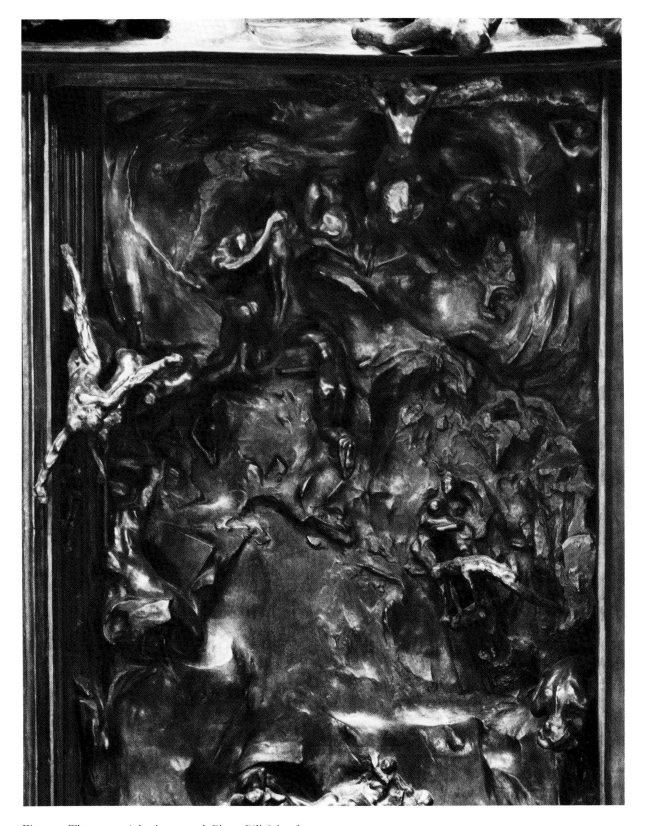

Fig. 179. The upper right door panel. Photo Bill Schaefer.

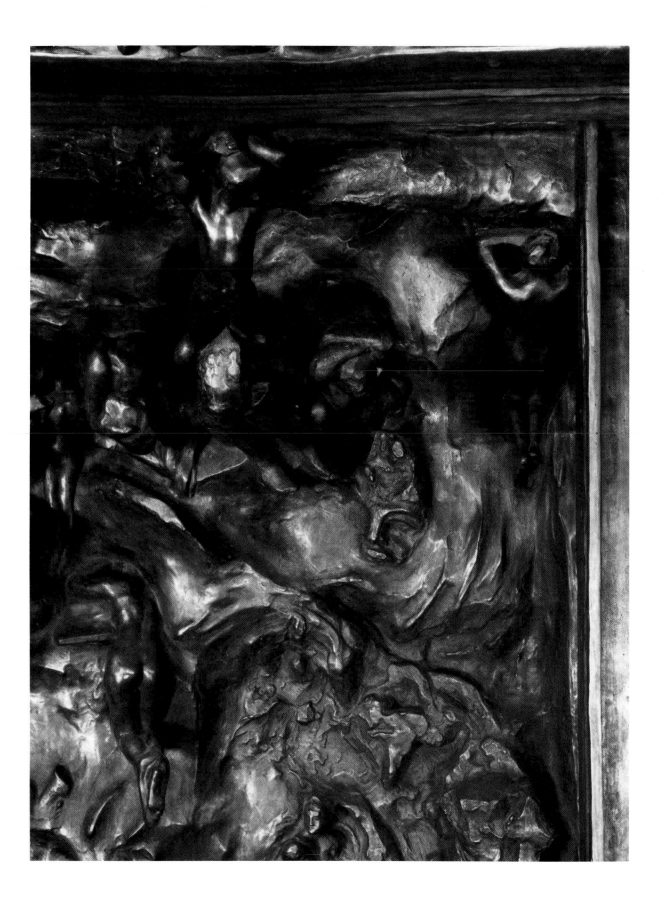

Fig. 180 (*facing*). The right corner of the upper right door panel. The Balzac-like face can be seen emerging from the background right of the center. Photo Bill Schaefer.

Fig. 181. Center section of the left door panel. Photo Bill Schaefer.

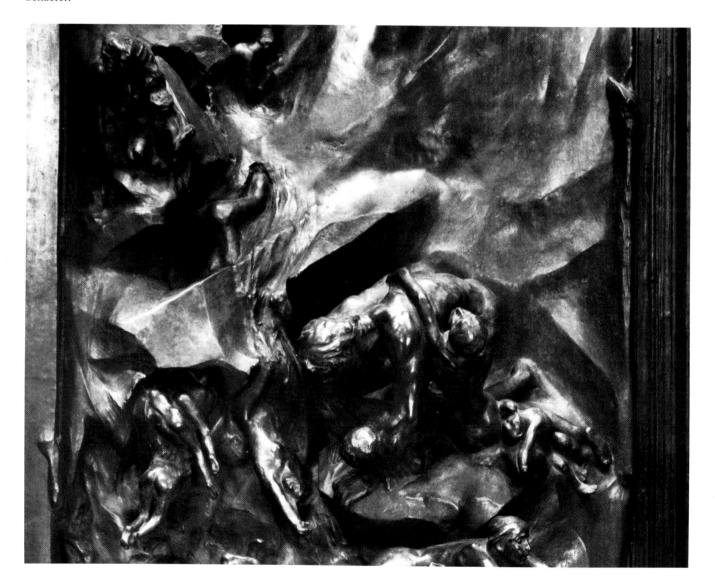

Fig. 182. Center section of the right door panel. Photo Bill
Schaefer.

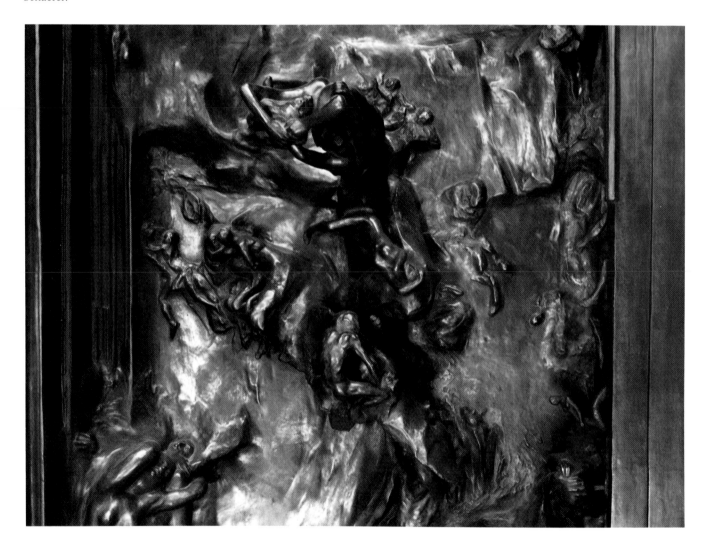

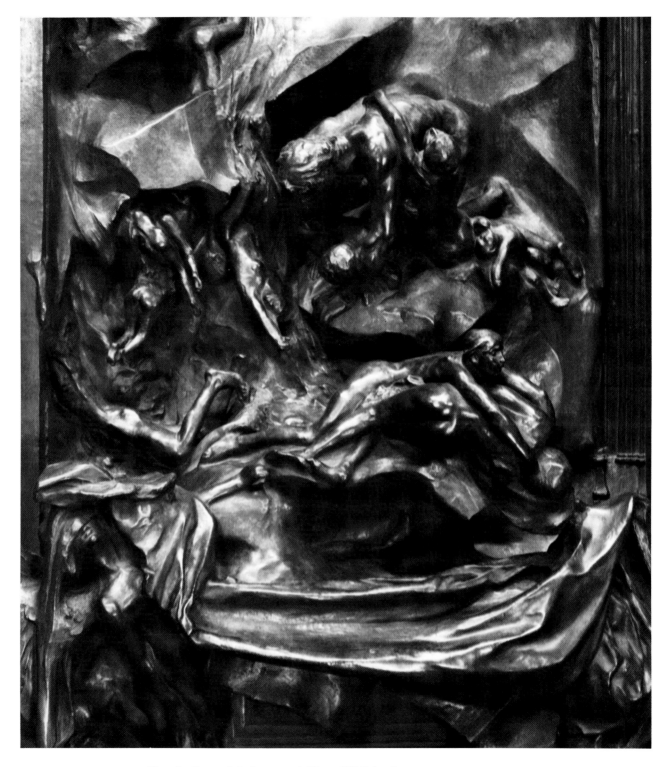

Fig. 183. Lower left door panel. Photo Bill Schaefer.

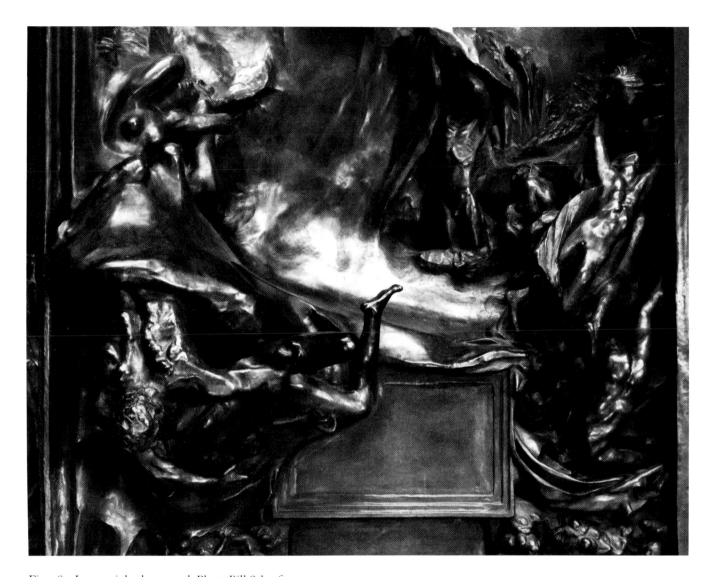

Fig. 184. Lower right door panel. Photo Bill Schaefer.

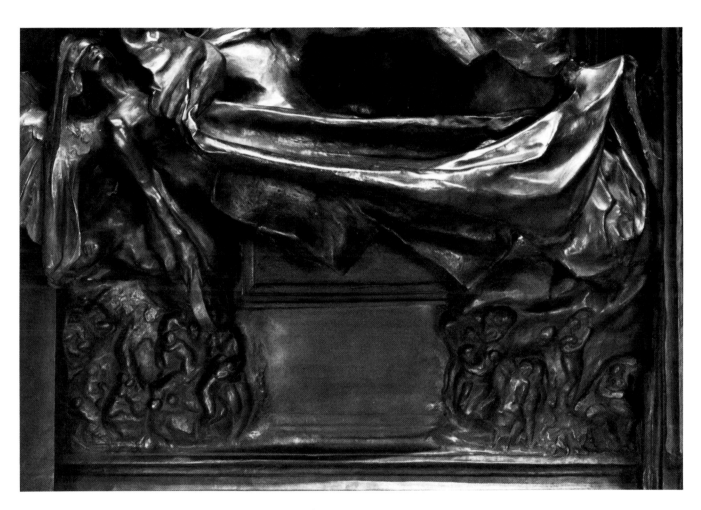

Fig. 185. The tomb in the left door panel. Photo Bill Schaefer.

Fig. 186. The tomb in the right door panel. Photo Bill Schaefer.

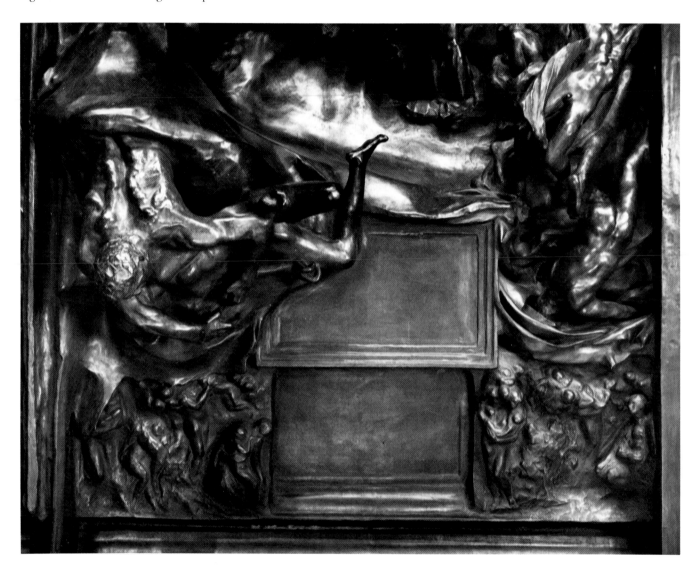

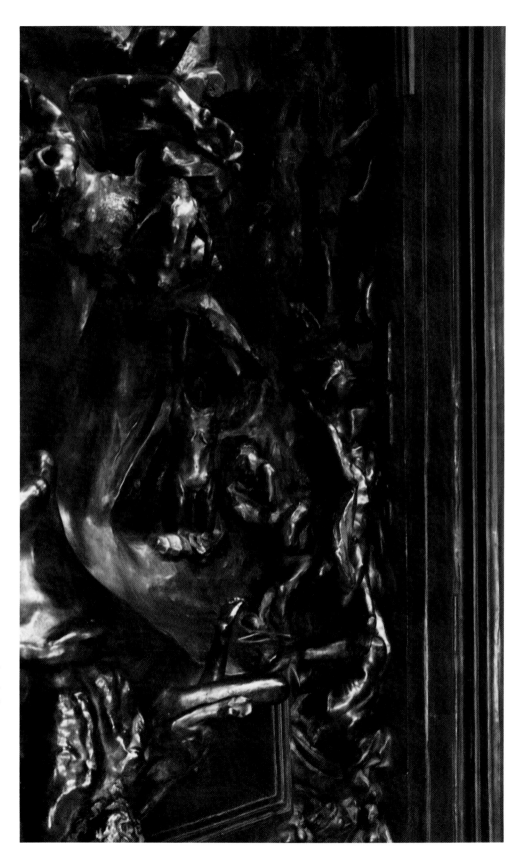

Fig. 187. Lower right door
panel looking into the corner.
Photo Bill Schaefer.

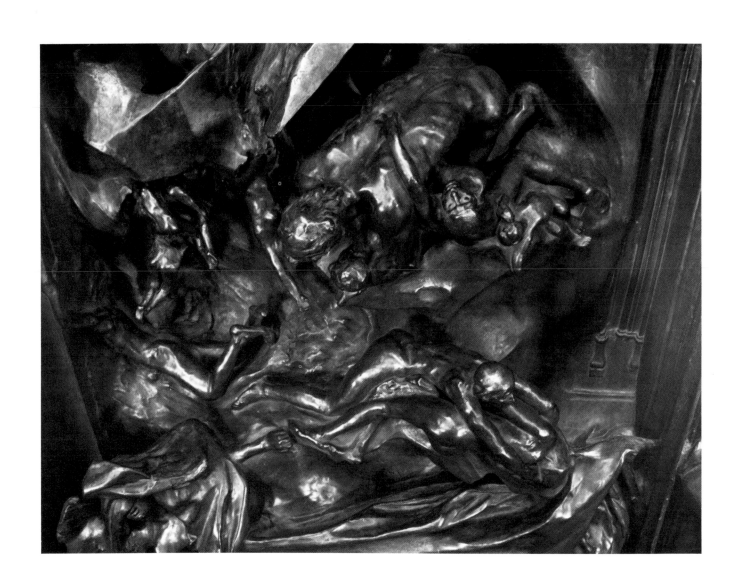

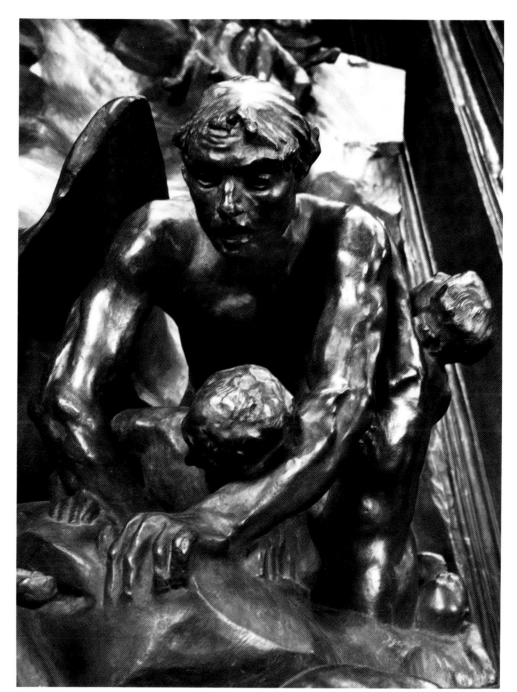

Fig. 188 (*facing*). Lower left door panel from above. Photo Bill Schaefer.

Fig. 189. *Ugolino*. Photo Bill Schaefer.

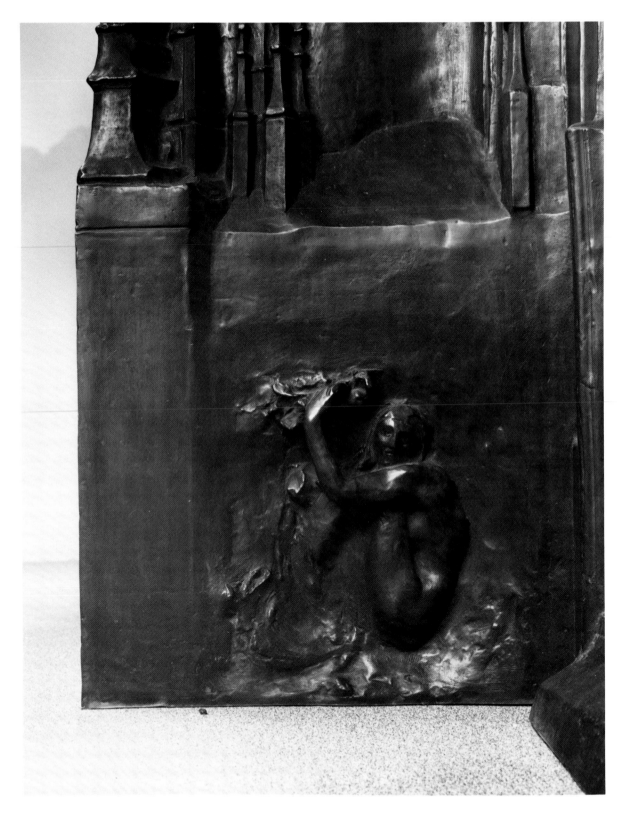

Fig. 190. Relief of Eve (or a Siren) in the lower left door jamb.
Photo Bill Schaefer.

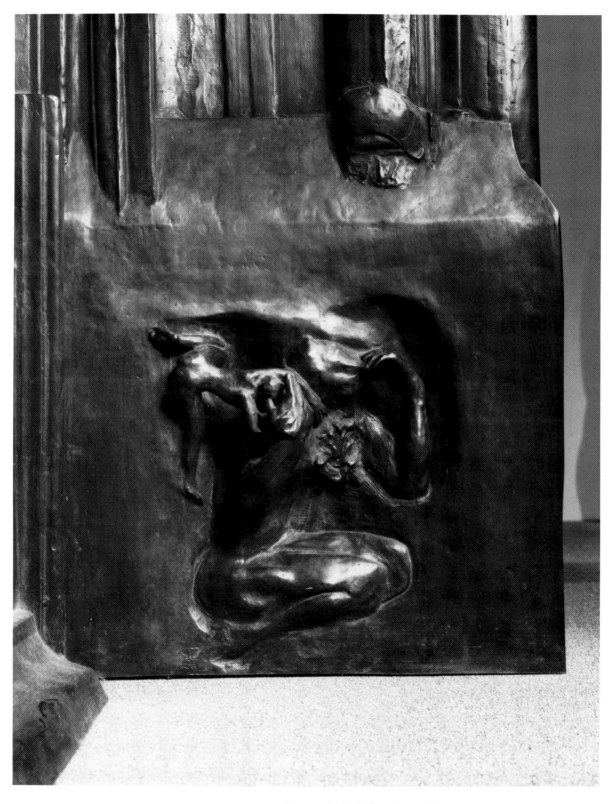

Fig. 191. Relief of Rodin's self-portrait, with a small figure that might be the offspring of the artist's imagination. Photo Bill Schaefer.

Rodin's figure sculptures, the artist preferred these angles, because they showed the volume or thickness of the work, its existence simultaneously in breadth and depth. Off-center prospects surprise by revealing how deep the portal is in its upper section and how greatly recessed the two door panels are. This view pulls us into and under the portal, where we can become immersed in the sculptor's infernal world. The oblique views are also most effective in displaying Rodin's creation of an elusive atmosphere over the surfaces that results from his accommodation of light and shadow. Writing about what he had learned from the study of Gothic cathedrals, Rodin observed, "It is always by light and shade that a sculptor as well as an architect shapes and models."[1]

So important were the views of his doors from off-center that Rodin may have introduced the stepped pilasters along the sides to make the doors more three-dimensional and to accentuate their height. In these photographs one can also appreciate the footings below the external side reliefs, whose cubic projections give a more solid stance to the portal and help to balance the projecting areas of the cornices.

The Three Shades that surmount the doors (Figs. 150, 151) are casts of the same figure arranged in symmetrical fashion as emblems of the futility of resistance to death, or as the dejected "shades" or spirits of the dead in the *Inferno*. In the absence of *Adam* and *Eve*, and as immediately recognized by Rodin's contemporaries, *The Shades* set the tragic tone of the portal's theme. They constitute a humanized Trinity that holds out not the promise of hope and salvation but only the certainty of death and eternal despair.

Formally, this trio both ends the upward movement of the eye and brings it down again into the gates and to *The Thinker*. The figures reinforce and strengthen the central axis of the portal against the shifting movement of the sculptural groups on either side. Their squared-off silhouette reiterates that of the doorway's frame. The extended left arms of this trio point outward and down, but not to the entrance of hell; strictly speaking there is neither an explicit entrance to hell nor, in the absence of *Adam* and *Eve*, a beginning or end to Rodin's epic. The cutting away of a portion of the topmost cornice, just below the central figure of *The Shades*, was done not to suggest a physical entry but to permit the viewer at ground level to see the full length of this form (Fig. 150). This is only one of several instances in which Rodin chose to preserve the line of a sculpture rather than that of the architecture. And by continuing and crisscrossing the thorn vine along the entire entablature, he made it clear that the break in the cornice was not meant to suggest an entrance to hell: indeed, in the center the vine serves as a barrier to passage.

How much Rodin relied upon artistic intuition in the designing of the architectural elements is apparent in the irregular spacing of the four inverted consoles or brackets that serve visually but not structurally to connect the top of the tympanum with the top of the doorway. Below the two brackets on the left are segments of two short flat moldings, and the subtle thickening of the cornice at this point seems to provide the necessary visual cushioning between the line of heads below and the hingelike elements above. The topmost cornice, interrupted by the cut-away center and the upper section of the brackets, is neither continuous nor consistent in design. It is always possible that these inconsistencies were intended to be only temporary, providing the artist with alternatives while he pondered his final choices. From what we know of Rodin's work with the figure in sculpture, however, it seems likely that for strongly held aesthetic reasons he was rejecting predictable regularity.

Rodin displayed a strong rhythmic sense in the design of the portal's structure. Starting with *Adam* and *Eve*, then *The Thinker*, and finally *The Shades*, he set out his biggest free-standing figures in a simple 2–1–3 sequence. This asymmetrical ascending sequence of accents is then developed downward in the passage from *The Three Shades* to the four brackets (between which weaves a double vine), to the two corner figural compositions separated by a single horizontal line of heads, and ending in the forward-projecting form of *The Thinker* at the center. The line of heads, seemingly without number, is repeated in the even less regularly aligned and numerous bodies of the frieze below. Both sequences are worked into the overall rhythmic pattern of the entire entablature, from the horizontal line of the lintel that runs under the feet of *The Thinker* to that of the bent necks of *The Three Shades*. These lateral sequences of architecture and sculpture are not obviously predictable and neatly layered, but are staggered and overlap. There is not one absolutely true horizontal or vertical line in the whole work. Warping was

accepted when it occurred by accident, as when the weight of *The Shades* bowed the cornice downward at the center, and elsewhere it was calculated for expressiveness rather than ideal beauty. One of Rodin's means of harmonizing sculpture and architecture was by making sculptural architecture, rather than the reverse as his critics such as Bourdelle wanted him to do. Rodin's architectural "distortions" served to break down architecture's independence from sculpture in the name of achieving greater visual interest and stricter overall unity.

From the three-quarter views of the entablature (Figs. 152, 153), one gets a sense of the vigorous movement—in, out, and in—of the entablature, a profiling that when found in the figure Rodin referred to as the "console" form, and that in this section of the portal can be seen as miniaturized by the inverted brackets, or architectural consoles. (This architectural element Rodin saw as inspired by the human form and he even demonstrated the analogy in a drawing, Fig. 192).[2] Crucial to Rodin's imparting of intense life and drama to his sculptures, by his own reckoning, was exaggeration. In terms of architecture this is manifest in the extraordinary size and forward projection of the tympanum's side moldings. They are almost a double flight of moldings, which have been cut back in a stepped arrangement that emphasizes the vigorous forward extension and lines up their edges in an implied plane with the head of *The Thinker*. Seen at this height and angle, the forward thrust of the tympanum itself complements the forward projection of *The Thinker*, who extends beyond its frontal limit. At this height, too, one can fully appreciate Rodin's decorative inventiveness and boldness, which are nowhere in the doors more apparent than in his treatment of the outer left side of the tympanum. The outermost molding terminates in the wings of an angel, the edge of the upper molding moves to the main body of the doors in a sweep of drapery, and the background of the truncated moldings becomes the downward serpentine pattern of *The Fallen Caryatid* and the angel, which in turn is prolonged by the use of a gigantic twisting leaf similar to the leaves in late medieval architectural decoration (Fig. 193).[3]

With almost a freehand drawing gesture, Rodin looped a large metallic band over the form of *The Fallen Caryatid*. Looking at both corners of the entablature, we can see that what Rodin created were asymmetrical sets of ba-

Fig. 192. Drawing of a nude woman's silhouette seen as the profile of a cornice, 1900–1910. Pencil. Musée Rodin. Photo Bill Schaefer.

roquelike giant hinge or bracket forms that were made pliant to sculptural needs with respect to the figures he inserted next to or within them. Because the figures in the two corners would not be the same, he did not make the brackets symmetrical. Similarly, Rodin read the capitals (below the corner figures) in terms of how they would best be integrated with the sculptures, and consequently modeled over their architectural designs. Thus the architecture came to be bent, curved, cut, and shaped to harmonize with the sculpture.

Given the advantages of the height from which these photographs were taken, we can see that it would have been both undesirable and impossible after 1900 for Rodin to have made the architectural frame of *The Gates of Hell* perfectly symmetrical in elevation, continuous in its lines and consistent in its paired elements. To have done so would have required drastic changes in the sculptures, a reversal of importance in their relationship to the architecture that there is no evidence Rodin had been converted to.

In the photograph taken from the right side of the door, we can see, like one of Redon's flowering heads, the anguished head of a man framed by large leaves (Fig. 153). It would have been immediately recognizable to those who knew Rodin's art as the severed head of *John the Baptist*, a work that Rodin had done in bronze and marble. Was Rodin consigning The Baptist to hell? Those who knew Rodin's art well were also aware that he often changed the titles of his sculptures. Thus freed from permanent specific identities, his favorite heads, bodies, and hands made many different appearances in his art and played different roles. In those countless hours during which he pondered the portal, Rodin was doing what he did when he paired his plaster figures. Oblivious of their past associations, he was looking for fresh and surprising chance unions, and in the case of *The Gates*, unions that would contribute to the thematic tone and animation of the architectural setting. Thus what we see here is simply a male head of sorrow.

In 1887, according to Bartlett, the upper left-hand corner of the portal was occupied by a *Mother and Child*. (This may have been a work Rodin called *Jeune mère à la grotte*.) The figure we see there today (Fig. 154), partly concealed by heavy drapery, was one of the earliest made for the doors and one of the first exhibited separately. Known as

Fig. 193. Late medieval foliate ornament. Saintes, Charente-Maritime, Archeological Museum.

The Fallen Caryatid, it was greatly admired by Rodin's critics, and he remade it in different materials and sizes. It is conceivable that it may not have found a permanent home in the portal until 1899–1900. Even though this crouching figure carries an urn or block on her left shoulder when seen by herself, in the doors Rodin felt that she did not carry enough visual weight to anchor the upper left-hand section, and this is probably why the drapery and scroll were added. Without the drapery, there would have been too large a "hole" made by shadows, and the broad planes of the cloth provide a larger light-reflecting surface. On the upper right, the counterpart to *The Fallen Caryatid* is the couple known as *The Damned Women* (or *Metamorphoses of Ovid*) (Fig. 155). This couple was made in the round, and when it came time to insert them in the doors, Rodin rotated the pair until he found the most effective viewpoint. That which he chose hides the second lover, but presents the back of the woman nearest to us as a large reflecting plane of light. From the niche of these lesbian lovers issues a barren thorn vine, and it is fair to assume that Rodin was very much aware of the symbolism (Figs. 156–59).

As we can tell from an old lithograph, the thorn vine was originally a heavy rope that Rodin twisted in an irregular design across the top, causing it to pass between, seemingly behind, and even in front of the consoles (Fig. 135). The use and conjunction of both twisted ropes and vines to decorate the frame of an entrance can be seen in late medieval art, notably in the Tomb of Margaret of Austria in the church of Brou at Bourg-en-Bresse.[4] (Rodin, who explored medieval churches all over France, may well have seen this specific example.) When he came to model over the rope and reworked the consoles, he made adjustments so that the vine would not pass in front of the second bracket from the right, to which he had added a standing nude (Fig. 158). It also appears that he remade the center section into a more obvious crossover of the vine, just below the middle figure of *The Shades* directly above (Fig. 157).

During his years as an architectural decorator in Belgium, Rodin often designed caryatids that supported balconies of Brussels apartment houses on the Boulevard Anspach.[5] Three of the figures attached to the brackets (extreme left, and second from the right) resemble caryatids by their upright postures and what could be con-

strued as supporting arm gestures (Figs. 156, 158). Except for the perfectly erect males, all the figures on the brackets are repeated from those in the doors below, most noticeably the seated man seen from the back (Fig. 157). Just at the feet of *The Shade* on the left (Fig. 157) a woman tries to scramble up and out of the gateway—not in apparent desperation but gracefully. Altogether, these small figures and the foliate motifs on the brackets are decidedly playful in feeling. No two brackets are alike in decoration or details of molding, and the presence of figures on the outer vertical edges of the brackets (only two are bare) softens the severity of their profiles.

Bartlett's lithograph, made before 1887, does not show a row of heads above that of *The Thinker*. From accounts by visitors written before 1887, it seems that there were at one time rows of masks at the top of the two door panels, but we cannot be certain that these were the same heads that are now on the cornice of the tympanum; possibly they were simply moved, probably in 1899 or 1900. Unlike the framing heads on Romanesque portals, the heads above *The Thinker* are not tied to any architectural axes in their orientation. They seem to grow out of the cornice in a random way (Figs. 156–59). Their tight proximity to one another carries with it no sign of mutual awareness or discourse. They are like a rosary of suffering. Most are mute, but there are occasional cries and signs of anguish. The interspersing of skulls between the heads, too animated or natural to be masks, prefaces the mixed company in the tympanum below. In that same spirit, and anchoring the misshapen cornice of heads at the far right, is the face of the older *Man with a Broken Nose* (Fig. 159).

When we take in the entablature as a whole, the vines become a crown of thorns, not just for *The Thinker* but for all the nameless souls who line the cornice above his head. We will never know for certain if Rodin deliberately assigned this tragic attribute of the crucified Christ to suffering humanity as part of his humanizing of man's fate.

The tympanum, made in the years between 1881 and 1884, was for writers in that decade quite simply the arrival and judgment of the damned in hell. As is plain to see from any viewpoint, there is a decided sweep of the figures from the upper left that continues behind *The Thinker*, then decelerates and slowly spirals back on itself and downward to the lower right (Figs. 160–67). It is also clear

that this frenetic crowd scene takes place behind and apart from *The Thinker*. His completely human body and physical detachment from the mob discount his role as being that of the infernal juror, Minos. Nor is *The Thinker* a literal eyewitness to the tragic spectacle all around and below him. As the artist, he is its re-creator by means of his imagination. If *The Thinker* is a judge, he has been presented with a case whose prior verdict he realizes he cannot reverse. That may be his decision. If he too is a victim, it is as a passionate pursuer of the unattainable in art. What most dramatically sets *The Thinker* apart from all others in *The Gates of Hell* is that he alone is shown in the act of striving with all his being to use his intelligence.

The unreasoning crowd takes no notice of the meditating man. Behind his back is an otherwise self-absorbed woman whose extended left hand makes the sign of an inverted benediction (Fig. 164). This gesture overlaps the thigh of a winged figure who tumbles in the direction of the downwardly directed fingers. Also behind *The Thinker*, as if sprung from the rock on which he sits, is the figure known as *The Crouching Woman* (Fig. 162). Her close proximity to the artist serves also as a connection with the unquiet throng and encourages the idea that what we see in the tympanum comes from *The Thinker*'s imagination. Within a decade, Edvard Munch, who admired Rodin and took considerable inspiration from his art, was to do a series of pictures of individuals in distress in which what is seen behind the disturbed foreground figure is what is in his brain. Even though there is no record of Munch's having visited Rodin's studio during work on *The Gates*, he could have seen reproductions of the tympanum in the press.

And the tympanum's crowd that photographs allow us to see so fully and clearly? Is it simply a group of impatient would-be passengers waiting for a tardy Stygian boatman? It cannot be those risen from the graves by the trumpet call of the Last Judgment, for there are skeletons in its midst, and they have no one-way ticket for Charon. Arthur Symons, who saw the tympanum in 1892, called it a "Dance of Death," and he may have come closest to Rodin's intention, for it is a meeting of the living and the dead as in the medieval treatment of a theme Rodin must have known by heart. In the midst of the crowd at the right, figures beckon in our direction: the older *Man with a Broken Nose*, and the only horned figure in the entire portal (Fig. 166). Yelling in our direction, the horned fig-

ure rises out of the crowd, the forefinger of his right hand pointing upward and the palm of his extended left hand downturned. This demon doesn't punish, nor is he an infernal usher, but he contributes to the bedlam. Perhaps he is recounting the past or foretelling the future, or, as in older art, he may be an interlocutor who invites us to join the action.

The tympanum is the only area in the doors in which Rodin started out with a pre-formed space, to which he adapted the scale and movement of his figures. It is also the area that has the greatest concentration of figures in the round. Rodin's treatment of the back wall of the tympanum recalls the ancient reliefs, such as that on the Parthenon: to achieve greater visibility from below, the upper portion of the wall projects forward beyond the lower area (Fig. 165). Not only do figures sweep laterally from the left across the tympanum, but at the right Rodin has made it seem as if others are pressing forward so that the two groups collide (Figs. 166, 167). At no point do the figures move in unison, as in medieval Last Judgments. The movement spills and tumbles, almost as a single figure, from left to right, and on the extreme right five women in a sequence like one figure slump to the ground in successive stages. This section of *The Gates* perhaps best exemplifies Rodin's intention of getting all that was possible from movement.

In the upper right-hand corner of the tympanum, resting on a ledge, is the prostrate form of a woman (Fig. 167). She has no physical or psychological relationship to those below, and her placement puts her apart from the illusion Rodin had built up in that whole area. The ledge on which her form rests is the upper frame for the frieze at the rear of the tympanum, and Rodin seems to have been constitutionally incapable of having an uninterrupted architectural element. But by "shelving" this horizontal figure, Rodin makes the work turn back on itself and draws our attention to the discontinuity of physical action and illusion, and to the fact that this is a work being done for his pleasure, which includes caprice.

The tympanum was made apart from the doors. Rodin thus worked on it in such a way that he could see it at eye level as well as from below. The deep recession of the boxlike form meant that when viewed from below it would be impossible to see the entire tableau. The great overhanging cornice would throw long and deep shadows over the figures with the rare exception of when the sun

was low and full on the portal. Rodin had to be aware of this. But he was also aware of historical precedents, in which entire sculptural programs could not be easily or distinctly seen because of their altitude in a structure, notably in the Gothic cathedrals. Rodin never visited Greece, but he could have studied plaster casts and known of the partial visibility of the Parthenon frieze, high up on the cella walls, shaded by the roof, and partly blocked by the columns when viewed from the ground outside the temple. Only today can we see with clarity and detail all of the Parthenon frieze that has survived, or, thanks to photography, the sculptures in the upper reaches of the cathedrals. In the past, there seems to have been no criticism of the sculptors for such relative visual inaccessibility, and they themselves may have rationalized what they did on the grounds that their work was a gift to the gods who were the ultimate audience. It is interesting that a few of Rodin's contemporaries likened the doors to the Parthenon's Panathenaic or Panhellenic frieze, and none criticized Rodin for the difficulty they must have had in reading the entire composition. It is not hard to imagine that Rodin became completely absorbed in creating a world and may have been unconcerned about complete legibility of the whole from ground level. However, when the tympanum was made, Rodin had every expectation that it would go with a new museum building and be seen by the public. He was not, in other words, aware that *The Gates* in his lifetime would not be bronze cast and that the great work could be done with no thought of its commissioners and public purpose. As Rodin did not intend a continuous narrative, a systematic program or method of classification, he may well have viewed his emerging portal as being above all a poetic and expressively decorative object. It would be something to be studied and enjoyed for its art of forms under light and shadow, whose durability and wonder depended upon its richness and daily cycle of revelation and concealment.

Several of the commentators saw the left external relief as representing Dante's Limbo, where the pre-Christian sinners were located (Figs. 168, 169, 170). (The presence of a centaur did not seem incongruous to such an interpretation.) What encouraged this identification is the presence of infants in the lower half of the relief, one of whom is actually outside the area and around the corner of the door, while another climbs out of its mother's arms. In the years before 1880, and even after working as a dec-

orator, Rodin had modeled for decorative purposes a large number of infants. From Rodin's viewpoint, the presence of the children, alone or with a mother, could have signified not just that they were unbaptized but also that they were the innocent victims of fractured families.

That this relief was also interpreted by some as evoking Dante's Circle of Lovers may be explained by the three couples, including one of a centaur and a woman, found in the upper half (Fig. 168). From old photographs that show this portion of the doors before 1900, it appears that Rodin made this vertical relief in two parts, and they were divided at a point just below the third couple from the top. Originally the top of the bottom half contained a crouching nude woman who seems to have been eliminated when the two halves were joined.[6] The lower section showing the mother with infant and the old and young women is directly related to reliefs Rodin did for vase decorations at the Sèvres porcelain factory sometime between 1878 and 1882.[7] Which came first is not clear. The conjoining of the two women whose physical disparity owing to age is so marked does not seem a likely subject to have originated in a decorative Sèvres vase; it could just as well have come first in Rodin's work on *The Gates*. The figure of the old woman, in a radically different pose, is found in Rodin's free-standing sculpture given such titles as *The Old Woman*, *Winter*, and *She Who Was the Helmet Maker's Once Beautiful Wife*, after a poem by François Villon (Fig. 194). The subject for the relief sculpture was reportedly the mother of one of the models used by Rodin's assistant, Jules Desbois, who having once been a model herself, consented to pose for both sculptors. (Desbois's version of the old woman is in the Musée Rodin.) From a surviving vertically truncated plaster it seems clear that with some, if not all, of the relief figures, but notably that of *The Old Woman*, Rodin modeled them in the round. Then, in order to insert the figure into the doors, but depending upon how high or low he wanted the relief of the figure to be, he would cut away what was not needed (Fig. 195). This was how he was able to have so many gradations of relief, which was one of his objectives for the portal as a whole.

Although writers sometimes described the background of the relief as being vapor, mud, or some other substance appropriate to hell, seen close up the rough surfaces do not constitute anything so specific. They are simply introduced to give the figures a nondescript but artistically

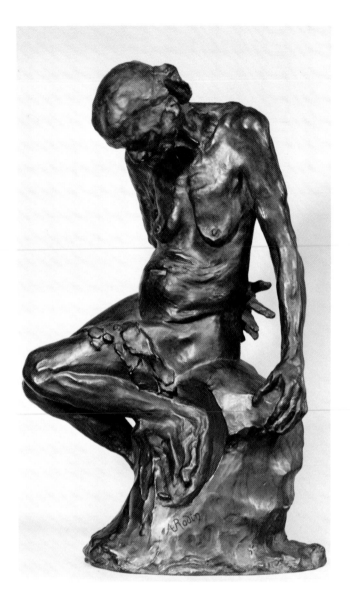

Fig. 194. *The Old Woman*, 1884. Stanford University Art Museum, gift of B. G. Cantor.

Fig. 195. Plaster version of *The Old Woman*, part of which has been cut away for use in a relief. Musée Rodin, Meudon. Photo the author.

Fig. 196. *Meditation Without Arms*, c. 1884. Plaster. Musée Rodin, Meudon. (The full version of this figure can be seen in the corner of the right side of the tympanum, Fig. 167.)

Fig. 197. Transfer print of a man holding a woman, which relates to the second couple from the bottom of the right external bas-relief (Fig. 174). Musée Rodin. Photo Bruno Jarret.

supportive context that is in some places a subdued contrast to and in others an enhancement of the modeling and movement. The absence of any presumption of architecture's independence is strongly demonstrated by the way the figures and their roughly modeled background inconsistently remain within the decorative moldings that normally would limit the area for the relief. Not unlike Romanesque sculptors, Rodin let the sculptures establish the limits of their field. Again, in his lifetime there were no recorded criticisms of this practice, and in fact, as we have seen, Bartlett went out of his way to say how much the side reliefs were praised by those who saw them for their color and line.

A three-quarter view of the base of the left side of the doors shows where Rodin cut away the vertical molding that divides the side relief from the left central door panel (Fig. 170). The moldings are Gothic, while the horizontal moldings of the base seem more like those of the Renaissance. Although of less vigor and range, the profile of the horizontal moldings of the base is a quiet counterpoint to the contours of the relief sculpture. Views of the doors such as this evoke comparisons with Rodin's editing of his partial figures, notably that of *Meditation*, which came from the tympanum (Fig. 196).

In some ways the right relief (Figs. 171–74) is more interesting than the left, notably in its topmost portion. There Rodin was very conscious of using his figures to effect a transition from the extreme frontal projection of the tympanum to the set-back surface of the sculptured pilaster. Accordingly he used the device of stacking motifs, with no pretense of intertwining and overlap. Seen on her side, a crouching angel, whose wings are pressed against and follow the tympanum's external molding, is set above the couple titled after Baudelaire's poem, *I Am Beautiful* (Fig. 172). Seen from the right side, the relief shows a sculptural line that starts with *The Thinker* and runs through the angel and the lovers below it to end in the legs of the man. (This sequence is not visible from ground level, but standing on his scaffolding, Rodin would have seen and realized its potential.)

As much as its flanking counterpart, the right bas-relief discourages sequential reading and it may be scanned top to bottom or the reverse without change of meaning. The connecting line between the figures is aesthetic, not narrative. That this section of the doors caused conflicting interpretations as to whether it was Dante's Limbo or the

Circle of Lovers was obviously caused by the coexistence of mothers, children, and couples. With the paired lovers the message is simply that of their ultimate incompatibility, or the futility of attempting a permanent carnal union. The lower two couples in particular show Rodin's gift for finding or inventing fresh and compelling gestures and postures for motifs of despair (Fig. 174). Rodin was being honest when he told Bartlett that he worked from life, and he was also being truthful when he told Bartlett that he followed his imagination. The postures and attitudes of his couples were not in the repertory of professional models, who mostly depended upon those in older art, nor were they accidentally struck by talented models improvising. They were probably visualized by the artist, who then posed his models accordingly, and they also resulted from the fortuitous encounter of independently made figures such as those of *I Am Beautiful*. There are drawings that have much in common with the two couples at the bottom of the right relief, and at least one drawing exists that shows Satan in the same pose with a woman as the lowermost couple (Fig. 197).[8] One cannot be certain, however, that the drawings preceded the sculpture. It was not uncommon, as we know from Rodin's drawings made for Baudelaire's *Les Fleurs du Mal*, that they were made from sculptures.

When Bartlett likened the portal to a perpendicular section of hell, he was probably thinking of the central door panels (Fig. 175), where figures are seen moving in almost every direction, twisting, turning, falling, without any orientation to gravity or a common ground. In their form before the final changes these two panels probably did not have as many figures, nor as deep a space. As noted earlier, from descriptions it is known that Rodin had divided each door into three zones, those of the upper and lower reliefs separated by a few major groups, notably the original form of *The Kiss* on the left, and the *Ugolino* group and *The Three Sirens* on the right. It still is not clear what caused him to remove the double line of masks at the top and the ones with the centaurs and tragic masks below. The changes must certainly have enlarged and opened up the space and allowed the introduction of many more figures in varied and strenuous movement, achieving what seemed more like a world unto itself. Rodin did not use the architectural borders as picture frames, through which we seem to look into depth, as he repeatedly attached figures to the moldings in an assortment of

ingenious ways. By this means the work loses consistency of illusion and is more self-consciously a work of art. Rodin was doing to hell itself and illusion what nineteenth-century poets and writers had done to medieval hell, using it as a metaphor rather than as dogma.

As we see them today, the doors do not open. By 1887, Rodin would have known that they did not have to serve a practical function in connection with a proposed new building. Thus unencumbered by practical considerations, he could work with the architectural borders of the central panels in terms of sculpture. Apart from the dramatic figure hanging from the floor of the tympanum just below and to the left of *The Thinker*, Rodin did not make significant inroads into the architectural moldings. An exception, found only on the fifth bronze cast of the doors, is in the upper left-hand corner of the left door panel, where a small standing nude figure, such as is repeated in the upper entablature, is shown on a shelf (Figs. 168, 176). Why this sculpture was omitted from the previous four casts is not known, for it appears, on its shelf, in the 1917 plaster (Fig. 77). According to foundrymen consulted both at the old Alexis Rudier foundry and at the Fondation Coubertin, just a few adjustments by Rodin would have been needed to allow the portals to open inward.

The upper areas of the central doors (Figs. 176–82) convey a strong sense of a deep space, tangible places, and tumultuous action. The improvisation here is highly visible. Rodin did not treat this section as he had the tympanum, which had a preexisting rationalized or boxlike stage space. Instead, he made it a series of spaces of differing magnitudes that merge imperceptibly. They are evoked by the sculptures and their changing sizes that confound any attempt to read a logical progression of figural scale as the forms move toward us or away from us (Figs. 178, 179). It is not hard to explain how these scale discrepancies came about. Rodin made most of his figures in different sizes and separately from the doors. He then tried them in the portal. When he had found their appropriate location, he did not remake the figures in sizes that would have submitted them to a fixed point of view of the beholder below (Figs. 176, 177). This cannot be attributed to negligence or laziness, since Rodin had ample time to study the effect of what he had achieved and his assistants could easily have enlarged or reduced individual figures as they did all the time for work exhibited apart from the doors.

By no means can these upper areas be called pictorial space, and they have no counterpart in any painting since the Renaissance, up to and including contemporary art of the late nineteenth century. (Such painting was determined by different perspective systems that presumed that the spectator was outside the painting.) Rodin did not set up and solve problems that he took from painters. His were new problems derived from unique explorations of what could constitute modern decorative sculpture. One can speculate that having first modeled low relief figures literally out of the background planes, and then having attached the smaller figures in the round to the door panels, he decided that he needed more action involving three-dimensional figures moving in space, and that he also wanted to continue the sculpture onto the lintel, or bottom of the tympanum. He could have then added the larger figures, like that of the man clinging to the lintel at the left (Fig. 176), from his repertory that we know populated the floor, tables, and shelves and even hung from the walls of his studio. The upside-down man with outstretched arms at right center just below *The Thinker* (Fig. 177) appears once only and could have been made specifically for this location. The larger figures that project out from the doors and are practically in the round could have served the function of bringing light into otherwise large areas of deep shadow.

The background of the upper part of the doors shows the variety of ways Rodin related his figures to the surface. Just as there is an inconsistency or shifting scale to the space, so too does the background change from hard to soft, smooth to rough, tangible to intangible. It is adapted to the form and nature of the figures, rather than the reverse. Like the space, the ground is made pliable to Rodin's thought. In the upper right-hand corner of the right door, for example, one can see part of a man's face taking form from or merging with the swirling background (Fig. 180). In the upper left door, just below the falling angel, a group of figures are caught in the coils of a gigantic serpent, evoking memories of Dante, but just to the right of them is a rectangular slab that probably served Rodin as an un-medieval light reflector (Fig. 178).

In these upper regions there is a strong counterpoint involving dramas of places as well as persons. Unlike illustrators of Dante's hell, such as Gustave Doré, Rodin avoided literally describing physical surroundings of the damned as detailed in the poem. Although more easily

seen in the plaster version of the portal without many of its figures, in the bronze cast it is still apparent that Rodin exuberantly improvised his background, creating big sweeps of curving planes of clay, occasionally punctuated by largely unmodeled flat slabs and roughly textured sections. They remind us of how Rodin's dictum that sculpture is the art of the hole and the lump can apply to abstract sculpture. The figures grow out of, spring from, or sink into this malleable background that was shaped to serve their movement. To have asked of Rodin that he be a systematic narrator, that he organize his space and background more rationally and descriptively, would have been like asking him to change his identity, renounce his genius, and become a second Jules Dalou. The way he was, he received greater acceptance by his contemporaries than by many today, who, despite all that has since happened in modern art, still want to see Rodin as a conventional illustrator and sculptor.

By the size and drama of the large figural groups, and by the design of the lower section of the doors, the viewer is drawn into and under *The Gates*. In the left door Rodin joined the different groups in a big roughly oval composition with *Ugolino* at the top and the figure of *Fortune* holding a wheel in her right hand recumbent on a tomb (Fig. 183). To effect this composition Rodin used the large shallowly concave forms of the drapery over the tomb and the diagonal and convex edges of background planes surrounding the *Ugolino* group. In the right door panel it is again the sweep of ground planes continued by drapery over the tomb that is the most obvious connective uniting groups that here swirl around a largely empty central area at the bottom of the door panel.

In the lowest zones the left door seems overweighted in terms of the density of sculptural motifs, but as one moves up the doors this relationship shifts (Fig. 175). Above *Ugolino* there is a large empty space, while to the right a cluster of figures takes form and pulls our attention in that direction. This shifting equilibrium that crisscrosses the central vertical molding continues to the top of the portal.

One should read the lower sections of the two doors together, as one zone, to see how they are related compositionally. *The Three Sirens*, just to the upper left of the *Ugolino* group, are at the apex of a right-angled triangle, whose hypotenuse runs diagonally downward, ending to

the right of the tomb in the right door panel (Fig. 175). The implied lines of this triangle are made up not only of the figures but also of the background surfaces whose curvature helps lead the eye from one mass or cluster of figures to another. Within each of the two doors, Rodin also made his compositions self-sufficient. That on the left has a rotary motion, and within the oval the major figures move laterally. On the right (Fig. 184), the design has a radial grouping around an empty center, a more open form and upward sweep, the latter being caused by vertical alignment of the figures seen to the left of the tomb and the stretching upward and downward of figures seen to the right. Far from being evidence that Rodin did not finish *The Gates*, the big "empty" planes are crucial both to the drama and to the composition: they set the desolate tone and allow the work to "breathe." If they had been filled, a terrible artistic congestion would have resulted, and the doors would have been formally chaotic. Rodin was no formalist, but neither did he have the horror of composition shared by the French Realist painters. He disliked the predictable machinelike order of his conservative colleagues. That he did not think of artistic order simply as a casual arrangement of works complete in themselves was shown by his rejection of *The Kiss* for the portal on the grounds that it was "too self-enclosed." Further, from close up we can see how the background planes are more often nearer to abstract sculpture than to a topography of hell, and that they are shaped to frame but also connect figural groups. The "empty" spaces serve to catch shadows, thereby emphasizing the relief of the illuminated figures. At other times they reflect sunlight onto them when they might be in shadow. Rodin refused to conform to the conventions of obvious linkage between figures and their submission to a preestablished compositional shape. He let the gestures and movements of whole bodies suggest his compositional patterns. Although not as great a composer, Rodin was as much an individual in his thinking about order as Michelangelo.

Until Rodin introduced the twin tombs in place of the mythological reliefs in 1899–1900, there was nothing to say that this epic was about life after death (Figs. 185, 186). Any doubt about the rectangular forms at the base of the doors being tombs should be put to rest by Rodin's marble sculpture of 1910, *Hand Rising from the Tomb*, in which

the same rectangular form is used for a sepulchre.[9] Having put the tombs into *The Gates*, Rodin then practically concealed the one on the left. He may have been uncertain how he was going to relate the figures to the tombs and decided to treat them as emblems of death and not have the figures interact with them at all. He solved the problem of how to fill the small rectangular areas flanking the bottoms of the tombs by introducing reliefs showing crowds of women and children, a motif that harked back to his vase designs at Sèvres.[10] Unrestricted by Dante's symbolism of the physical depths of hell, he could introduce the maternal theme at the bottom of the doors without concern for the depths of their damnation. They are the wreckage of fractured families. Here again, unrestricted by a fixed viewpoint, Rodin did not worry about discrepancies between the relatively small size of the lowest reliefs and the larger figures immediately above them, only about "color and effect."

The eye-level area of the doors was of course particularly important for Rodin. Here he put some of his strongest conceptions, including *Ugolino and His Children*, and presumably *Paolo and Francesca* (Fig. 183). (Without specific nomination by the artist, one can't be sure of the latter's identification.) In Rodin's lifetime only a few commentators nominated the couple just below the *Ugolino* group for the title of the adulterous lovers. One could see Paolo and Francesca not only in this pair but also in the door at the right in the inverted couple over the tomb (Fig. 186) and to the far right in the corner where they are shown back to back (Fig. 187). This same couple is seen from another orientation above the kneeling man in a cave. The bottom couple of the external right bas-relief is also eligible, as well as the one at its top, and was so interpreted by Bartlett.

Confounding attempts to tie Rodin's figures to Dante's text is the fact that he often repeated the same body part on different figures. The best example is that of the head of the woman clearly visible below the *Ugolino* group (Fig. 183), which by itself Rodin called *The Head of Sorrow*, and its reemployment for the head of Ugolino's dying son who clings to his father's back (Fig. 188). (The latter may have been the first use of this marvelously expressive head that is without specific gender.) The same couple, shown back to back and known separately from the doors

as *Fugitive Love*, is used twice in the lower right door panel and in fairly close proximity to each other (Fig. 184). The upper body and gesture of the right arm of *Fortune* (Fig. 185), who lies across the left tomb, comes from one of the tympanum figures (whose horizontal orientation apart from the portal won her the title *The Martyr*). She can be seen behind *The Crouching Woman* just to the left of *The Thinker* (Fig. 162). The inverted man clutching the woman next to the right tomb is the same figure who clings to the lintel at the top of the left door, and who, at the top of the right relief panel, grasps *The Crouching Woman*. The woman in the arms of the inverted man who overlaps the tomb also appears in the upper left section of the tympanum, just above the kneeling figure with her hands behind her head (Fig. 162). Such repetitions and variations defeat linkage with Dante, but they encourage the thought that *The Gates* give us the infernal wanderings and trials of a single man, woman, and child.

The absence of costume and the dungeon setting where they died also obscures the identification of the *Ugolino* group for those who are unfamiliar with Dante and know nothing of the history of *The Gates*. Certainly at the portal's beginning, Rodin counted on a public that had been schooled in Dante's poem, but from the outset he also wanted sculpture that did not depend upon literature for its meaningfulness and that in the broadest sense would be thematically self-evident.

Once we are pulled into the region close to the doors, and move or look left and right, we have more intimate contact with the many individual dramas of the portal and can see how Rodin's formal families relate to each other in depth. Viewed from any angle, including that from above (Fig. 188), the *Ugolino* and *Paolo and Francesca* groups are powerful and a joy to see against one another. At eye level, just follow the light patterns beginning with those on the drapery below (Figs. 182, 183) and you can see how you are pulled from one group to another in an unobvious but compelling way. Stand to the left and close to *Ugolino*, the only time in the doors that a father is shown with his children, and you will see the moment when hunger had more power than grief, as if written on the father's face (Fig. 189). Bend down and look carefully at *Fortune* and you will find that there is another figure behind her, like a second self (Fig. 185). Move to the right

Fig. 198. *The Sculptor*, c. 1880. Drawing. Location unknown.

door and look into the area behind the jamb (Fig. 187): you will find a grove of living forms, a tiny torso juxtaposed with what seems a gigantic upstretched arm. *The Gates* are generous in surrendering their secrets, and one wonders if ever before there was made such a public work that solicited so much private seeing.

None who wrote about Rodin's gates in the studio before 1899 mention the two reliefs at the base of the doors (Figs. 190, 191). The reliefs appear in photographs of the assembled doors taken in 1900 and perhaps date from that period, that is, from what may have been Rodin's last work on the sculpture. Taken as part of the large rectangular areas at the bottom of the doors and inside the left and right reveals, they seem clearly not to have been adapted to a preexisting field, and we can infer that originally the doors looked quite different in these areas. It appears that Rodin modeled these figures on large flat slabs of clay, set them into the reveals, and then modeled over the existing architectural moldings to accommodate the slabs. Not only are the two flanking moldings different, but the reliefs are joined to the areas above them by a modeled slanting plane rather than by molding.

The reliefs are interesting because, strictly speaking, they are not built up from a flat rear plane. In the relief on the right, the surface seems to have been hollowed out to receive the left arm of the kneeling figure, while the small feminine figure he seems to reach for, or let go of, seems to have been made in the round and then attached to the relief. This is but another example of Rodin's versatility and imagination, a way of making a relief in his personal recapitulation of that sculptural form. While the low positioning of the reliefs, which most viewers miss entirely, may seem odd, recall the placement of the head that was also used for *John the Baptist* and the form of the child that Rodin attached to the outside of the doorway. Rodin was endlessly inventive in breaking the rules and resisting conventionality.

The exact identity of the woman in the left relief is not known. She has been called a Siren, and Eve.[11] What we see is a seated nude, shown in side view with her left thigh drawn up against her torso and her left arm reaching up to some form that looks vaguely like a leafy branch possibly with fruit on it, but with her head turned in our direction. There is no sign of the lower portion of her left leg, though by her upturned left forearm there is what

may be the stump of a once extended leg. It is far from clear that the lower portion of the woman's body terminates in a fish tail or some other reptilian or animal form appropriate to a siren or mermaid. Even for Rodin it would have been unusual to have joined a human and nonhuman form below the knee. It is much more likely that she is Eve, reaching for the apple. Since Rodin knew that the State would not pay for the life-size statue of Eve to stand next to his doors, he may have decided around 1899 to introduce her into the gates anyway just as Adam had been transformed into *The Shades*. It has been suggested that she is looking (over her shoulder) at the figure in the relief on the other side of the doorway, but this seems doubtful because her eyes are only sketchily indicated and there is no evidence of a focused gaze.[12] If anything, she is like other women in *The Gates* who look within themselves—appropriate for Eve, who is in the act of breaking God's commandment.

I agree with Albert Alhadeff in his identification of the naked kneeling male figure as a self-portrait of Rodin, and I also agree with J. Schmoll that this relief was inserted in the doors when they were finished, as the artist's "signature." (I cannot agree with Schmoll that this occurred sometime after 1900.) There is no paradox in having two creators in the doors: *The Thinker* represents the poet, or creators in general, and at all times. The resemblance of the bearded profile of the kneeling man to later photographs of Rodin by Steichen and others is certainly reassuring if one wants to see this relief as a self-portrait of the sculptor. In my first book I read this figure as God, and "The Creator," relegated to an inferior position in Rodin's scheme of things, and I would now amend that view to be that Rodin shows himself as a godlike artist: not shown actually working, but cogitating, in the manner of *The Thinker*. The presence of the small feminine figure may have been intended to suggest a muse, or a figure that has emanated from the artist's imagination. (There are drawings by Rodin of the sculptor at work as a nude figure with a small nude woman hovering over him; Fig. 198.)[13] Thus in the left relief, Rodin may have been showing the moment that opens his story of endless human suffering, and in the right relief the godlike artist who visualizes for us this tragic history: a biblical beginning and an artistic conclusion; God "fecit," Man "execudit," Rodin "sculpsit."

11

Rodin and His Time

According to Rodin, "A true artist always puts something of his time in his art, and also his soul."[1] The vagueness of Rodin's political and religious ideas, so characterized in his lifetime by friends, makes the relevance of the artist's time to *The Gates* almost as difficult to determine as the spiritual ingredient. Not one contemporary commentator observed any connection between the sculptural program of the doors, for example, and the politics, or their consequences, of the Third Republic: specifically its war with the Catholic Church that took the form of the laic laws enacted in the 1880's that removed the influence of the Church from public education.[2] Common sense, the lessons of the history of art, and the desirability of taking the artist at his word encourage at least reviewing the admittedly modest circumstantial evidence concerning Rodin's political, social, and religious beliefs that could have influenced his decisions with regard to the theme of his portal.

Rodin came to art and began his career under the Second Empire of Louis Napoleon, but there is no evidence that he was either a monarchist or a republican at that time. Unlike Dalou's self-imposed exile in England after the Commune, Rodin's move to Belgium for seven years was for economic rather than political reasons. Presumably Turquet's inquest into Rodin's background and years in Belgium satisfied him that the artist was not a supporter of the monarchist party that had only been supplanted as the dominant force in French government by 1879. Rodin had competed for monuments to the French Republic, and in 1880 the city of Paris gave him the commission for a statue of d'Alembert to go on the northwest corner of the rebuilt facade of the Hôtel de Ville, which had been totally destroyed during the Commune. Rodin did not belong to Freemasonry, some of whose members like Ferry and Gambetta were in the most important positions of political power at the end of the seventies and eighties. When *The Vanquished* was denied the top prize and criticized as a life cast during the Salon of 1877, Rodin is reported to have said, "Until now I believed that in France art was respected, but I see that an artist has to belong to some kind of Freemasonry."[3] Since Jules Ferry, whose Under Secretary of State for Fine Arts helped exonerate Rodin of the charge of casting from life, was a Freemason, perhaps the sculptor changed his views.

No question that Rodin and his art thrived under the Third Republic without his joining this secret society. Not only did he win and accept high honors that included several promotions in the Legion of Honor, but also he was president of several Salon juries. The State acquired eighteen of his sculptures, admittedly with far more honor than financial profit to Rodin, and in 1916 the Chamber of Deputies accepted his donation of all his art and property in order to establish the Musée Rodin.

Carrying more weight in the case for Rodin's republican sympathies is the fact that many of his friends, champions, and portrait subjects were ardent supporters of the republic. His entrée into the art political world of the Third Republic was through Mme. Edmond Adam's salon, which was crowned by the presence of such Republican leaders as Gambetta and Ferry. Emile Zola presided over the Society of the Fellows of Letters, which commissioned Rodin to do the monument to Balzac. Victor Hugo, Henri

Rochefort, and Georges Clemenceau all impatiently sat for their portraits by Rodin. Four more dedicated republicans would be hard to find. The impatience of the last three at giving time to an artist would not have been overcome if he had been anti-republican.

Assuming that Rodin was a republican, it is also likely that in his own vague way he was a republican socialist. His proposed *Monument to Labor*, conceived in the midnineties, was to be a tribute to the worker. During a time of great unrest among the workers of France, Rodin interpreted *The Thinker* as reflecting on the neglect of the "little people" who provided the country with its energy and productivity.[4] On the other hand, he was opposed to the child labor laws passed after the turn of the century not because he was indifferent to the abuses of children by industrialists but because he saw these laws as ending the apprentice system in art, which he believed to be the essential foundation for the education of artists. Rodin's self-image was always that of a worker, and when he achieved financial success, he lived like a worker with money.

Anti-Clericalism, the Church, and Religion

When we remember the pessimism of *The Gates*, we wonder what in Rodin's time and political environment could have been its source. Like many who were sympathetic with the Republic, Rodin gives some evidence of not having been wholeheartedly in favor of all that was done, especially in the anticlericalism and the secularization of education undertaken by the State. After 1903, when the French government disbanded the religious sects, Rodin told his English secretary, Anthony Ludovici, of his doubts about the consequences of this action:

The condition of the Church of France was a source of grave anxiety to Rodin who deplored the abolition of religious societies which deprived poor children of the teaching afforded them by these institutions. He believed that the young and illiterate of all nations require dogma, and that the art underlying the ritual of the Holy Catholic Church had a refining influence upon the mind of all classes. He regarded the steady decline of the Church of France as a distressing sign of the times.[5]

It is hard to see Rodin in 1880 believing that the young required dogma, unless it was to be something to react against as they matured, but it is easy to see his then having admiration for religious art in view of his devotion to

medieval art and architecture. This statement of concern also shows Rodin's lack of awareness that the Church had been setting up private parochial schools long before. As many historians of religion in France have pointed out, the second half of the nineteenth century saw the rechristianizing of the middle class and the dechristianizing of the working class, with which Rodin identified.[6] But even if Rodin's statement reflects attitudes that changed after 1880, when he began work on the portal, what seems relevant to the earlier period is his concern that the decline of the Church was a distressing sign of the times and resulted in considerable spiritual cost to his society. Ironically, Rodin's imagery of a suffering humanity might have appealed to the Freemasons, who wanted to establish humanity as the object of worship rather than God.[7]

Rodin's religious beliefs are as difficult to pin down as his political attitudes. At least once he referred to God as a modeler: "If we can imagine the thought of God in creating the world, he thought first of all of modeling, which is the unique principle of nature."[8] The single most telling statement by the artist with regard to his religious beliefs was made before 1911 to Paul Gsell and published in their conversations titled *L'Art*:

If one means by religious a man adhering to certain practices, who bows before certain dogmas, evidently I am not religious. Who is still in our age? But in my opinion, religion is something else beside the babbling of a credo. It is the feeling for all that is unexplainable or unexplained in the world. It is the adoration of the unknown force that maintains universal laws and preserves the types of beings; it is the suspicion that all that is in nature is not manifest to our senses, and that there is a great domain of things that neither our eye nor spirit is capable of seeing; it is also the longing of our conscience for an infinite, for eternity, a longing directed toward knowledge, and love without limits, perhaps illusory promises, but which in this life make our thought vibrate as if it had wings. In this last sense I am religious.[9]

Ludovici had no doubt whatsoever about Rodin's essentially religious makeup:

Rodin's great reverence for nature, and his keen appreciation of the "all-pervading domain of mystery which is everywhere under our feet and among our hands," formed the basis of his religious convictions; for the fact that he was a profoundly religious man may be gathered from his very works themselves. Such pieces as The Creation of Man, The Hand of God, and The Creation of Woman bear sufficiently eloquent testimony of his pious spirit. . . . The Bible, too, was one of his favorite

livres de chevet and he delighted in expounding his own subtle interpretations of many of its passages. "How foolish people must be not to see the truth of this book!" he often declared. "Its pages teem with morals that are perennially modern!"[10]

Camille Mauclair, Rodin's older friend, said much the same thing but more succinctly: "The symbolism and philosophy of the artist are independent of all religious doctrine; his ardent spiritualism excels in disengaging the symbols of diverse cults, and he is sustained above all by a profound and incessant consultation of nature [and] an exceptional sense of expression by movement."[11]

When Rodin's sister died in 1862 and he sought solace and a new vocation, the twenty-two-year-old Rodin turned to one of the many newly formed Catholic sects, the Fathers of the Very Holy Sacrament. It was not his decision, but that of the sect's leader, according to Rodin's most important biographer, that he leave the order to pursue the life of an artist. Without explanation, Judith Cladel then goes on to say: "At that tender age, having lost his formal faith, but remaining, as he said, essentially and profoundly religious, he devoted to Nature the love that familial education had first pushed him to consecrate to God; thereafter, confounding in this love divine work and the Creator, he will often evoke the all-powerful and ingeniously join him with his conceptions of the artist: 'The first thing of which God thought in creating the world was modeling.'"[12]

Obviously during his months with the order, Rodin was exposed to intense religious instruction and dogma, if not the refining influence of religious art. When his passion for making art manifested itself during his novitiate, Rodin made this known to the head of the order.[13] Father Eymard had recognized that Rodin's mind, heart, and aptitudes lay with art; he had provided the young novice with a shed to work in, and Rodin had modeled his portrait. Just when, why, and how Rodin became the "rebel" against religious authority, Cladel does not say. What appears to have been his possible late reconversion to religion, as suggested by the large bare crucifix that stood in his bedroom at Meudon when he died, was common to many French intellectuals and artists, just as was his aesthetic admiration for the mass.

When in 1894 Rodin made his moving and daring image of *The Crucified Christ Comforted by Mary Magdalene*, it was as a spiritual self-portrait during a time of great personal crisis involving his art and his relationship with his mistress, Camille Claudel.[14] Rodin also identified the crucified figure as Prometheus, and the consoling woman was referred to as an ocean spirit. Otherwise, with rare exceptions, Christ does not appear in Rodin's art, writings, or recorded conversations.[15] From the moment Rodin placed *The Thinker* in the center of the tympanum of *The Gates*, this passionate student of the Gothic cathedrals could hardly have been unaware that he was figuratively replacing Christ with man in the seat of judgment. It is the suffering of humanity rather than that of the Savior that Rodin expresses in his epic as a whole. We are still left with the question of just what were the influences on Rodin that caused him to create a monument to human suffering.

Before 1880, Rodin had done only a few sculptures that showed an individual in emotional distress, but these few are important. One of the first may have been the seated figure of *Ugolino*, done after Rodin returned from Italy and proof of his deep involvement with Dante's *Inferno* at least four years before the portal was commissioned. The second, which was begun before and overlaps the seated *Ugolino*, is *The Vanquished*, in which Rodin's wounded warrior expresses the despair of the youth of France incurred by war. The third example is that of the mortally wounded warrior of *The Defense*. While making decorative art in the 1870's in order to support himself, as Ruth Butler has pointed out, Rodin would have seen in the sculpture salons that the important sculptors of the day were treating serious themes that depicted the suffering secular heroes and heroines from literature and war, motifs not so favored during the Second Empire.[16] It was thus the example of a national tragedy and the response to it of French salon sculptors that encouraged Rodin to turn in to emotional themes that were connate with his serious nature.

Possible Artistic Influences

In the 1870's many French sculptors showed a decided interest in Florentine sculpture of the fifteenth century, and this would not have gone unnoticed by Rodin. Encouraged also by developments in his own art that seemed to have brought him close to Michelangelo, he sought out these Renaissance exemplars. It is also reasonable to assume that after being in Italy and seeing Michelangelo's exalted images of heroic as well as suffering figures, Rodin

began to dream of an epic work of his own and to pursue his interest in Dante. This took the form of making a sculpture of one of the most tragic figures in the *Inferno*, Ugolino, and led to a large number of drawings that, as we have seen, showed violent and often self-tortured figures.

Rodin's choice of Dante as the source of his public sculptural epic had enough artistic precedents at the time to make it acceptable to his commissioner. While Rodin was to go beyond his contemporaries—sculptors and painters such as Gustave Doré—in creating a more generalized theme of human suffering, artists like Carpeaux were nevertheless a point of departure and undoubted influence. And so must have been the big canvases of Delacroix and Géricault that Rodin unquestionably studied in the Louvre. Delacroix's *Barque of Dante* with its writhing titanic sinners was a model of modernizing both Dante and Michelangelo. Delacroix's *Massacre at Chios* and Géricault's *Raft of the Medusa* confronted Rodin on an heroic scale with the innocent nameless victims of political tragedies. In the case of Géricault, Rodin had the example of a tragedy in which the artist relied upon the public's familiarity with the painting's title to supply the source and full story of the victims' plight. Whether or not Rodin actually saw Daumier's paintings and reliefs of refugees, again victims of war and political oppression, we cannot be sure. If Rodin's *Gates of Hell* are grandiose, it is because he was following a great nineteenth-century tradition in art and literature. If Rodin was inspired to rival Michelangelo's *Last Judgment*, he had Géricault's *Raft of the Medusa* before his eyes as encouragement. When he determined to personalize Dante's *Inferno* and make it more of his time, he had not only Delacroix but Hugo, Balzac, and Baudelaire from whom to draw courage and inspiration. These artistic precedents are unquestionably part of "the something of his time" to which Rodin was referring and help to account for the tone and scope of the portal's sculpture.

Rodin and the Romanticist Writers and Poets

Rodin's originality as an artist derives in no small part from the fact that culturally he was self-taught. From his writings and those of his biographers, Rodin's self-education in the history of art is already well known. His at-

traction to certain periods and styles of art was encouraged and fortified by his exposure to romanticist writers, notably Victor Hugo. From Rodin's biographers, book receipts that date back to Belgium in the seventies, and his extensive library in the Musée Rodin,[17] we know the artist shared the avidity for self-education that one finds among certain of those who have had little formal education. It was also a symptom of Rodin's obsession with originality that he was not interested in literary criticism or commentary, but preferred to read poets and novelists in the original. Even while he was a student at the Petite Ecole, between the ages of fourteen and seventeen, Cladel records that Rodin "was intoxicated with poetry: Hugo, Musset, Lamartine excited him and inspired in him the desire to read their predecessors—Homer, Virgil, Dante—and from that time, Dante struck his imagination like a hot iron. He attended courses in literature and history at the Collège de France; he read Edgar Quinet and Michelet." Writing of his life in Belgium, Cladel adds, "He was walled in by his thoughts, his pockets were full of books that he read avidly during meals, and even while walking the streets: the need to educate himself had become an obsession."[18] Bartlett noticed the same passion: "Rodin has always been a great reader, not of novels, but of Aeschylus, Dante, Shakespeare and Lamartine. Always carries a book in his pocket."[19] Rodin was never given to trying to impress visitors to his home by his wealth or learning, and the large library he left was not for decoration, but to satisfy his own passion for knowledge.

As Rodin left no written diaries or journals, it is hard to know what he read specifically at what time, or what impressed him sufficiently to shape his thinking about *The Gates*. As an example of this difficulty, in 1905 Camille Mauclair wrote: "It is well to note that Dante, Hugo, Rousseau, Baudelaire, Gluck, and Beethoven are, by the admission of the artist, his greatest source of emotions and daily reference for his thought."[20] Like many who have been poor and treat books with respect, if not reverence, from what I have been able to see in Rodin's extensive library, with rare exceptions, he did not mark passages in his books, though he sometimes drew a sketch in the margin.[21] Occasionally he titled a sculpture after a poem, such as Musset's *Une Nuit de Mai* or some of the poems in *Les Fleurs du Mal* or in Hugo's *Châtiments*. Besides the illustrations he did for Gallimard's copy of *Les Fleurs du*

Mal, he also drew illustrations in some copies of works by Octave Mirbeau and other contemporaries.[22] His friends and admirers after 1880 included many important writers and poets, notably Robert Louis Stevenson, Georges Rodenbach, Rainer Maria Rilke, and Octave Mirbeau, and the sculptor felt comfortable with these contacts.[23] While Rodin had many friends among the artists, he may have felt that in certain ways he had much in common with poets and writers, and this would have included not just attitudes toward art but, just as important, toward life. One is left with the strong sense that such was Rodin's confidence in his own imagination and ability to work from personal experience of life that he did not feel the need to consistently illustrate the authors he read or literally follow their ideas. He was in effect following the example of the writers he admired and in romanticist fashion personalizing his own experience of life in his art. No stronger proof exists than in the relation of *The Gates of Hell* to Dante's *Inferno*.

Although Rodin was born at a time when Romanticism was waning because its values no longer attracted the most gifted younger poets and artists, on the basis of the evidence, he seems to have been most strongly drawn to romanticist poetry and its sources in older authors. He could well have come to *The Divine Comedy* and been drawn to Dante as the source of his *Gates of Hell* because of Dante's powerful influence on so many poets and artists whom Rodin admired.

Rodin's Hell Revisited

Before looking at what was relevant in romanticist poetry to Rodin's view of hell, we must consider as objectively as possible what is and is not shown in *The Gates*. First and foremost, Rodin's netherworld is not a Christian hell. There is no God, no Christ, no saved, and no Satan. (There seems to be only one demon, who is in the tympanum.) Although we know that Rodin originally intended to have the figures of Adam and Eve on either side of the portal, we cannot be absolutely certain that Eve is to be found in the final version of the doors and that Rodin retains a reference to original sin. Assuming that Eve does appear in the lower left reveal of the doors—which would imply the existence of a first cause for Rodin's cosmogony—there is no reference to man's redemption by the

Savior. Nor do *The Gates* have a familiar land- or hellscape in terms of the world as we know it. We can speak of Rodin's hellscape as having a variegated terrain, one that unexpectedly metamorphoses, say, from hard to soft and above all is desolate and sterile. There is a collapsing of topographic distinctions as well as perspectives. There is no rationalized and consistent space overall or spatial sequence as in Dante's netherworld. Given the depths of the portal and its intended placement out of doors, it is not hard to see how Rodin wanted the recessed panels to be largely blanketed by shadows. In short, Rodin's version of an inferno is a place difficult if not impossible to describe or visualize, or to traverse in memory.

Rodin's hell is without Leviathan jaws and a definite entrance. It has tombs but no rotting corpses. The dead are alive. Except for one skeleton and a couple of skulls, the dead are in their own physically healthy bodies. Their faces show that they are often the speaking dead. They are not in repose but rather in constant movement, and unlike those in Dante, the crowds or groups are disorganized. There is no government in Rodin's netherworld. The damned do not suffer from externally applied punishment but from within. Violent movement seems self-initiated. Among the suffering are couples in various phases of love, and it is fair to say that they and many isolated figures seem afflicted by passion or relentless drives. A few figures are alone and simply sit or stand, seemingly doing nothing, or not responding to anything outside themselves. The population includes representatives of all ages, as well as a few creatures of theology (fallen angels), myth (centaurs), and allegory (a fallen figure of Fortune). Rodin's cosmogony has a questionable beginning but certainly no end. There is no intimation of another world outside it. It is as if the world Rodin shows us were eternal. One could even infer that humanity was itself responsible for such a dismal fate.

The Hell of the Poets

In the romanticist poets Rodin would have read numerous speculations on God, but none that retain the image of a personal deity. Alfred de Musset spoke for many of his fellow writers when in his *Confessions of a Child of This Century* his hero, Octave, says, "Thou, son of God, whom men forget, I have not been taught to love thee. . . .

My religion, if I had any, had neither rite nor symbol, and I believed in a God without form, without a cult, and without revelation."[24] Hugo inferred God from his creation, and one senses echoes of this in Rodin's thought. When asked to define God, Hugo answered in a way that would have touched the sculptor: God was "an infinite look into eternal sorrow."[25] For most poets, as well as for Rodin, the image of God is unclear ("I realize that God seems vague," Hugo's *Dieu*), and none of the poets have God intervening in the fate of mankind. In Hugo's words, "God does not judge us."[26] (It was Hugo himself, the orphic poet and political leader, who called his century to judgment.) In *Le Voyage*, Baudelaire saw life as a netherworld controlled by fate. For Hugo fate was demonic. For some poets hell symbolized the locus and price of freedom. For Hugo, men were blind but free to rise or fall. This included descending the great chain of being so that souls might inhabit rocks and trees. (One remembers the Balzac-like face emerging from the background in the upper right door panel of *The Gates*, and arms emerging from mounds, or the woman sinking into the terrain near the right tomb.)

In his pioneering book *The Hour of Our Death*, Philippe Ariès writes: "One notes also the complete disappearance of hell. Even those who believe in the devil limit his power to this world and do not believe in eternal damnation. This will not surprise us; we have already noticed the phenomenon since the beginning of the 19th century."[27] The hell of the romanticist poets, as characterized by John P. Houston and other scholars, was one of Christianity without redemption and original sin without Christ.[28] The traditional Christian view of the world had been rejected by the romanticist poets at the beginning of the last century. Gautier saw Europe as having been invaded by a spiritual darkness. Satan and sin had been secularized. The poets resisted the idea of organized religion, believing that God transcended sectarian boundaries. The netherworld for the modern poets was unlike that of Dante or Milton, being verbally expressible but visually incoherent, a strange chaos that might consist of deserts and oceans, glaciers and mountains, chasms and nothingness. The rare furniture of hell is the tomb in Gautier's *Comédie de la mort* (Comedy of Death): void and desert metaphorized the vacuity or ennui of human existence. The infernal geography is sometimes described as going

through bizarre metamorphosis, as in Hugo's *The End of Satan*. The single most dramatic feature of romanticist hell was the absence of light. Common to their infernal vision, but particularly in Hugo and Baudelaire, was darkness, funereal shadows blanketing the hellscape, where sorrow was queen.

The poets wrote of death's siren call (as in Petrus Borel's "It calls me without cease").[29] The insatiable curiosity about and the appeal of knowing what lay beyond the grave caused Baudelaire and others to imagine their own deaths. Their poems became like variations on Dante's voyage through the Inferno. (For some writers it was the wreckage left by the disbelief in the church.) Those who inhabited the infernal regions might engage in eternal blasphemy and self-love, violence and eroticism (including occasional necrophilia), manifest malaise or fear, spleen and ennui. Failure to find love unites Faust, Don Juan, and Napoleon in Gautier's *Comédie de la mort*. Occasionally this population includes skeletons or foul figures, but for Borel the cruel irony was that after death man was given back the same body in which he had suffered during life. Unlike the early Christian ideal of repose in death, the pessimistic romanticist view of hell supposed perpetual futile movement, agitation without purpose or goal. (This was the romanticists' "horror of movement.") It is hard to imagine Rodin unmoved by reading Gautier's *Ténèbres* (Shadows) and the line, "And when will our passion be finished?" Hell's victims were those who lived the agonies of a dualistic existence, in Baudelairean terms, always experiencing the simultaneous appeals of God and Satan. The artist's professional hell was to experience dreams unrealized by action. Baudelaire longed for release from a world where action was not the sister of dream.

Hugo and Baudelaire were prophetic poets and believed in ultimate reunion with God. Hugo even reunited the devil with the deity in *The End of Satan*. Most apt for Rodin were those romanticists like Gautier who did not believe in original sin or salvation, and for whom the netherworld was inexorable. "God will never come" (*Ténèbres*). The infants in *The Gates* remind us that Borel saw this underground existence as "both man's origin and end."[30]

In trying to reconstruct the literary sources of Rodin's view of life and evoke that aspect expressed in *The Gates*, one could begin with Lamartine and his philosophy of unanimism by which he posited a "nature spirituelle" to

which the soul has access by intuition, sensibility, and communion. Unanimism is a poetic idea, one in which all men are brothers, constituting the "universal life," or "the great All" so admired and used by Michelet and Hugo, and crucial to the concept of a great Chain of Being.[31] The notion of the one and the many had strong currency among the romanticists because it implied a basis for unity and harmony in the universe. Michelet (whom Rodin read and admired) and Quinet believed that humanity was progressing toward a distant goal as a result of its combined efforts. Victor Hugo directed his love toward mankind, and his view of the ladder of being that runs from God to matter presupposes Lamartine's views. For Rodin, who saw his fate in the flesh, the concept of a universal brotherhood in and under the skin that replaced theology must have been strongly appealing.

The connection between Rodin and Hugo may be especially significant. Rodin not only knew Hugo's work but also was able to observe this promethean writer at first hand in the course of doing the bust of him in 1883. It is highly probable that the sculptor had read much of the writer's poetry even before their meeting. Hugo once described the masses as his muse, and one of the poems he wrote that could have inspired Rodin to contemplate a modern hell on earth is *The Cellars of Lille*. In this poem, written as part of a collection of poems titled *Châtiments* (Punishments) that attacks the regime of Louis Napoleon, Hugo sought to awaken the public to the dismal destitution of the poor caused by those who exploit them. This poem of a "gloomy hell" deliberately evokes Dante's *Inferno*. The lines selected here are encouraged by Rodin's practice, seen in his illustrations for *Les Fleurs du Mal*, of responding to a single line if not a whole poem:

. . .
One day I went down into the cellars of Lille;
I saw this gloomy hell.
There, underground, are phantoms in rooms,
Pale and bent over . . .

Under these vaults, there is suffering; the air seems like poison;
The blindman, groping, gives a drink to the consumptive;
Water pours through the gutters;
. . .

There is never any light . . .
In the subterranean passages . . .
. . .

Destitution! Men dream while gazing at women.
. . .

There lies despair . . .
. . .
There, in the depths of horror, crawl emaciated figures
As naked as worms.

There, buried deeper than the sewers, shiver
Families who have left behind both life and light,
Trembling groups;
. . .

There, having no bed, the poor mother
Puts her little children, trembling like birds, to sleep
In a hole she has dug;
Alas! these innocent souls with their dovelike gaze
Find at their birth a grave
Instead of a cradle.
. . .

Withered old men in the throes of death,
. . .
And ghostlike children at the breasts of their statuelike mothers!
Oh, Dante Alighieri![32]

The view of this life as hell, as a kind of world prison, was well established by 1880. The concluding lines of Flaubert's *Voyage en Enfer*, a poem about Satan showing the poet an earthly panorama of vice and suffering, are a good example:

— Will you show me your kingdom? I asked Satan.
— There it is!
— What do you mean?
And Satan answered:
— The world, you see, is hell.[33]

Sainte-Beuve saw in Paris a modern-day hell because of the desperation and emptiness of its inhabitants. Balzac changed the title of his great collection of novels about all phases of contemporary French life from *Studies in Manners* to *The Human Comedy*, just as Gautier titled his poem *Comédie de la mort*, so that it would be a secularized inversion of Dante's *Divine Comedy*, and it has a subsection called *Death in Life*. The "hellish Paris" that Balzac wrote about helped to inspire the monomanias or passions that drove his characters so often to their own destruction as well as that of others, as in *The Chouans*. Balzac's view of hell was metaphorical, like that of his romanticist predecessors. He was a passionate novelist attracted to love and its perversions. For him human passions were eternal, encouraged by social life, and part of life, and for that reason not necessarily wrong. (He in fact believed they were essential to society.) The alienation one finds in some of Balzac's characters is fostered by the impersonality of

the large city, such as Paris, where their passions were even greater for being solitary.[34] Rodin did not only Balzac's portrait, but also that of Sainte-Beuve, and he could have known the latter's writings, such as *Les Rayons jaunes* (The Yellow Rays) about the sordidness of life in the modern city and the sense of emptiness and desperation that many of its inhabitants feel.[35]

On the rare recorded occasions when Rodin talked to others about the purpose of his *Gates*, he made it sound as if he were only interested in pure sculpture for his own pleasure. In this attitude he would have had a model set by Victor Hugo, who argued for "useless poetry" in the preface to his *Les Orientales*. But Hugo was not consistent in this view, and as seen in his 6,000 lines of polemics against Louis Napoleon in *Châtiments*, he had other purposes for poetry as well. It is reasonable to assume that Rodin had the purpose of holding a poetic mirror up to his audience so that it could see the hell of its time. Such an intention was in the tradition of nineteenth-century art and letters. His view of eternal damnation, with the few exceptions cited, was uncharacteristic in terms of those who came before him in the nineteenth century, but related to that of Edvard Munch before 1900. Although *The Gates of Hell* do not refer explicitly to the modern city as a contemporary inferno, we know that Rodin had misgivings about the modernizing of the city in which he lived, and his portal was intended to stand in the very heart of Paris.

The poet whose work comes closer than that of any other, including Dante, to expressing what we see in *The Gates of Hell* is Baudelaire. Arthur Symons noted in his journal in 1892 that Rodin told him he had first read Baudelaire in 1857, the year *Les Fleurs du Mal* was published, and Mauclair observed that a copy of these poems was always on a table in Rodin's studio.[36] One could more appropriately title the portal *The Flowers of Evil* than *The Inferno*. (There is more perfume than sulphur in *The Gates*.) Both works are a poetic voyage among the invisible ruins of those structures that previously gave spiritual stability to humanity. Neither artist referred to positivism, materialism, scientism, or any other external source of mankind's spiritual plight. Both show the horrors of the human condition caused by the insatiable desire for freedom and the prolongation of an existence of frustration and despair. Baudelaire and Rodin built their art on the artistically fruitful but humanly painful friction of dualities: extracting beauty from the struggles of flesh and spirit, the bestial and spiritual that coexist simultaneously in men and women. For both, sensuality played a full role in art as they shared the joys of contemplating the nude. Rodin was far more sympathetic and compassionate toward women than the poet, crediting them with feelings and a soul. But the sculptor shared the poet's view that women can destroy men, once even expressing it in Baudelairean terms: "Women understand love much better than we do. But through love they kill us. It is a delicious poison that they pour for us."[37] Paul Valéry's characterization of the art of Baudelaire applies equally well to that of Rodin: "Luxe, forme et volupté."[38]

Baudelaire was the French poet most associated with *The Gates* by contemporary commentators. These critics were men of letters and would have known by heart many of the verses and certainly the spirit of *Les Fleurs du Mal*. Though not their literal illustration, one can find echoes in the portal of several Baudelairean themes. As in *Les Aveugles* (The Blind), there are the nameless groups or crowds, somnambulistic beings with their sightless vision given to inner listening. As in *Le Coucher de Soleil Romantique* (The Setting of the Romantic Sun), there is solitary personal confinement and disillusion as man is withdrawn from God. Boredom and desperation (ennui and spleen) seem to form and deform sculptured bodies. In *Le Reniement de St. Pierre* (The Denial of St. Peter), Satan's evil consists of destroying man's will, and Rodin may have responded with figures thrown back upon themselves with an implied incapacity for action. One could excerpt from the portal numerous striving figures and couples to be conjoined with Baudelaire's *Le Paradis Artificiel*; Rodin told a Dutch visitor that the portal was about all phases of love and passion, and we see in the reliefs and full-figured forms all stages of seduction and disillusion. *Les Plaintes d'un Icare* (The Complaints of Icarus) and *Le Voyage* voice the impulses and expressions of those throughout the portal who manifest rootlessness and restlessness, the urge to escape, who "flee the infinity you carry within" and whose eyes see only the memories of suns or "only the boring spectacle of immortal sin." The fruitless, devastated plains, submerged in shadows, that comprise the Baudelairean landscape are not foreign to *The Gates*. When Rodin originally broadened the side moldings of

the doors in order to throw more shadow onto its panels, perhaps he had in mind Baudelaire's "empire of night."

'The Thinker' as the Poet

That something of his time Rodin put into his art was vested in *The Thinker*. Never have I been convinced that Rodin ever contemplated having *The Thinker* as we know him represent Dante alone. When Rodin came to model *The Thinker*, I believe he had already made the decision to depart from Dante, to universalize and personalize the medieval vision of hell. What Rodin could have learned about art and the artist's role from Hugo, Baudelaire, Balzac, Musset, Vigny, and others helps us to understand why when first exhibited independently of the portal this sculpture was titled by Rodin *The Poet*. Inside or outside *The Gates*, he was paying tribute to the contributions poets from Virgil through Dante to Baudelaire and Hugo had made to society. (It was the poets themselves who gave Rodin the precedent of putting the poet in hell.)

In Rodin's time the word poet included painters and sculptors as well, and Rodin believed in a fraternity of all artists.[39] What the nineteenth-century poets told Rodin about what an artist should be was complemented by what he had seen in the sculptors he admired and what his own experience and nature confirmed. In many ways the form and attitude of *The Thinker* convey these attributes. The artist-poet must be more intense in his living, more profound in his thought, and more eloquent in his expression than all others. The true artist-poet is immovably or still-centered, possesses Hugo's ideal "soul of crystal," and must experience solitude to be creative. The indispensability to the poet-artist of self-knowledge is best expressed in Paul Valéry's paraphrase of Baudelaire's *L'Irrémédiable*: "Yes, I have seen myself. I have gazed clear-sightedly at all the evil that is in me, and here I am, God of myself, fully aware of my good and of my evil."[40] The artist must be a disciplined observer of himself and others, seeing within and without. He must conceal himself in his art, and through his art fuse his internal life with the world around him. Vigny saw the poet alone as having the vision of light while others were in darkness, for he exemplified the spirit of study and contemplation. Victor Hugo's "I am a consciousness" could be inscribed on the sculpture's base. The poets might disagree on what was to be the supreme con-

templation (society and self, man and nature, man and god, infinity or the beyond, the beauty and permanence of art, etc.), but all agreed that contemplation was necessary. (It would have been in Rodin's nature not to choose from among polarities but to fuse them by focusing on the act of contemplation.) The powerful physical form of *The Thinker* incarnates both Hugo's and Rodin's self-images as worker-poet-artist of enormous will, a titan of thought and action, and he could easily have evoked the nineteenth-century poets' self-image as Icarus or Prometheus on the rock. Victor Hugo, thinking of the poet as a magus leading society, titled him "Penseur," and he explained that penseur was an active noun.[41]

Unnoticed or not realized by most who look at *The Thinker* is that he manifests the dual condition of being both tense and calm. Tension rises from the feet but the hands are relaxed. In the context of Rodin's time and his exposure to the poets, *The Thinker*'s dualistic condition can be interpreted as incarnating the warring directives of the poet's heart, engagement with the polarities of reality and appearance, and the ideal and the real. His combined states remind us of the romanticist poets' plea for action to be wed to thought. Hugo valued the poet more highly than the artist because of his aptitude for thought and philosophy as opposed to the artist's interest in the execution of ideas. When Rodin spoke of *The Thinker* being "no longer dreamer, but creator," he was giving artist and poet creative parity.

Rodin as Romantic Realist or Realistic Romantic

In talking to Bartlett, Rodin referred to himself as a "realist," and he said to Mauclair, "I am a realist and a sculptor."[42] But Mauclair nonetheless saw a romanticism in Rodin's realism: "The principal part of his work . . . interprets Dante, Hugo, mythology, with a passionate romanticism of which the élan, feelings, and gestures are always comprehensible."[43] Edmond de Goncourt recognized two strains in Rodin's artistic makeup: *The Burghers of Calais* represented his realistic view of humanity, but *The Gates of Hell* represented a poetic humanity. Like Balzac (and as in the evolution of Rodin's *Monument to Balzac*), the sculptor was both observer and visionary. But though Rodin could find agreement with Pasteur as to the importance of exact observation as the basis of their

work,[44] Rodin was no Frémiet, no recorder of facts content to dazzle us with cold and mindless virtuosity. No pure realist made *The Gates of Hell* and its fallen angels.

Rodin was of a generation that could see the accomplishments and deficiencies of romanticism. Like Baudelaire, Rodin wedded warm emotions to cold reason. With Balzac he was more moved to create by feelings than by ideas. Rodin did not see himself as an illustrator in the sense of many great romanticist artists: "I do not deny that I have a taste for symbols and synthesis, but I do not invent them after literature in order to interpret them. Nature gives them to me."[45]

Rodin and his generation were the beneficiaries of the artistic freedoms won by the great romanticists, such as Delacroix and Victor Hugo, in principle to treat any subject, and to hold that practical or moral purposes need not be joined with beauty. They had set the example of revolt, but they were disciplined rebels who broke with outworn conventions, rejecting empty formulas and rhetoric, as Rodin was to do in sculpture. In so doing they were models of prodigious energy and production. Rodin's experience throughout his life of being overwhelmed by the abundance of nature reminds us of Chateaubriand and Balzac. Hugo's view of nature as a woman was certainly congenial to Rodin. (The same might have been true of Balzac's view that creativity was a matter of sexual prowess.) The romanticists' humanizing and sexualizing of the muse seen in the poems of Musset and Baudelaire was given sculptural form by Rodin.[46]

With the great writers and artists before him Rodin shared the knack of getting things done by hard work. Like the romanticists, and no more than they, Rodin did not seek a dream world in which to escape, as he found a way through his sculpture to live in the world of his time. When he turned from his drawings based on Dante, it was because they did not measure up to his view of reality. That may have been the realist in him. When he relied upon his imagination to create *The Gates of Hell*, that was the romanticist strain in his makeup.

Rodin's famous love affair with medieval and sixteenth-century art was preceded by that of the romanticists, and Victor Hugo's admiration of the Middle Ages may have been an incentive for Rodin's lifelong study of the cathedrals. In Rodin's drawings and writings on the cathedrals there is a mixture of romantic and realistic strains, as when he combines a reverence for observed facts in terms of what was done, and emotional metaphors to convey to us his love of the life they expressed. Rodin's lament for the loss of the faith that inspired the cathedrals and the skill that put that faith into stone showed his awareness if not sadness over the fact that the world was far from fixed and certain, and was in a constant state of change that he felt was mostly for the worst. Just as he sought the intimate and the universal in *The Gates*, he sought the constants in terms of spiritual cost to people's experience of a world in flux. In somewhat romanticist fashion, Rodin would often turn from the ugliness of modern Paris to the beauty of medieval churches, but he wanted the art he made to be an integral part of his time. His romantic imagination was tempered by his respect for the tough laws of reality, and in this he could have felt kinship with Balzac and Stendhal.

In art Rodin was an idealist about how artists should be taught, but he was enough of a realist to know that the system should be reformed and not overthrown. He was at most a reluctant revolutionary, at least a dedicated reformer. Just as Delacroix did, he fought the conservatives but accepted state commissions and honors. In some ways Rodin saw himself working for a universal audience, and in others he was proud of being his country's greatest sculptor. He wanted his art to speak to humanity, but in a French accent. Rodin knew what it was to be a victim of the art world's injustice, but unlike Vigny he did not choose alienation or isolation. Instead he sought vindication through the fullest possible participation in that same art world. Like the romanticists and realists in art and literature before him, Rodin fought against bourgeois conservatism and its emphasis upon the rational because he had the fullest confidence that in time he would impose his vision on the public, and he was right.

12

Conclusion

What 'The Gates of Hell' Did for Rodin and His Art

Until Rodin's death, the plaster version of *The Gates* that remained in the studio served as a white eminence behind much of the sculptor's art made for public presentation. Apart from the portraits and monuments he completed, so much of the art that we associate with Rodin, *Adam*, *Eve*, *The Thinker*, *The Kiss*, *The Prodigal Son*, *She Who Was Once the Helmet Maker's Beautiful Wife*, derived from his work on the great doors. The subject, size, and boldness of the portal's undertaking attracted many critics for the first time to the artist's studio, where they were introduced to and wrote about the new middle-aged genius of French sculpture and the greatest sculpture of the century. No question but that *The Gates* strongly helped establish Rodin's international reputation. They thus served him almost as well as if they had been publicly installed. The qualification comes from the fact that the unwillingness of the French government to call for their casting encouraged the critical opinion during the artist's lifetime that Rodin was incapable of finishing a major project. That prejudice persists among certain critics to this day, and Rodin is still viewed as having been a master of only the fragment despite the several monuments he completed.

More than twenty-five years before Picasso completed the "unfinished" *Desmoiselles d'Avignon*, Rodin already differed from his own contemporaries by undertaking to improvise a major and commissioned work without knowing what it would look like. In 1880 he decided to break with traditional narration and the custom of combining a series of set pieces in relief into a symmetrical sequence of panels. Rodin's gamble comprised harmonizing a vast composition intuitively, guided only by his untested sense of a new aesthetic wholeness for sculpture and architecture. The importance of *The Gates* for Rodin's art, besides underwriting confidence in his own judgment, was to justify his reputation as a marvelously prolific artist. During the first four years the sculptor chose to work in a highly spontaneous way with living subjects who were often not professional models. The flood of small figures that he created were made without the self-conciousness that had previously caused him and his contemporaries to set their figures into art poses. Nor did he have to spend the time for refinement and enlargement that he would have experienced in making statues. This period was crucial to naturalizing Rodin's art, to his liberation from the influence of Michelangelo, Goujon, and other predecessors.

Rodin's reputation with his contemporaries as a great psychologist and dramatist of the body comes from this monument and its offspring. *The Gates* confirmed Rodin's genius as an interpreter of the passions and the tragic in life. Historically he had no superior in sculpture when it came to depicting sensuality and suffering. Contemporary critics viewed the great portal as the work of an important as well as compassionate commentator on French society of the fin-de-siècle, and he was ranked with the great writers such as Hugo, Balzac, and Baudelaire. Thus in the years immediately following 1880, Rodin found himself by working from life without preconceptions of the heroic and of style. His newly won naturalism was the foundation for the composition and dramatic power of

his unconventional monuments, such as *The Burghers of Calais*.

When the portal was not cast by 1885, and as he became involved with other commissions such as *The Burghers*, Rodin must have realized that if only to recover his financial costs, which exceeded the government's allocations, and to enlarge his reputation, he would have to exhibit and sell individual works from *The Gates*. This was nothing new: such a practice was customary among sculptors who made large monuments. Beginning in 1883, with the showing of *The Fallen Caryatid*, Rodin carried out this reasonable plan with success. Because so many of the figures in *The Gates* are small and not easily seen because of their orientation to gravity or distance from the observer, when exhibited apart from the doors people did not know their place of origin. Such examples would include the *Fugit Amor*, *I Am Beautiful*, *Lust and Greed*, *The Fallen Caryatid*, and *Metamorphoses of Ovid*. (The last two named are partly concealed by drapery and architectural decoration in the upper left and right corners of the portal.) The titles of these excerpted works usually gave no clue to their infernal parentage, and the offspring could lead their own lives under different names. When *The Thinker* was enlarged and first publicly exhibited in Paris in 1904, few among the critics and the public knew or remembered its source, and in 1906 Rodin gave it an entirely different interpretation in which the figure became a symbol of the worker during the social upheaval of the time.

Untrained and inexperienced in conventional methods for working on such a large commission as the portal, Rodin developed his own ways of working that also ensured his productivity as an artist in the eyes of critics and the public. As almost all the figures that went into the doors were made in the round rather than relief, including those such as *The Kiss* that did not make it permanently into the artist's "Noah's Ark," Rodin could assign one of the several plaster casts made of each work for bronze casting or carving. Having several plasters made of each piece not only protected a conception against loss through breakage but also allowed him to repeat the motif in the doors, thereby prolonging the life of a favored idea and good modeling. We have seen how these casts made it possible for Rodin to effect new couplings, to change ori-

entations in relation to gravity, and to employ fragmentation to obtain a different figural focus.

The partial figure, which constitutes one of Rodin's strongest influences on modern sculpture, owes some of its beginnings to his sculptural epic. The emergence of a solitary arm from a moundlike surface in the corner of the right door panel, and the lower halves of bodies falling into or out of caves, are thematic uses of figural segments. The removal of the hands and right arms of *The Three Shades* had both a thematic and formal justification: stressing the futility of resistance to death and opening up the body's left profile, which had been blocked by the full right arm. The figure known as *Meditation* first appears in the right-hand section of the tympanum, but apart from the portal she was also exhibited without arms—which accentuates the sensuous profiles of the body and compacts the whole into a more condensed expression.

The Gates liberated Rodin's imagination with regard to composition, as announced at their very summit by tripling the figure of *The Shade*. No previous sculptor had multiplied the same figure in a single composition in order to create a group. The sculptor's democratizing of the body meant suffusing the entire figure with expressiveness, so that we are moved by any of its prospects. Knowing the *The Three Shades* atop the doors would ultimately be set against a wall, Rodin was in effect showing us what we could not otherwise see in the round. (He employed the same relief device when he confronted two casts of *She Who Was Once the Helmet Maker's Beautiful Wife* and set them in a cave.) Evolved in the first years of the 1880's, Rodin's criteria for a successful composition such as *The Three Shades*, *Fugit Amor*, or *I Am Beautiful* required good modeling of the figures to be joined, a tension or fruitful dramatic friction at their points of contact or where they nearly touched, and their containment within an implied cube.

Rodin's elevation of the étude to a complete work of serious art having new artistic wholeness and inconsistency of mode began on the background planes of the portal. As an example consider the crouching woman almost invisible from below the gateway who is embedded high up in the right-hand door (Fig. 180). Detached from the portal, the head redone, and the whole enlarged, this crouching woman constitutes one of Rodin's most daring con-

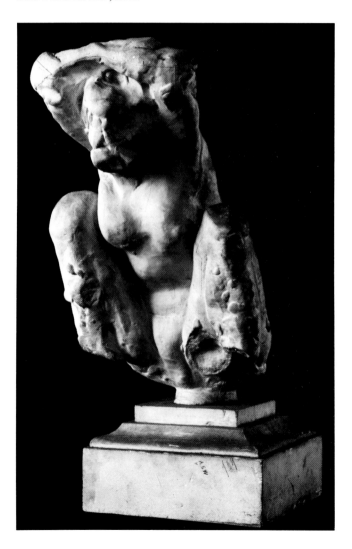

Fig. 199. *The Crouching Woman*. Plaster. Musée Rodin, Meudon. Photo Bruno Jarret.

ceptions. In it he has joined the graceful and the grotesque by mixing different modes of modeling in a brutally truncated figure that wears the scars of studio accidents (Fig. 199). Being cast in bronze or carved in stone were not the only warrants of Rodin's satisfaction that a given work was complete. The very fact of the crouching figure's enlargement signified that determination as well. (Rodin customarily bronze-cast a work on demand from a client, and it is not surprising that with all the more cosmetically attractive sculptures available the conversion of the plaster of the crouching woman into bronze or marble found no commissioners.)

Inconsistency of mode also included fabricating or pairing figures from previously made parts without concern for anatomical accuracy or unity of scale. The figure of *The Falling Man* that appears three times in the portal is seen in three different orientations: upright, horizontal, and inverted. There were no anatomical adjustments to accommodate the body's different responses to gravity. On the two occasions when the same male figure grasps a different woman, his arms are changed but not the position of the muscles in the man's upper back. Rodin obviously did not consider such literal details sufficient cause to redo the upper portion of the man's body. Visual plausibility superseded anatomical accuracy. On two occasions Rodin joined the enlarged or life-size version of *The Shade* with two half life-size figures from *The Gates*, *The Fallen Caryatid* and *Meditation Without Arms* (Figs. 200, 201). This indifference to consistency of scale is a legacy of the portal in that there is no single viewpoint to which the figures are adjusted in terms of size, and the large cohabits with the small. The sculptor's belief that a figure was never finished and always susceptible to being done differently had to have been developed by those countless hours of working on the portal and the frequent reutilization of the same heads and bodies.

The roughly twenty years spent bringing *The Gates* into being must have given Rodin additional courage and conviction about his role as an artist. Had he not proved the humanistic scope of which sculpture was still capable in modern times? And despite occasional doubts about whether or not he had created certain excessive effects, had he not continued and gone beyond the great traditions of decorative art? He had won his gamble in his own eyes

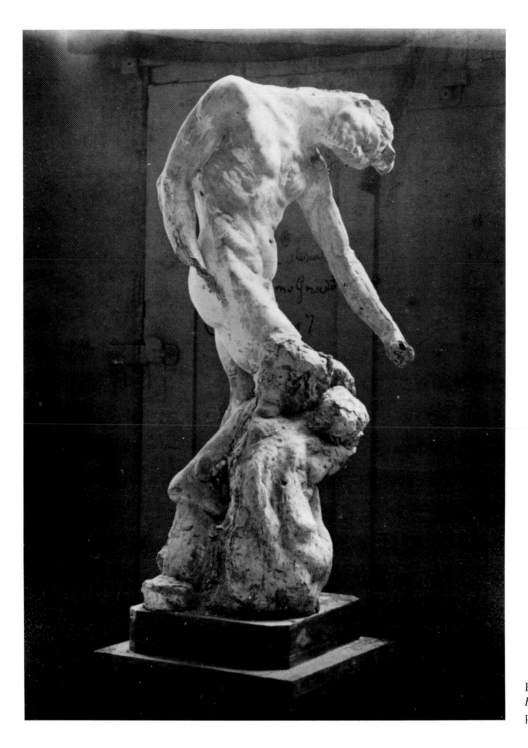

Fig. 200. *The Shade*, with *The
Fallen Caryatid*. Plaster. Old
photograph in the Musée Rodin.

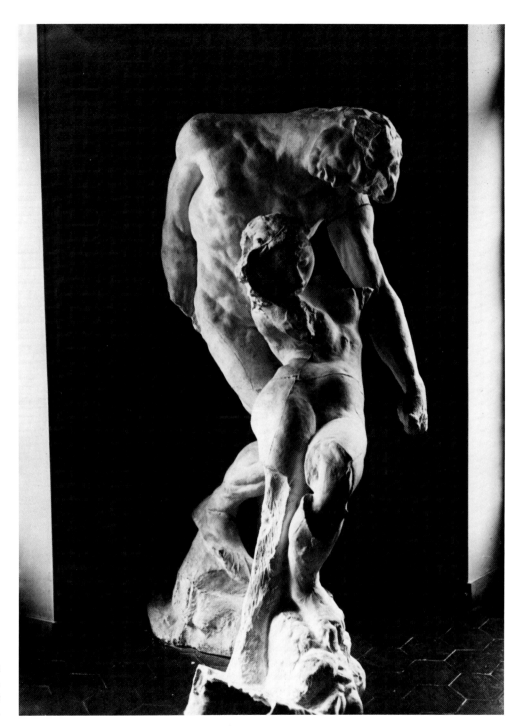

Fig. 201. *The Shade*, with
Meditation Without Arms.
Plaster. Old photograph in the
Musée Rodin.

and in those of many of the most respected critics and artists.

'The Gates of Hell' Are a Monument to Art and Life

During the early years in which the doors took form, Rodin never forgot that they were to go before a museum of decorative arts. It was the dramatic opportunity for the sculptor to show the world his ideas about decorative art that had come from intense and extensive personal study rather than from the confirmation of accepted attitudes and practices in his era. In his 1901 interview with the writer Le Nain Jaune, during which he expressed doubt that the government would ask for delivery of his doors for their assignment to the new Museum of Decorative Arts in the Louvre, Rodin was characteristically candid about what had been his purpose: "As for me, I am indifferent to whether the door is here or there. I have wanted to give a new interpretation to bas-reliefs, a work where the decorations are a part of the ensemble and give, by the play of lights, a variable diversity to the sculptural motifs. I hope I have succeeded in this, and that alone interests me." In this last section, Rodin's achievement is summarized in terms of propositions.

Rodin made sculptural architecture. Rodin treated the architecture of his portal from his experience as a sculptor of the human form. He loved and respected architecture, and knew the cardinal rule that sculpture should be subordinate to architecture. But when he began to reflect on the interaction of the architecture of the door with light, the surrounding space, and the sculpture, he made decided changes that went against such hallowed traditions as symmetry of the whole and repetition of paired parts, regularity of spacing and placement of decorative features, clarity and consistency of design of the various elements, and straight continuous edges. He actually modeled clay over the capitals of the side reliefs as well as the floor of the tympanum and on the moldings throughout the door, thereby muting the severity of their surfaces and profiles. Seen in three-quarter view, the whole portal projects forward and backward like a console or one of his expressive sculptures.

Architecture was not inviolable with regard to reliefs. Throughout the doors it is clear that the architecture does not frame or enclose all the sculpture. Rodin made sculptural extensions of moldings, as in the sides of the tympanum, and he simply attached sculpture to the frame. When architecture did establish a field for reliefs, figures would cling to, push off from, or overlap its borders contrary to the rules that required that the framing features be adhered to and kept clear. If Rodin needed more space for a figure, he would cut away part of its frame. (In this regard he was Romanesque rather than Renaissance.)

Rodin broadened the historical exemplars of decorative sculpture. For the Ecole des Beaux-Arts the most admired decorative sculpture was that of the Greeks, and it was from this art that rules were generated: the sculptor must respect the lines and planes of architecture; the more light the greater the relief; bas- and demi-relief were best indoors where there was little, or reflected, light; high relief was best where there was the most light but there should not be a confusion of shadows; the "color" of sculpture derived from the moral tone of the subject matter.

Rodin drew the attention of fellow sculptors not just to the expressive decorative sculpture of Michelangelo and Jean Goujon but also to that of the Gothic cathedrals, where the placement of high and low reliefs was not governed by Greek laws, where shadows had a greater role to play and symmetry was not required for balance. He believed that the cathedrals were designed on the same principle as living bodies: harmony resulting from the counterbalancing of masses. In the tympanum of the doors where there was least light, Rodin placed figures in high relief, probably inspired by his study of ancient sarcophagi and medieval tympana. His use of foliate decoration in conjunction with architecture was decidedly not Greek but rather late medieval in spirit.

Rodin's natural or roving perspective broke with illusionistic reliefs. In the last century the model of illusionistic painting based on Renaissance one-point perspective had become dominant in relief sculpture over the Greek model with its neutral background and adherence to an implied frontal plane. Rodin's predecessors and contemporaries such as Dalou designed their reliefs on the model of rationalized space in painting so that figures diminished logically in size according to their distance from the foreground and the stagelike settings augmented the illusion of recession into infinite space. Shadows cast by foreground features onto the relief surface sometimes caused spatial confusion as consistent recession and scale reduc-

tion was contradicted. Dalou and others did, however, employ a full range of reliefs, from low to high, and their conceptions sometimes did include figures in the round. Rodin's range of relief thus had precedence in his own time.

Rodin rejected the consistently illusionistic background as well as the neutral empty back plane advocated by the Ecole. His environments are far more abstract than those of his contemporaries and are no more governed by a single vanishing point than are his figures. In the 1880's, Georges Seurat developed a roving perspective, whereby each figure within his *Un Dimanche à la Grande Jatte* was rendered as if the viewer were standing next to it, but the entire setting was constructed from a single viewpoint. As seen in our tour of *The Gates*, Rodin's rendering of his figures and their ground is from the plural points of view of a constant voyager.

'The Gates' are an audacious example of modern decorative art. Just as with his coupling of figures, Rodin's successful and dramatic joining of sculpture and architecture depends upon their interaction at the points of contact, strong formal contrast, and parity of quality of execution. The order of the overall portal does not depend upon the juxtaposition of discrete stabilized units set within a prearranged, strictly symmetrical plan. The compositional coherence and largeness of effect that we associate with modern art were developed often intuitively during the process of creation, and their comprehension depends upon our ability to read the work as a totality—seeing and sensing everything at once rather than sequentially, not unlike an Impressionist painting.

'The Gates of Hell' are a synthesis of past and present. They have within them something of antiquity in the form of passionate mythological creatures who incarnate the human and bestial. If the doors had been prefaced by Adam and Eve, or if the relief figure in the lower left jamb is that of Eve, along with the presence of falling angels there is reference to the Bible and original sin. *The Gates* have something medieval about them in the allegorical figure of Fortune, a horned demon, the tympanum's Dance of Death, and eternal damnation. Their scope and a few themes such as adultery, treachery, and destruction of the family invite comparison with Dante's epic voyage through hell. The portal's tormented population seems descended in art from the Last Judgments of the cathe-

drals, Michelangelo, and Rubens, and in poetry from the romanticist netherworld.

In their entirety, the doors resemble none of these precedents. There is no symbolic sign language as in Last Judgments that assigns meaning to right or left, high or low, and the center. Nor is there a hieratic focal figure who is responsible for locating the damned in any particular part of hell. Disparities in figural size do not come from the world of rank but depend upon artistic judgment. There are no scales of justice and there is no salvation, no saved enjoying the torments of the damned. Just as there is no comforting bosom of Abraham, there are no menacing jaws—only the tombs. There is one serpent whose coils enfold naked bodies; otherwise, hell is internal and eternal, a drama of persons more than places.

Rodin's contemporaries saw themselves and the troubled spirit of their time in these doors: "Above all it is about life," "Here are our brothers," "It is us." They detect resonances of Hugo and Baudelaire in what was interpreted as Rodin's rendering of "the invisible conflicts" of their age.

The view from the tombs confirms that hell is in life, before and after death (Fig. 202). Only the presence of the tombs separates the living from the dead. There are no decaying corpses and the rare skeleton is animated. As in the boulevard paintings of the Impressionists, the portal's crowds are atomized. Unlike the former, however, Rodin's figures do not lose their individuality even though anonymous: the couples and groups are linked by spiritual pain, not by hedonistic Impressionist pleasures. Instead of social diversion there are suggestions of social perversion. The crowds have no cohesion or concerted externally directed action. There are no fiery marshals. Except for an occasional centaur or serpent, we are given the tormented but not the tormentors. Individuals, couples, and groups experience unrelieved restlessness, striving, and despair, not unlike Baudelaire's Icarus. Rodin's hell is about humanity's condition of being without hope and a perpetual prisoner of passion in this life and the next. The hell of Rodin's hell is that the future is a prolongation of the past.

Rodin's hell is poetic and not theological. The doors are a secular monument: the result of culture without cult. They were made from the artist's private experience, for his personal pleasure, to be shared with the public; they were not for sectarian congregations. *The Gates* affirm

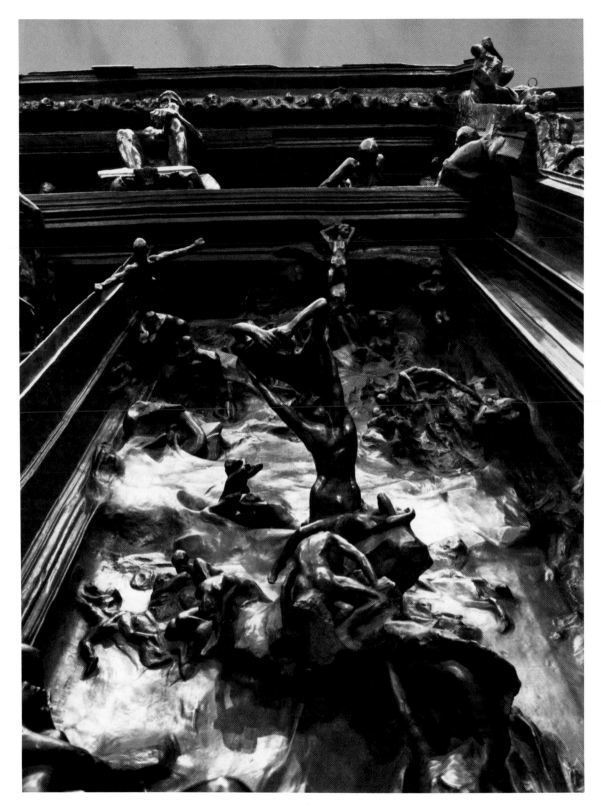

Fig. 202. View of *The Gates* from the tomb in the right door
panel. Photo Bill Schaefer.

art's power to rival or complement letters in revealing society to itself and the driving motives in life. By his own account, and confirmed by the portal itself, Rodin followed no "classification, method of subject, no scheme of illustration, or intended moral purpose." There are scant vestiges of the illustrative and narrative, as with the *Ugolino* group, but overall the portal has a disjunctive narrative style, a montage of poignant episodes, not unlike the character and "architecture" of *Les Fleurs du Mal*. Verbal sources were supplanted by moods and experiences of what Rodin saw, felt, and imagined in the moving flesh of his models. He came to see the great writers and poets in terms of his own art. By following his imagination, Rodin was emulating literary predecessors such as Baudelaire, Hugo, and Balzac in modernizing Dante and seeing the *Inferno* in the life of modern urban society, Balzac's "hellish Paris." The medieval inferno had been extinguished. Satan and hell were metaphors of humanity's fears for the worst that happens in life. Evil does not explicitly appear or is not figured in Rodin's hell. If Adam and Eve are absent, we cannot say with certainty that the damned are sinners. *The Gates of Hell* are thus a poetic monument to the spiritual victims of life.

Man in the role of the artist replaces Christ in the seat of judgment (Fig. 203). God and Christ are absent, if not dead. *The Thinker* as artist-poet in the jurist's seat decides to make no moral judgment. Rodin seems to be saying through *The Thinker* that damnation was predetermined by the now absent god and that he cannot or will not alter the decision or personally condemn or absolve those with whom he identifies. Is not the artist-judge a prisoner of his own passion? *The Gates* may be read as humanity damned not by an invisible deity but by its own passionate nature—or that God has chosen not to intervene. The artist's role therefore is to re-create society compassionately for its own contemplation. The crown of thorns atop the doors is for suffering mankind. Rather than the traditional palm branch as a sign of divine recognition of the martyr, the thorn vine is also for the artist, for in Rodin's words, "Every masterpiece is the result of a martyrdom."[1] *The Thinker* as artist and poet is both judge and prisoner of his time, place, and humanity. He alone strives by detachment to calmly use intelligence, but his context and physical tension suggest susceptibility to sexual passion, and he is possessed by the mania of seeking the unattainable

in art to which all must be sacrificed. By his location, as if looking down at us, and his total, undistractable introspection, *The Thinker* also invites the beholder's descent into the self. *The Gates of Hell* are therefore a poetic synthesis of past and present and the suffering of society and the self.

'The Gates' are a monument to art and life. They are an original brilliant solution to the modern problem of how to create a symbolic portal for an art museum on the artist's own terms. The doors are a model of the nineteenth-century ideal of "fine usage" of older architectural decoration. Rodin was not engaging in deliberate historicism or self-conscious eclecticism: his different sources were connected by evolution from Romanesque to rococo and, like the Bible, were perennially fresh and modern. Rather than quote them, Rodin's instinct and challenge was to lovingly redesign his sources and fuse them into a new organic unity. In the same way, the doors are a personal homage, a partial recapitulation and extension of the history of sculptural relief that went beyond the capacities of Rodin's ablest contemporaries. In the round and in relief, Rodin revealed and paid tribute to all that figural movement could express.

It is doubtful that even in 1880 when they were begun *The Gates* were a complete expression of Rodin's life attitude. As he often did in conversations, he tempered his pessimism by saying that through the portal's creation at least earthly salvation or happiness was possible by serious sustained work: "Happiness is found in one's self: work brings it."[2] Rodin was also saying that the work of art must derive from ceaseless study of life, which is always the source of truth, expression, and beauty no matter how tragic the theme. Not the least of Rodin's private hells was his life of striving to master nature's abundance. The more he studied, the more he did; the more he changed and matured as a person, the greater his dissatisfaction with what he had done. *The Gates* were completed in 1900, but so tied was art to his life that it was impossible for Rodin to view them as perfect by the time of his death in 1917.

In an ironic way, *The Gates of Hell* are a monument to art and life. Recall the obvious: there is marvelous movement and vitality to these damned figures even after death. Their forms are eloquent of energy still unspent or banked. Rodin could not have brought himself to render

a lifeless form even for the dead. He saw beauty as well as expression in the spiritual agony of his subjects and marveled at all the possible configurations of despair and the body's refusal to be resigned to its fate. (When he looked at Rose on her deathbed, he recalled what a fine model she had been.) As he came to conceive the portal, Rodin won an environment in which, free from gravity, customary artistic logic, and linear narrative, he could dispose the human figure in every conceivable orientation, thereby proving his point that there was a democracy not only in death but in the expressive potential of every part of the body. The modernity of *The Gates of Hell* is finally in their poetic synthesis of past and present, society and the self, in a modern style.

The Gates have imperfections, but like the imperfections in the Bible, the Piazza San Marco, and the Cathedral at Chartres, they are the imperfections of life itself, and they are probably a more intimate record of their creator's changing thoughts and feelings during the time of their creation than any sculpture ever made before. Historically *The Gates* rank as one of the great works of the human imagination. Bartlett put it well: "*The Gates of Hell* are for pilgrimages."[3]

Fig. 203 (*facing*). *The Thinker* in *The Gates*, seen from below. Photo Bill Schaefer.

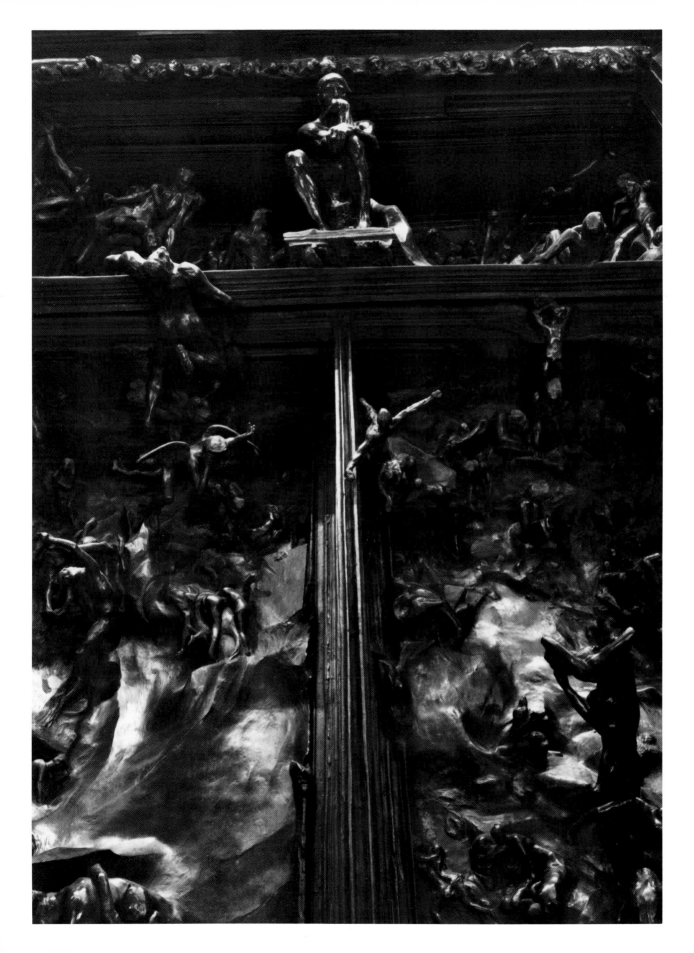

Notes

Notes

The most extensive and up-to-date Rodin bibliography is found in J. A. Schmoll gen. Eisenwerth, *Rodin-Studien: Persönlichkeit—Werke—Wirkung—Bibliographie* (Munich: Prestel Verlag, 1983).

1. How 'The Gates of Hell' Came About

1. The decree is in the Rodin dossier in Archives Nationales de France. For other interpretations of the history and meaning of *The Gates*, see Albert E. Elsen, *Rodin's Gates of Hell* (Minneapolis: University of Minnesota Press, 1960), and also Elsen, *Rodin* (New York: Museum of Modern Art, 1963); John L. Tancock, *The Sculpture of Auguste Rodin* (Philadelphia: Philadelphia Museum of Art, 1976); Jacques de Caso and Patricia B. Sanders, *Rodin's Sculpture: A Critical Study of the Spreckels Collection, California Palace of the Legion of Honor* (San Francisco: Fine Arts Museums of San Francisco; Rutland, Vt.: Charles E. Tuttle, 1977).

2. For a good illustrated biography of Rodin see Robert Descharnes and Jean-François Chabrun, *Auguste Rodin* (New York: Macmillan, 1967).

3. Judith Cladel, *Rodin: The Man and His Art* (London: Century, 1917), p. 267.

4. See the articles by Truman H. Bartlett entitled "Auguste Rodin, Sculptor," first published in *American Architect and Building News*, vol. 25 (1889), reprinted in Albert E. Elsen, ed., *Auguste Rodin: Readings on His Life and Work* (Englewood Cliffs, N.J.: Prentice-Hall, 1965), esp. p. 121. (All references to the Bartlett articles are to the reprint.)

5. For the rear view of Neyt and *The Age of Bronze* see Albert E. Elsen, *In Rodin's Studio* (Ithaca, N.Y.: Cornell University Press, 1980), plates 2–5, and the discussion on pp. 157–58. See also Bartlett, p. 43.

6. Judith Cladel, *Rodin, sa vie glorieuse, sa vie inconnue*, definitive ed. (Paris: Bernard Grasset, 1950), p. 36. The bust of Castagnary was actually a portrait medallion for Castagnary's tomb in the Montparnasse Cemetery.

7. *Ibid.*, p. 137.

8. *Ibid.*

9. Bartlett, "Auguste Rodin, Sculptor," p. 48.

10. Another note in the Bartlett file at the Library of Congress says, "The subject was chosen by the sculptor. It is a wild [or mild?] kind of hell."

11. Serge Basset, "La Porte de l'Enfer," *Le Matin* (Paris), March 19, 1900.

12. Gustave Coquiot, *Rodin à l'Hôtel de Biron et à Meudon* (Paris: Ollendorff, 1917), pp. 75–76.

13. Cladel, *Rodin: The Man*, p. 267.

14. Camille Mauclair, *Auguste Rodin, l'homme et l'oeuvre* (Paris: La Renaissance du Livre, 1918), p. 8.

15. Frances Yates, "Transformations of Dante's Ugolino," *Journal of the Warburg and Courtauld Institutes*, vol. 14 (1951).

16. Cladel, *Rodin: The Man*, p. 270.

17. Cladel, *Rodin, sa vie*, p. 139.

18. Bartlett, "Auguste Rodin, Sculptor," p. 69.

2. Living with Dante Through Drawing

1. Judith Cladel, *Rodin: The Man and His Art* (London: Century, 1917), p. 270.

2. Judith Cladel, "La Jeunesse de Rodin," *La Revue Universelle* (Paris), May 1, 1935, p. 320.

3. Judith Cladel, *Rodin, sa vie glorieuse, sa vie inconnue* (Paris: Bernard Grasset, 1950), p. 139.

4. *Ibid.*, p. 378.

5. On the dating of Rodin's "black" drawings see J. Kirk T. Varnedoe, "Rodin as a Draftsman: A Chronological Perspective," in Albert E. Elsen and J. Kirk T. Varnedoe, *The Drawings of Rodin* (New York: Praeger, 1971).

6. *Les Dessins d'Auguste Rodin*, with a Preface by Octave Mirbeau (Paris: Goupil, 1897).

7. *Ibid.*, plates 21, 58, 60.

8. Truman H. Bartlett, "Auguste Rodin, Sculptor," first published in *American Architect and Building News*, vol. 25 (1889),

reprinted in Albert E. Elsen, ed., *Auguste Rodin: Readings on His Life and Work* (Englewood Cliffs, N.J.: Prentice-Hall, 1965), p. 70.

9. Throughout I have used the Charles S. Singleton translation for Dante Alighieri, *The Divine Comedy: Inferno* (Princeton, N.J.: Princeton University Press, 1970). The lines here are from Canto III, p. 25.

10. See *The Doré Illustrations for Dante's Divine Comedy* (New York: Dover, 1976), p. 8.

11. Singleton trans., Canto V, p. 47.

12. Dante Alighieri, *L'Enfer: Poème en xxxiv chants*, tr. Rivarol (Paris: Librairie de la Bibliothèque Nationale, 1886), vol. 1, p. 71.

13. See Ruth Butler, "Rodin and the Paris Salon," in Albert E. Elsen, ed., *Rodin Rediscovered* (Washington, D.C.: National Gallery of Art, 1981), esp. fig. 1.55, p. 45, of Jean-Baptiste Hugues's "Shades of Francesca da Rimini and Paolo Malatesta."

14. Singleton trans., Canto V, p. 55.

15. *Ibid.*, Canto VI, p. 59.

16. *Ibid.*, Canto VII, p. 77.

17. See Claudie Judrin, *Les Centaures* (Paris: Musée Rodin, 1981).

18. Singleton trans., Canto XXV, p. 263.

19. *Ibid.*, pp. 265, 267.

20. *Ibid.*, Canto XXVIII, p. 295.

21. For an interesting interpretation and chronology of the many drawings Rodin did on this subject see Claudie Judrin, "Rodin's Drawings of Ugolino," in Elsen, *Rodin Rediscovered*.

22. Singleton trans., Cantos XXXII, XXXIII, pp. 347, 349.

23. See J. Kirk T. Varnedoe, "Early Drawings by Auguste Rodin," *Burlington Magazine*, April 1974, p. 198.

24. Singleton trans., Canto XXXIII, pp. 351, 353.

25. Henri Dujardin-Beaumetz, "Rodin's Reflections on Art" (1913), reprinted in Elsen, *Auguste Rodin: Readings*, p. 163.

26. See Frances Yates, "Transformations of Dante's Ugolino," *Journal of the Warburg and Courtauld Institutes*, 14 (1951): 92.

27. Judrin, "Rodin's Drawings of Ugolino," p. 199.

3. *The Architectural Genesis of 'The Gates of Hell'*

1. The suggestion of the influence of de Triqueti's doors is made by Jacques de Caso in his review of my *Rodin's Gates of Hell* (Minneapolis: University of Minnesota Press, 1960) in the *Burlington Magazine*, February 1964, pp. 79–82. These doors are difficult to photograph in their entirety. A good photograph of two of the panels can be found in Bo Wennberg, *French and Scandinavian Sculpture in the Nineteenth Century* (New York: Humanities Press, 1978), p. 76. See J. Kirk T. Varnedoe, "Early Drawings by Auguste Rodin," *Burlington Magazine*, April 1974, p. 201, for a discussion of the Percier doors. Rodin may have seen a drawing of these doors in the Louvre, as they were dismantled in 1850.

2. Varnedoe, "Early Drawings," p. 202, n. 19.

3. Camille Mauclair, *Auguste Rodin, l'homme et l'oeuvre* (Paris: La Renaissance du Livre, 1918), p. 20.

4. Serge Basset, "La Porte de l'Enfer," *Le Matin* (Paris), March 19, 1900.

5. Truman H. Bartlett notes, Library of Congress, Washington, D.C.

6. "He is lucky not to have gone to the Ecole des Beaux-Arts." Robert Descharnes and Jean-François Chabrun, *Auguste Rodin* (New York: Macmillan, 1967), p. 20.

7. Roger Marx, *Auguste Rodin: Céramiste* (Paris: Société de Propagation des Livres d'Art, 1907), pp. 42–44. In Bartlett's notes we read about an incident in which Rodin asked his jealous superior at the Sèvres factory if he could have a particular vase that he had made. The superior refused and the matter went before Turquet. "Turquet ordered the vase made by Rodin valued at 2,000 francs to be given to him. Superintendent said it was not a proper thing to give vases of that value to 'common men.' Turquet ordered it done."

8. This is Tancock's reading and it is convincing. See John L. Tancock, *The Sculpture of Auguste Rodin* (Philadelphia: Philadelphia Museum of Art, 1976), p. 235.

9. Mauclair, *Rodin, l'homme* (1918), pp. 25–26.

4. *How 'The Gates of Hell' Were Made: The First Campaign, 1880–1889*

1. Letter from Rodin to Commissioner, October 20, 1881, Rodin dossier, Archives Nationales, Paris.

2. See J. Kirk T. Varnedoe, "Rodin's Drawings," in Albert E. Elsen, ed., *Rodin Rediscovered* (Washington, D.C.: National Gallery of Art, 1981), p. 166, n. 9.

3. Judith Cladel, *Rodin, sa vie glorieuse, sa vie inconnue* (Paris: Bernard Grasset, 1950), p. 140.

4. Letter from Rodin to Commissioner, December 11, 1881, Rodin dossier, Archives Nationales, Paris.

5. Roger Ballu to Commissioner, 1882, Rodin dossier, Archives Nationales, Paris.

6. Roger Ballu, "Rapport à Monsieur le Ministre de l'Instruction Publique et des Beaux-Arts," November 13, 1883, Rodin dossier, Archives Nationales, Paris. See also Ballu's report dated January 23, 1883.

7. "My friend Rodin tells me that you would like to have my opinion on the decorative portal that he is executing for the Ministry of Fine Arts. This is a pleasant rather than an easy task for me, for I think so highly of his work which has been begun, that it would be difficult for me, without appearing to exaggerate, to enumerate all the great artistic virtues that it combines; let it suffice for me to say that in my opinion it will be . . . one of the finest works of art of this century and perhaps also the most original." Quoted in Robert Descharnes and Jean-François Chabrun, *Auguste Rodin* (New York: Macmillan, 1967), p. 84.

8. Truman H. Bartlett, "Auguste Rodin, Sculptor," first published in *American Architect and Building News*, vol. 25 (1889), reprinted in Albert E. Elsen, ed., *Auguste Rodin: Readings on His*

Life and Work (Englewood Cliffs, N.J.: Prentice-Hall, 1965), p. 74.

9. Truman H. Bartlett notes, Library of Congress, Washington, D.C.

10. *Ibid.*

11. "The master works on 'La Porte de l'Enfer' for the future Palace of Decorative Arts." Paul Guigou, "La Sculpture Moderne," *La Revue Moderne* (Paris), September 30, 1885, p. 75.

12. This comment from Emile Michel (in an incomplete clipping without citation in the Musée Rodin archives) was echoed in Rodin's second show at the same gallery in 1889 by Rodolphe Darzen, "Chronique d'Art," *La Jeune France*, January 1888.

13. This document is in the Musée Rodin file on Gonon.

14. Rodin dossier, Archives Nationales, Paris.

15. Octave Mirbeau, "Auguste Rodin," *La France*, February 18, 1885.

16. This photograph is reproduced in *Auguste Rodin—Plastik, Zeichnungen, Graphik*, a catalogue edited by Claude Keisch for the Staatlichen Museen zu Berlin/DDR, 1979, p. 107.

17. In addition to the Musée Rodin collection, there are a large number of Rodin drawings of moldings in the Philadelphia Museum of Art. Unfortunately they are not dated, and it seems that they were done largely after 1890.

18. Rodin dossier, Archives Nationales, Paris.

19. *Ibid.*

5. *How Rodin Worked on the Sculpture*

1. Truman H. Bartlett, "Auguste Rodin, Sculptor," first published in *American Architect and Building News*, vol. 25 (1889), reprinted in Albert E. Elsen, ed., *Auguste Rodin: Readings on His Life and Work* (Englewood Cliffs, N.J.: Prentice-Hall, 1965), p. 106. (All references to the Bartlett articles are to the reprint.)

2. *Ibid.*, p. 102.

3. *Ibid.*, p. 44.

4. *Ibid.*, p. 26.

5. Truman H. Bartlett notes, Library of Congress, Washington, D.C.

6. Bartlett, "Auguste Rodin, Sculptor," p. 30.

7. Judith Cladel, *Rodin, sa vie glorieuse, sa vie inconnue* (Paris: Bernard Grasset, 1950), p. 141.

8. Edmond and Jules de Goncourt, *Journal, Mémoires de la vie littéraire*, vol. 8, 1889–91 (Paris: Flammarion, 1851–95), p. 168.

9. Bartlett notes.

10. "Un Chef-d'oeuvre retrouvé: Deux sculptures d'enfants par Rodin," *Plaisir de France*, May 1971.

11. This observation was first made by William Harlan Hale, *The World of Rodin, 1840–1917* (New York: Time-Life Books, 1969), p. 89.

12. Bartlett, "Auguste Rodin, Sculptor," p. 42.

13. I discuss these proposed sources in my forthcoming book, *Rodin's Thinker and the Dilemmas of Modern Public Sculpture*, Yale University Press.

14. Cladel, *Rodin, sa vie*, p. 142.

15. Camille Mauclair, *Auguste Rodin: The Man—His Ideas—His Works* (London: Duckworth, 1905), p. 65.

16. I discuss the history of this sculpture in some detail in my forthcoming book on *The Thinker*.

17. For a reproduction of this work see Robert Descharnes and Jean-François Chabrun, *Auguste Rodin* (New York: Macmillan, 1967), p. 38. This information on Rodin's use of a plaster cast is given in J. A. Schmoll, *Torso—das Unvollendete als Kunstlerische Form* (Bern: Franke, 1959), p. 24.

18. For reproductions and discussion of this now lost monument see Albert Alhadeff, "Michelangelo and the Early Rodin," *Art Bulletin*, 45 (December 1963): 363–67.

19. Letter from Rodin to Marcel Adam reprinted in *Gil Blas*, July 7, 1904.

20. Cladel, *Rodin, sa vie*, p. 135. Cladel makes an interesting comparison with Puget's *Satyr* and points out that the model for *Adam* was a sidewalk strongman named Caillou.

21. Mauclair, *Rodin: The Man* (1905), p. 208.

22. *Ibid.*, p. 67.

23. Bartlett, "Auguste Rodin, Sculptor," p. 50.

24. For reproductions of the Eves by Guilbert and Dubois see Albert E. Elsen, ed., *Rodin Rediscovered* (Washington, D.C.: National Gallery of Art, 1981), pp. 312, 26.

25. Mauclair, *Rodin: The Man* (1905), pp. 206, 209.

26. For a brilliant discussion of the meaning and history of this motif see Leo Steinberg, "Michelangelo's Florentine Pietà: The Missing Leg," *Art Bulletin*, 50 (December 1968): 343–53.

27. From an unsigned, untitled article from *La Revue* (Paris), November 1, 1907, in the Musée Rodin archives.

28. Cladel, *Rodin, sa vie*, p. 140.

29. Bartlett, "Auguste Rodin, Sculptor," p. 90.

30. *La Revue* (Paris), May 1906.

31. Bartlett, "Auguste Rodin, Sculptor," p. 72.

32. M. d'Auray, "Chronique d'art," *Courrier du Soir* (Paris), June 26, 1889.

33. See Albert E. Elsen, *In Rodin's Studio* (Ithaca, N.Y.: Cornell University Press, 1980), plate 36.

34. The poem was *La Beauté*: "I am beautiful oh mortal as a dream carved in stone, and my breast upon which each dies in his turn is made to inspire a poet with love, just as eternal and silent as matter."

35. For a reproduction of the Sèvres vase showing the old and young woman together see Roger Marx, *Auguste Rodin: Céramiste* (Paris: Société de Propagation des Livres d'Art, 1907), plate XVII.

36. Bartlett, "Auguste Rodin, Sculptor," p. 89.

37. Mauclair, *Rodin: The Man* (1905), pp. 22–23.

38. Frederick Lawton, *The Life and Work of Auguste Rodin* (London: Unwin, 1906), pp. 162–63.

39. Hugues le Roux, untitled article in *Le Temps* (Paris), June 20, 1889.

40. W. G. C. Byvanck, *Un Hollandais à Paris en 1891* (Paris: Perrin, 1892), p. 8.

41. Bartlett, "Auguste Rodin, Sculptor," p. 90.

42. Le Roux in *Le Temps*, June 20, 1889.

43. For a thorough presentation of this subject see Victoria Thorson, *Rodin's Graphics: A Catalogue Raisonné of Drypoints and Book Illustrations* (San Francisco: Fine Arts Museums of San Francisco, 1975), pp. 82–105. See also Claudie Judrin, *Rodin et les écrivains de son temps* (Paris: Musée Rodin, 1976).

44. De Goncourt, vol. 7, p. 169.

45. Thorson, p. 79.

46. As both artists came to decide upon an overall structure for their emotional and infernal themes, they would have looked for and developed more internal rapport with individual works, as well as filled out where the structure required. While both began with certain key works, *Les Fleurs du Mal* and *The Gates of Hell* were arrived at more or less inductively. Individual poems like plaster figures stand on their own. The two created more works than they could use: for years edit and exile were the order of the day. Both were coldly dedicated to honing an art inspired by passion. They labored long, by trial and error, over their arrangements, and in the end poet and sculptor counted on the cumulative effect of the whole. Paralyzing illness followed by death prevented the two men from personally carrying out the final realization of their works. For all the thought and care Baudelaire and Rodin gave to their monuments, neither lived to see contemporary critics appreciate their compositional achievements. Just what Rodin's contemporaries did say about his work before 1890, however, is available to us.

6. The Commentators, 1885–1889

1. Edmond and Jules de Goncourt, *Journal, Mémoires de la vie littéraire*, vol. 7, 1885–88 (Paris: Flammarion, 1851–95), pp. 92–93.

2. Truman H. Bartlett, "Auguste Rodin, Sculptor," first published in *American Architect and Building News*, vol. 25 (1889), reprinted in Albert E. Elsen, ed., *Auguste Rodin: Readings on His Life and Work* (Englewood Cliffs, N.J.: Prentice-Hall, 1965), p. 68. (All references to the Bartlett articles are to the reprint.)

3. *Ibid.*, p. 69. 4. *Ibid.*, pp. 70–78.

5. *Ibid.*, p. 79. 6. *Ibid.*, p. 68.

7. *Ibid.*, p. 75.

8. Camille Mauclair, *Auguste Rodin: The Man—His Ideas—His Works* (London: Duckworth, 1905), p. 207.

9. *Ibid.*, p. 209.

10. See Auguste Rodin, *L'Art, Entretiens réunis par Paul Gsell*, 2d ed. (Paris: Grasset, 1911), p. 101.

11. *Ibid.*, p. 200.

12. Bartlett, "Auguste Rodin, Sculptor," pp. 62–63.

13. *Ibid.*, p. 95.

14. Auguste Rodin, untitled article in *Antée* (Paris), June 1, 1907.

7. The Last Campaign, 1899–1900

1. The other names that I have been able to decipher are Arrighi, Vimnera, Husson, Edmond, Raphael, Bandettini, Fromont, André Demont, Maguery, Tosi, J. Joseph, Pierre Detruy, Frédéric Paillet, and Bongini.

2. The plaster mold makers should not have been paid as much as the more skilled professional sculptor assistants who actually did modeling, so that the figure cited for Guiochet's hourly wage is probably a little high.

3. Léon Maillard, *Auguste Rodin, statuaire: Etudes sur quelques artistes originaux* (Paris: H. Floury, 1899), p. 77.

4. Judith Cladel, *Rodin, sa vie glorieuse, sa vie inconnue* (Paris: Bernard Grasset, 1950), p. 20.

5. Alhadeff correctly identifies the relief as a self-portrait but misreads Bartlett's text, and he mistakes Rodin's *Orpheus and Eurydice* for the relief in question. See Albert Alhadeff, "Rodin: A Self-Portrait in *The Gates of Hell*," *Art Bulletin*, 48 (1966): 393–95. For this reason neither Alhadeff nor anyone else can so far prove the relief was done before 1889. I believe it dates from 1900, as that is when Rodin thought he was through with the work. In a paper given at the 1979 International Congress on Art History at Bologna, J. A. Schmoll argued that the portal was completed at the end of Rodin's life, based on the previously cited request by Bénédite for the final funds owed Rodin. Schmoll believes this self-portrait was not added until long after 1900. (His paper will be published as part of the proceedings of the Congress.) Schmoll did not have access to the materials on which I first presented my views. His argument of the influence of Goethe on the making of the reliefs of mothers and children flanking the tombs after 1902 is canceled by their appearance in photographs taken of the doors in 1900 (Fig. 136). It appears that Schmoll did not know Alhadeff's article and does not credit him for being the first to make the important identification of the self-portrait, which could not have been based on Gertrude Kasebier's portrait of the sculptor made in 1908 as Schmoll contends. Schmoll continues his argument in his recent book, *Rodin-Studien: Persönlichkeit—Werke—Wirkung—Bibliographie* (Munich: Prestel Verlag, 1983), but his interpretation remains unconvincing; see pp. 224–25 and n. 13, p. 386.

6. Judith Cladel, *Le Sculpteur Auguste Rodin, pris sur la vie* (Paris: La Plume, 1903), p. 52.

7. Judith Cladel, *Rodin: The Man and His Art* (London: Century, 1917), p. 280.

8. *Ibid.*, p. 280.

9. John L. Tancock, in *The Sculpture of Auguste Rodin* (Philadelphia: Philadelphia Museum of Art, 1976), p. 105, quotes from Gaston Varenne, "Bourdelle inconnue: Les rapports entre Bourdelle et Rodin (documents inédits)," *La Revue de France* (Paris), October 1, 1934, p. 458: "Bourdelle said to Rodin, 'I would have fear . . . if one opened the door that it not hit me in the eye. It is neither a wall nor a door.' To make his point Bourdelle had hung his hat from one of the projections of the sculpture." The problem with this story is that the central door panels would have opened inward, not outward, and unless Bourdelle was in the studio in 1899–1900 when the doors were fully assembled, he would have had trouble hanging his hat on them because Rodin had removed all the projecting forms. No question Bour-

delle disliked the doors and he was to develop his own pseudo-archaizing flat-surfaced architectural sculpture.

10. Cladel, *Rodin, sa vie*, p. 141.

8. 'The Gates of Hell,' 1900–1917: Complete But Not "Finished"

1. Léon Maillard, *Auguste Rodin, statuaire: Etudes sur quelques artistes originaux* (Paris: H. Floury, 1899), p. 86.

2. This article by Hauser is in the Musée Rodin archives, and as sometimes happens there is crucial information lacking because of faded ink or careless cutting by one of Rodin's clipping services.

3. Maillard, p. 68.

4. J. A. Schmoll, paper given at 1979 International Congress on Art History, Bologna.

5. Rainer Maria Rilke, *Auguste Rodin* (1903), in Albert E. Elsen, ed., *Auguste Rodin: Readings on His Life and Work* (Englewood Cliffs, N.J.: Prentice-Hall, 1965), p. 125.

6. Quoted in John L. Tancock, *The Sculpture of Auguste Rodin* (Philadelphia: Philadelphia Museum of Art, 1976), p. 102.

7. Kenyon Cox, "Rodin," in his *Painters and Sculptors* (New York: Duffield, 1907), p. 138.

8. For years it was believed that Jules Mastbaum paid for the first bronze casting of the doors for the Musée Rodin, but a communication from Hélène Pinet, archivist at the Musée Rodin, dated June 23, 1983, informs me that it was Matsukata who paid for this cast. Mastbaum did pay for the very first casting, the one that went to the Rodin Museum in Philadelphia. Unfortunately there is still no plaque in the garden of the Paris Musée Rodin crediting Matsukata.

9. Judith Cladel, *Rodin, sa vie glorieuse, sa vie inconnue* (Paris: Bernard Grasset, 1950), p. 141.

10. *Ibid.*, p. 142.

11. Léonce Bénédite, "Auguste Rodin," *Gazette des Beaux-Arts*, 14 (1918): 22.

12. Henri Frantz, "The Great New Doors by Auguste Rodin," *Magazine of Art*, September 1898, p. 276.

13. Bénédite, "Auguste Rodin," p. 32.

14. Gustave Coquiot, *Auguste Rodin à l'Hôtel de Biron et à Meudon* (Paris: Ollendorff, 1917), pp. 102–3.

15. "Le Musée Rodin," *Cri de Paris*, December 16, 1917.

16. Robert Descharnes and Jean-François Chabrun, *Auguste Rodin* (New York: Macmillan, 1967), p. 96.

17. In 1921, during the course of a trial on charges brought by the State against a founder who was casting Rodin's work without authorization, it was shown that Bénédite had authorized the enlargement of Rodin's *La Défense* after the artist's death; the enlargement was commissioned by the government of the Netherlands as a gift to the city of Verdun. The transcripts of this trial are in the Musée Rodin.

18. Cladel, *Rodin, sa vie*, p. 397.

9. 'The Gates of Hell' Viewed by Rodin's Contemporaries

1. Léon Maillard, *Auguste Rodin, statuaire: Etudes sur quelques artistes originaux* (Paris: H. Floury, 1889), p. 81.

2. Octave Mirbeau, "Auguste Rodin," *La France*, February 18, 1885.

3. Truman H. Bartlett, notes in the Library of Congress, Washington, D.C.

4. Félicien Champsaur, "Celui qui revient de l'Enfer: Auguste Rodin," *Le Figaro*, January 16, 1886.

5. W. C. Brownell, "Auguste Rodin," *Scribner's Magazine*, September 1901.

6. Henri Frantz, "The Great New Doors by Auguste Rodin," *Magazine of Art*, September 1898; Edouard Rod, "L'Atelier de M. Rodin," *Gazette des Beaux-Arts*, May 1898.

7. Gustave Geffroy, "Auguste Rodin," in *Auguste Rodin et son oeuvre*, special edition of *La Plume*, 1900.

8. M. d'Auray, "Chronique d'art," *Courrier du Soir* (Paris), June 26, 1889.

9. The client, a man named Ionides, used the title "Le Penseur" in a letter acknowledging receipt of the sculpture. The letter is in his file in the Musée Rodin.

10. Georges Rodenbach, untitled article in *Journal de Bruxelles*, June 28, 1889.

11. Camille Mauclair, "L'Art de M. Auguste Rodin," *La Revue des Revues*, June 15, 1898.

12. Serge Basset, "La Porte de l'Enfer," *Le Matin* (Paris), March 19, 1900.

13. Rainer Maria Rilke, *Auguste Rodin* (1903), in Albert E. Elsen, *Auguste Rodin: Readings on His Life and Work* (Englewood Cliffs, N.J.: Prentice-Hall, 1965), p. 128.

14. Truman H. Bartlett, "Auguste Rodin, Sculptor," first published in *American Architect and Building News*, vol. 25 (1889), reprinted in Elsen, ed., *Auguste Rodin: Readings*, p. 77. (All references to the Bartlett articles are to the reprint.)

15. W. G. C. Byvanck, *Un Hollandais à Paris en 1891* (Paris: Perrin, 1892), p. 8.

16. Mirbeau in *La France*, February 18, 1885.

17. Champsaur in *Le Figaro*, January 16, 1886.

18. Edmond and Jules de Goncourt, *Journal, Mémoires de la vie littéraire*, vol. 7, 1885–88 (Paris: Flammarion, 1851–95), p. 93.

19. D'Auray in *Courrier du Soir*, June 26, 1889.

20. Roger-Milès, untitled article in *Evénement*, June 23, 1889.

21. Rodenbach in *Journal de Bruxelles*, June 28, 1889.

22. Gustave Geffroy, "Le Statuaire Rodin," *Les Lettres et les Arts*, September 1, 1889. Reprinted in *Claude Monet, A. Rodin* (Paris: Galerie Georges Petit, 1889); and as "Auguste Rodin," in Gustave Geffroy, *La Vie artistique* (Paris: E. Dentu, 8 vols., 1892–1903), vol. 3, pp. 62–115.

23. Anatole France, "La Porte de l'Enfer," *L'Echo de Semaine* (Paris), June 17, 1900.

24. Judith Cladel, *Le Sculpteur Auguste Rodin, pris sur la vie* (Paris: La Plume, 1903), p. 52.

25. Stuart Merrill, "La Philosophie de Rodin," in *Auguste Rodin et son oeuvre*, special edition of *La Plume*, 1900.

26. Camille Mauclair, *L'Oeuvre de Rodin* (Paris: La Plume, 1900).

27. Roger-Milès in *Evénement*, June 23, 1889.

28. D'Auray in *Courrier du Soir*, June 26, 1889.

29. Theodore Child, "High, Original Art: Auguste Rodin," *The Sun* (New York), February 1, 1891.

30. Mirbeau, in *La France*, February 18, 1885; Camille Mauclair, *Auguste Rodin: The Man—His Ideas—His Works* (London: Duckworth, 1905), p. 87.

31. Paul Guigou, "La Sculpture moderne," *La Revue Moderne* (Paris), September 30, 1885.

32. Bartlett, "Auguste Rodin, Sculptor," p. 75.

33. Judith Cladel, *Rodin, sa vie glorieuse, sa vie inconnue* (Paris: Bernard Grasset, 1950), p. 144.

34. G. Dargenty, untitled article in *Courrier d'Art*, July 1, 1886.

35. Bartlett notes.

36. Maillard, p. 85.

37. *Ibid.*

38. Frantz in *Magazine of Art*, September 1898.

39. Roger Marx, quoted in Frederick Lawton, *The Life and Work of Auguste Rodin* (London: Unwin, 1906), p. 107.

40. Kenyon Cox, "Rodin," in his *Painters and Sculptors* (New York: Duffield, 1907), p. 137. See also Brownell in *Scribner's Magazine*, September 1901.

41. Jacques-Emile Blanche, *Portraits of a Lifetime*, trans. Walter Clement (London: J. M. Dent, 1937), p. 118.

42. Bartlett notes.

43. Judith Cladel, *Rodin: The Man and His Art* (London: Century, 1917), pp. 280–83.

44. *Ibid.*, pp. 276–77.

45. Cladel, *Rodin, pris sur la vie*, p. 29.

46. Lawton, pp. 160–61.

10. A Tour of 'The Gates of Hell'

1. Auguste Rodin, *Les Cathédrales de France* (Paris: Armand Colin, 1914), n.p.

2. This drawing was reproduced by Kirk Varnedoe in his essay "Rodin Drawings," in Albert E. Elsen, ed., *Rodin Rediscovered* (Washington, D.C.: National Gallery of Art, 1981), and he discusses it on pp. 180–81. Rodin, speaking of Gothic molders in his book *Les Cathédrales de France*, said, "Woman, eternal model, gives these undulating forms."

3. Denise Jalabert, *La Flore sculptée des monuments du Moyen Age en France* (Paris: Picard, 1965).

4. For an excellent photo of the canopy of the tomb of Margaret of Austria see Wim Swaan, *The Late Middle Ages: Art and Architecture from 1350 to the Advent of the Renaissance* (Ithaca, N.Y.: Cornell University Press, 1977), plate 127.

5. For photographs of these caryatids see Robert Descharnes and Jean-François Chabrun, *Auguste Rodin* (New York: Macmillan, 1967), pp. 42, 43.

6. For the reproduction of the left bas-relief see Léon Maillard, *Auguste Rodin, statuaire: Etudes sur quelques artistes originaux* (Paris: H. Floury, 1899), facing p. 78.

7. Roger Marx, *Auguste Rodin: Céramiste* (Paris: Société de Propagation des Livres d'Art, 1907), plate XVII.

8. According to Claudie Judrin, *Rodin et les écrivains de son temps* (Paris: Musée Rodin, 1976), p. 42, this is a transfer drawing made either on tracing paper or by a process called "chromograph," which, like his casting in plaster, allowed Rodin to make variations on the original without actually reworking it.

9. Georges Grappe, *Catalogue du Musée Rodin* (Paris: Les Documents d'Art, 1944), no. 417. For a good discussion of these reliefs as well as of those having the tragic masks that preceded them see J. A. Schmoll, *Rodin-Studien: Persönlichkeit—Werke—Wirkung—Bibliographie* (Munich: Prestel Verlag, 1983), pp. 225–28.

10. See Marx, *Rodin Céramiste*, plates VI, VII, XI, XIV, XV.

11. Albert Alhadeff considers her a Siren; see "Rodin: A Self-Portrait in The Gates of Hell," *Art Bulletin*, 48 (1966): 393–95. Schmoll thinks she is the fallen Eve; see *Rodin-Studien*, p. 224.

12. See Alhadeff, "Rodin: A Self-Portrait," pp. 393–95.

13. See Rosalyn F. Jamison's fine study, "Rodin's Humanization of the Muse," in Elsen, *Rodin Rediscovered*, p. 106.

11. Rodin and His Time

1. Henri Dujardin-Beaumetz, "Rodin's Reflections on Art," in Albert E. Elsen, ed., *Auguste Rodin: Readings on His Life and Work* (Englewood Cliffs, N.J.: Prentice-Hall, 1965), p. 53.

2. See E. M. Acomb, *The French Laic Laws* (New York: Columbia University Press, 1940).

3. Robert Descharnes and Jean-François Chabrun, *Auguste Rodin* (New York: Macmillan, 1967), p. 52.

4. Rodin made this comment in an unsigned interview titled "Le Penseur de Rodin," which appeared in *La Patrie* (Paris) on April 22, 1906—the day after *The Thinker* was inaugurated before the Panthéon in Paris. The reporter wrote: "I asked the maker of *The Thinker* what his feelings were about the work and its social significance." Rodin's reply is quoted at length: "My work, why must one speak of it? It magnifies the fertile thought of those humble people from the soil who nevertheless generate powerful energy. It [*The Thinker*] is in itself a social symbol, like the sketch of this Monument to Labor that we dream of erecting in honor of national labor and the workers of France.

"All those who believe and grow, do they not appropriate energy from the obscure but steady force of artisans who produce the public riches, and from the methodical gleaners of the good grain as opposed to the sowers of weeds? One can never say enough, in this period of social troubles, about how vast the difference is between the mentality of the workers and the spirit of the unemployed of this country.

"*The Thinker* on his socle . . . dreams of all these things, and be assured that in him vain utopias will not germinate, there will

not come from his lips unpious words; his gesture could not be that of a provocateur abused by false promises. Yes, let us exalt the little people and tomorrow we will have brought a remedy to social conflict."

I discuss Rodin's interpretation of his enlarged statue before the Panthéon in terms of the social conflicts of the time in my forthcoming book, *Rodin's Thinker and the Dilemmas of Modern Public Sculpture*, Yale University Press.

5. Anthony M. Ludovici, *Personal Reminiscences of Auguste Rodin* (New York: J. B. Lippincott, 1926), p. 75.

6. Adrien Dansette, *Religious History of Modern France*, vol. 2 (New York: Herder and Herder, 1961), p. 359.

7. See C. S. Phillips, *The Church in France, 1848–1907* (London: Russell and Russell, 1967), p. 186.

8. Camille Mauclair, *Auguste Rodin, l'homme et l'oeuvre* (Paris: La Renaissance du Livre, 1918), p. 62.

9. Auguste Rodin, *L'Art: Entretiens réunis par Paul Gsell* (Paris: Grasset, 1911), p. 233.

10. Ludovici, pp. 74–75.

11. Mauclair, *Rodin, l'homme* (1918), p. 25.

12. Judith Cladel, *Rodin, sa vie glorieuse, sa vie inconnue* (Paris: Bernard Grasset, 1950), p. 84.

13. *Ibid.*

14. For an interpretation of this work see my *In Rodin's Studio* (Ithaca, N.Y.: Cornell University Press, 1980), p. 180. See also Jacques de Caso and Patricia B. Sanders, *Rodin's Sculpture: A Critical Study of the Spreckels Collection, California Palace of the Legion of Honor* (San Francisco: Fine Arts Museums of San Francisco; Rutland, Vt.: Charles E. Tuttle, 1977), pp. 92–97.

15. J. Kirk T. Varnedoe, "Rodin's Drawings," in Albert E. Elsen, ed., *Rodin Rediscovered* (Washington, D.C.: National Gallery of Art, 1981), p. 155 and n. 5, p. 156.

16. Ruth Butler, "Rodin and the Paris Salons," in Elsen, *Rodin Rediscovered*, pp. 23–24.

17. Rodin's library housed in the Musée Rodin is not yet available for use by scholars although specific inquiries about certain books can be accommodated.

18. Cladel, *Rodin, sa vie*, p. 150.

19. Truman H. Bartlett, "Auguste Rodin, Sculptor," first published in *American Architect and Building News*, vol. 25 (1889), reprinted in Elsen, *Auguste Rodin: Readings*, p. 108. (All references to the Bartlett articles are to the reprint.)

20. Camille Mauclair, *Auguste Rodin: The Man—His Ideas—His Works* (London: Duckworth, 1905), p. 213.

21. Claudie Judrin, *Les Centaurs* (Paris: Musée Rodin, 1981), p. 7.

22. See Victoria Thorson, *Rodin's Graphics: A Catalogue Raisonné of Drypoints and Book Illustrations* (San Francisco: Fine Arts Museums of San Francisco, 1975), for an inventory of Rodin's illustrations.

23. For Rodin's relation to writers see Judrin's excellent *Rodin et les écrivains de son temps* (Paris: Musée Rodin, 1976).

24. Alfred de Musset, *Confessions of a Child of This Century*, trans. P. Jazet (New York: Current Literature Publications, 1908), p. 305.

25. Henri Peyre, *Victor Hugo: Philosophy and Poetry*, trans. Roda P. Roberts (University: University of Alabama Press, 1980), p. 47.

26. This is a line from Hugo's "Ce que dit la bouche de l'homme," in John P. Houston, *Victor Hugo* (New York: Twayne, 1974), p. 102.

27. Philippe Ariés, *The Hour of Our Death* (New York: Knopf, 1981), pp. 576–77.

28. See especially John P. Houston, *The Demonic Imagination* (Baton Rouge: Louisiana State University Press, 1969).

29. *Ibid.*, p. 68.

30. *Ibid.*, p. 69.

31. Albert J. George, *Lamartine and Romantic Unanimism* (New York: Columbia University Press, 1940); see especially the Introduction.

32. This excerpt is from Peyre, *Victor Hugo*, pp. 89–91.

33. M. Z. Shroder, *Icarus: The Image of the Artist in French Romanticism* (Cambridge, Mass.: Harvard University Press, 1961), p. 152. This is an outstanding book and extremely helpful in placing *The Thinker* within the context of nineteenth-century poets and writers.

34. See V. S. Pritchett, *Balzac* (New York: Knopf, 1973), p. 164.

35. Houston, *Demonic Imagination*, p. 50.

36. Arthur Symons, "Notes on Auguste Rodin," *Apollo* (London), August 1931, p. 126; Mauclair, *Rodin: The Man* (1905), p. 213.

37. Cladel, *Rodin: The Man and His Art* (London: Century, 1917), p. 107.

38. Paul Valéry, "Baudelaire," in Henri Peyre, ed., *Baudelaire, A Collection of Critical Essays* (Englewood Cliffs, N.J.: Prentice-Hall, 1962), p. 16.

39. Shroder writes: "The word *poète* was a Romantic term of approval and a password to acceptance in the *cénacles* and the studios . . . but it carried a broader meaning than 'he who writes verse.' The poet, in the absolute sense in which the Romantics of 1830 understood the word, was the man of imagination, the creative genius—versifier, novelist, painter, sculptor, musician. In fact, the emphasis laid on imagination and on creative activity was so great that the poet—and, indeed, the artist, though the use of this word was somewhat more strict—did not even have to be concerned with art at all." Shroder, p. 9.

40. Valéry, p. 174.

41. Shroder, p. 88.

42. Bartlett, "Auguste Rodin, Sculptor," p. 81; Mauclair, *Rodin: The Man* (1905), p. 209.

43. Mauclair, *Rodin: The Man* (1905), p. 213.

44. Dominique Fourcade, *Henri Matisse, écrits et propos sur l'art* (Paris: Hermann, 1972), p. 179.

45. Mauclair, *Rodin: The Man* (1905), p. 60.

46. See Rosalyn F. Jamison, "Rodin's Humanization of the Muse," in Elsen, *Rodin Rediscovered*.

12. Conclusion

1. Truman H. Bartlett, notes in the Library of Congress, Washington, D.C.

2. Truman H. Bartlett, "Auguste Rodin, Sculptor," first published in *American Architect and Building News*, vol. 25 (1889), reprinted in Albert E. Elsen, ed., *Auguste Rodin: Readings on His Life and Work* (Englewood Cliffs, N.J.: Prentice-Hall, 1965), p. 108.

3. Bartlett notes.

Illustration Credits

The illustrations numbered below are courtesy of the following institutions and individuals:

Musée Rodin, Paris, *frontispiece*, 2–4, 8–9, 11–12, 14–16, 18–19, 23–25, 27, 31, 33, 35–37, 39–44, 47–48, 50–56, 58, 60, 72, 74–77, 117–31, 133–34, 136, 141–42, 197, 199–201
Albert E. Elsen, 1, 5–7, 38, 45–46, 57, 61, 78–116, 135, 137–40, 195–96
B. G. Cantor Art Foundation, New York, 63–64, 146–92, 202–3
Museum of Modern Art, New York, 10, 17, 20–21, 26, 32, 143–45
Alinari, 28, 34, 59, 62, 66–68
Philadelphia Museum of Art, 22, 49
Horst W. Janson Photographic Archive, New York, 29, 71
Stanford University Art Museum, 70, 194
Fogg Art Museum, Cambridge, Mass., 13
The Louvre, Paris, 30
Anderson, 65
Ny Carlsberg Glyptothek, Copenhagen, 69
Ruth Butler, Boston, 73
Gabe Weisberg, Washington, D.C., 132
Archeological Museum, Saintes, Charente-Maritime, 193
J. Kirk T. Varnedoe, New York, 198

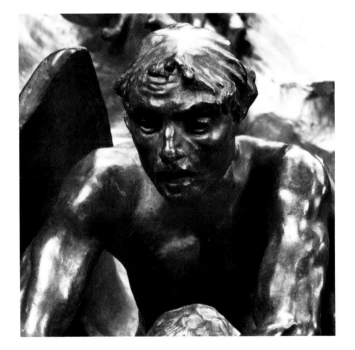

Library of Congress Cataloging in Publication Data

Elsen, Albert Edward, 1927–
 The Gates of hell by Auguste Rodin.

 Bibliography: p.
 1. Rodin, Auguste, 1840–1917. Gates of hell.
I. Title.
NB553.R7A693 1985 730'.92'4 84-51717
ISBN 0-8047-1273-5
ISBN 0-8047-1281-6 (pbk.)